TEXT BY CARISSA BLUESTONE

FOREWORD BY ELIZABETH KOLBERT

ABRAMS, NEW YORK

PHILIPPE BOURSEILLER

FOREWORD

he book that you are holding in your hands is based on contradiction or, if you prefer, disproportion. Each date presents a bit of advice for ordinary urban and suburban living: dispose of leftover paint properly; check your car's exhaust; boil only as much water as you need when

making tea or coffee. Paired with each proposal is one of Philippe Bourseiller's spectacular photographs of the natural world–Alaska's Denali Massif, Hawaii's Kilauea Volcano, or Patagonia's Cerro Torre. On the left is the quotidian, on the right the sublime.

The amazing thing about this disproportion is that it turns out to be not at all disproportionate. How we go about our daily lives-what we eat, how we get to work, where we build our houses-has a transformative effect not just on our immediate surroundings, but on places as far away as the North Pole and Antarctica. In days spent moving from underground parking garages to hermetically sealed office towers and back again to air-conditioned homes, this fact is easily overlooked, and therefore it is all the more imperative that we attend to it. The food we buy in the supermarket often comes from halfway around the world; by purchasing it, we may be supporting the destruction of distant forests and indigenous cultures. The fertilizer we apply to our lawns washes off into streams and

eventually into the sea, where it contributes to algae blooms that produce eutrophic "dead zones" where no fish can survive. The water we pump from underground aquifers cannot be replaced as quickly as it is withdrawn; what we waste running half-empty dishwashers today will be lost to future generations that surely will need it.

Global warming is perhaps the clearest example of how our ordinary, everyday actions alter the planet. One of the most astonishing places that Philippe Bourseiller photographed for this volume is Greenland, which, after Antarctica, is home to the world's largest ice sheet. Last summer, I visited Greenland to interview scientists who were studying the effects of warming on the ice. I spent a day in a village on Disko Bay watching icebergs float out to sea and while I was there I spoke with some native fishermen. They described how they have seen the icebergs in the bay steadily grow smaller in recent years; instead of towering mountains of white that drift around for weeks, the icebergs now tend to be low and more likely to break apart. They also told me that for as long as anyone could remember, the bay had remained frozen over for several months each winter. For the last few years, however, there has been open water in Disko Bay all year long. The fishermen are alarmed by the change, as we all should be.

Sea ice reflects sunlight; open water absorbs it. Great stretches of Arctic sea ice are disappearing and as they vanish the earth's reflectivity decreases. The result is a feedback mechanism that amplifies human-induced global warming and pushes us closer and closer to catastrophe. Scientists warn that if we do not take steps soon to curb our emissions of greenhouse gases, we could begin to melt not just the sea ice, but the Greenland ice sheet itself. Greenland's ice sheet holds enough water to raise global sea levels by 23 feet.

mericans make up only 4 percent of the world's population, and yet we produce nearly a quarter of the world's greenhouse gas emissions. This imposes on us a particularly heavy responsibility for the way the planet is changing. Roughly three-quarters of all electricity in the United States is produced by burning fossil fuels, so every time we flip on the lights, turn on the coffee maker, or watch the news on TV, we are adding to the problem, if indirectly. We contribute to it directly whenever we go out for a drive. Probably the singlemost important step any individual can take to reduce his or her emissions is to purchase a fuel-efficient car and then, as often as possible, leave it in the garage. Global warming is not a problem that can be "solved" by individual actions; it demands a concerted international effort-one that will stretch over decades. However, unless we Americans take steps to reduce our impact on this issue, it is hard to imagine how it can ever be addressed successfully.

One of the themes of Philippe Bourseiller's photography is the power of nature; another is nature's vulnerability. This, too,

seems to be a contradiction that ultimately is not. The forces that have shaped the planet over eons-whether volcanic eruptions or tectonic shifts-remain beyond man's influence. A human figure walking across the Greenland ice sheet or scaling Trou de Fer on Réunion appears as little more than an orange or gray dot in Bourseiller's photographs. At the same time, we tiny human beings have already proved to be quite capable of, and indeed adept at, destroying species that inhabited the planet long before our own species evolved. We are now in the process of altering the chemistry of the earth's atmosphere by burning fossil fuel deposits that were laid down during the age of the dinosaurs. Already we have succeeded in raising carbon-dioxide concentrations to a

level higher than at any other point in the last 3.5 million years. "The lifetime of one human being is nothing on a geological scale, but the traces he leaves behind can be unbelievably destructive," Bourseiller observed.

For all their grandeur, the photographs collected in this volume are elegiac. "I do not change or transform reality," Bourseiller has said about his work. "I am content with just seizing an instant of it. I hope my photographs help people become aware and fully conscious of the fact that the extraordinary landscapes that surround us are extremely fragile and they must be protected constantly."

-Elizabeth Kolbert

CATEGORIES

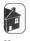

Home

January: 2, 4, 5, 7, 13, 16, 26, 28 February: 3, 6, 7, 10, 15, 17, 21, 25, 28 March: 1, 18, 23, 26, 30 April: 2, 17, 19, 22, 25, 26, 28 May: 4, 7, 14, 20, 22, 23, 25, 28, 30, 31 June: 1, 2, 5, 6, 7, 11, 13, 21, 22, 24, 26, 27, 30 July: 5, 8, 18 August: 7, 9, 21, 24 September: 5, 6, 14, 21, 24, 25, 30 October: 9, 12, 16, 17, 18, 20 November: 5, 6, 7, 10, 14, 15, 16, 18, 21 December: 5, 6, 8, 11, 14, 16, 17, 19, 28, 30

Shopping

January: 1, 8, 9, 12, 17, 20, 22, 30, 31 March: 5, 9, 11, 15, 19, 24 April: 1, 15, 18, 27, 29 May: 2, 5, 8, 9, 13, 17, 18 June: 12, 15, 16, 23, 28 July: 6, 11, 17, 23, 25, 27, 28, 29 August: 3, 10, 11, 19, 22, 23, 27, 28, 29 September: 2, 9, 23, 26, 27, 28, 29 October: 3, 5, 7, 10, 15, 19, 21, 24, 27, 29, 30 November: 4, 8, 9, 17, 19, 26, 30 December: 12, 15, 18, 21, 22, 23, 24, 27, 29

Leisure

January: 10, 11, 24 February: 2, 4, 5, 14, 26 March: 12, 13, 14, 17, 22, 27, 29 April: 6, 13, 14, 16, 21 May: 6, 12, 16, 19, 26 June: 3, 4, 8, 9, 14, 17, 19, 20, 29 July: 4, 10, 13, 14, 15, 16, 19, 20, 21, 26, 30, 31 August: 2, 6, 14, 15, 18, 20, 25, 31 September: 1, 7, 13, 19 October: 26, 31 November: 24 December: 25, 26, 31

Transportation

January: 19, 25 February: 11, 16, 19, 20 March: 6, 8, 20, 31 April: 4, 11 May: 10, 21, 27 June: 18, 25 July: 2, 12, 22 August: 1, 4, 5, 8, 13 September: 3, 10, 22 October: 2, 14, 28 November: 2, 22, 27 December: 1

Health / Family

January: 15, 18, 21, 23, 27 February: 1, 13, 22, 23 March: 2, 3, 4, 10, 28 April: 3, 5, 7, 8, 10, 23, 30 June: 10 July: 3, 9, 24 August: 12, 17, 26 September: 8, 11, 18 October: 1, 4, 6, 8, 11, 23 November: 11, 12, 23, 29 December: 2, 7, 20

Office

January: 14 February: 9, 18, 27 March: 7, 16 April: 9 May: 1, 15 July: 7 August: 30 September: 4, 15, 16, 20 October: 13, 22, 25 November: 1, 3, 13, 20, 28 December: 3, 9, 10

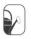

Gardening

January: 3, 6, 29 February: 8, 12, 24 March: 21, 25 April: 12, 20, 24 May: 3, 11, 24, 29 July: 1 August: 16 September: 12, 17 November: 25 December: 4, 13

Yow to be a conscientious consumer.

Everything we buy has a direct or indirect effect on the environment. Before buying a product, we must ask ourselves several questions: How was it made? Did its manufacture produce pollution? Does it use too much energy? Can the packaging be recycled? Does the availability of this product here mean the depletion of resources elsewhere?

Action to protect the environment can begin at the market stall or supermarket shelf. Begin to think about the items that you can buy from local craftspeople-candles, honey, or greeting cards, for example-because the closer you are to the source of the product, the easier it is to estimate its ecological footprint.

One of the best ways to enact change is to vote with your dollar. Buy only what you need, buy the best, most eco-friendly items available, and don't let trends fill up your home with useless purchases.

Niger River, Mali

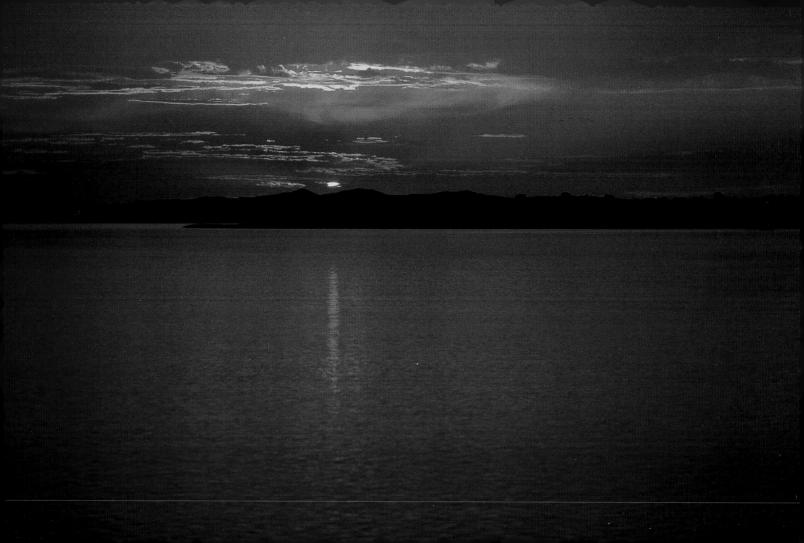

Turn down your heating by 5°F.

Buildings are a major source of the greenhouse gases responsible for climate change. Forty-seven percent of the energy used in the home is for heating and hot water. Carefully managing our domestic heating allows us to minimize global warming and to avoid further polluting the air around us.

Our homes are often heated to excess. The ideal living room temperature is 68°F, and bedrooms are comfortable at 64°F when you're under the covers. Each 5°F increase in temperature produces a 7% to 11% increase in energy consumption (depending on how well-insulated your home is). Use your heat wisely, and insulate well.

Recycle your Christmas tree.

As soon as Christmas is over, countless Christmas trees are dumped on sidewalks, to be picked up with the household waste and burned in incinerators. This process, which is costly for the community, involves the waste of a raw material that could benefit the soil. Some towns collect the trees for composting. In Georgia, more than 135 communities and organizations sponsored a Bring One for the Chipper Christmas tree composting event. Since its inception, the program has recycled almost 4.8 million trees. Besides providing mulch, recycled trees can be used in larger environmental projects like stabilizing shorelines and eroding beachfront. The National Christmas Tree Association can help you locate a local program or give you tips on starting one if your town does not collect Christmas trees.

Also, consider alternatives, like a potted Christmas tree that can later be planted in the garden.

Lobby for the right for access to renewable electricity.

In some states it is possible to sign onto renewable energy choices through your electricity provider. Other states do not provide this option. Renewable energy has far less negative impact on the environment than fossil fuels and nuclear power. If you are able to invest in renewable energy, usually it is not delivered to your location, but rather is supplied elsewhere on the grid; your contribution goes to "displacing" the use of nonrenewable power elsewhere.

Find out how you can buy green electricity. If you do not have access to it through your utility, press your local officials to make it an option. Everyone should have the right to invest in renewable energy.

Stream, Rocky Mountain National Park, Colorado

Improve the efficiency of your radiators.

The world's consumption of energy produces vast amounts of pollution and waste, especially that produced by the nuclear industry. Today there are 437 nuclear power stations in the world, 104 of which are in the United States; an additional 30 are under construction; and 74 more are in planning stages. Among them they produce 16% of the world's electricity and 10,000 tons of nuclear waste per year, in addition to the 200,000 tons already in existence.

To reduce your domestic energy consumption, make your radiators more efficient by placing reflective panels behind them that will bounce the heat back into the room. Bleed trapped air out of hot-water and steam radiators several times each season; the less air in the system, the more heat it will emit.

Prevent erosion.

Soil erosion is one form of soil degradation caused by water and wind, and aggravated by human development practices. The texture of the soil, the angle of the slope it is on, and the quality of the vegetative cover all play a part in erosion. Erosion degrades the health of the soil, impacts water quality through runoff, and damages river banks and pond edges. Some indicators of problems with erosion include bare spots on the lawn or property, muddy water in a stream or drainage ditch, exposed tree roots, silt build-up, and the widening and deepening of stream channels.

Minimize erosion by mulching, and installing gutters and downspouts that discharge onto the lawn (protect the soil at the outlet using splash blocks or drainage tile).

Klyuchevskaya Volcano, Kamchatka, Russia

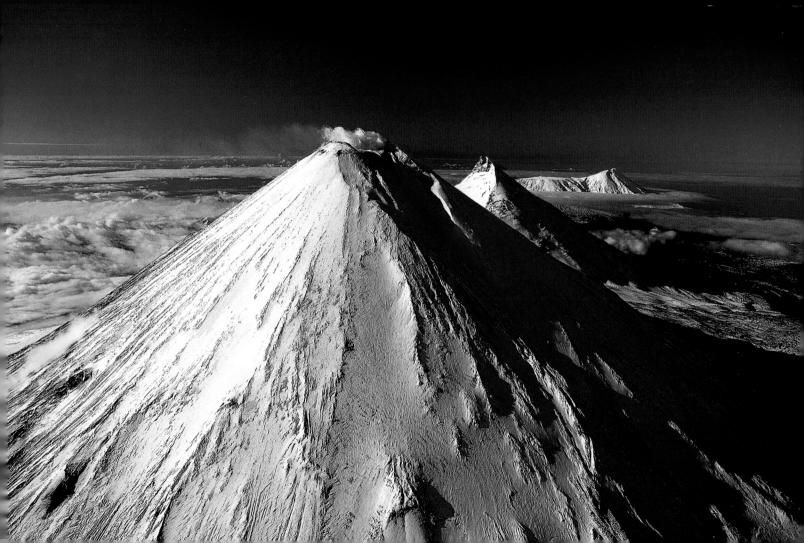

Reduce the amount of water flowing into your toilet's tank.

The average American uses 140 to 170 gallons of water at home each day. The toilet is the biggest water-waster in the bathroom, even more than the shower: A standard toilet made before 1994 can use $3\frac{1}{2}$ to 7 gallons per flush.

By placing a bottle filled with sand in your lavatory cistern you will reduce the volume of water used with each flush, saving the volume of the bottle each time you flush. Don't use a brick-pieces of decaying brick can get into the toilet's system and cause leaks. Better yet, replace your toilet with a low-flow toilet, which can decrease water use to 1.6 gallons for every flush.

Recycle your cellular phone.

Americans throw out more than 125 million cellular phones each year, resulting in more than 65,000 tons of waste that is laced with toxic components like lead and mercury. On average, cellular phones in the United States are discarded and replaced with newer models after only 12 months. In developing nations, cellular phones help people in areas that lack reliable landlines.

Your cellular phone can have a second life. Many charities collect old phones, refurbish them, and send them to people in need. You can resell a newer phone on eBay. And be sure to check with the manufacturer of your phone—they may have a take-back program that will recycle it properly.

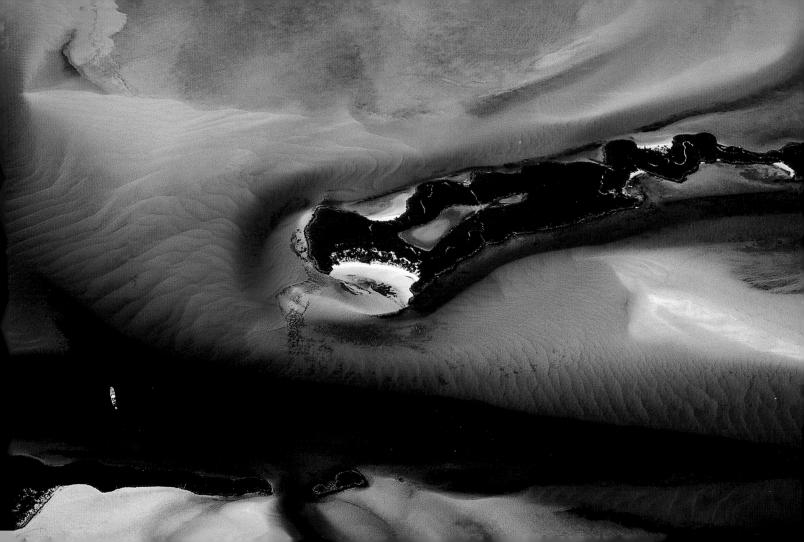

Make it a rule to buy organic produce.

To protect crops from parasitic insects and plants, farmers use pesticides; to increase the yields of their crops, they spread fertilizers that contain highly toxic chemicals. World consumption of these chemicals is growing: it leaped from 30 million tons a year in 1960 to 140 million tons in 2000. The U.S. Environmental Protection Agency (EPA) estimates that pesticides contaminate groundwater resources of 38 states; 67 million birds were among the victims of pesticides in the last year.

Organic farming spares the environment this degradation. To help encourage it, look for organic produce.

Some good choices for immediate consideration are peaches, strawberries, red and green bell peppers, apples, celery, and spinach because these products retain very high levels of pesticide residue. You can then broaden the range of products for which you buy organic at your own pace. At the farmers' market, ask vendors about their growing methods. Many small farms follow the tenets of organic agriculture but cannot officially advertise as being organic because they have not obtained certification—a difficult and expensive process.

Calculate your ecological footprint.

Want to know your impact on the planet in acres? An ecological footprint is the amount of land each of us would need to sustain our individual consumption of resources from fossil fuels to food. Currently, the global ecological footprint is 23% bigger than what the earth could technically regenerate in a year. Based on current population there are roughly 4.5 acres worth of resources per person. The average American uses 23.7 acres (second only to the United Arab Emirates), while the average U.K. citizen uses 13.8 acres, the average Chinese person uses 4.1 acres, and the average Bangladeshi uses only 1.3 acres.

Calculating your personal footprint will give you an idea of where you stand compared to the national averages—and the more sobering picture of how many Earths would be needed to sustain life if everyone shared your footprint.

Orangutan, Malaysia

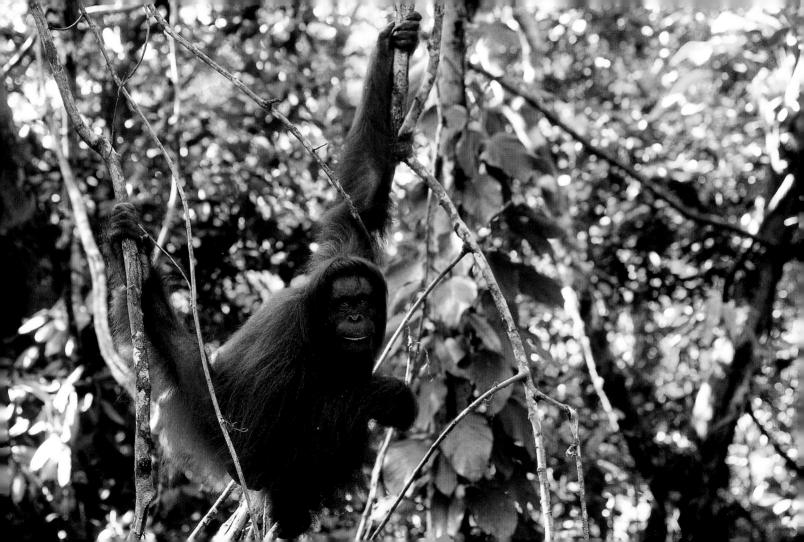

Do not feed wild animals.

Whether they are birds or mammals, on land or at sea, feeding wild animals changes their diet and can alter their behavior; they may grow accustomed to the presence of humans and risk becoming dependent on receiving food instead of obtaining it themselves. Moreover, touching them may endanger their health by exposing them to illnesses to which they are not immune—as well as putting your own health at risk.

Be content to watch wild animals from a distance without trying to attract them with food. Make sure you put your own food and trash out of reach of wild animals, so they are not tempted to help themselves while you are not looking.

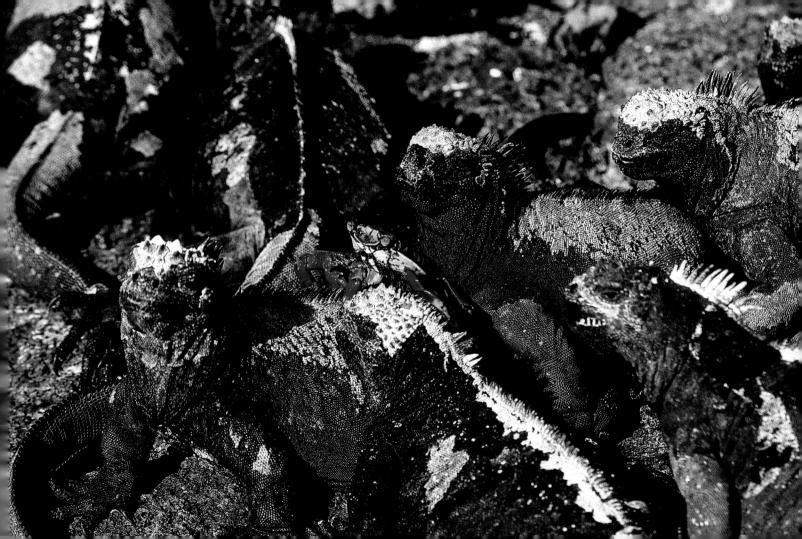

Invest in socially responsible companies.

Socially Responsible Investing (SRI) not only looks at the bottom line, but also at the environmental and social impact of where your money goes. SRI seeks out companies that demonstrate that they have obligations toward the environment and society, and not just to the consumer; companies that develop collaborative relationships with employees and investors; and finally, businesses that are honest and transparent in their reporting processes. Such investments support projects that encourage social integration and job creation, as well as initiatives in areas such as ecology, renewable energy, fair trade, and organic farming and food.

Make ethical investments. Show businesses that there is more to the bottom line-that improving the conditions of the planet and our societies is just as important as making a profit.

Tabular iceberg, Antarctica

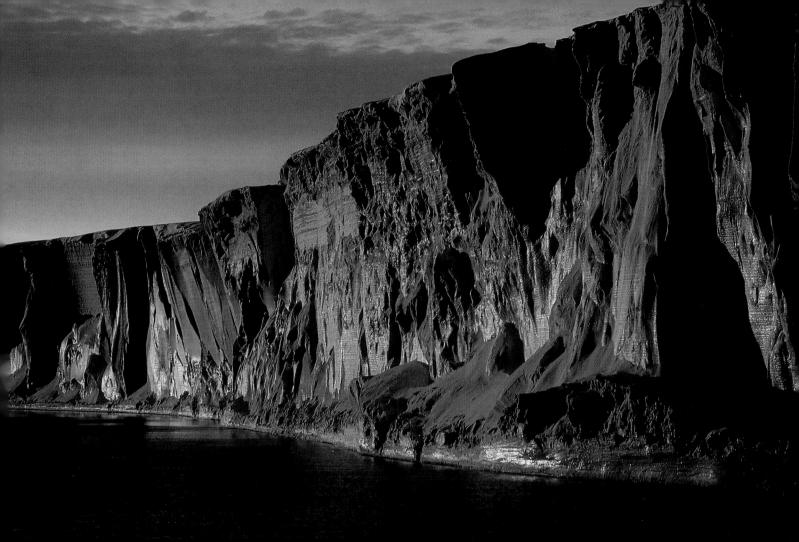

Use the refrigerator properly.

Refrigerators and freezers require large amounts of energy to chill foods. However, with a little care you can avoid waste without losing any of the benefits of this essential everyday comfort. Perhaps the greatest impact on energy use of a refrigerator is the temperature of the room it is in. A 10°F decrease in the ambient room temperature can decrease energy use by 40%.

Do not place your refrigerator or freezer near a heat source, such as an oven, a microwave placed on the appliance, a heater or radiator, or a south-facing window. Also, take care not to place hot dishes in the refrigerator, or to overfill it. Make sure the door closes tightly—if the seal loosens at all, the cool air will escape, wasting energy. And if you hear the compressor come on a lot you may have a leak.

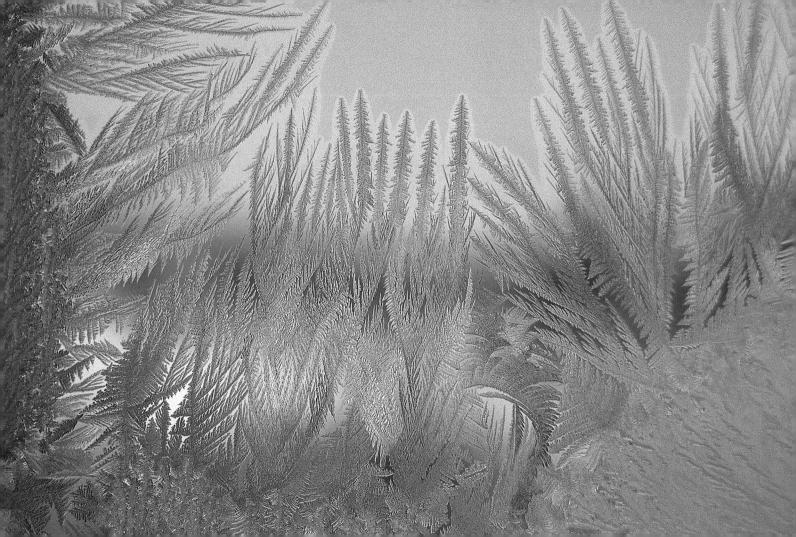

Coffee, milk, and sugar: Say "no" to individual portions.

Coffee in miniportions uses 10 times as much packaging as when it is purchased in bulk. This extra packaging adds 20% to 40% to the cost of a product.

At your workplace, suggest that individual servings of coffee, tea, sugar, and cream be replaced by large packages for everyone's use. You will reduce the amount of packaging and the cost. The price of individually packaged foodstuffs is often in inverse proportion to the serving size.

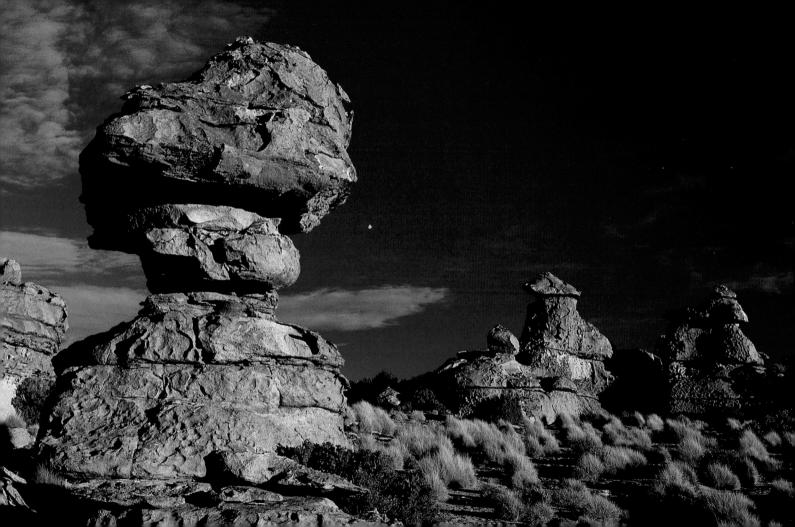

Act to preserve the environment without waiting for someone else to do it first.

It is easy to think that one small, damaging action does not endanger the earth's future. In practice, however, such actions are never isolated events! It is the repetition and accumulation of all these small acts that take on dramatic proportions. In the same way, a small, isolated gesture to preserve the environment will not improve matters on its own. It is all the simple gestures, repeated every day by millions of people, that will have a significant effect when added together. If the majority adopts them as a new way of life, they will contribute to preserving the planet and its riches for future generations.

Do not wait for your neighbor to act. Make the first move. He or she is probably waiting for you to take the first step.

Swans, Japan

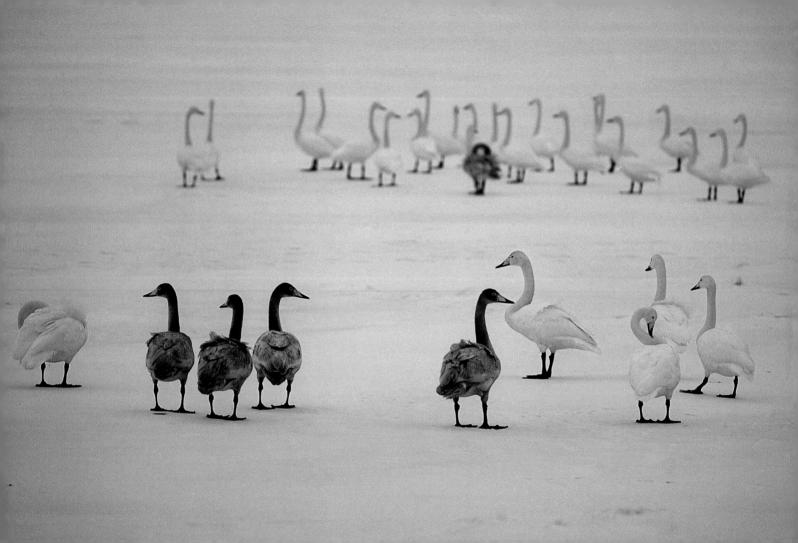

Switch off lights you don't need.

Greenhouse gases are naturally present in the atmosphere and maintain temperatures on Earth that are favorable to life. Too much greenhouse effect, however, leads to warming of the global climate. In the space of a century, world energy demand—used for electricity, heating, and transportation, for example—has increased twentyfold. If current trends continue unabated, the world's energy consumption will double by 2030. Most of this energy comes from oil, gas, and coal, which produce greenhouse gases.

Make a point of switching off lights that do not need to be on, especially when you leave a room, and try to use daylight instead wherever possible. The less that electricity is used, the less energy is needed, and therefore less greenhouse gas is pumped into the atmosphere.

Blue siderites, Poland

Refuse to buy objects made from ivory.

Massacred for the ivory that is its defense against attack, the African elephant has almost disappeared from the planet. In Kenya and Tanzania, about 70,000 African elephants were killed each year between 1975 and 1980. Between 1980 and 2000, their numbers fell from 1.4 million to 400,000.

Although the international ivory trade was banned in 1990, ivory jewelry and statuettes can still be bought in African and Asian markets. Traders may offer to sell ivory objects illegally. Do not yield to the temptation to buy them: This encourages trafficking and, since this trade is illegal, you will not be allowed to take them home.

Piton de la Fournaise Volcano, Réunion

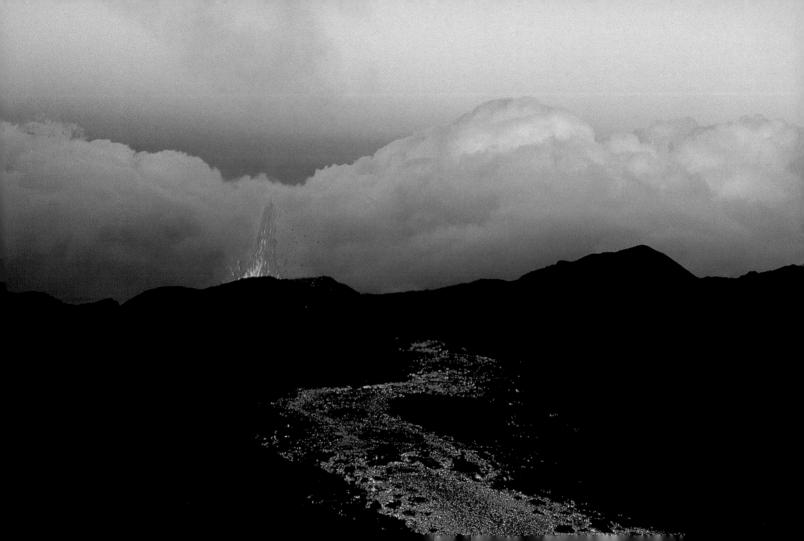

Rediscover your grandmother's remedies.

Chemicals have invaded our lives. In the 1980s there were 500 times as many chemical products as during the 1940s. Today, an average family uses 30 gallons of various chemical cleaners each year. These products, which generally contain substances harmful to health and the environment, inevitably find their way into water, air, and soil.

Rediscover your grandparents' natural remedies: dishwashing solution for removing oil stains, white vinegar for removing mold or mildew, baking soda for scouring, cedar chips for keeping moths away, lemon juice for polishing copper or disinfecting surfaces, and so forth.

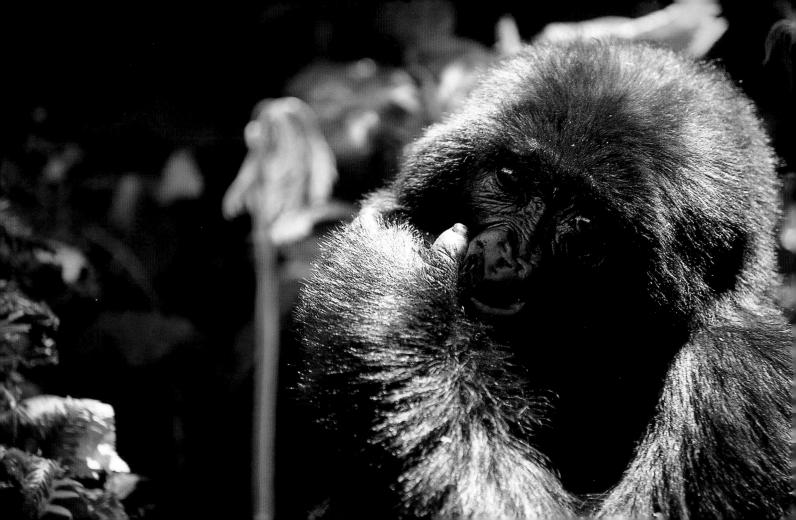

Drive more slowly.

It has taken nature 250 million years to produce the oil that we will probably use up in the next century. America consumes more than 20 million barrels of oil per day, nearly half of which is in the form of gasoline. Use of oil for transport in the United States rose 4% in 2007, and American gasoline consumption accounts for 11% of the world's oil production.

Gas mileage declines quickly when traveling above 60 miles per hour. Going from 55 to 75 miles per hour can increase your fuel consumption by 20% or more. Even decreasing your speed by 5 miles per hour will boost your fuel efficiency by a couple of gallons.

Write to manufacturers urging them to keep GMOs out of animal feeds.

In 2005, 222 million acres of transgenic crops were grown worldwide; about 60% of these were grown in the United States. The global spread of GMOs is not the response to a need for new varieties; it is dictated purely by the desire for short-term profits. Present labeling regulations do not require disclosure of products from animals that have been fed GMOs (such as meat, fish, eggs, dairy products, desserts, or prepackaged meals). Eighty percent of GMOs find their way into our food by this indirect route.

You can write to farmers and distributors and urge them to keep GMOs out of animal feeds. In this way, you will keep them off your plate and protect the environment.

Do not throw out your children's old toys.

Unchecked consumption of the world's natural resources and increasing production waste are mostly because of the actions of the United States, Europe, and Japan, home to 20% of the world's population. An American produces 1,460 pounds of household garbage per year, or about twice as much as a European, and 10 times as much as someone in a developing country. During its lifetime, a child born in an industrialized country will consume more resources and generate more pollution than 40 children in a developing country.

When your child outgrows a toy, it is pointless to keep it as a relic; encourage your child to donate old toys to charities, or to children's hospitals or foundations, and explain the benefits of doing this.

Mono Lake, California

Avoid big box stores.

In wealthy countries today, consumers travel by car to do their shopping in big box stores built on the edges of urban areas. They store their food in freezers, which use more energy because products are sold in overpackaged portions. This system gives large retail organizations a high degree of control, which they use to force down farm prices or to import products from countries where labor is cheap and environmental legislation almost nonexistent.

Shop closer to home. Every new supermarket that opens causes hundreds of jobs to be lost. Pollution and congestion would be a fraction of what they are now if consumers frequented their local shops.

Green your workout.

A chain of gyms in Hong Kong is experimenting with treadmills that capture the energy generated by joggers, sending it to a battery that helps to power the gym. But until such practices are widespread, the average fitness center excels at wasting energy. First, there's the electricity needed to power all of the machines, lights, and personal TVs. Then there's the air-conditioning needed to keep a poorly ventilated room full of sweating people at a reasonable temperature. In the United Kingdom, the British Trust of Conservation Volunteers has created a Green Gym program where participants burn calories while doing environmental conservation activities like tree-planting or creating and maintaining community gardens.

Instead of joining a gym consider walking, jogging, or biking outside. If you cannot get off the treadmill, be aware of how you use resources at your local gym. Invest in a reusable water bottle and encourage your gym to replace bottled water vending machines with fountains or coolers. Bring your own towels to cut down on the amount of laundry the gym does (chances are they are not using biodegradable soap). Look for PVC-free workout gear—yoga mats, for example, come in a variety of natural materials.

Lake Magadi, Kenya

Support animal-friendly or animal-free circuses.

Wild animals used in circuses or traveling shows rarely live in humane conditions; they are often deprived of any kind of regular veterinary care and are usually chained in one position for long periods of the day with no opportunity to move. Federal legislation meant to protect these animals is ineffective and rarely enforced. In addition, the transitory nature of circuses means that violators are rarely, if ever, pursued and prosecuted.

Do not patronize circuses or traveling shows that keep wild animals in captivity. Some communities have passed ordinances that prevent these shows from operating within their jurisdictions. Encourage your community to pass such an ordinance.

Use public transportation.

Air pollution is at the top of the list of problems caused by motor vehicles, followed by car accidents, noise, erosion of habitats by roads and freeways, and damage to plants and animals. Finally, cars take up too much space in cities, where 4 out of 5 trips are made by car. This congestion costs us dearly: Drivers in one-third of U.S. cities spend the equivalent of one workweek in bumper-to-bumper traffic every year.

Use public transportation wherever possible. A bus can take 40 single-passenger cars off the road. Public transportation saves more than 855 million gallons of gasoline per year.

Have your boiler serviced regularly.

Domestic hot water should never be above 120°F. Above that temperature the excessive heat tends to lead to lime scale and corrosion of pipes and apparatus. Lime scale increases heating costs by insulating the water from the heating source, and therefore more energy is needed to heat the water. Moreover, a badly maintained boiler can also lead to air pollution within the home.

To check whether your apparently harmless boiler is poisoning the air in your home or contributing excessively to warming the planet, have it serviced once a year. If your boiler is more than 15 years old, consider replacing it with a newer model, which will likely be at least 30% more efficient.

Don't patronize fast-food chains.

One billion people around the world live in poverty. More than 800 million of them go to bed hungry every night. In 2000, the United Nations made a commitment to halving the number of malnourished people in the world by 2015, making it one of the 8 Millennium Development Goals; by the end of 2007 they were only one-third of the way toward realizing this goal. Meanwhile, no part of the world is spared the wave of fast-food chain restaurant openings, a veritable standard-bearer of globalization.

If you visit fast-food restaurants, think about what you are doing, and make your children aware of the other results of mass-produced food: polluting, intensive and industrial agriculture, poor nutritional quality, mountains of nonrecyclable packaging, and standardization of tastes.

Turn off the vegetables early.

Climate change will have severe repercussions on plant and animal life. By changing natural habitats, it will create havoc, especially with species distribution. Many terrestrial species whose habitats will change will not be able to migrate quickly enough, will have nowhere to go, or will not have time to evolve and adapt to new conditions. Thus climate change is likely to threaten a quarter of the world's species directly. Certain studies have even suggested that by 2050 almost 1 in 5 species will have disappeared from the planet, even in the unlikely event that global warming is minimal.

In the kitchen, switch off the gas or electricity a few minutes before cooking is complete. You will make use of residual heat, which will continue the job while saving energy.

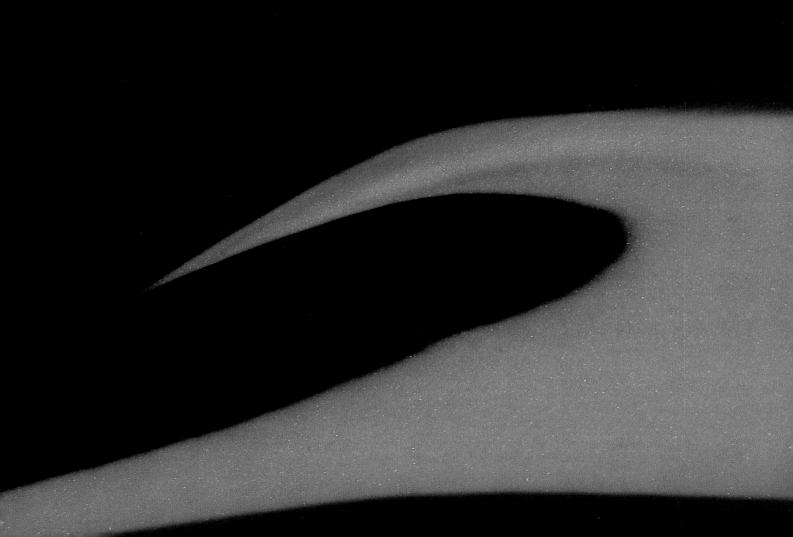

Compost nonrecyclable cardboard and paper.

You can reduce the volume of your trash by 80% simply by sorting your packaging and composting all waste that is suitable. Yard trimmings, food residue, and other compostable items account for about a quarter of our annual waste.

You can add some types of nonrecyclable paper and cardboard (such as tissues, wipes, egg cartons, and ash from your fireplace) to your compost as well. Their fibers will aerate the compost and thus help the organisms that cause decomposition.

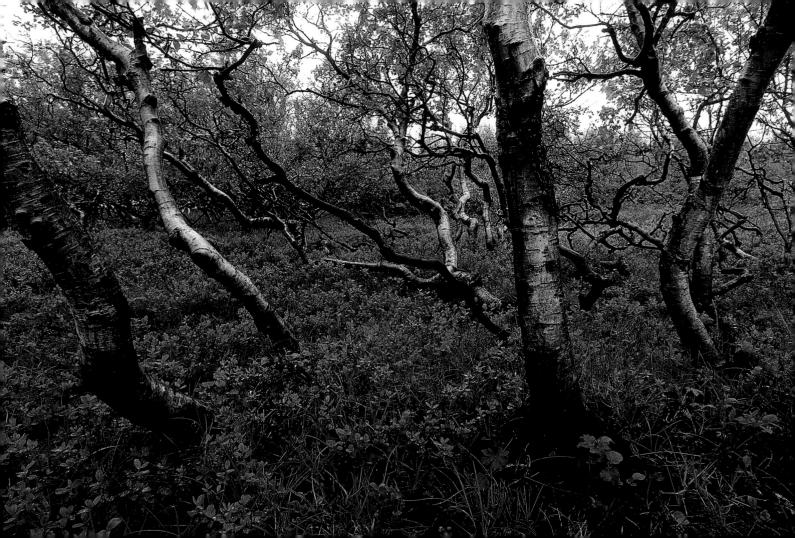

Pack waste-free lunches.

A home-packed lunch can generate a tremendous amount of waste when it's wrapped in disposable baggies, plastic wrap, or tinfoil and contains a lot of individually packaged goods like juice containers. The average child that brings his or her lunch to school generates roughly 67 pounds of trash per school year. Everything in a waste-free lunch is either consumed, recycled, or reused. Sending your child to school and yourself to work with a waste-free lunch saves you money, provides more nutritionally balanced meals, and reduces landfill waste.

Start with a reusable lunch sack and make sure drink containers, sandwich and snack containers, and utensils are also reusable. Use cloth napkins. Buy snacks like cookies in bulk, not in individual packets. If you have to invest in plastic baggies, buy recycled ones and reuse them as much as possible.

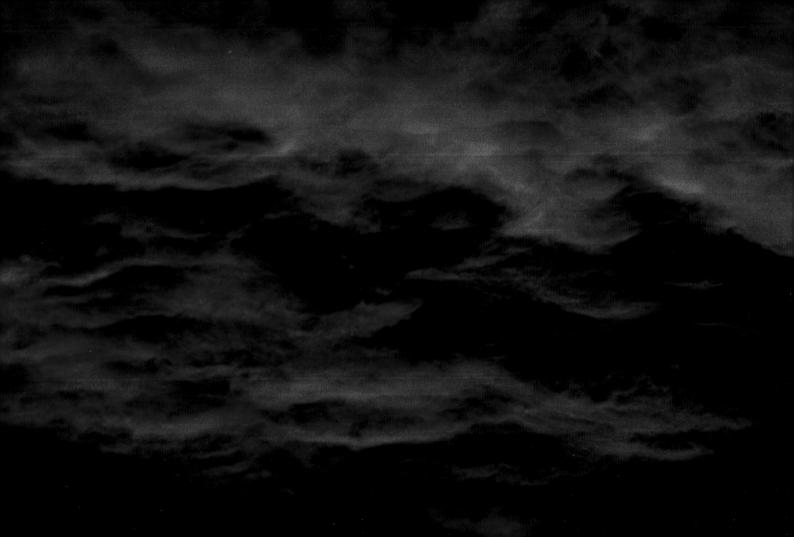

Choose your bank wisely.

Financial institutions use your money—think of all those monthly fees—to make investments; many major banks sign off on billions of dollars of loans to such enterprises as fossil fuel plants and unsustainable logging outfits. You often have very little control over which businesses receive your bank's money, but some money houses do offer special accounts and credit cards that send a portion of the fees you pay to finance nonprofits. Some community investment banks are some of the greenest banks around and many offer credit cards to nonmembers that funnel up to 50% of funds directly into environmental stewardship in a particular region of the country or into small business loans for low-income and underserved customers.

Research your bank's investment and lending history, and its commitment to reducing its own carbon footprint.

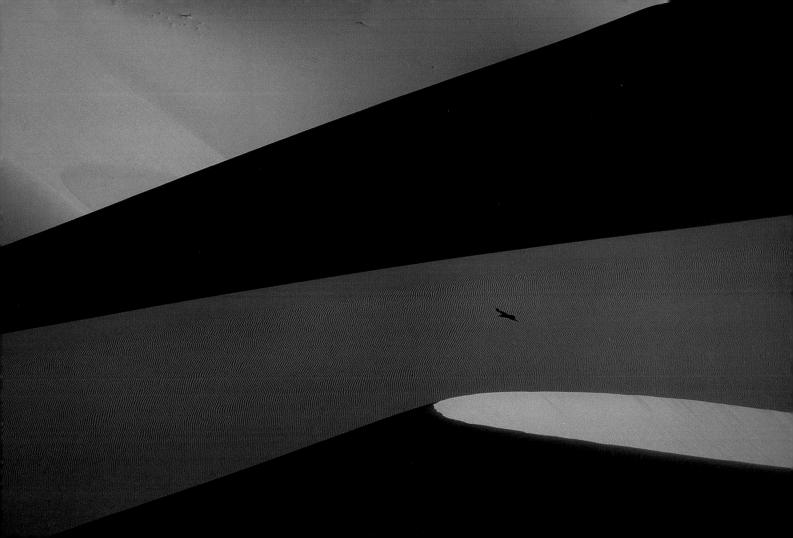

FEBRUARY 1

Do not use mothballs in wardrobes.

The mothballs people place in wardrobes give off naphthalene and paradichlorobenzene fumes. The former is a carcinogenic substance; prolonged, repeated exposure to high concentrations can damage the nervous system and affect the lungs, causing headaches, fatigue, and nausea. Most toxic substances we use are intended to eliminate something, so we should not be surprised that they are detrimental to our health.

In your drawers and wardrobes, choose bags of lavender or cedar chips, which smell so much nicer than mothballs. Protect delicate woolen clothes by keeping them in sealed boxes.

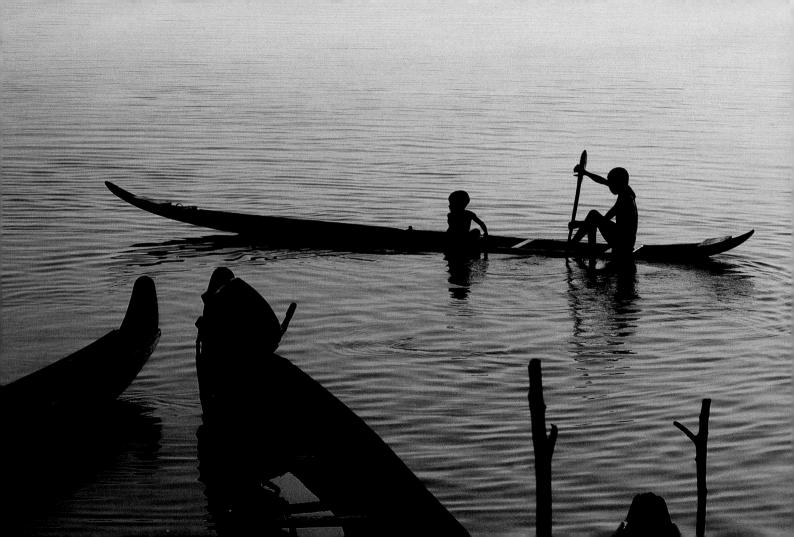

Be a citizen scientist.

For more than a century, amateur bird-watchers have helped conservationists keep an eye on early winter bird populations. Each year the National Audubon Society has organized the Christmas Bird Count, an all-day census undertaken by a huge network of nature lovers. The data retrieved from this count represents the longest running database in ornithology, which has been used to monitor the status and distribution of bird populations across the Western Hemisphere—a project that no one group of scientists would have the time or funding to accomplish on its own. There are other major projects monitoring watersheds or weather patterns.

Lend your eyes and a little of your time to help with the next Christmas Bird Count-where you might learn how to recognize sparrows, cormorants, finches, herons, and gulls, among other things-or other censuses. You can also simply speak to the rangers at your favorite park to see if they could use your help on your next hike.

Turn off the tap while you brush your teeth.

Earth has been nicknamed the "blue planet" because of its abundance of water. This is misleading, however. If all the water on Earth could be contained in a big bucket, the frozen fresh water at the poles and in glaciers would fill a small cup, and all the fresh water available to people—lakes, rivers, and ground water—would fit into a teaspoon. Our natural fresh water reserves are not expandable, and they must be shared among an ever-growing global population.

Turning off the tap during the time it takes to brush our teeth saves almost 5 gallons of water. That is more than an average citizen of Kenya makes do with throughout an entire day.

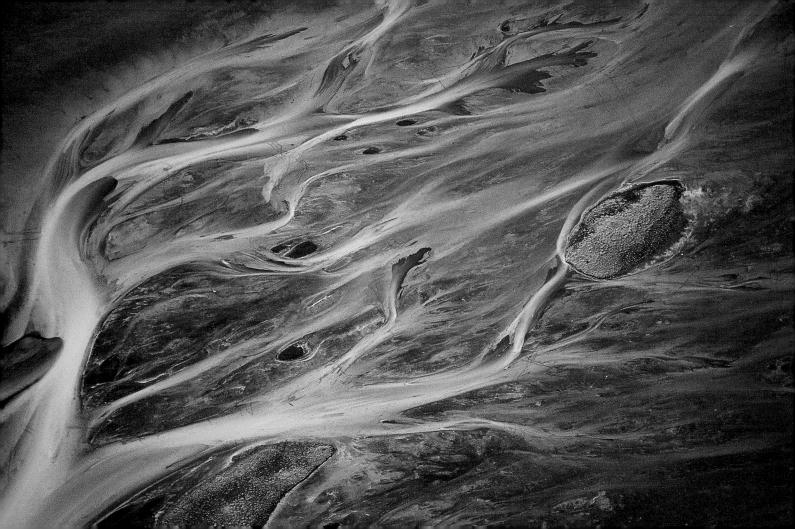

Recycle magazines and newspapers.

Each year, America uses over 85 million tons of paper. In 2006, 52% of this waste was recycled, but that still leaves roughly 46 million tons of remaining paper that could be reused. Those 46 million tons could save 782 million trees.

Do not contribute to this cycle: Recycle used paper and cardboard. It will be used to make new paper and cardboard, as well as egg cartons, packaging, tissues, paper napkins and tablecloths, and toilet paper. As for your recently bought catalogues and magazines, before putting them in the recycling, offer them to the waiting room of your local laundromat, dentist, or hairdresser, where they will be read again and again.

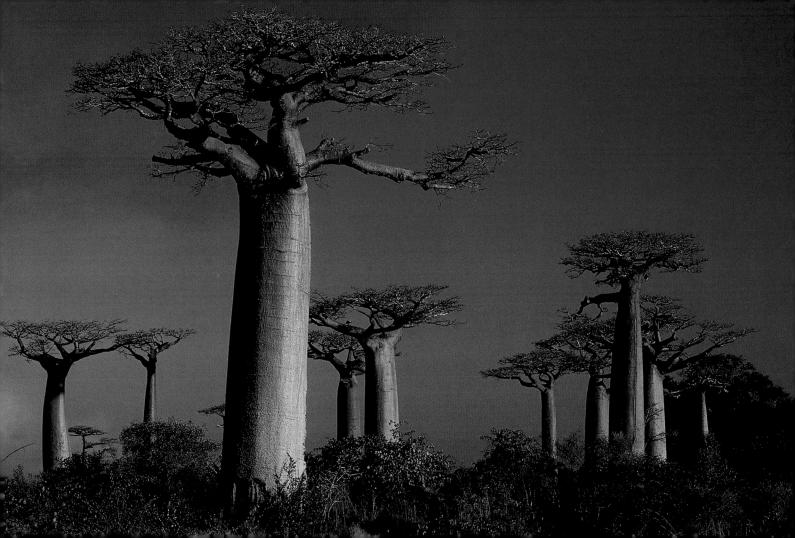

Do not litter in the mountains or on high summits.

Mount Everest, the highest point on the planet, has been a well-traveled destination for decades. As many as 300 climbers a day may gather at base camp during the peak season, and the area has suffered considerable pollution as a result. Recently, several cleanup campaigns have removed piles of trash from the roof of the world; the first operation at base camp eliminated 30 tons of waste. Nor has Mont Blanc in Europe been spared by the 3,000 climbers who trample its summit every year. Between 1999 and 2002, cleanup operations removed almost 10 tons of waste from the summit. The fragile environments of the high summits are sensitive to the slightest disturbances and easily damaged by mass tourism.

Do not contribute to the degradation of high places; leave nothing behind, and pick up what others irresponsibly throw away.

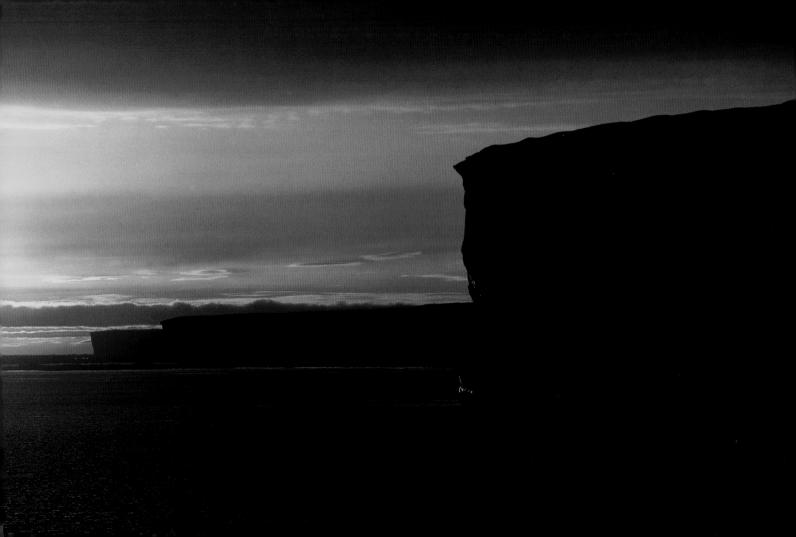

Do not leave the tap running while you wash dishes by hand.

When a tap is turned on, 2 to 7 gallons of pure drinking water flow out every minute. Indeed, we are easily fooled by the generosity of our taps. Each time we use them, a large part of the water goes down the drain without even being dirtied.

When you wash the dishes by hand, fill the sink rather than washing each plate under a continuously running tap. Better yet, invest in a water-efficient dishwasher—if you use a machine wisely, it'll likely use less water than even careful hand-washing practices.

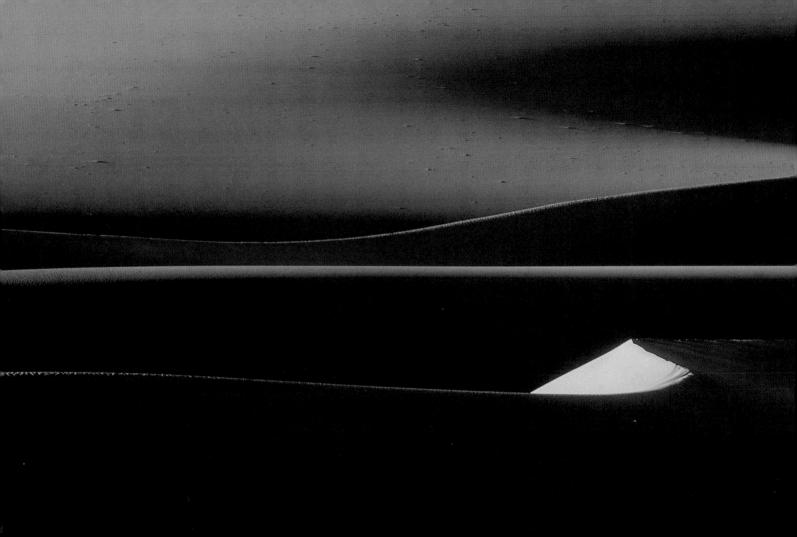

Don't prerinse dishes.

Your dishwasher will use the same amount of water and energy whether or not you prerinse your dishes. In most cases, simply scraping off food scraps should be enough for your dishwasher to do its job, especially if it is an updated model. Prerinsing can waste up to 20 gallons of water.

If certain types of dishes or foods prove problematic for your dishwasher, set aside a small amount of dishes to wash by hand—fill up the sink basin rather than let the tap run while you wash. Otherwise, let the dishwasher do all the work.

> Air bubbles trapped in ice, Canada

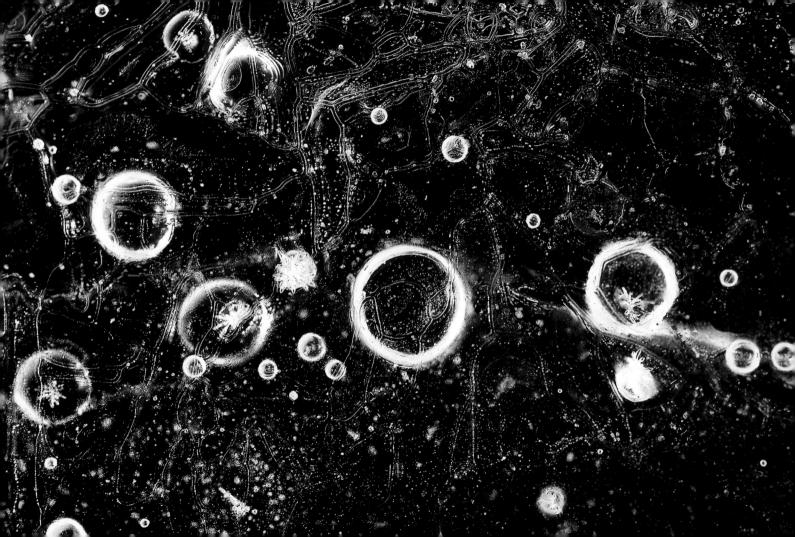

Collect rainwater.

Nature gives us rain, and for this, we pay nothing. Like solar and wind energy, collecting rainwater is a means of protecting the environment in a sustainable way. The rain that falls on the roofs of our houses could cover as much as 80% of our current annual domestic water consumption. In addition, collecting rainwater prevents it from flowing along the street, picking up pollutants, and depositing them into storm drains and eventually into our waterways. Rainwater collection systems do double-duty, conserving water and protecting our environment from pollutants.

Have a rainwater collection system fitted to your house to meet outdoor water needs, like watering the lawn and washing the car. At the very least, put a rubber garbage can beneath your rain gutter to collect water.

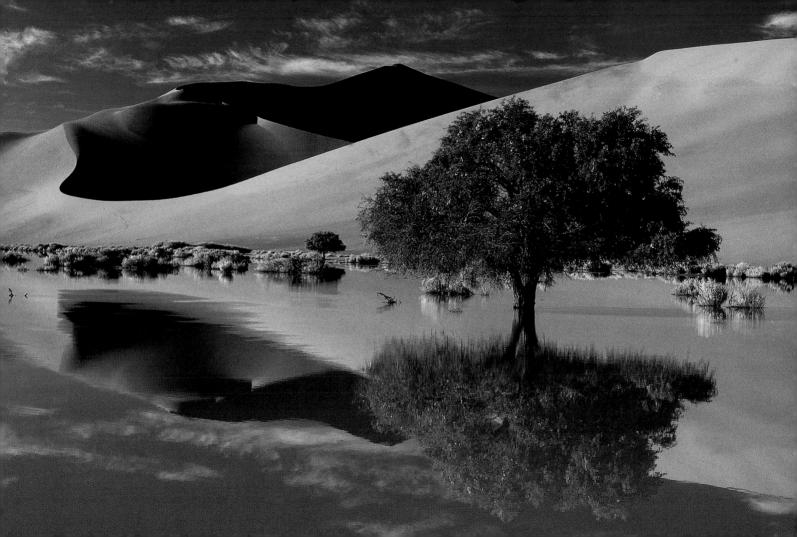

Take legal action, if necessary.

State environmental agencies, burdened with protecting and restoring your state's environment, may fail to do so, at times out of negligence but more often due to lack of state funding. Do not let your state put environmental concerns last on the list of budgetary priorities—human health and safety is at stake. Pay attention to your state's budgetary process and monitor the trend in funding for environmental programs.

If you want to be involved in public inquiries, do not hesitate to approach a lobbying group or, if necessary, to complain about a government body or a company if it does not comply with environmental legislation.

Sort your trash actively and effectively; make inquiries.

Take part in your local recycling program: Note the collection times and learn how to sort from your local public works department. Proper sorting is vital to making your recycling efforts meaningful. Be sure to consult the guidelines until they become second nature. Recycling is important, but it is essential to do it properly.

If you are uncertain about what to do with a particular item of waste, call the public works department or local recycling center-don't just throw it in with your recyclables or other trash. If your local authority does not offer sorting facilities, take your waste to a recycling center yourself.

Don't idle your car.

One of the gases that contributes most to the greenhouse effect is carbon dioxide. Since 1900, emissions of carbon dioxide have risen dramatically as a result of growing consumption of coal, oil, and gas, and its concentration in the atmosphere is the highest it has been in the last 20 million years. The average American passenger car produces nearly 12,000 pounds of carbon dioxide per year.

When you start your car engine, it is pointless to run it while remaining stationary in order to "warm it up." Instead, just drive gently for a few miles: The engine will warm up while avoiding needless pollution, carbon dioxide emissions, and fuel consumption.

> Waterton-Glacier International Peace Park, Montana

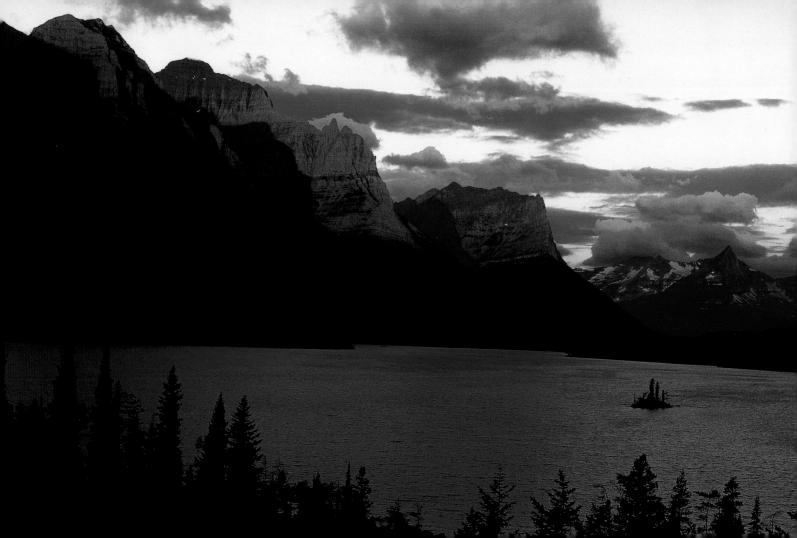

Plant native vegetation in your yard.

If you plant greenery that only thrives in a specific climate, you could expend gallons of water and pounds of fertilizers and other growing aids just trying to keep it alive. Indigenous plants are already accustomed to the demands of their environment, and they often require much less effort to keep healthy—that means less wasted water, less fertilizer, and less need for pest control.

Planting native species also encourages natural biodiversity and lessens the risks associated with introducing non-native plants that could spread and change natural habitats, thereby affecting local wildlife.

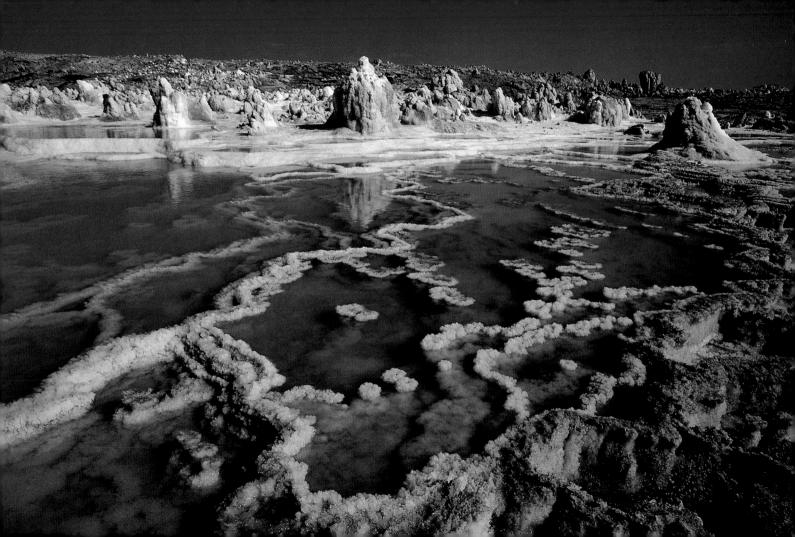

Suggest composting at your children's school.

Nearly 80% of a school's trash is generated in the cafeteria. Much of this waste is organic and can be converted into compost. This entirely natural fertilizer improves the soil, increases the soil's ability to retain air and water, checks erosion, and reduces the need for chemical fertilizers. One pound of organic waste produces almost 6 ounces of compost.

The composting of organic waste is unquestionably in the best interest of the community. Many schools that have already implemented composting programs have done so in ways that require students to participate in the process, whether through work in science classes or by making the students responsible for sorting their recyclables and organic materials at every meal. Not only does this approach reduce waste, it teaches kids the benefits of composting.

For your children's cafeteria, or your workplace eatery, take the initiative by explaining the economic and ecological advantages of composting. Encourage them to study the foods that are discarded most and urge them to think of alternatives, or of solutions to the waste problem.

Islets, Galápagos Islands

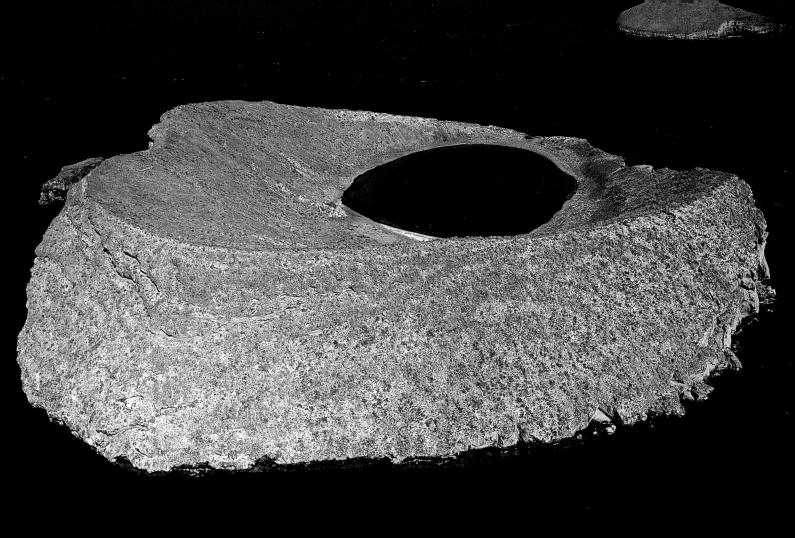

Build a better bouquet.

A lovely bunch of flowers bought from the florist or the supermarket may have been grown in a greenhouse thousands of miles away (79% of cut flowers come from Latin America). Apart from the environmental issue of transportation over long distances, the boom in horticulture in some developing countries has a high social and environmental cost. In Colombia, the flower industry uses enormous amounts of polluting pesticides and exposes poorly paid garden workers to chemicals that may be carcinogenic or toxic. In drier regions, such as Kenya, horticulture requires substantial amounts of water and, as a result, overuses local water resources.

Consider giving an organically grown potted plant from a local nursery as a gift rather than a bunch of flowers. It will last far longer. If you want a traditional bouquet, seek out organic and fair-trade flowers and look for the Fair Trade or VeriFlora labels, which ensure that your flowers come from farms with high environmental and labor standards.

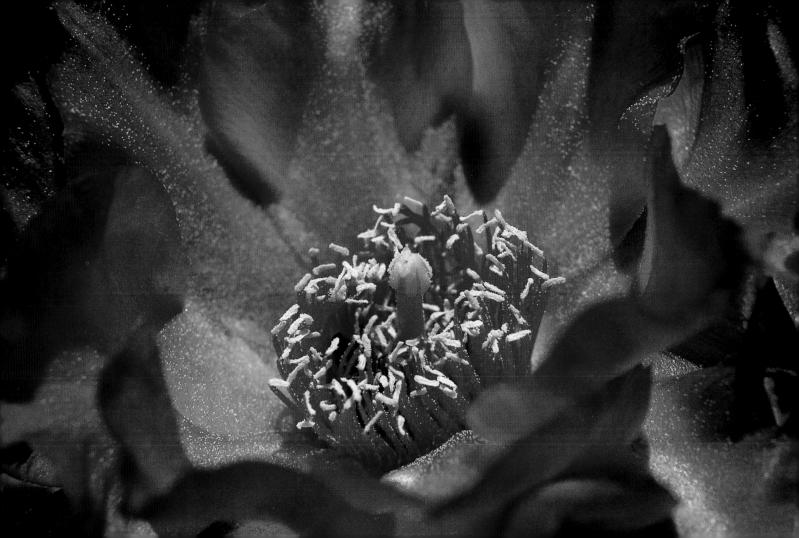

Give your home a cool roof.

We all know that dark-colored clothing absorbs more heat than light-colored clothing. The same rule holds true for roofs—the darker the roof, the more heat transferred into the home. In a hot climate, choosing light-colored materials that reflect the sun's rays will keep cooling costs down. The roof will last longer, too, as it will be protected from ultraviolet rays. In an urban area, a cool roof is an alternative to a green roof (a full rooftop garden) to help alleviate the heat island effect (higher temperatures and pollution thanks to the predominance of nonreflective asphalt and concrete).

Depending on the type of roof you have, you may be able to create a cool roof with a simple coating; sloped roofs may require special shingles, though costs of cool roofing materials are generally comparable to standard supplies.

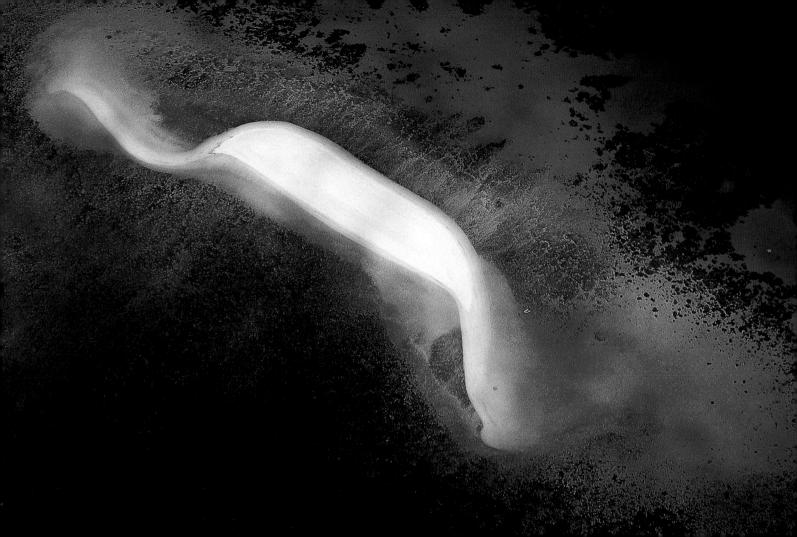

Rent a "green" car.

Most of the major car rental agencies now have some hybrids in their fleets; specialized local agencies have more alternatives like electric cars. Nationwide car-sharing programs like Zipcar may also be an alternative. A low yearly membership fee allows you to reserve cars (many of which are compact and fuel efficient) for a few hours or by the day in any of the company's affiliated cities. By becoming a member, you help support car-sharing ventures.

The next time you rent a car, rent green. The bigger the demand for hybrids and alternative-fuel vehicles, the greater the investment in these programs by big agencies will be.

Consider a sustainable prefabricated home.

Green designers today have given the prefabricated home—often derided for being cookie-cutter and aesthetically unpleasing—a second chance by creating eco-friendly and compact units that are incredibly stylish. When done right, prefabs are greener than building from scratch. The lack of a foundation means less impact on the land where the home is sited. Green prefabs have features like solar panels, sustainably harvested wood and recycled materials that don't off-gas, and energy-efficient heating and water systems and appliances.

Green prefabs can help you live small in style and enjoy "new construction" that doesn't pollute-at a lower cost than building a green house from scratch.

Mountain goat, Waterton-Glacier International Peace Park, Montana

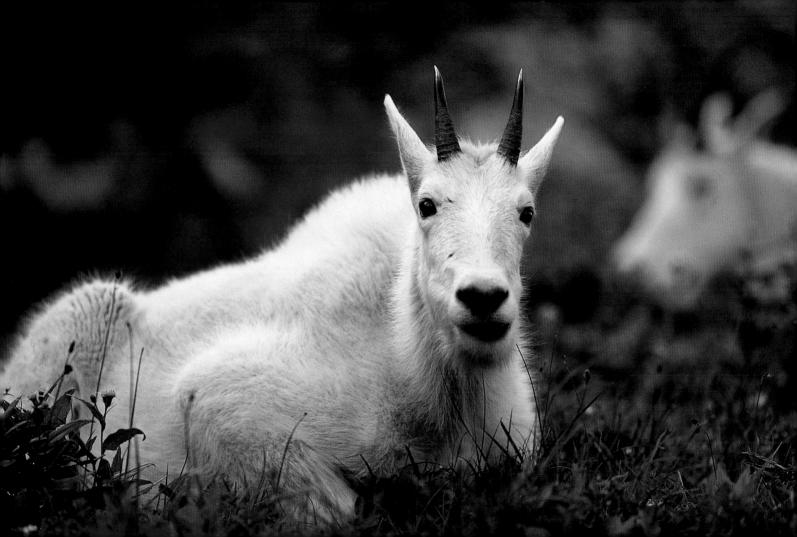

Say no to Styrofoam.

Polystyrene foam, known to most people by its brand name Styrofoam, requires fossil fuels to produce and takes centuries to degrade when left in landfills. The flyaway pieces that do break off can endanger wildlife. Although some companies recycle the molded Styrofoam packing that comes with most electronics and appliances, the process is expensive—\$2,000 a ton, compared to less than \$100 a ton for glass—and therefore it's not likely to become more widespread. Several U.S. cities have banned restaurants from using polystyrene food containers; you can form a citizen's group to urge city council members in your town to pass similar initiatives.

Avoid Styrofoam takeout containers and ask your workplace to replace Styrofoam coffee cups with compostable options. Recycle packing peanuts by bringing them to packaging or shipping stores for reuse.

- FEBRUARY 19

Deice the driveway responsibly.

Americans use hundreds of thousands of tons of deicing chemicals each winter. Rock salt and calcium chloride can leach into groundwater and destroy vegetation; the runoff from these products can enter streams and lakes, harming fish. Magnesium chloride, which is popular and generally considered less toxic, may contain other chemicals—some brands contain cyanide derivatives to prevent clumping.

Opt for deicers that are nontoxic and don't contain rock salt or chlorides. Calcium magnesium acetate and potassium acetate are biodegradable and not as corrosive as rock salt.

Consider a hybrid car.

Hybrid cars combine an electric motor and an internal combustion engine. They run on electricity in town and use gasoline at highway speed, at which point, ingeniously, the batteries are recharged by the movement of the car. Thanks to this optimized use of energy, hybrid cars offer excellent performance and are much cleaner in town; they produce 75% less pollution than standard vehicles.

Hybrids are still more costly than comparable cars, but prices continue to drop as more models are produced and the demand for fuel-efficient cars grows.

Caymans, Venezuela

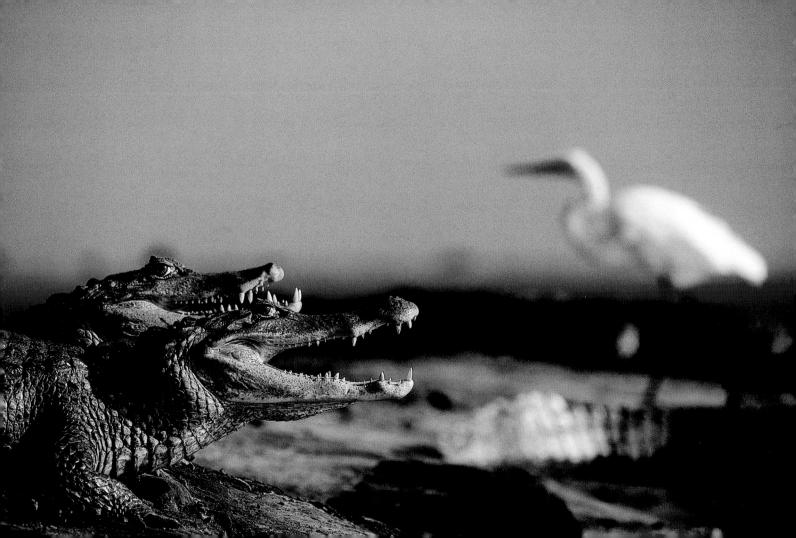

Use a low-flow showerhead.

To attempt to meet our escalating need for energy, humans have built dams and diverted rivers: 60% of the planet's rivers have been tamed in this way, and more than 45,000 large dams produce 20% of the world's water. Building these dams, however, has displaced between 40 and 80 million people—few of whom were consulted before-hand—and has caused extensive deforestation and species loss. Showers account for 17% of indoor water use, adding up to more than 1.2 trillion gallons per year.

You can reduce water consumption by replacing your showerhead with one that aerates and increases the flow of the water to produce a finer spray. A low-flow showerhead uses only 1 to 2 gallons per minute, depending on the model (much less than a conventional showerhead); it costs around \$12 for a standard model and \$40 for a designer model. Many have "pause buttons" as well, so you can stop the water flow while you soap up or shampoo.

Donate your leftover medicines so that they can be distributed for reuse.

Every day in developing countries, 30,000 people die for lack of medicines or the money to buy them, while we throw our unused medicines in the trash. But there are humanitarian organizations that collect these unused medications and redistribute them to the poorest people around the world. One organization, Aid for AIDS, annually redistributes nearly \$5 million of medicine to people in developing countries who are HIV-positive or living with AIDS.

Find a nonprofit organization that accepts unused medicine donations. This is also a safer choice for your household, because it will reduce the amount of medicine that could fall into a young child's hands. Forty percent of poisonings involving children are a result of ingesting medications.

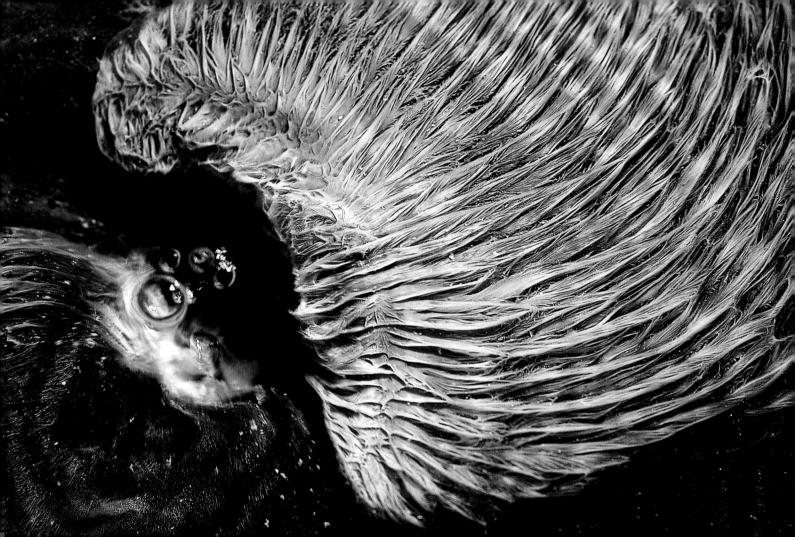

Have your heating checked and maintained regularly.

Air pollution is always more obvious in the middle of a traffic jam than when you are back at home. However, even indoors, you are not immune from harmful emissions, especially carbon monoxide. This gas is produced by incomplete combustion of coal, wood, gas, or fuel oil, which may be caused by a blocked flue, the use of old or badly maintained stoves, boilers, or oil heaters, or clogged ventilation ducts that prevent air circulation. Carbon-monoxide poisoning kills more than 500 Americans each year.

Keep your air clean: Have your home and water-heating equipment checked and maintained by professionals-and don't forget the ventilation ducts.

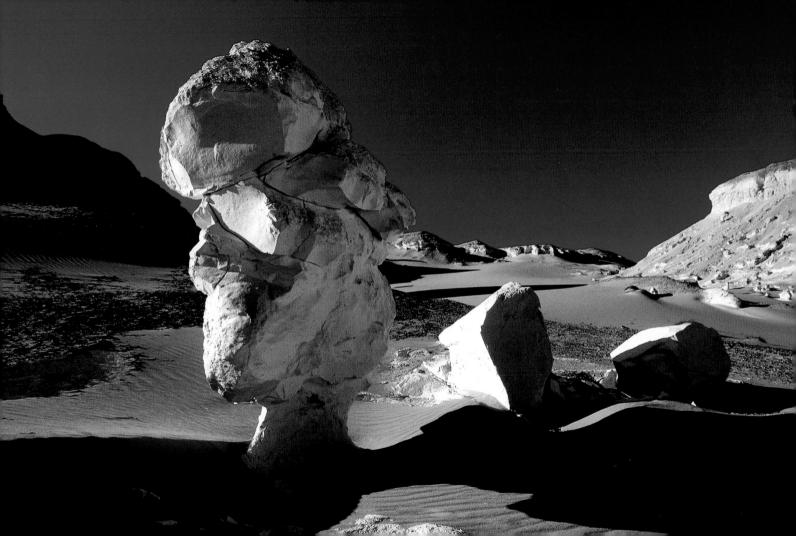

Make compost with organic waste.

In nature, compostable waste, like the waste found on the forest floor, decomposes into soil through the action of microorganisms and returns energy and nutrients to the forest floor. Our trash contains a large amount of organic waste, which, instead of being returned to the natural cycle, is cut off from the soil and added to our landfills.

Leaves, branches, and grass from the garden, eggshells, fruit and vegetable peelings, coffee grounds, tea bags, and bread from our tables can all join the compost heap. If mixed well and aerated regularly, stirred to avoid clumping, and kept sufficiently moist, in a few weeks this will yield compost, a natural fertilizer that is good for the soil.

Whether you make a compost heap, use a bin, or bring it to your local farmers' market, there is certainly a composting option suitable for the amount of space you have available.

Birch, Lassen Volcanic National Park, California

Reuse water.

One-third of the world's population is living in areas with moderate to severe water shortages. In the United States, the government estimates that 36 states will face water shortages in the next 5 years.

Look for ways to use leftover water. Clean water that's been left in the kettle for a few days can be used to fill the sink basin to wash dishes. You can water indoor and outdoor plants with water that's been used to cook pasta or clean vegetables. Think of all the water that is wasted as you wait for the shower to heat up-collect the water in a bucket and use it to water plants, mop the kitchen floor, or hand wash delicate clothing.

Do not drop your garbage indiscriminately when traveling.

American domestic waste now goes to different destinations, depending on where you live and the type of waste. Eight states still send 80% of their solid waste to landfills. Eighteen states incinerate less than 1% of their waste. Across the country, however, the average rate of recycling is 32%. This is not the case everywhere, however. Worldwide, only 20% of household waste is treated in one of these ways. In some poor countries, rubbish bins are rare or altogether absent.

Do not drop your trash just anywhere—especially if you are on an excursion—even if the environment already appears to be dirty or strewn with dumped waste. Take your trash back to where you are staying and dispose of it properly.

Seashell, France

Opt for electronic banking and billing.

In the United States the act of paying household bills accounts for 800,000 tons of paper waste every year, or the equivalent of 17 million trees. Only about 15% of wired households opt exclusively for online billing.

Sign up for online banking and pay as many of your bills as possible electronically. Be sure you decline the option to receive paper statements when you sign up for these programs. Don't print ATM receipts as they're a chief source of litter and are almost always unnecessary—ATM and debit transactions show up on your online banking statement within 24 hours if not immediately.

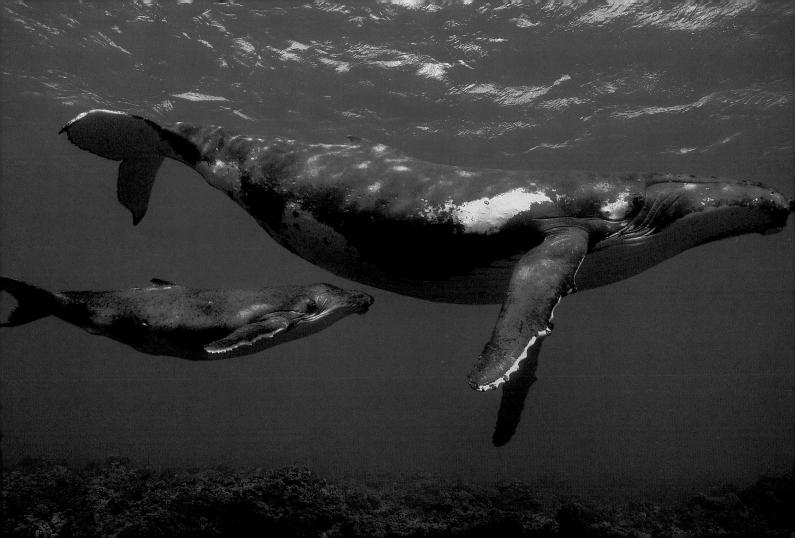

Do not defrost in the microwave.

Renewable energy—from the sun, wind, the heat under the earth's crust, waterfalls, tides, the growing of vegetables, or the recycling of waste—is infinite. Harnessing it produces little or no waste or polluting emissions. In countries like Germany, government officials have recognized the benefits of investing quickly and heavily in these technologies and they have set a goal to transition to 100% renewable energy. Part of this goal is to reduce their energy needs by 37%.

Rather than adding to your electricity bill by using the microwave to defrost your food, remember to take food out of the freezer earlier and let it defrost at room temperature.

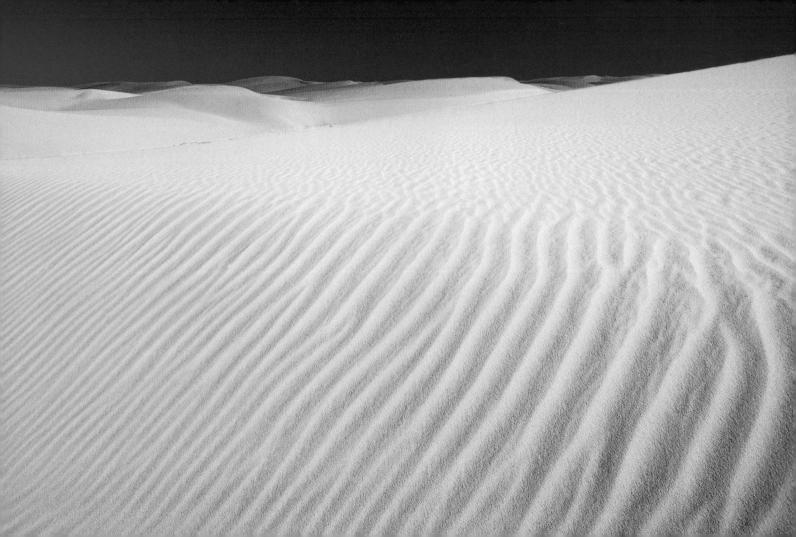

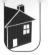

Boil only as much water as you need.

Whether you use an electric kettle or a saucepan, heating water uses energy. There is no point in doubling the energy you use for no purpose: Boil only what is necessary. A British study found that if all English people—who are great tea drinkers—did this on just one day, the energy saved could power all the country's street lamps through the following night.

When you boil water for tea or a hot drink, try to boil only what you need, or pour the surplus into a thermos flask to keep the water very hot until you need it.

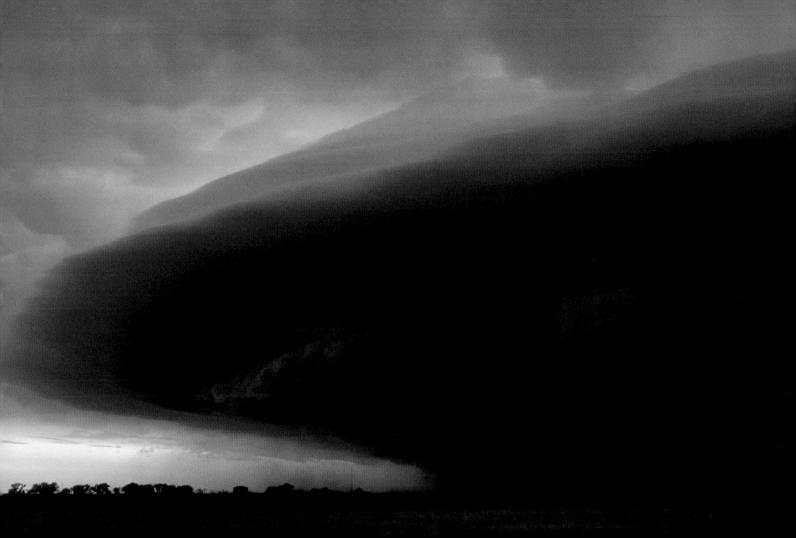

Research the impacts of aquaculture before eating farmed fish.

At present, fish farming accounts for 43% of the world's fish production. The earth's population is growing as well as its demand for fish, and in spite of regulations many wild species continue to be in peril because of overfishing. Aquaculture is often criticized for its negative environmental impacts: To produce 1 pound of farmed salmon, 3 pounds of wild-caught fish are needed to provide meal and oil. And, like all intensive farming, fish farming uses chemicals and antibiotics, which affect humans. It is also said that wild caught fish is generally healthier because they have a more varied diet and get more exercise than penned fish.

Support sustainable aquaculture. Tilapia, catfish, and many varieties of shellfish can often be farmed safely. Organizations like Seafood Watch and the Marine Stewardship Council have developed strict criteria for sustainable fish farming and offer advice to the public about how to choose the best fish.

Introduce environmental education to schools.

Many local environmental nonprofits or natural reserves offer free or low-cost education presentations or field trips for school-aged children—often it is simply a matter of asking. They usually focus on environmental problems facing your area, or tours of the natural features it has to offer.

If you would like environmental education to have a higher priority in your children's education, spend some time investigating the organizations that offer educational resources. It is a good way to increase awareness among students, teachers, and other parents.

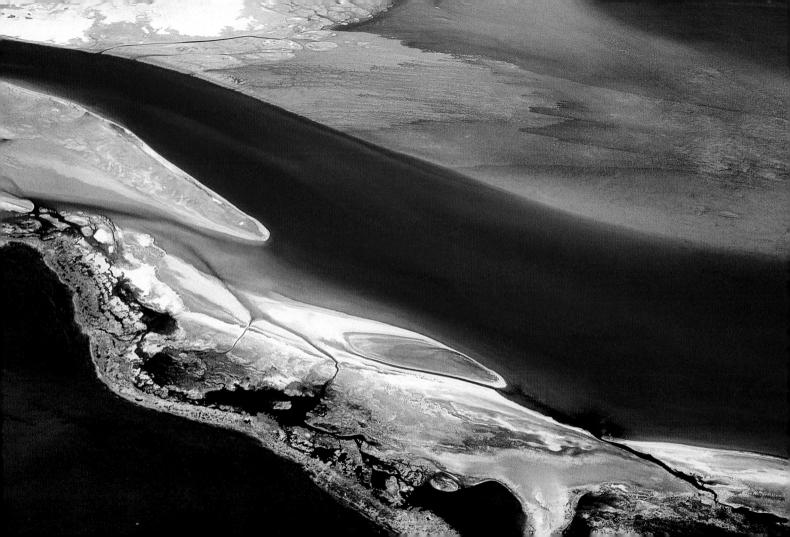

Consider a career move.

Today universities offer many more master's programs in environmental fields from policy to education to business administration. TerraPass, one of the most popular carbon offset programs in the country, was once nothing more than a startup, created by students and professors at the University of Pennsylvania.

If your job is at odds with your concerns, consider moving in a different direction. You might not have to reinvent the wheel: You can offer your current skills to businesses with better practices—they all need consultants, marketing professionals, lawyers, accountants, or assistants. If you're the entrepreneurial type, think about starting your own green business.

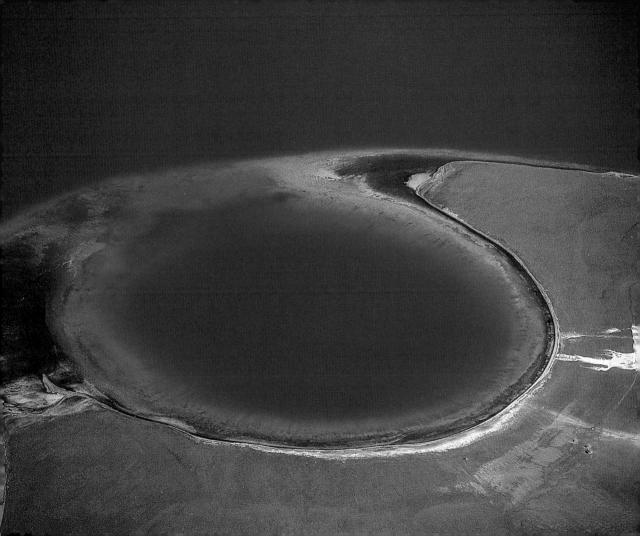

Discover Slow Food.

The Slow Food movement began as a response to the industrialization of the food system, and the subsequent loss of food varieties and flavors. The movement begar in Italy and has moved around the globe. In 1900 there were about 200 varieties of artichokes in Italy: Today only a dozen survive. The mission of the Slow Food moven is to educate consumers on land stewardship and ecologically sound food productic encourage cooking as a method of strengthening relationships between people; further the consumption of local, organic, and seasonal food; and create a collabora tive, ecologically oriented community.

Opt for diversity and discover Slow Food. This international movement opposes the standardization of tastes imposed by fast food. It has more than 80,000 members in 50 countries.

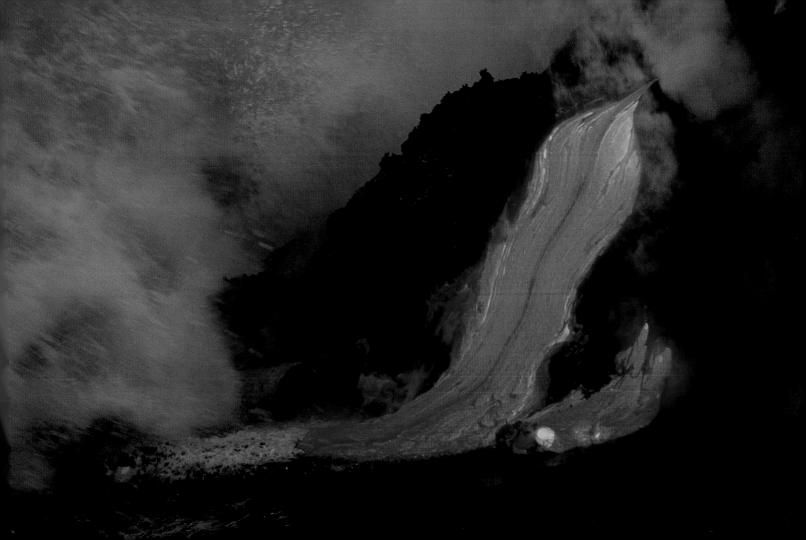

Consider getting rid of your car.

The toxic fumes emitted by industry and vehicles contain nitrogen dioxide and sulfur dioxide. In the air, these compounds are converted into nitric acid and sulfuric acid, which fall back to earth in rain. Acid rain eats away at the stone of historic buildings, destroys forests, acidifies lakes and rivers, and attacks crops. Atmospheric pollution has done more damage to the Acropolis in Athens in 25 years than natural erosion has done in 25 centuries.

If you live in a large city and use your car only occasionally, consider using public transportation and/or joining a car-sharing program. It often works out to be more economical if you take into account the cost of buying a car, depreciation, insurance, gas, a parking space, and parking fines. The average family spends about 16% of its income on car-related costs.

Do not throw out reusable paper products.

Europe, Japan, and North America combined are home to just 20% of the world's population but swallow up 63% of its paper and cardboard. Increasing consumption of these products is relentless: The wealthiest countries use 3 times as much paper today than they used in the 1960s. By 2010, the volume of paper used worldwide could increase by as much as 50%.

To avoid contributing to this overconsumption, cut back on your paper use, and keep reusable paper products, such as manila envelopes and file folders. Cut scrap paper into quarters and use it to write phone messages rather than buying a new pad. And recycle all eligible paper and cardboard products.

Properly dispose of old car batteries.

Car batteries are rechargeable electric cells containing lead and acid. These substances are extremely toxic to nature: A battery left in the countryside pollutes nearly 50 square feet around it for several years. The lead used in cars, in general, is the largest remaining source of lead pollution, and the majority of current lead use is for car batteries.

To recycle your old battery, call your department of public works to find out where to bring it, or take it to your local resource recovery center.

Sea of clouds, Indonesia

Say "no" to digital displays.

At present, a quarter of the world's population controls three-quarters of the energy produced on the planet, while a third of the world's population does not even have electricity. For example, the United States uses 22 times as much energy per inhabitant as India does. Part of the energy consumption in wealthy countries is due to superfluous gadgets.

If you are choosing between two different models of refrigerator, oven, or microwave, choose the one with a mechanical display rather than one with a digital display; the digital display is always on and wastes energy.

Ventilate your home regularly.

Indoor air pollution affects all enclosed spaces. This can be caused by a ventilation system that does not remove stale air properly, by a faulty gas stove or heater, or by the improper use of products that require a high degree of air circulation to dissipate pollutants, such as paints, varnishes, and household cleaners. Some pollutants, such as mites and molds, are of natural origin.

On average, we spend 80% of our lives in buildings. The quality of the air indoors can therefore have a major effect on our health. To circulate the air and remove pollutants, ventilate your indoor space regularly and generously, even in winter.

Take a different approach when buying clothes.

We rarely question the social and environmental impact of the clothing we buy. Who made it and what is it made of? How far did it travel before being sold? Polyester, nylon, and fake fur are not biodegradable, and their manufacture from nonrenewable petrochemical products requires large amounts of water and energy. Growing cotton uses large quantities of pesticides. Wool, linen, and hemp, on the other hand, are more environmentally friendly, as is organic, locally made cotton. Green designers now have a slew of renewable and biodegradable fabrics to choose from, including cloth made from bamboo.

Choose clothing and shoes that are made from organic crops and manufactured in the United States or Canada or fairly traded. Consider buying second-hand clothes from thrift stores and consignment shops or durable clothes that won't go out of style in one season.

> Vermilion Cliffs National Monument, Arizona

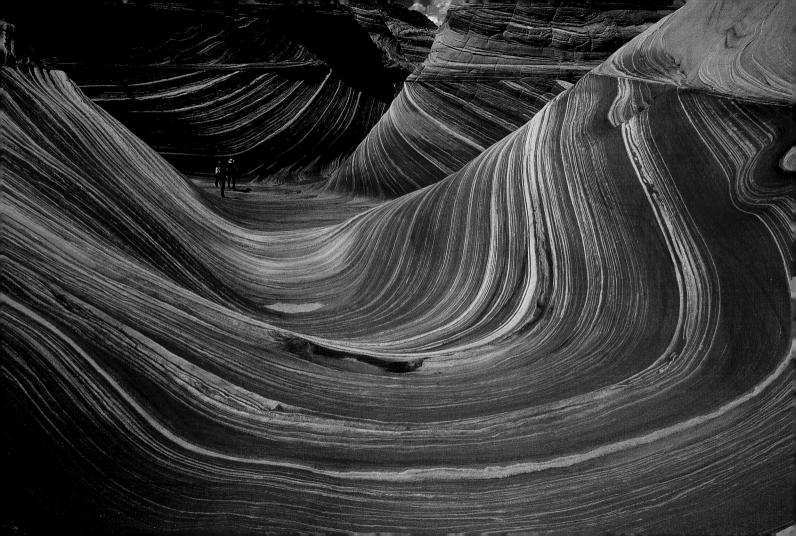

Make your vacation carbon-neutral.

Many people have gotten into the habit of purchasing carbon credits to offset the emissions generated by their air travel. But your impact doesn't end when you step off the plane, so be sure to calculate the emissions for your entire trip. Travel Green estimates that the average 1-night hotel stay generates 34 pounds of carbon dioxide. In response to this some hotels have started to offer emissions-offset programs to guests, usually a few dollars per night. Car and boat travel should also be part of the equation when estimating how much carbon your trip produces.

Remember that carbon-neutral is not synonymous with sustainable, so be sure to stay in eco-friendly accommodations, use public transportation, be conscientious of water and energy use (particularly in nations where these resources are scarce), dispose of waste properly, and tread lightly in general.

> Grand Teton National Park, Wyoming

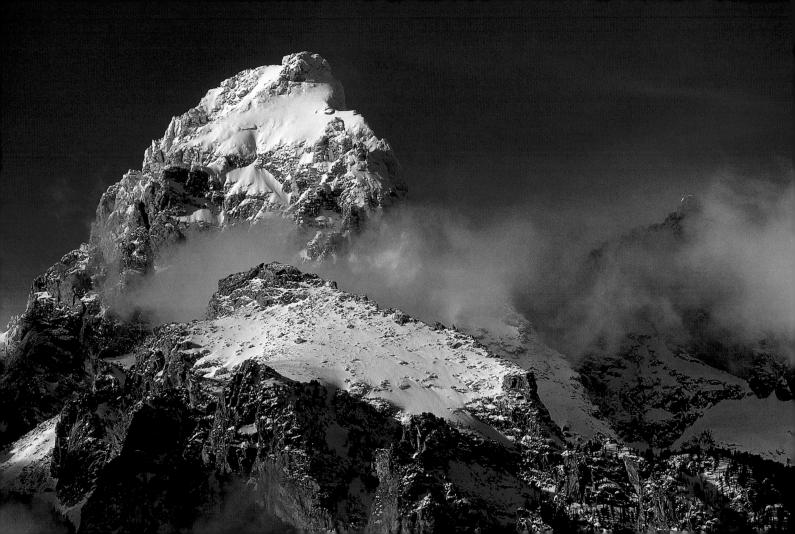

Don't keep exotic animals as pets.

Over the last decade it has become fashionable to keep exotic animals as pets. These animals, snatched by the thousands from their natural habitats and carried to the other end of the world, end up in captivity, where they usually survive for a short time, being suited neither to their new climate nor to life out of the wild. The black market for exotics has devastated the populations of some unfortunate species. The highly sought-after horned parrot of New Caledonia, for example, has been the victim of ferocious poaching: Only 1,700 remain in the wild. Similarly, there are more tigers in captivity than living in the wild, and only a small percentage are those in zoos; the rest live in circuses, roadside menageries, big-cat rescues, and in backyards, as pets.

Think carefully before imprisoning a languid iguana or a brilliantly colored parrot in your home.

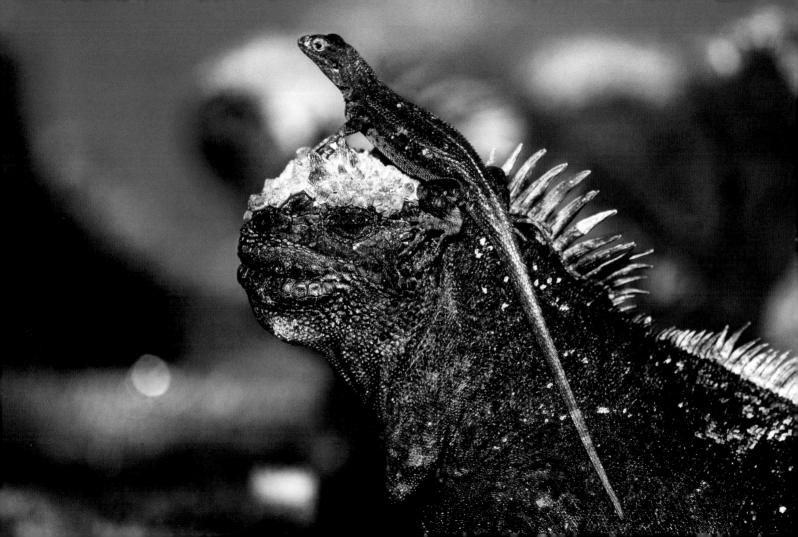

Invest in products and souvenirs that encourage sustainable living.

During the last century, whales, tigers, rhinoceros, and elephants reached the edge of extinction. Every day, several dozen species vanish from existence. Half the plant and animal species on Earth may disappear before the end of the twenty-first century. Over exploitation is one of the leading causes, because poaching—whether for meat, eggs, feathers, or skins—is very lucrative and is a strong temptation to people living in poor countries.

In developing countries, poaching often brings greater profits than respectable jobs in a sustainable industry. The best way to discourage poaching is to invest in products that have been developed sustainably, for a fair wage, in equitable conditions. It may take some extra time, but do some research on the country you are visiting and seek out sustainable cottage industries that employ native people. Then buy their wares.

Caterpillar, Death Valley National Park, California

Choose goods with less packaging.

When we buy something, we tend to look at its quality and its price. Little attention is paid to the packaging, even though it accounts for part of the cost of the product-sometimes a considerable part.

Why does a tube of toothpaste have to come in a cardboard box? Why do printer cartridges come in both cardboard and plastic packaging?

When you have a choice between equivalent products, choose the one with less packaging—or even better, packaging made from recycled materials and fully recyclable. If a favorite brand of yours habitually uses excess packaging for its products, call in or e-mail a complaint.

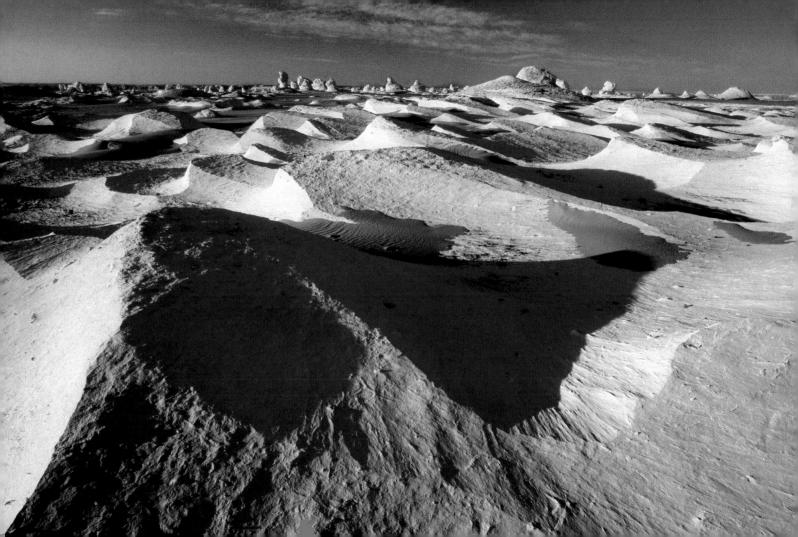

Find out how your local authority manages waste.

In addition to ecological benefits, recycling also creates jobs. More than 1.5 million people worldwide are employed in the recycling industry. Recycling creates 36 jobs per 10,000 tons of recycled material compared to 6 for the same amount of material brought to traditional disposal facilities.

Ask your local authority how it manages your area's waste. Is it dumped or burned, and where? If your local authority has not put in place a comprehensive recycling program, ask why. Encourage other voters to ask similar questions.

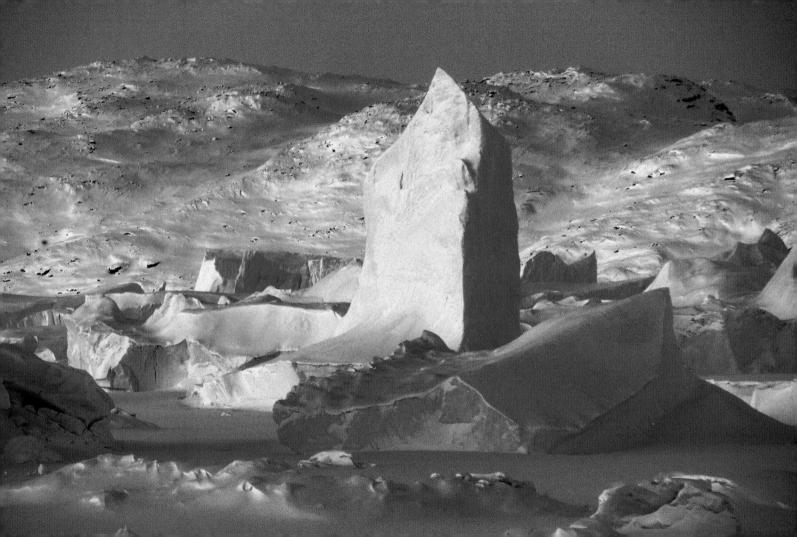

Drink a different kind of green beer.

Americans consume more than 7 billion gallons of beer each year, and per capita consumption increases drastically on St. Patrick's Day.

A handful of small and midsize breweries around the country, including New Belgium, Brooklyn Brewery, and the larger Sierra Nevada, have taken major steps to reduce their environmental impact. They support renewable energy sources by buying power from wind farms and generate a good portion of their own power through methods like recapturing steam to use in the boiling process and cleaning wastewater with bacteria that create energy-producing biogas. They send grain waste to local farms or use it for composting in their own gardens. And they use up to 50% less water than industrial brewers, who need 5 to 6 gallons of water to create one gallon of beer. Some breweries have gone organic, too, only using pesticide-free barley and hops.

Instead of dropping food coloring into a can of Budweiser, use St. Patrick's Day as an excuse to seek out a local brew that is truly green.

Use aerators on faucets.

Eighty percent of the fresh water used in the United States irrigates crops and generates thermoelectric power. A one-acre cornfield gives off 4,000 gallons of water per day in evaporation. Throughout the world, irrigated areas—which have multiplied sevenfold in the space of a century—use up to two-thirds of the water that is drawn off rivers and from aquifers. The amount of water drawn off is expected to rise by 14% by 2020.

You can reduce your domestic consumption by having faucets fitted with aerators. These cost about \$6. The flow will feel stronger, but it actually contains less water and more air. Conventional faucets use 3 to 7 gallons a minute; aerated faucets can reduce use to 1.5 gallons per minute.

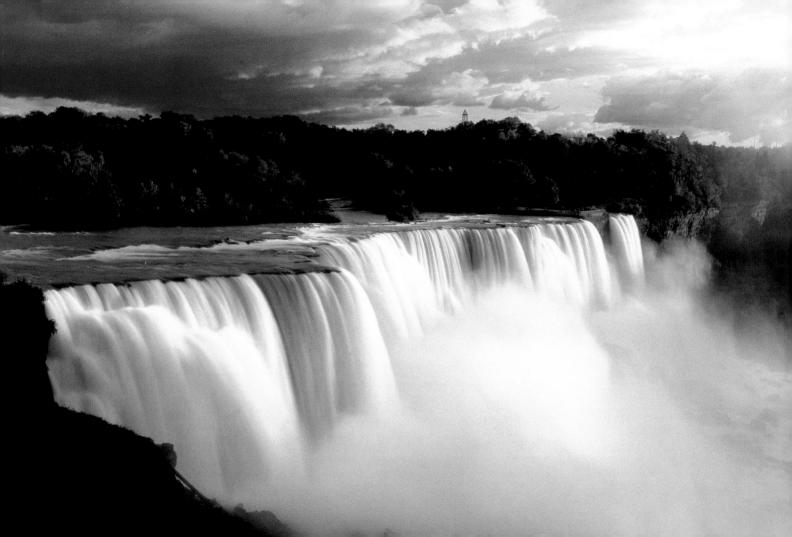

Know the pros and cons of MP3s.

Downloading music files from sources like iTunes means you get the music without the CDs and those bulky plastic jewel cases (most of which are made from molded polystyrene and not easily recycled). Although downloading music seems to produce a fraction of the emissions involved in putting an actual CD in an actual store, the e-waste generated by computers and MP3 players, which have incredibly short shelf lives, may in fact cancel out the benefits of downloading. Not to mention that patronizing those real-life stores can foster small, local businesses that buy and resell unwanted CDs.

You can help make your MP3 player a more ecologically sound investment by buying the greenest equipment you can find (that includes your computer), burning as few CDs from MP3s as possible (on rewritable discs), and extending the life of the player. Some savvy techies have opened up repair shops that fix players that are past warranty—or seem beyond hope; these same organizations also buy broken players and resell them. And as you're making the transition to digital, recycle old jewel cases and CDs by giving them away or sending them to organizations like GreenDisk, which recycles them into new office products.

> Bolshoi Semiachik Volcano, Kamchatka, Russia

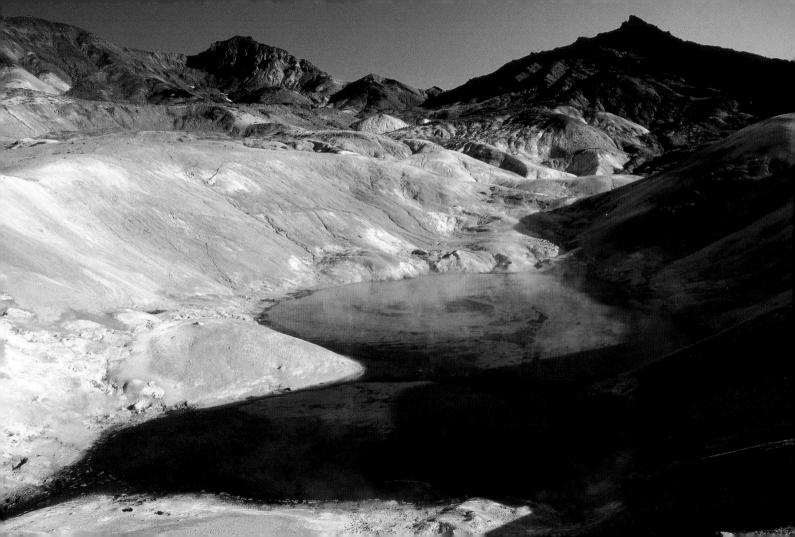

Run your car on vegetable oil.

Biofuels are clean-burning alternatives to both conventional diesel and gasoline. Cars running on traditional biodiesel (a mix of vegetable oil and animal fats, available in some states at special gas stations) give off 78% fewer emissions. "Secondgeneration" biofuels currently in the works promise to be even greener, as scientists will focus on converting agricultural waste and non-food-based materials like grasses into clean-burning fuels, thereby ensuring that we won't have to clear land to grow more crops just to provide the vegetable oil for biodiesel.

In the meantime, anyone with a diesel engine can convert their vehicle to run on straight vegetable oil (SVO). SVO-compatible engines can run on waste oil discarded by restaurants, store-bought oil, and regular diesel when necessary. Each year the U.S. produces more than 11 billion liters of waste oil, most of which comes from deep fryers—that's a lot of free fuel!

Celebrate the vernal equinox—the arrival of spring—by doing something for the earth.

Every year, nearly 15 million acres of land become desert, worldwide. Overgrazing, excessive deforestation, rain and wind erosion, and salt contamination all cause soil degradation. Already, desertification has affected a global area equivalent to the combined territory of United States and Mexico, and every day the earth's productive capacity is reduced. The planet will need to feed roughly 8 billion people by 2025. We must seek to halt the practices that cause desertification and invest in methods to stop it.

The vernal equinox falls on March 20 or 21 every year. On that date, day and night last equal lengths of time. It is an ideal opportunity to offer the planet a few hours of respite. This vernal equinox, make a gesture for the earth—the choice of what to do is vast.

Mount St. Helens National Volcanic Monument, Washington

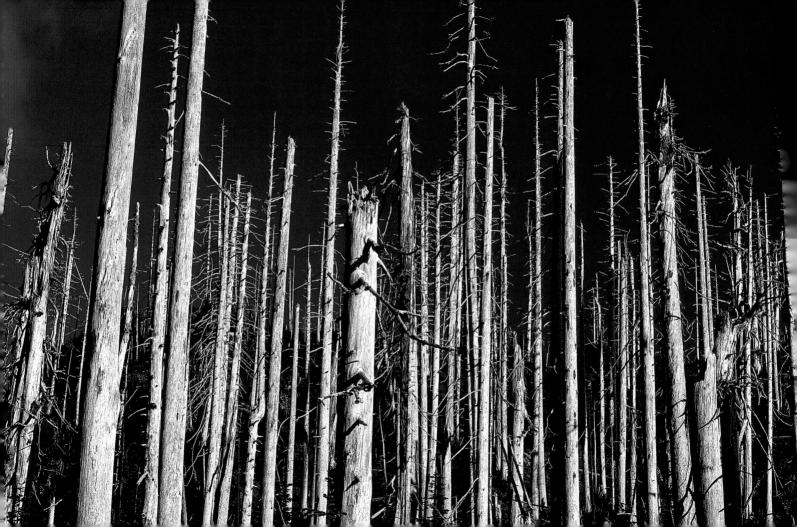

10

Do not let the children play with water.

It seems to us so natural that our taps deliver clean water that we assume it is a lifetime guarantee to everyone. This is not the case. Every morning, millions of people walk several miles to collect the water that is essential to meet their modest needs. The average African woman walks more than 3.5 miles per day to obtain water for her family—or the equivalent of a marathon every week. March 22 is World Water Day every year, and aims to make people in the world aware of the importance of preserving this vital resource.

Teach your children to treat water with respect. The faucet in the bathtub and the garden hose are not toys—do not let your children play with running water.

Run the dishwasher only when it is full.

A large volume of the water taken from nature to meet humanity's growing needs is drawn from rivers. Rivers such as the Colorado in the United States and Mexico, the Jordan in the Middle East, the Indus in Pakistan, the Yellow River in China, and the Nile in Egypt vanish into the earth at certain times of the year in certain places because their flow is not enough to reach the sea. Rivers and streams in the United States suffer the same fate because of groundwater depletion. This happens during the dry months of the summer when the baseflows of rivers are low and water is being pumped to irrigate lawns and gardens, as well as for use in homes.

The average dishwasher uses 9 to 12 gallons per cycle; consider upgrading to a more efficient model, which can use as little as 4 to 7 gallons per cycle. To further save water, use the dishwasher sparingly—only run it when it is completely full.

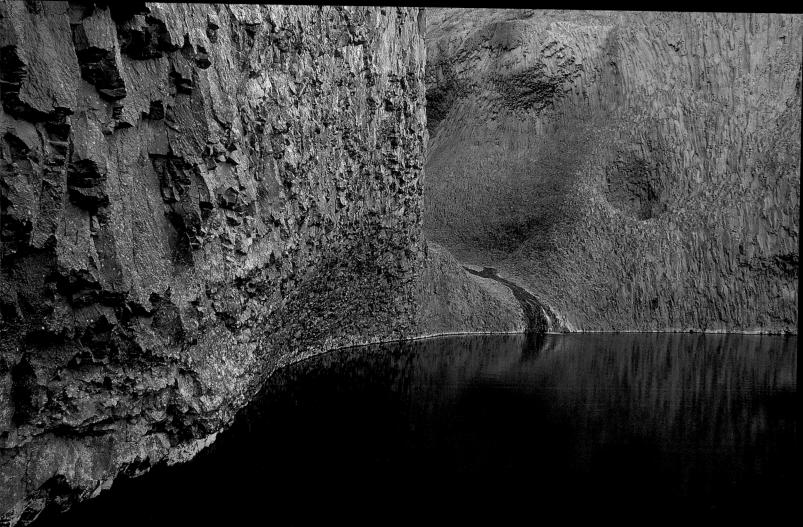

Try trading skills instead of purchasing services.

People all around you have a wealth of specific talents and knowledge that perhaps you do not share. Your own abilities may take another form. These may range from the sophisticated—computer programming, financial investment, or portrait photography—to the basic, like lifting boxes or feeding a cat while the owner is away.

Instead of looking in the phone book for a service for hire, reach out to your neighbors and friends and offer to trade talents. Perhaps someone living near you will offer the help you need in moving house, in exchange for your help with child care. It is another way of encouraging a more humane society.

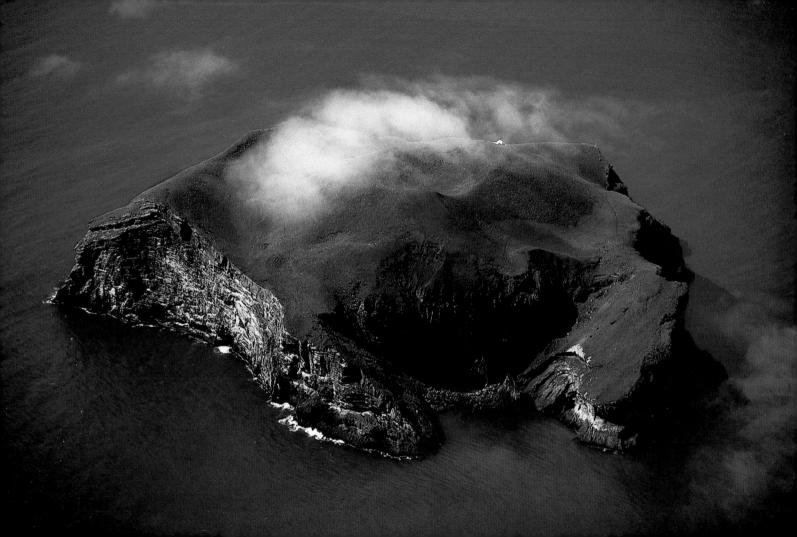

Water your garden in the evening.

All the water we use runs into rivers, where it flows to the sea to evaporate and fall back to the earth once more as rain. This endless process is called the water cycle. The water that quenches our thirst today may have been drunk by dinosaurs millions of years ago, for the amount of water on our planet is always the same. We need to look after it as our population continues to grow and our use of water increases.

Wait until evening to water your garden; during the cooler hours of the night, plants lose less through evaporation, and use half as much water. Also keep the weather forecast in mind: There is no sense watering your garden if rain is in the forecast. It is pointless to water the lawn in the dry summer months—your shriveled grass will become green as soon as the rains return.

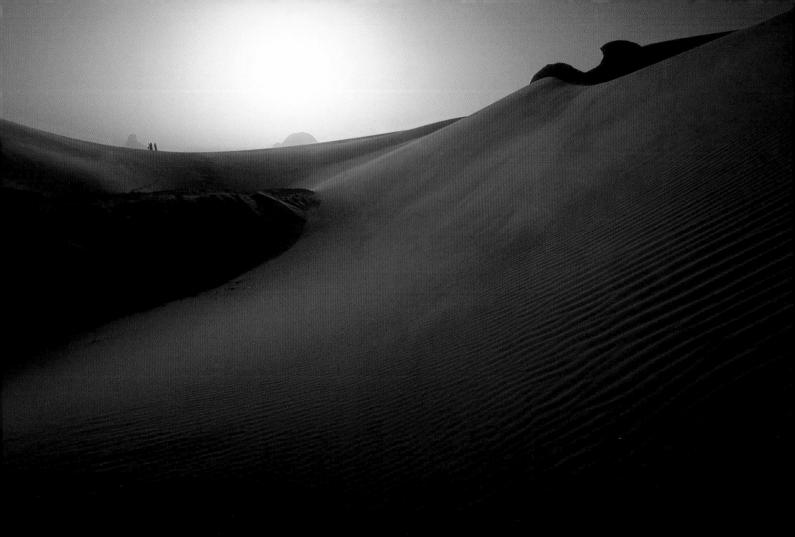

Choose a dishwasher with a "booster" heater and lower your water heater temperature.

More than a third of the electricity used by an average household goes to supply power for washing machines, dishwashers, and clothes dryers.

To reduce this consumption of energy, choose a dishwasher with a "booster" heater. This will add about \$30 to the cost of a new washer, but it should pay for itself in water-heating energy savings after about a year if you also lower your water heater temperature. Some dishwashers have boosters that will automatically raise the temperature, while others require a manual change before beginning a wash cycle.

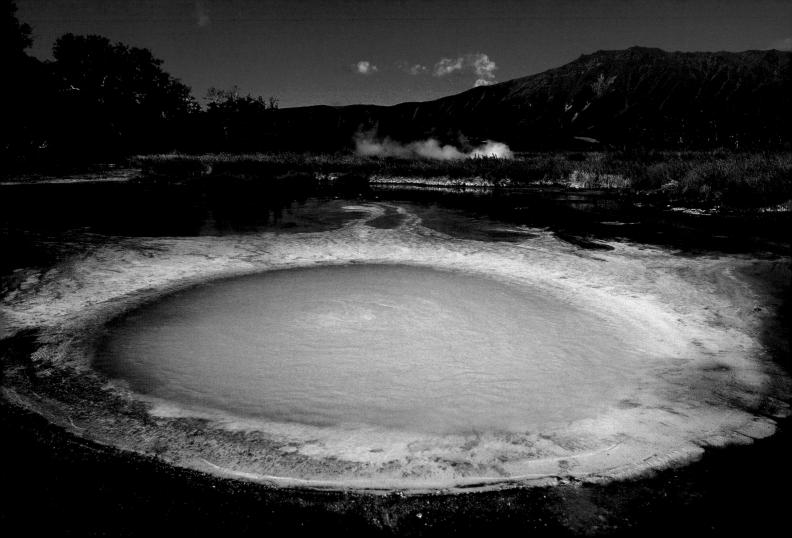

Consider a toy library.

Too many children never experience childhood. More than 300,000 young boys worldwide are enlisted as child soldiers. Many are not even 10 years old. A total of 218 million children between the ages of 5 and 17 are forced to work and almost 126 million work under dangerous conditions.

To teach your children values that are not oriented exclusively toward consumption or buying things, consider organizing a toy library with their friends in the afternoons. The variety of shared toys will certainly please them, and the toys will be used by more than one child.

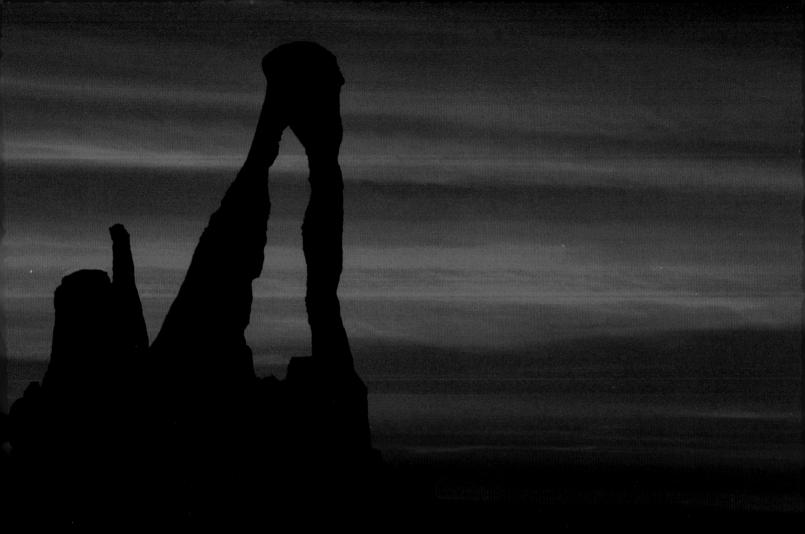

Leftover and stripped paint should go to the dump.

Painting a house is a polluting business. Cans of leftover paint, soiled cloths and packaging, solvents, and glue thrown in the trash become mixed up with other household waste. They have a damaging effect on the decomposition of the gases produced by incineration and on the effluent from dumps. If the liquids are poured down a drain, their toxicity interferes with the processes of water treatment stations. Half of all this waste is not treated and thus ends up in rivers and the sea. Three quarters of marine pollution comes from fresh water.

There are several ways to minimize the polluting effects of painting your house: Use eco-friendly paints, take careful measurements, and buy only the amount of paint that you need; once you are done with the project, take leftover paint to a paint exchange program or donate it to a local charity; finally, if you must dispose of the paint in the trash, be sure to let it dry completely (adding sawdust or kitty litter as needed) before putting it in the garbage.

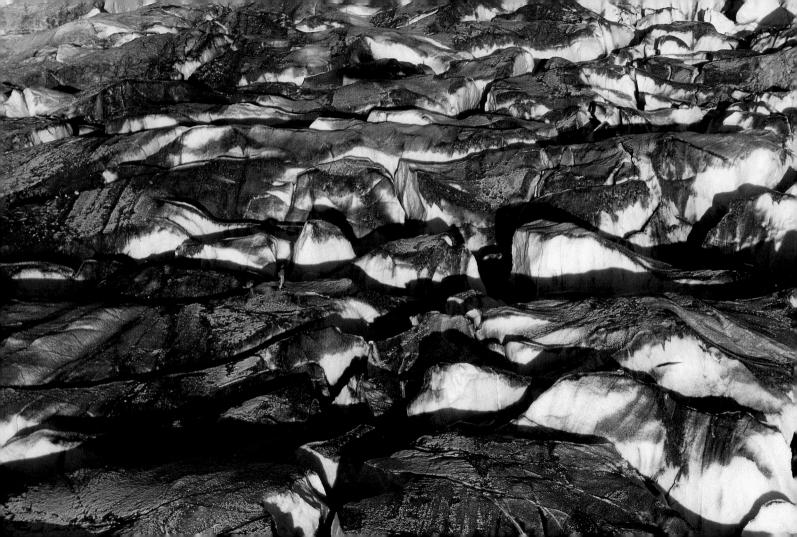

Participate in a Lights Out program.

Cities around the globe have staged Lights Out events, wherein residents and businesses are encouraged to turn off all nonessential lights for one hour. In 2007 London saved 750 megawatts of electricity when nearly 2 million lightbulbs went dark—that's enough juice to power 3,000 televisions for a year. Earth Hour, Sydney's local event, went global in 2008.

Stay apprised of upcoming Earth Hour and Lights Out events and encourage friends and local businesses to participate. On a smaller scale you can stage personal lights out events anytime—shut everything off, including computers and TVs during peak usage hours, light up a few nontoxic candles or solar-powered lanterns and spend the time reconnecting with family and friends.

Leatherback turtle, French Guiana

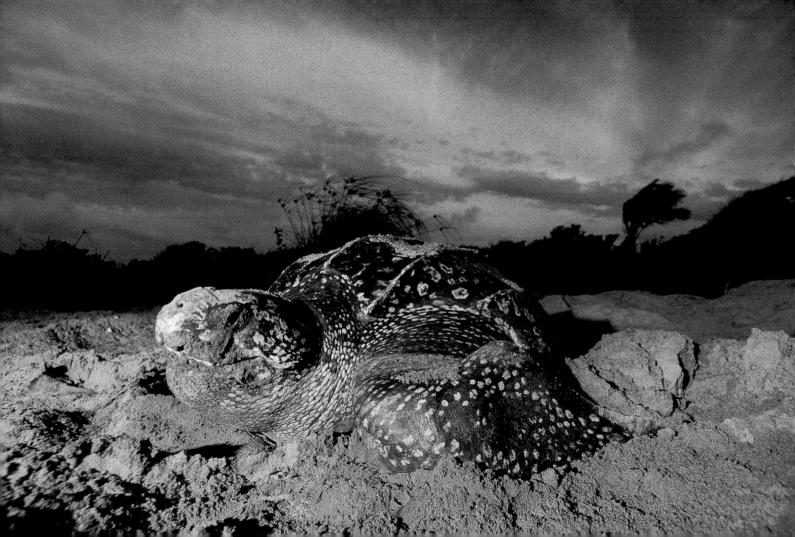

Take a shower rather than a bath.

More than a third of humanity lacks adequate sanitation. It is estimated that half the world's hospital beds are filled with patients suffering from preventable, water-borne diseases. The World Health Organization estimates that more than 2.5 billion people do not have access to basic sanitation, and more than a billion people use unsafe sources of drinking water. This lack of access to clean water kills 4,000 children every day.

Don't take for granted what the rest of the world sorely needs. The average American wastes up to 30 gallons per day. Moderate your water use-start by taking shorter showers. A 5-minute shower uses 10 to 25 gallons, while a filled bathtub holds 70 gallons of water.

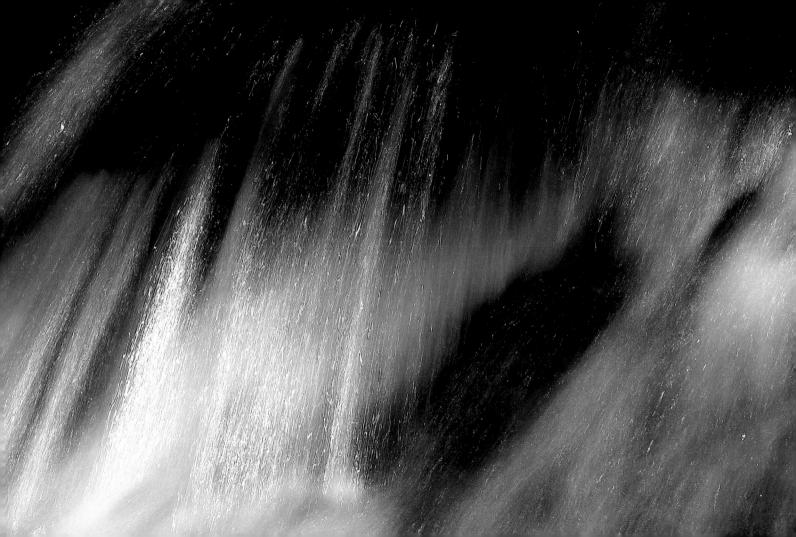

Use information technology rather than traveling.

To reduce the risk to climate change, the concentration of carbon dioxide in the atmosphere would need to be reduced by one-third to one-half of what it is now. That means that the Kyoto Protocol, which was considered too demanding by the United States—the world's chief producer of greenhouse gas emissions—falls far short of what is needed to stabilize our global climate.

Reduce transportation costs and save time by using the Internet or telephone when possible. Some tasks can also be carried out by video conferencing, telephone conferencing, and e-mail.

Fair trade isn't just for coffee and tea.

Fair trade accounts for a small fraction of world trade—only 3.3% of coffee sold in the United States is fair trade certified. Yet it directly benefits more than 7 million people in about 70 countries and enables them to meet their needs for food, health, housing, and education. Broadening the fair-trade market to embrace new cooperatives in developing countries relies on demand, which in turn depends upon the awareness of consumers in the United States, Europe, and Japan.

Don't stop with fair-trade coffee and tea. Broaden your purchasing to include other widely available fair-trade products, such as bananas, chocolate, honey, orange juice, pineapples, rice, sugar, and even flowers.

Yellowstone River Canyon, Wyoming

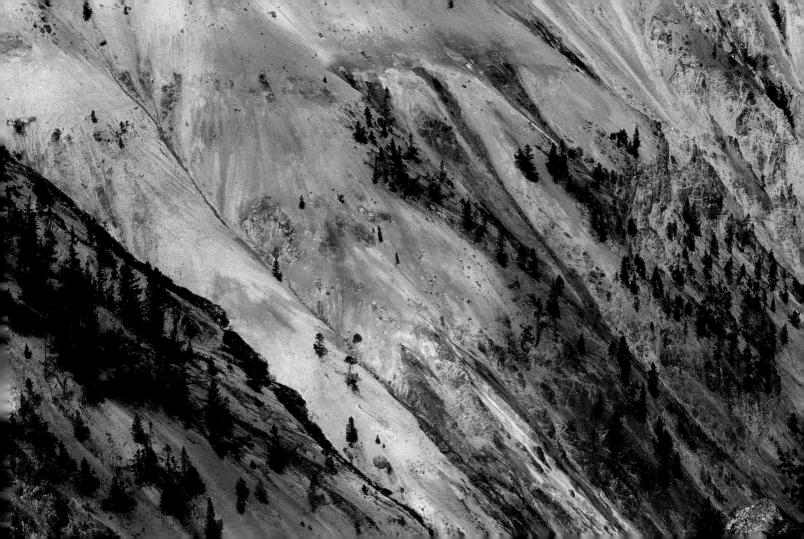

Report illegal dumping.

Illegal dumping is a growing problem in the United States. It should be a concern to everyone, since it often is seen as a "gateway" act; if it is tolerated in a particular area of a community, it sends the message that other illegal activities may also be tolerated. Since no federal statutes exist to protect the environment from illegal dumping, some states have tried to mitigate the problem with a variety of regulations. Apart from being a blight on the landscape, bulky waste can also contain dangerous substances that can pollute the soil, water, and air.

If you notice illegal dumping happening in your neighborhood, make a note of the location, the surrounding environment, and type of waste, and report it to your public works department or board of health. They have the power to have it properly removed, even from private land.

Icebergs, Greenland

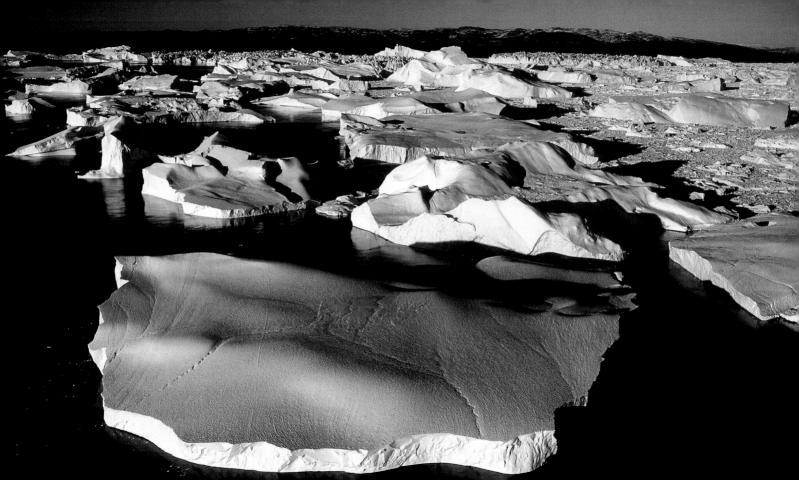

🕖 APRIL 3

Do the small things, but don't lose sight of the big picture.

Making small adjustments to our daily habits is important. For example, if every household replaced one regular bulb with a compact fluorescent, it would prevent the equivalent of the emissions generated by 1 million cars. However, we cannot alleviate the strain on our planet simply by buying better dish soap or using rechargeable batteries. As we implement the small improvements, we must keep in mind the need for greater change—reducing the amount of gas we use by driving hybrids is good, but creating public transportation infrastructures that eliminate the need for personal automobiles is much better. Some of the big-picture actions we should keep in mind are ridding ourselves of oil dependence; reducing the amount of land we require for food and limiting the environmental impacts of big agriculture; reimagining our communities and living standards to curb unsustainable suburban sprawl; and electing officials, from the local level to the presidency, that have clear environmental priorities and policies.

Don't compartmentalize your efforts: understand where each gesture fits into the larger context of sustainability and always look for ways to make a leap toward greater change.

Try an electric bicycle.

Preserving the quality of the air around us is indispensable to life. Air pollution kills 3 times as many people as road accidents. It causes respiratory diseases (chronic bronchitis, asthma, sinusitis) and is responsible for 3 million deaths worldwide every year.

Try an electric bicycle. It is an attractive alternative to the car for short journeys. The electric motor ingeniously spares your legs by reducing the effort needed to pedal, and the removable, easily rechargeable battery has a range of 12 to 26 miles, depending on the terrain. Above all, it emits no pollution, is silent, and is considerably faster in a traffic jam.

> Uzon Caldera, Kamchatka, Russia

Make administrators commit to sustainable schools.

There's more to greening our schools than advocating for healthy lunches. Recycling programs can reduce waste in both the cafeteria and the classroom. School buildings can receive green retrofits that reduce energy use and remove toxic substances. School grounds can go from chemical-drenched lawns to food-producing gardens and outdoor earth-science labs.

Join with fellow parents—and teachers and students—to demand that your school pass a resolution that addresses the whole picture of sustainability. You will provide a framework that will ensure that future administrative decisions are approached from a health-conscious, planet-saving mindset.

Ask your school to put the "field" back in field trip.

Most kids view the field trip as one of the small perks of enduring another school year. Even trips to educational institutions like museums and historic sites generate the kind of excitement that textbooks often fail to do. Field trips are great motivators and in turn great opportunities to introduce kids to the natural areas close to them and get them thinking about possible solutions to environmental issues.

Suggest that your school dedicate one or more of its annual field trips to environmental education—visits to recycling centers, hands-on work at urban farms, or hikes with park rangers are just a few examples of environmentally themed field trips.

Take the time to think about life on this planet generations from now.

In 1990 the United Nations created 8 Millennium Development Goals to attend to the crises faced by current populations. These goals ranged from alleviating extreme poverty and hunger to introducing sustainable development worldwide and came with a target date of 2015. Today more than 1 billion people still live on less than \$1 per day, 800 million people still go hungry, 1.1 billion do not have clean drinking water, and 1.6 billion are without electricity. At this rate, most of the goals will not be achieved by the 2015 deadline. Reaching the middle of the century, the earth will be home to 9 billion people: an additional 3 billion mouths to feed, all needing housing, water, and light. Furthermore, if each inhabitant of developing countries uses as much energy as someone living in Japan did back in 1973, world energy consumption will be 4 times what it is today!

Other generations will live on the earth after us. How will we keep up with the demands on our shrinking resources? What are we going to leave for them?

Bacteria, Kamchatka, Russia

🕨 APRIL 8

Go bicycling as a family.

In the United States today, roughly one-third of children (about 25 million) and twothirds of adults are overweight. The reasons for these extra pounds lie in the power of TV and in lack of physical exercise. Make time to take your children out on a bike ride, an activity that is as beneficial for their health as it is environmentally friendly.

Take more trips closer to home. Instead of planning a long family car trip, explore your local flora and fauna by bike. If you live in an urban environment, be sure to teach your children defensive riding habits when sharing the streets with cars; if you live in a rural area, encourage your children to use their bikes as much as possible, rather than relying on the family car for transportation.

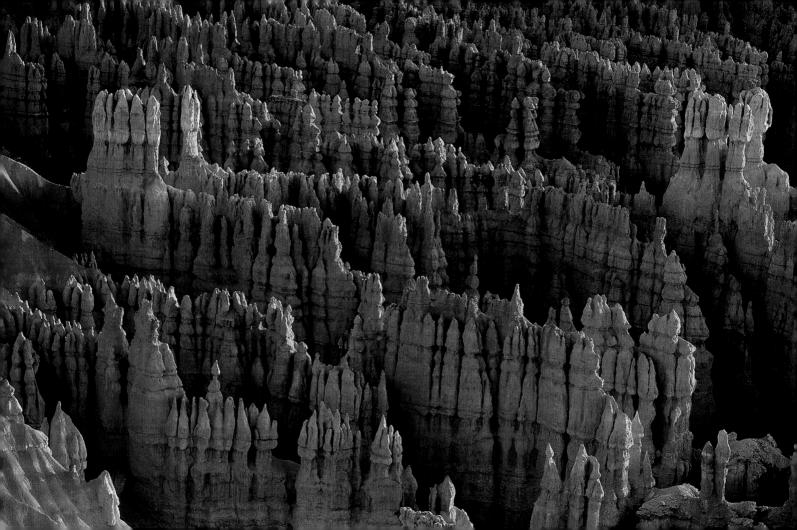

Use rewritable CDs or flash drives to back up files.

Forgo the spindles of cheap one-use CDs that fill the shelves of office supply stores and spend a little more on a small pack of rewritable ones. CDs are recyclable but only a few companies in the United States offer this service and tons of discarded discs end up in landfills every year.

Store data on rewritable discs or on a USB flash drive.

Buy organic food for your baby.

Studies have shown that human exposure to pesticides can cause neurological disturbances, increase the frequency of certain cancers, damage the immune system, and reduce male fertility. Pesticides also degrade soil and contaminate drinking water, leading to significant cleanup costs. These chemicals also kill nontargeted insects and affect organisms throughout the food chain. A conventional farmer can use any of 450 different authorized pesticides; an organic farmer can use just 7 natural pesticides, and that usage is strictly controlled.

If "going organic" for the whole family seems daunting, at least give priority to feeding organic food to babies and young children. Pesticides can increase susceptibility to certain cancers by breaking down the immune system's resistance to cancer cells. Infants and children are among those at greatest risk.

> Grand Staircase-Escalante National Monument, Utah

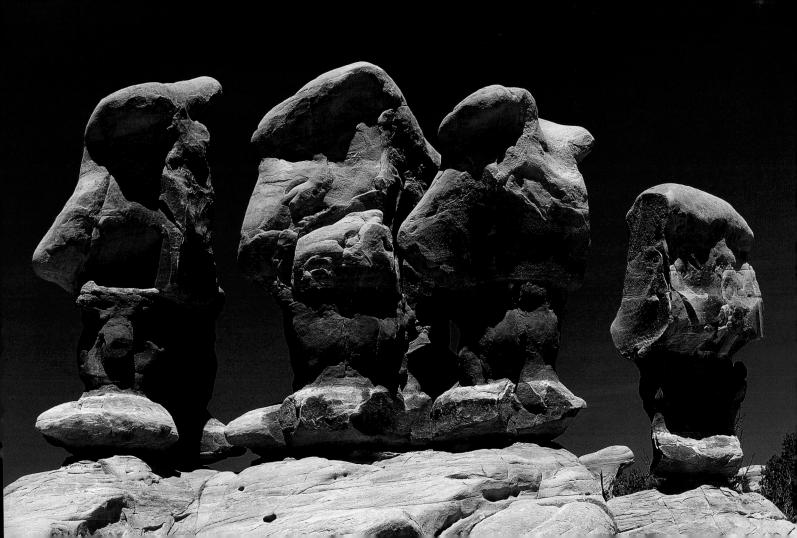

Demand better public transportation.

So few U.S. cities have adequate public transportation that those of us who are blessed with it tend to resign ourselves to problems with a "something is better than nothing" attitude. But public transportation only remains a viable alternative to car culture as long as it serves as many people as possible and remains efficient and affordable.

Are those smoke-belching buses affecting downtown air quality? Ask your city to switch to hybrids or biofuels.

Not enough stops on a system or not enough service outside of peak hours? Write to city representatives to let them know where service is lacking (remember, the decision-makers often don't spend a lot of time on public transport).

Get involved with local advocacy groups—the Straphangers Campaign, for example, fights for better service on New York City's indispensable subway system—or start a campaign of your own.

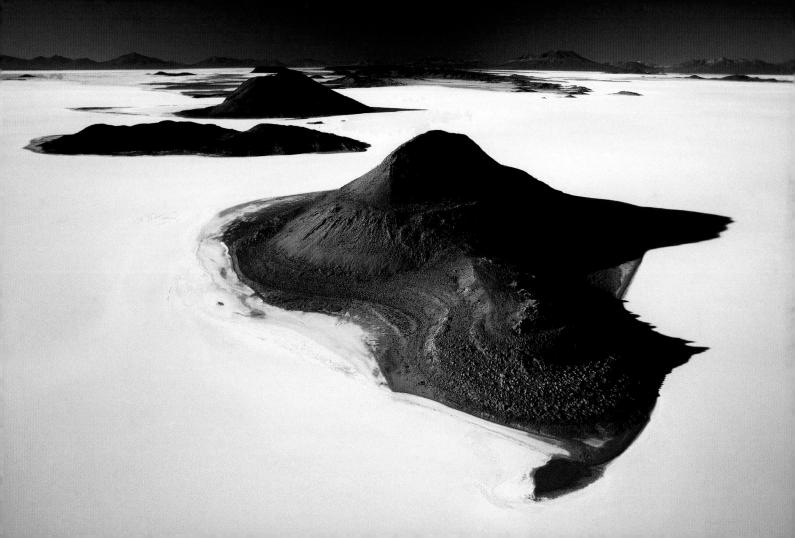

Use natural treatments for plant diseases.

In both agriculture and gardening, the intensive use of chemicals and defoliants impoverishes the soil, which, in the long term, becomes sterile. Even worse, repeated, systematic treatment with these agents encourages the development of resistance in the targeted pests. Since the 1950s, the number of insect and mite species immune to insecticides has increased from a dozen to about 450.

The best way to deal with plant diseases is to prevent them in the first place. Choose the right plants for your site, use disease-resistant varieties, keep a clean garden, create well-balanced soil, and don't overwater or overmulch.

Respect the environment when driving an off-road vehicle.

Long before human beings appeared, the earth had already seen several mass extinctions of species as a result of climate change, volcanic eruptions, and changes in sea level. The most well-known of these, 65 million years ago, wiped out the dinosaurs and 70% of species on Earth. The one we are experiencing at present has an extinction rate between 1,000 and 10,000 times higher than the most severe of its predecessors.

When you drive an off-road vehicle, do not go where you are not allowed; use trails that are wide enough to drive along without damaging them or the surrounding environment, and control your speed so you don't disturb walkers and animals.

The use of recreational ATV (All Terrain Vehicle) can cause a lot of damage: Bikers cut renegade trails through undisturbed forest and wetlands, and the vehicles emit both air and noise pollution—gas-powered ATVs are up to 10 times more polluting than cars. If you do invest in an ATV, buy an electric model, stick only to designated trails, and educate other riders about respecting the land.

Namib Desert, Namibia

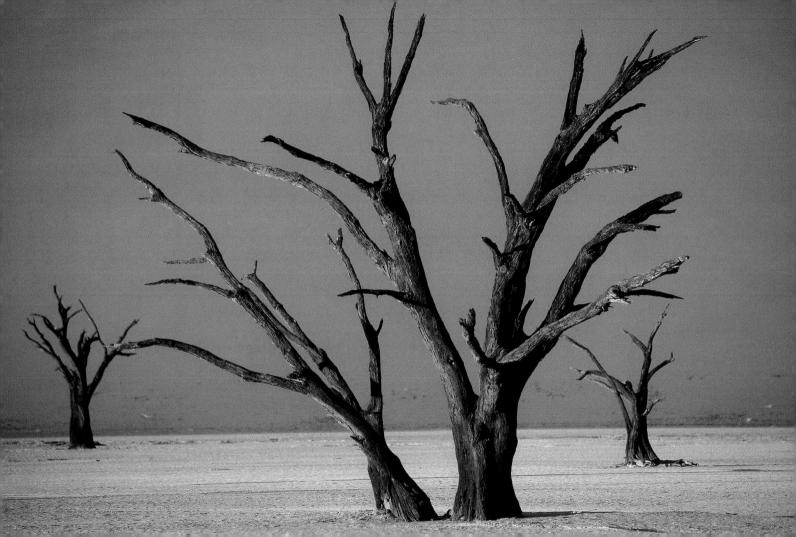

Offset the greenhouse gas emissions your air travel produces.

Although planes are technically public transportation, air travel is not greener than car travel—in fact, it's far more destructive. A 747 jet aircraft consumes 5 gallons of fuel per mile flown. Airplanes account for 12% of the United States' transportation-related carbon-dioxide emissions released each year. Around the world, airplane emissions are expected to triple by 2050.

There are many Internet sites that enable you to calculate the greenhouse gas emissions your next air journey will produce. One transatlantic flight produces almost half as much carbon dioxide as a person produces, on average, in meeting all their other needs (lighting, heating, and car travel) over a year.

Organizations such as TerraPass offer carbon credits and use the money to fund clean energy or reforestation programs. Even travel booking sites and some airlines have started to offer these credits as add-ons when you purchase airline tickets. If you can't avoid flying, be sure to offset the impact of your trip.

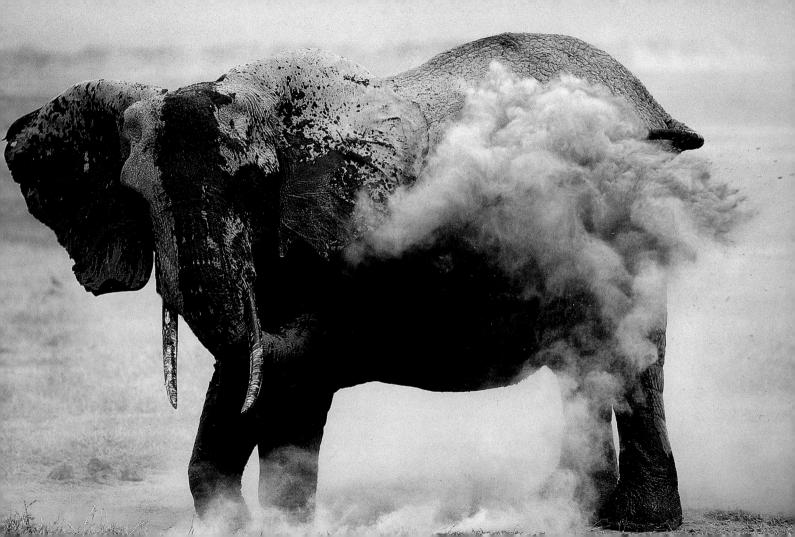

File your taxes electronically.

Each tax season the IRS issues nearly 8 billion paper forms or the equivalent of nearly 300,000 trees. E-filing, which now accounts for 57% of all returns, significantly reduces the amount of paper used. The IRS has set a goal to have 80% of returns e-filed by 2012, but this can't be achieved unless consumers continue to use the service and urge tax professionals to e-file whenever possible.

File your personal income tax returns online. You'll save paper-and get your refund faster.

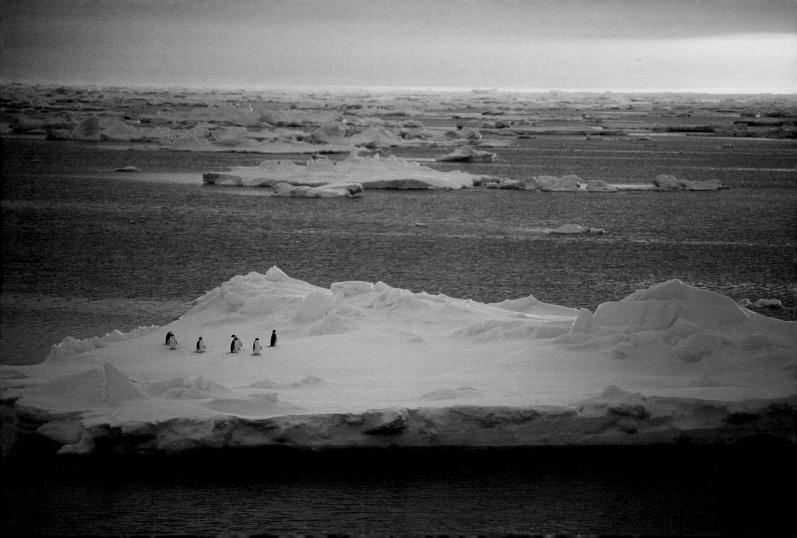

Be unobtrusive while out hiking.

Twenty-one species of birds in the United States are now extinct. Birds are vulnerable to habitat damage from intensive agriculture and forestry, the growing impact of development on the land, unrestricted water use, and pollution of all kinds.

When you are out hiking, treat wildlife with respect. Do not disturb animals, especially young animals and chicks. Watch them discreetly, at a distance, without disturbing their quiet and tranquility.

Trace leaks.

On average about half the water in cities and in distribution grids worldwide is lost to leakage. According to the EPA, a faucet that leaks one drop per second can waste up to 3,000 gallons of water per year. A leaking toilet can lose 150 to 200 gallons a day.

Trace the leaks in your home's plumbing. Test your toilet by adding natural food coloring or dark-colored powdered drink mix to the tank's water. Wait 30 minutes and then check the bowl to see if any of the colored water has leaked out of the tank. Use your water meter to help you find other phantom leaks: Take readings before and after a 2-hour period in which no one uses any water—if there is any discrepancy you might want to call a plumber to check for leaks.

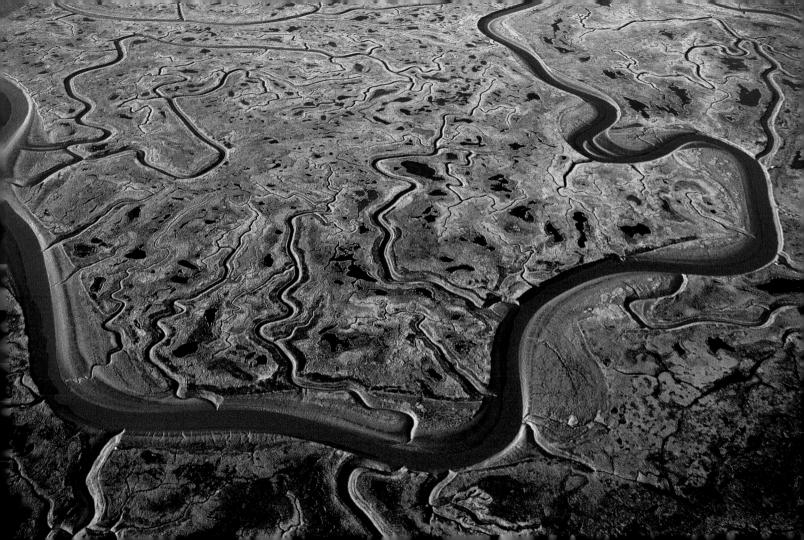

Count your carbon calories.

Every food product you purchase has two caloric values: the amount of energy you receive from it (the value printed on the side of the package), and the amount of energy required to produce it. In today's food industry the second caloric value comes from a variety of sources: namely, the human energy involved in production and the fossil fuels that drive the machinery used in the farming process and power the production of chemicals. Some of the statistics are hard to swallow: The modern production and distribution system spends 10 to 15 calories for every calorie it produces; the United States expends 3 times the energy per person for food that developing countries use per person for all energy activities.

Tesco, the United Kingdom's biggest supermarket chain has vowed to add "carbon labels" to all of its products to help shoppers understand the carbon footprint of each purchase. So far, no U.S. chain has made the same pledge, but while waiting for official labeling, you can inquire by studying carbon scorecards compiled by organizations like Climate Counts, which rate major companies based on their efforts to reduce their carbon calories.

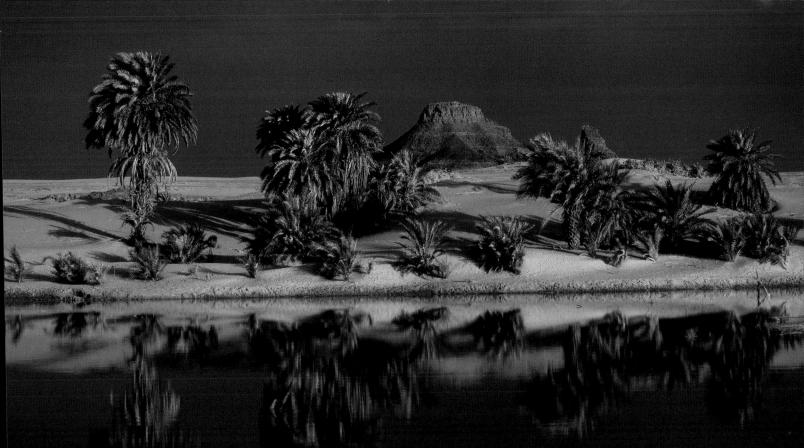

Create a green roof.

Ever wonder why it's always a few degrees warmer in the city than in the suburbs? Concrete and asphalt, the predominant materials of a major metropolis, do a great job of absorbing the sun's heat. This is called the urban heat island effect, a phenomenon that can be mitigated by turning wasted rooftop space into garden. Green roofs aren't just a few potted plants—they have soil layers and drainage systems. They help filter air pollution, extend a building's life by protecting it from ultraviolet rays, reduce storm water runoff (which can instead be collected and recycled within the building), and keep interiors cooler in summer.

Though North America's greatest examples of green roofs are on corporate and university buildings, it's possible to add a simple green roof to many residences. If you're an apartment dweller, you and your neighbors can advocate for green roof retrofit.

Weed mechanically or by hand.

Each year Americans pour 100 million pounds of chemicals onto their lawns. Excessive use of pesticides threatens biodiversity and fresh water resources, two essential elements of life on Earth.

Avoid using chemical weed killers. To remove weeds from your garden, hoe regularly and pull weeds out before they can seed. Vinegar or lemon juice can also be used to kill some weeds.

Protect rivers: Don't dump or litter in storm drains.

No fewer than 114 great rivers, or half the planet's biggest watercourses, are severely polluted. The Ganges, sacred though it is for Indians, receives 450 million gallons of wastewater every day, which transform it into a vast open sewer. Worldwide, 2 million tons of waste are poured into lakes and rivers every day. As a result, at least a fifth of the planet's 10,000 species of freshwater fish are either extinct or in danger of extinction.

Protect rivers from all pollution. Don't dump into storm drains, which discharge into water bodies without any filtration or treatment. Also, don't drop litter in the street or countryside. Sooner or later, it will be washed into a river, lake, or harbor.

Do something for the planet on Earth Day—and every day.

In 1998, 25 million environmental refugees fled from desertification, deforestation, industrial accidents, and natural disasters. This was more than the 23 million who became refugees because of war. As a result of climate change, environmental refugees will become ever more numerous, driven from their homes by droughts, floods, extremes of weather, or rising sea levels. The United Nations estimates that by 2010 the world will have 50 million environmental refugees; by 2050 we may have as many as 150 million refugees as coastal flooding, erosion, and desertification worsen.

Every year on April 22 more than 180 countries celebrate Earth Day. Join the party: Take part in events organized that day. Then, through your own behavior, make every day an earth day.

Apply Slow Food principles to the rest of your life.

The credo of the Slow Food movement can be extended to many different areas from clothing design to architecture. The Slow movement asks us to slow down, engage with, and reflect upon all of the things we bring into our lives, whether goods or experiences. "Slow design" artisans produce handmade goods of high quality in which materials are sourced locally (and are often recycled) and nothing is mass-produced. A "slow home" is designed by an architect (instead of a developer) who takes the time to tailor the property to the needs of the owner and of its environment. "Slow travel" may mean you spend all of your time in one place and really get to know it instead of from city to city or sight to sight.

Overall, the "slow" life focuses on quality, social and environmental responsibility, creativity, and personal engagement-try to embrace this antidote to conspicuous and hasty consumption of inferior, mass-produced goods and experiences.

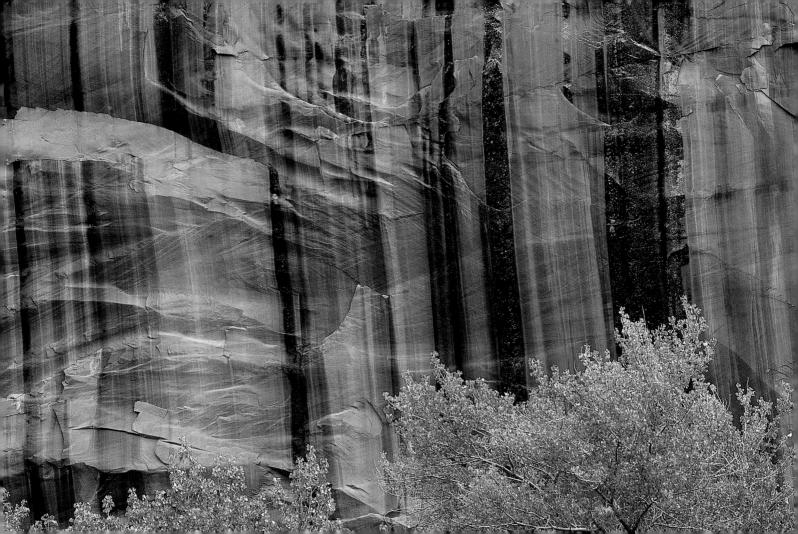

Choose compost and natural fertilizers rather than chemical fertilizers.

Overuse of chemical fertilizers containing nitrogen contributes to pollution of water by nitrates. Highly soluble, these chemicals are easily washed away by rain and carried into rivers and aquifers. Nitrates contribute to the eutrophication of rivers by causing them to become overrich in nutrients, so that algae grow rapidly and deplete the oxygen supply, which suffocates all water life. Large amounts of nitrates in ground-water interfere with drinking-water supplies.

In your garden, use natural fertilizers (stone meal, bone meal, or wood ash) and compost made from organic waste to improve soil structure and fertility naturally, effectively, and sustainably.

Give your home a "spring greening."

A spring cleaning is a great way to clear out clutter, shake off winter doldrums, and refresh our living spaces.

Be sure to replace those toxic cleaning supplies with eco-friendly versions. Before you toss something out make sure it cannot be reused; DIY (do-it-yourself) magazines and Web sites offer tons of fun and creative ways to repurpose common household items. Sort through all throwaways to make sure you are recycling or donating as many items as possible. Take the time to perform simple, resourcesaving repairs like fixing leaks. And as you take stock of your home, make a list of the things you want to improve upon: toxic or inefficient products that still need to be replaced and energy-conservation measures that you have yet to adopt.

Guelta (water hole), Chad

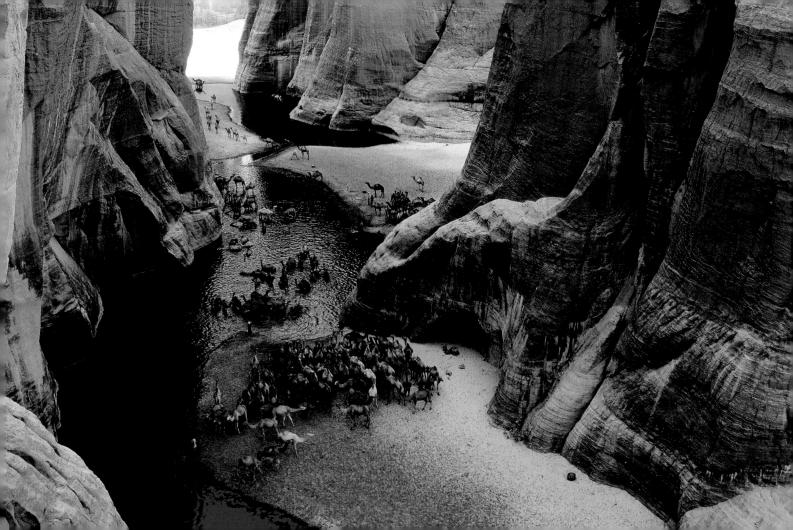

Do not pour cooking oil down the drain.

A city of 100,000 people produces nearly 80,000 gallons of wastewater every day. Before being returned to nature, this dirty water must be cleaned in a treatment plant.

Avoid pouring food oils in the sink: Vinaigrette, oil from tuna cans, and oil used for frying form a film on water that interferes with the functioning of water treatment plants by suffocating the bacteria that remove pollution. It is better to put such oils aside in a closed plastic container that, once full, can be discarded with other nonrecyclable waste.

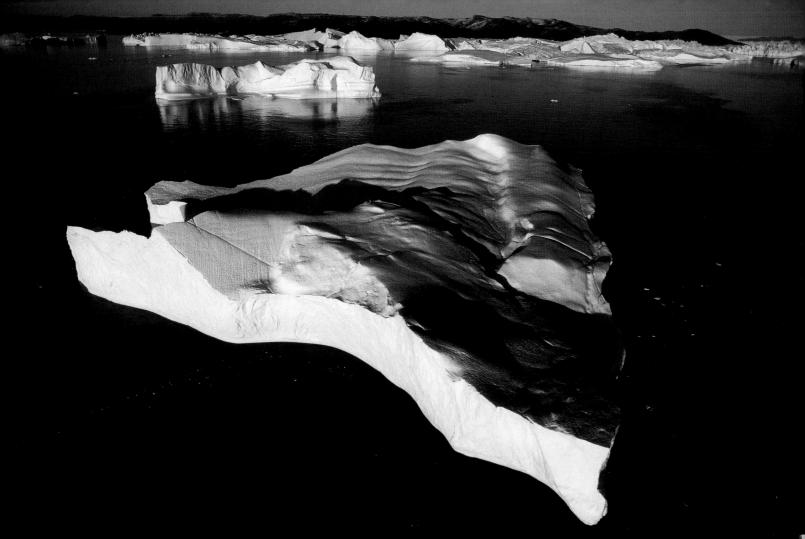

Buy toilet tissue made from recycled post-consumer paper.

Americans go through about 400 million miles of toilet paper each year. If every home replaced just one roll of regular toilet paper with a recycled roll, it would save nearly 500,000 trees.

But don't grab any package emblazoned with "100% recycled." Always look for the percentage of post-consumer content (these vary, but several brands use up to 80%). The presence of post-consumer waste asserts that a certain amount of raw materials came from recycled paper. In addition, look for FSC (Forest Stewardship Council) certification, which means any virgin materials used were harvested sustainably, and avoid products with fragrances, dyes, inks, and chlorine bleach.

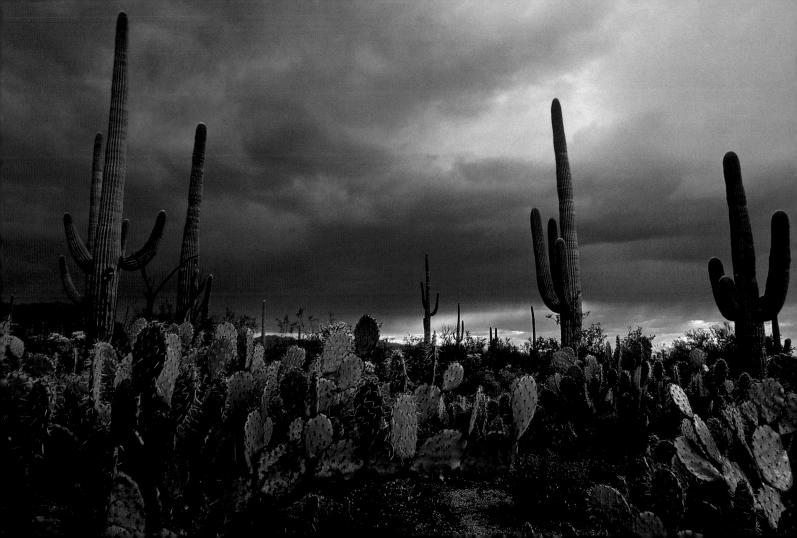

Use photovoltaic panels to produce electricity for your home.

Solar energy is available everywhere. It is free and easily harnessed by fitting photovoltaic (PV) panels to your roof. PV panels convert sunlight into electricity without producing noise, pollution, or dangerous waste in the process.

Grants and tax breaks are often available for solar-panel installations, and if you produce more electricity than you need, you can feed the excess energy back into the public grid and receive credits or refunds from the electric company.

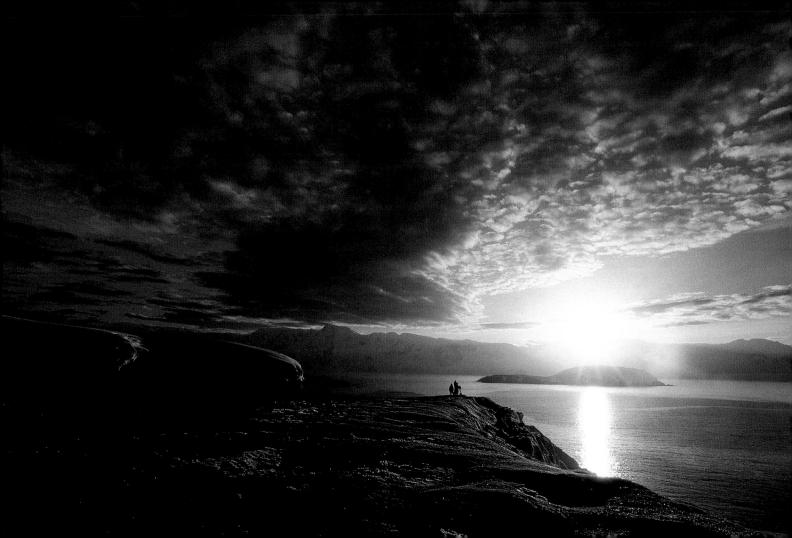

Shop at the local produce market.

Three quarters of the edible varieties of produce that were cultivated at the beginning of the twentieth century have disappeared. Today's fruits and vegetables, which have survived the race to increase productivity, are mostly hybrid varieties chosen for their ability to withstand the various demands of mechanized farming and produce distribution. Picked prematurely and ripened artificially, once they are on the shelf, their appearance is almost perfect—and generally hides their lack of flavor and nutritional value.

Buy your fruit and vegetables in the market, from local producers. You will be supporting the local economy, and your purchases will be environmentally friendly, because they involve less transport and packaging, and therefore less waste and pollution. They will taste better, too.

Lake Turkana, Kenya

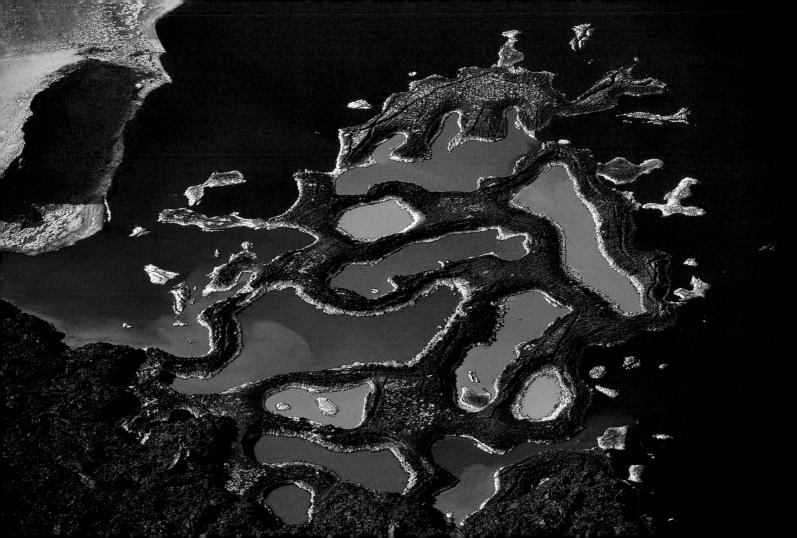

Demand organic products in institutional cafeterias and eateries.

Every year throughout the world about 3 million people are poisoned by, and 200,000 die from, pesticides. In fact, today these products are between 10 and 100 times more toxic than they were in the 1970s. A common way for pesticides to affect human health is for the chemicals to seep into groundwater supplies, which provide the bulk of our drinking water. Since it takes several centuries for these supplies to be replaced, this contamination poses a grave threat. Therefore, practicing less-polluting agricultural methods also safeguards the future of our drinking water supplies.

Organic food also has a place in educational institutions and places of business: Help your child's school and the cafeteria at your workplace begin to buy more organic and locally grown products.

> Piton de la Fournaise Volcano, Réunion

Choose "draft" quality when printing.

Printer cartridges contain pollutants such as aluminum, iron oxide, and plastic. Luckily, the cartridges are perfect for recycling. Whether damaged or empty, they can be dismantled and reassembled; defective parts may be recycled, and refilled cartridges are of comparable quality to new ones. Ink powder, which is highly toxic, contains chemical pigments made from cyanide. If this finds its way to the dump, it will contaminate soil and water. During the recycling process, this powder is instead incinerated at 2,700°F.

The best way to reduce the pollution produced by ink cartridges is to use less ink. Remember to choose "draft" quality for all print jobs that do not require flawless print quality—in other words, most of them. Only print when necessary, as well.

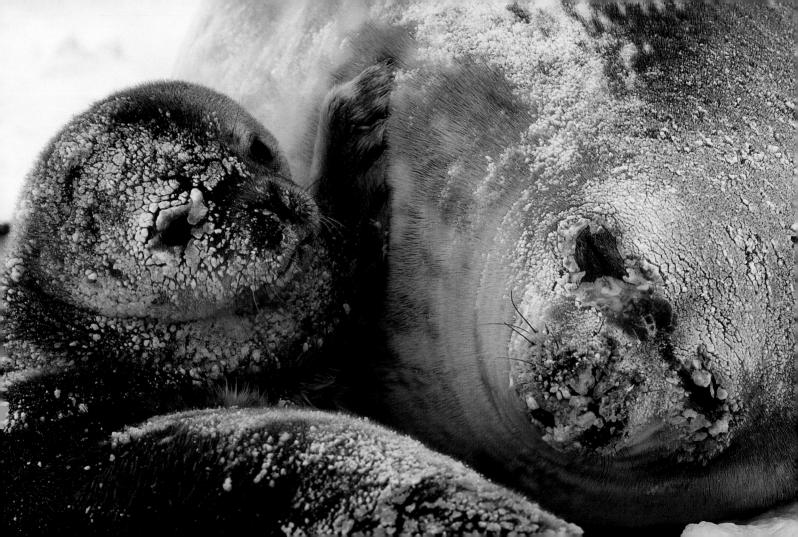

Support Community Sponsored Agriculture.

The average American-grown tomato may travel as much as 1,500 miles from vine to salad bowl in a journey that leaves a trail of serious environmental and societal consequences. The food shipping industry relies heavily on cheap energy sources, and air pollution from food transport contributes to our smog-choked atmosphere. Farmers see only a fraction of every dollar spent on their produce while the rest is paid to various middlemen in the food production process. Unable to compete with large-scale farms, small farmers are forced to close up shop.

Community Sponsored Agriculture (CSA) programs seek to alleviate these problems by localizing food production and consumption. Consumers who invest in a farm at the beginning of a growing season receive regular deliveries of seasonal, usually organic, vegetables that have been locally produced, and are able to develop a relationship with their farmer and food provider.

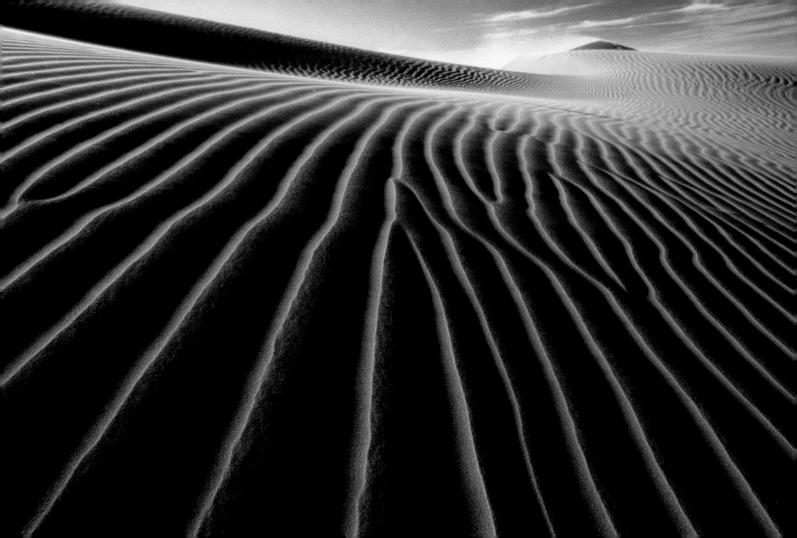

Cover soil to protect it from evaporation and weed growth.

When weeds appear in the garden, there is a strong temptation to eliminate them using an environmentally damaging chemical treatment. It is better, however, to prevent them from growing in the first place by using natural mulch cover that also helps to keep moisture in the soil. Protected from weeds as well as from drying out excessively, the garden will be healthier.

You can mulch the soil around the base of plants, trees, and bushes using hay, dried grass cuttings, leaves, wood shavings, chippings, cocoa bean shells, and so forth. Mulching also protects soil from the action of sun and wind, and helps to keep it moist.

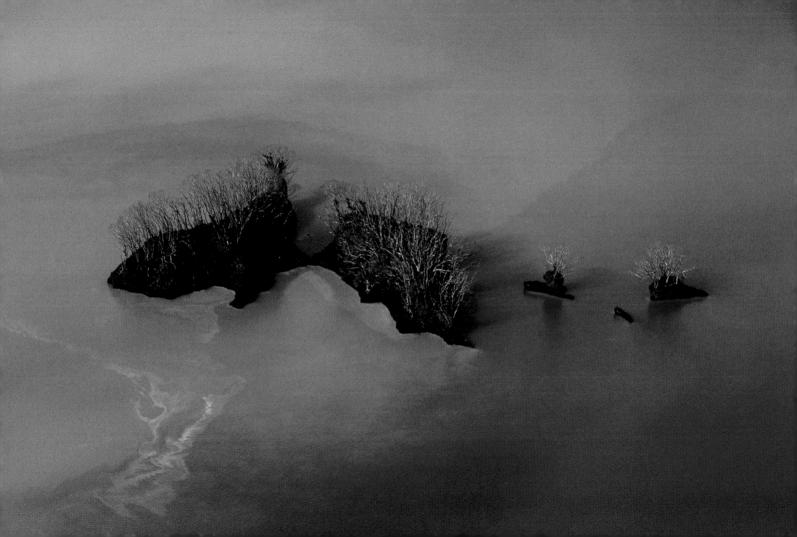

Invest in a tankless water heater.

Water heating is responsible for 25% of a household's energy use. Standard tank water heaters are energy wasters—as the stored water cools it must constantly be reheated. A boiler that heats water only as required is better than one that works continuously.

A tankless water heater, which can run on gas or have an electric ignition, only uses energy when you need water, and can deliver as much as 200 gallons of hot water per hour. Tankless water heaters can also save as much as 50% of the cost of heating water.

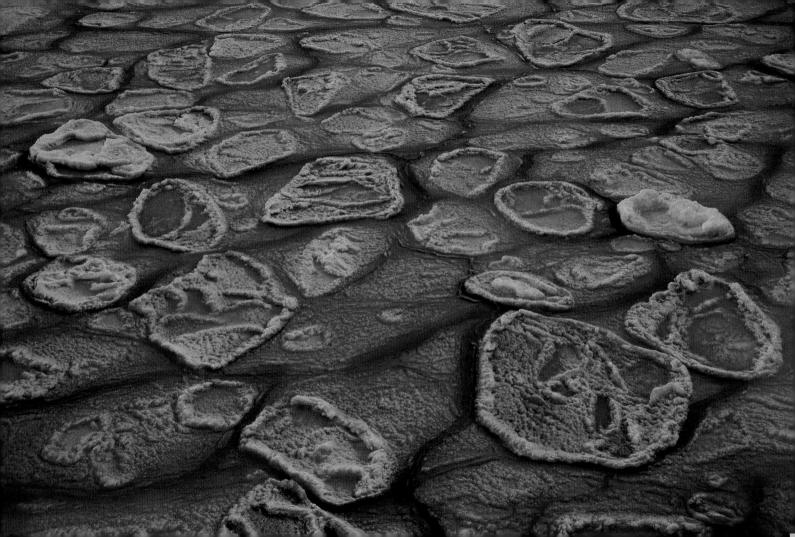

Use concentrated dishwasher liquid.

Packaging has gone beyond the function of protecting a product and informing the consumer, and has become a marketing tool. Overpackaged goods vie with each other to seduce potential buyers at first glance, so that a product that was not on the shopping list ends up in the shopping basket.

When buying dishwasher liquid, ignore boxes of individually packed tablets and instead choose less polluting and more easily carried alternatives, such as refillable packages, especially concentrated liquids. Dishwasher detergent in tablet form is also higher in phosphorus, which disrupts ecosystems when released into our waterways.

> White Sands National Monument, New Mexico

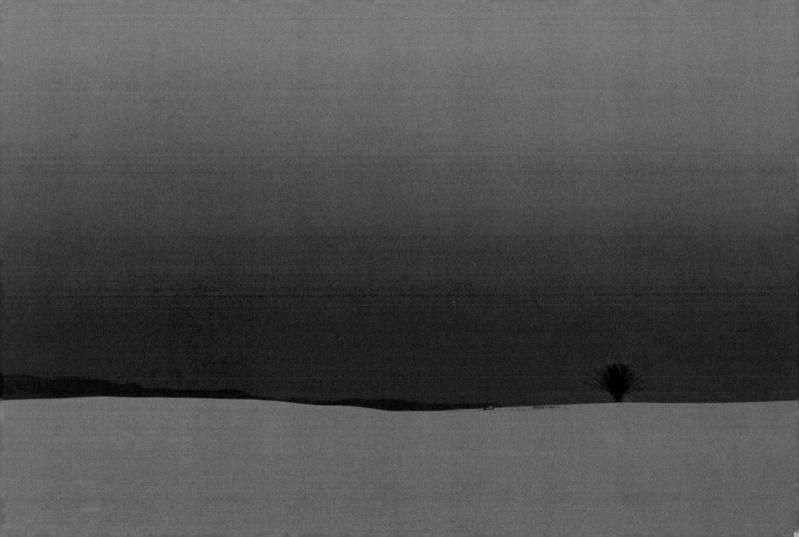

Protect endangered habitats.

Approximately 15,589 plant and animal species face extinction. Approximately onethird of all U.S. plant and animal species are at risk for extinction. In the eastern United States, forest ecosystems contain the greatest number of endangered and threatened flora and fauna; in the West, the rangelands are home to the most endangered and threatened species. Wetlands, which comprise only 5% of the continental United States, contain nearly 30% of the endangered or threatened animal species, and 15% of the listed plant species.

Threatened and endangered species can be found throughout the United States in all kinds of ecosystems. Learn the species that are listed in your area and commit to assisting in the preservation of their habitat.

Osprey Reef, Australia

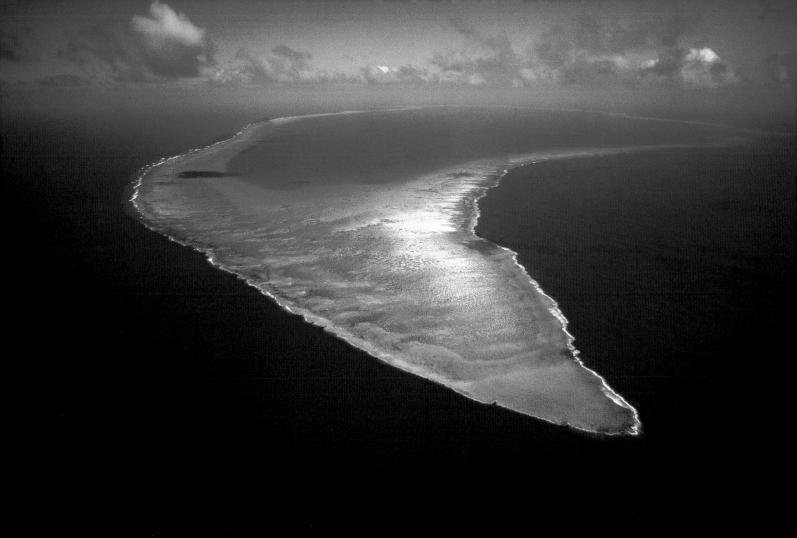

7

Install a dual-flush toilet.

All our buildings are supplied with drinking water, yet only 1% of the water treated to those standards is actually drunk. A dual-flush toilet can reduce the use of potable water for nonpotable actions. Although Europeans and Australians have been using them for some time, the dual-flush option was introduced to the United States just over 8 years ago. A dual-flush toilet has two buttons—use a full flush for solids or a reduced amount of water to flush liquids.

Dual-flush fixtures are now more widely available and will allow you to reduce your household water consumption by half.

Monument Valley National Monument, Utah

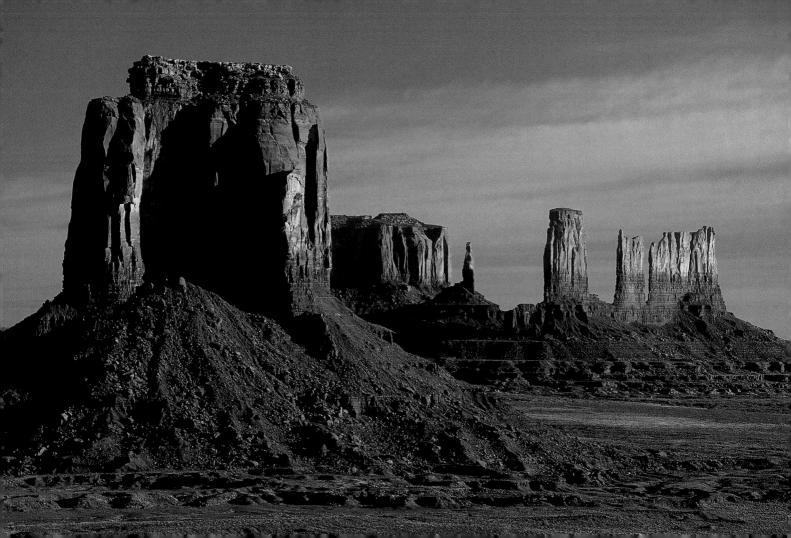

Choose cruelty-free cosmetics, labeled with the Leaping Bunny logo.

The Coalition for Consumer Information on Cosmetics was created in response to a lack of certified cruelty-free labels in the cosmetics and body care industry in the United States. The Leaping Bunny logo is an internationally recognized, comprehensive standard, and many popular products abide by it. Without independent oversight, many companies claim to be cruelty-free in the production of their goods but have found ways to violate consumer trust: By contracting out animal testing they can claim that they don't test on animals; or, by testing the ingredients separately on animals, they can then claim that the product is free of animal testing.

Don't be fooled by claims of cruelty-free production. Without the Leaping Bunny certification, the only way to learn what the claim on a label means is to contact the manufacturer directly.

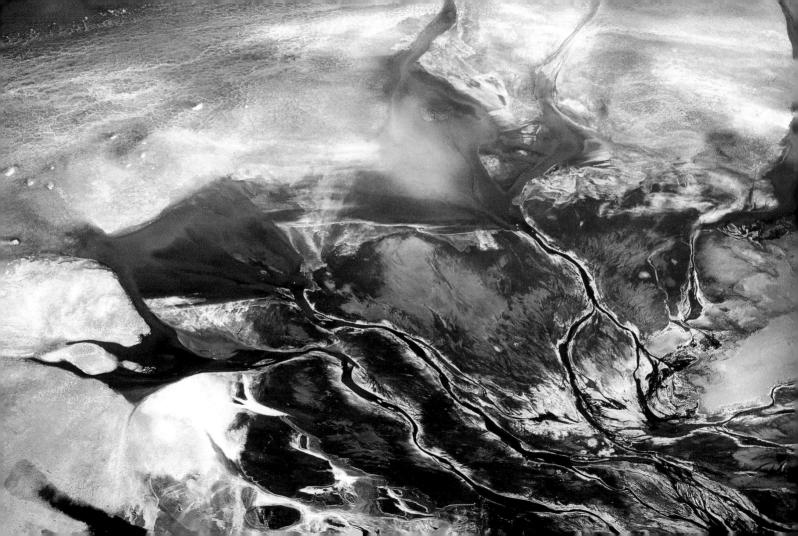

Buy products that are durable and can be repaired.

Every manufactured product often requires a degree of raw materials and energy from the environment out of proportion to its weight. If wealthy countries maintain their present rates of consumption, each individual will consume an average of 100 tons of the earth's nonrenewable resources and more than 134,000 gallons of fresh water each year (30 to 50 times the amount that is available for each person in the poorest countries). Buying durable goods that can be repaired will help reduce the impact of this consumption.

The next time you buy something, ask the seller about the length of its guarantee, how easily it can be repaired, and whether spare parts are available.

Descent into a glacial crater, Greenland

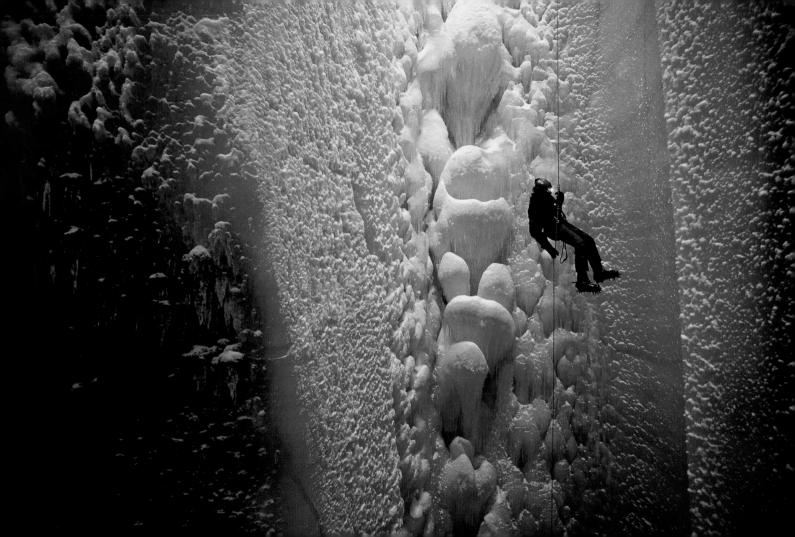

Take part in National Bike Month.

The League of American Bicyclists has been celebrating National Bike Month in May for almost 50 years. Bike-to-Work Week, a celebration of the national campaign to get commuters out of their cars and onto a bicycle seat falls mid-month.

When Bike-to-Work Week rolls around, use it as an excuse to tune up your bike before summer so it will be ready to take around town. If you don't know how to tune your bike or change a flat tire, take a class; many bike shops offer them for free, or for a nominal fee. Organize a group to help clean up a local bike path or rally a group of your colleagues to lobby for better bike-storage facilities at work.

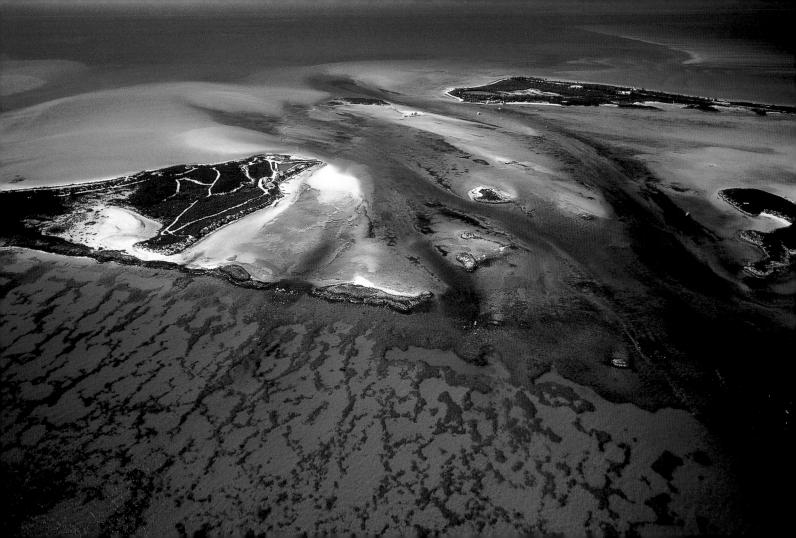

Keep ash and eggshells to use in the fight against slugs.

Eliminating unwanted visitors to the garden does not necessarily require chemicals. Tricks and traps sometimes work much better, are easier on your pocket book, and cause absolutely no damage to the natural environment.

Use cunning to wage war on slugs and snails. Drive them away by spreading ash or crushed eggshells around the plants you wish to protect or, alternatively, plant herbs. Slugs dread pungent aromatic plants. You can also lay planks alongside your flowerbeds. All you need to do is turn them over regularly to collect and destroy the slugs that seek shelter from the sun beneath them.

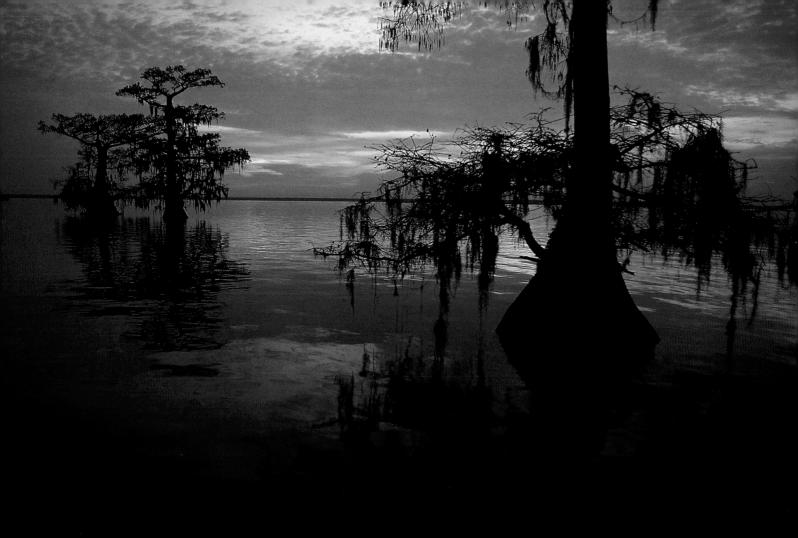

Visit regional nature preserves and state parks.

America's countryside constitutes an extraordinary natural and cultural heritage. State parks and forests; nature preserves that are privately run but open to the public; and historic sites offer insight into regional, natural, and cultural histories. The views and recreational challenges of our country's national parks might inspire awe and wonder, but it is ordinary, everyday nature and history that tells us who we are.

Find a state park, forest, or reserve in your area. Learn about the species that inhabit it and any developments that might threaten it.

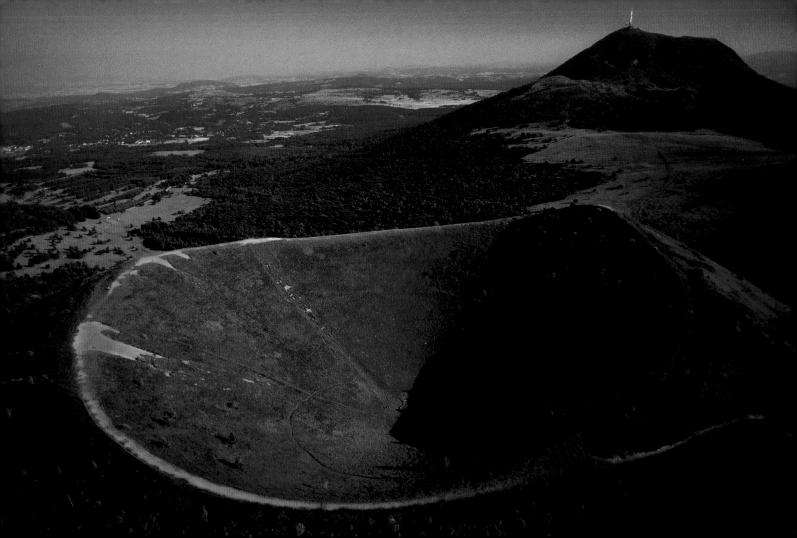

Give your clothes a second life.

Fashions change and clothes gradually accumulate in wardrobes. If they are in good condition, they can be put back into circulation on the second-hand market, sold cheaply, distributed to charities, or if you know how to sew, repurposed into new garments.

The second-hand market offers an economic, environmentally friendly alternative to new clothes. On average, the manufacture of 1,000 items of clothing produces 500 pounds of waste as cloth, paper, and packaging. To work, however, the second-hand market needs consumers.

Sift through your clothes, and donate those that have gone out of fashion to charitable organizations (such as the Salvation Army or Goodwill Industries International, Inc.) that put out collection containers, or organize door-to-door collections. Your town hall can also tell you about clothing collections. And remember to patronize second-hand shops.

,

Freshen the air naturally.

Plug-in or aerosol air fresheners not only create nonrecyclable waste, they pollute the indoor air with phthalates and chemicals like benzene and formaldehyde. In addition, plug-in room deodorizers constantly drain energy.

To freshen the air without polluting your home, try burning beeswax candles (make sure that any scent added is not the work of chemicals), hanging bundles of dried herbs or lavender, filling a bowl with pinecones, or simmering either a few slices of lemon or a small amount of cinnamon or cloves.

Do not print out your e-mail.

Paper and cardboard, which are both recyclable, make up 80% of office waste. Despite the introduction of the paperless office, workplaces continue on an upward trend in paper use.

To reduce this wasteful consumption, do not automatically print out the e-mails you receive. Organize your computer to file your e-mail electronically, and only print out e-mail when it is essential. The average office worker uses 10,000 sheets of paper a year-don't be part of the statistic!

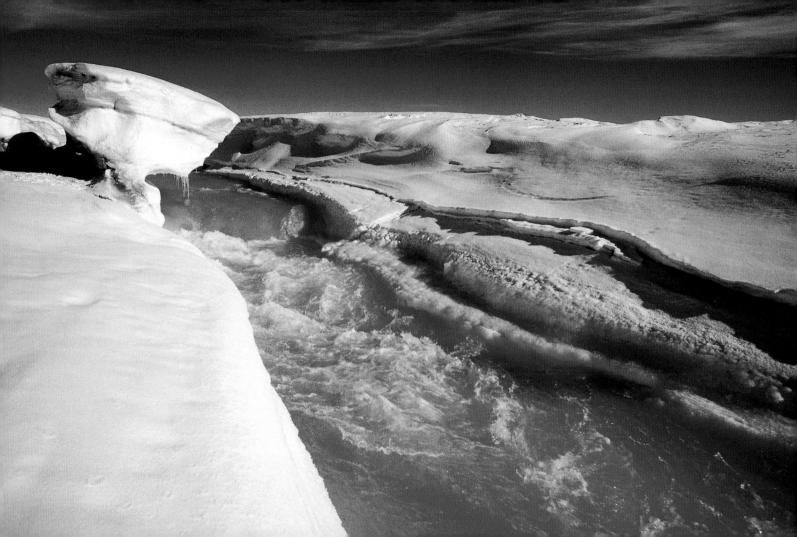

On horseback, respect the environment.

Nature constantly provides us with a multitude of free goods and services: clean air to breathe, a favorable climate, food (including a considerable reserve of biodiversity), fresh water (that is naturally purified), medical treatments (many of which remain undiscovered), energy resources, natural plant pollination by wild species (notably of a third of the plants we use for food), and more. Our dependence on the natural world should encourage greater respect in us, since the future of our species depends on it.

Horseback riding is a very environmentally friendly way of seeing the countryside. However, when on horseback always keep to marked routes. Stay out of sensitive areas such as meadows and wetlands unless there are designated trails. To minimize the risk of spreading invasive species, after rides inspect your gear and your horse to make sure they're not transporting insects, pollen, or seeds.

Dallol Volcano, Ethopia

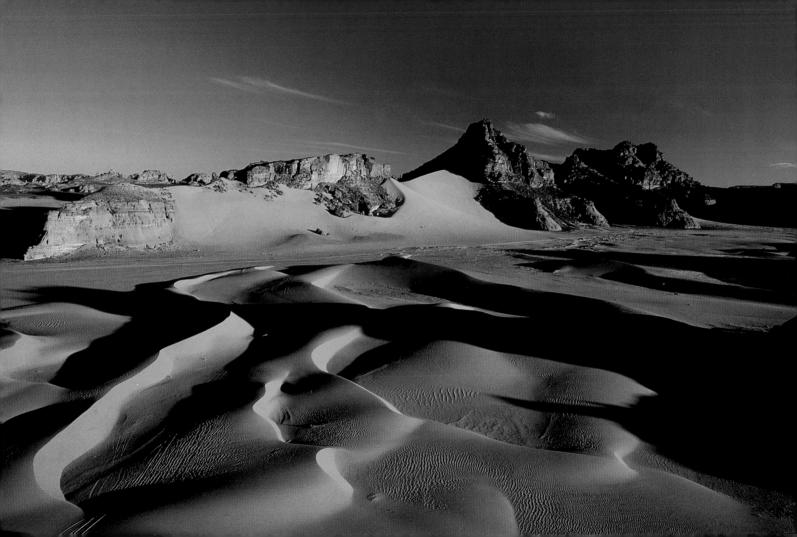

Check into alternatives before sending old or unwanted carpet to the landfill.

More than 2.3 million tons of carpeting material ends up in American landfills every year. Seventy percent of it was replaced for reasons other than wear. Replacing a carpet is not only economically expensive, but also environmentally costly.

If you're simply tired of the color, find a service that will redye your carpet rather than replacing it. These companies can also restore an old carpet to its original quality. Several major manufacturers offer carpet recycling programs—in the first 10 years of its reclaimation program, DuPont recycled more than 2,000 tons of used carpet.

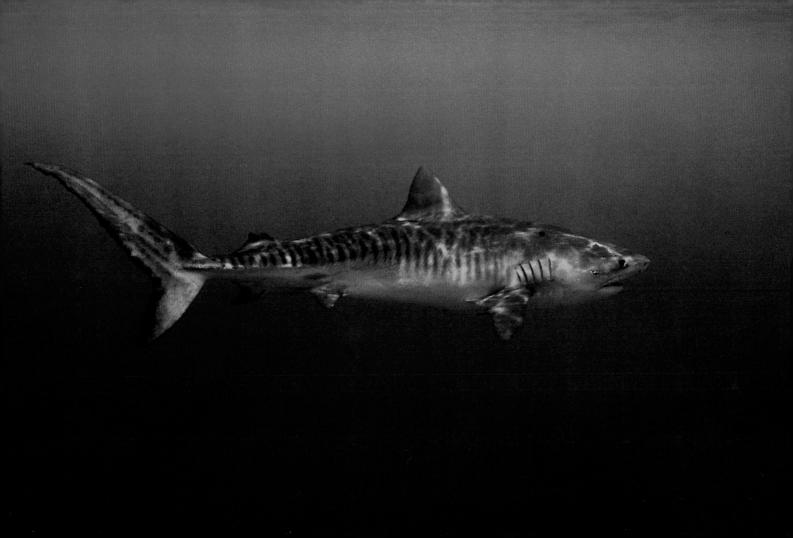

Find alternatives to plastic wrap.

Many plastic wraps cannot be recycled, and some contain PVC or phthalates-not exactly something you want covering your food. Aluminum foil is a friendlier option because it can be recycled and 100% recycled versions are readily available; however, foil can react with some foods and leach aluminum. Better "plastic" wraps are available, too.

When shopping, look for corn- or starch-based bioplastics that are biodegradable and recyclable. In the kitchen, you can cut down on the need for any of the above by covering dishes with other dishes or pot lids. In sack lunches, pack foods in reusable containers.

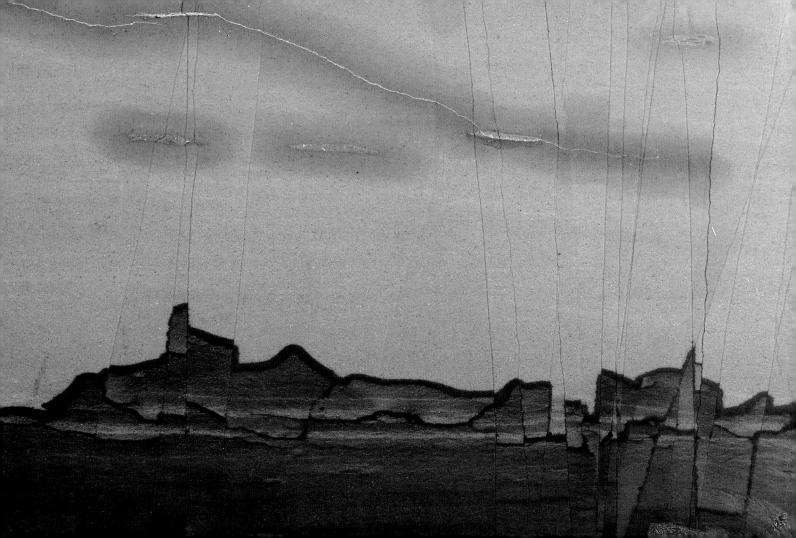

Sign petitions.

The size of a budget allocated to a certain activity gives an indication of its economic importance or humanitarian value. Worldwide defense spending is over \$1 trillion, whereas international development aid does not even amount to \$60 billion. In 2007, more than 40% of dollars from U.S. taxpayers went to military spending, while only 12% was spent trying to alleviate poverty and only 3% was allocated for environmental issues.

What sort of world do we want? Support public campaigns—sign petitions. By keeping quiet, we become the architects of global catastrophe.

Wayana Indians, French Guiana

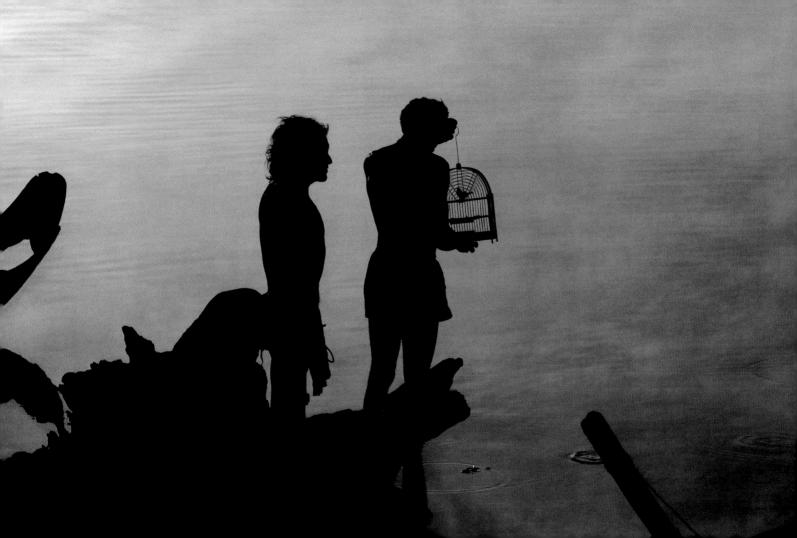

Clean the coils on your refrigerator.

Refrigerators are notorious energy guzzlers—and they're always on. They use about 5 times the energy used by TVs and more than twice as much energy as dishwashers or washing machines.

Check your refrigerator's electricity consumption: Dust or pet hair on the coils at the back can cause your compressor to have to work harder and may increase energy use by 30%. Clean the coils every 3 months. Keep the inside clean, too. The more jam-packed the fridge, the harder is it for the cold air to circulate.

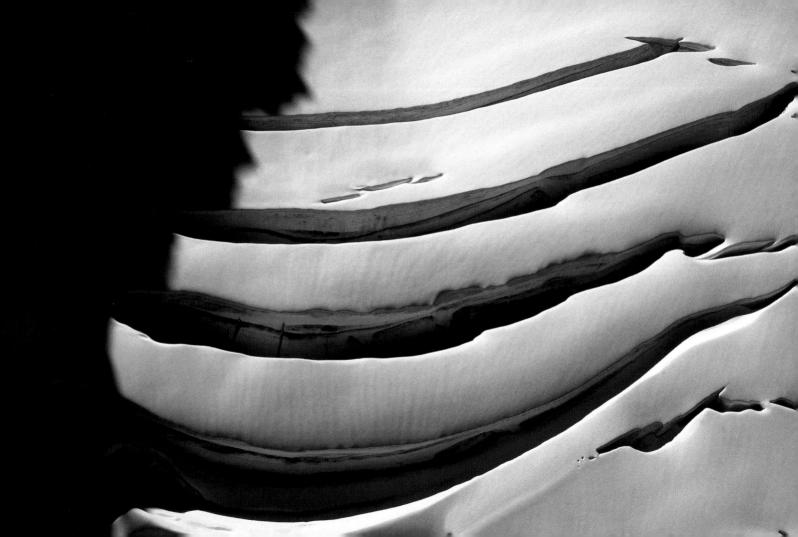

Use bicycle couriers.

With the materials and resources that it takes to produce a single midsize car, 100 bicycles could be produced. Around 8 million Americans live in areas that continually fail to meet federal air quality standards.

In town, the bicycle, which produces neither greenhouse gases nor pollution, is one of the most promising transportation solutions. For your business needs, use bicycle couriers if they exist in your town. You will be contributing to improving urban air quality, supporting a sustainable means of transport, and reducing your company's carbon footprint.

Reduce the amount of electricity used for lighting.

Electricity for lighting accounts for an average of 15% of your annual electricity bill and is the second biggest item after refrigeration. By taking a few simple measures, you can save up to 70% of the money you spend on electricity for lighting. You will also preserve the planet's energy resources and its atmosphere.

Choose natural light wherever possible, switch off unnecessary lights, and choose bulbs with a wattage that suits your needs. Do not use halogen lights as spotlights, install energy-saving bulbs, and install lighting with motion-sensor capabilities on your stairs and in hallways.

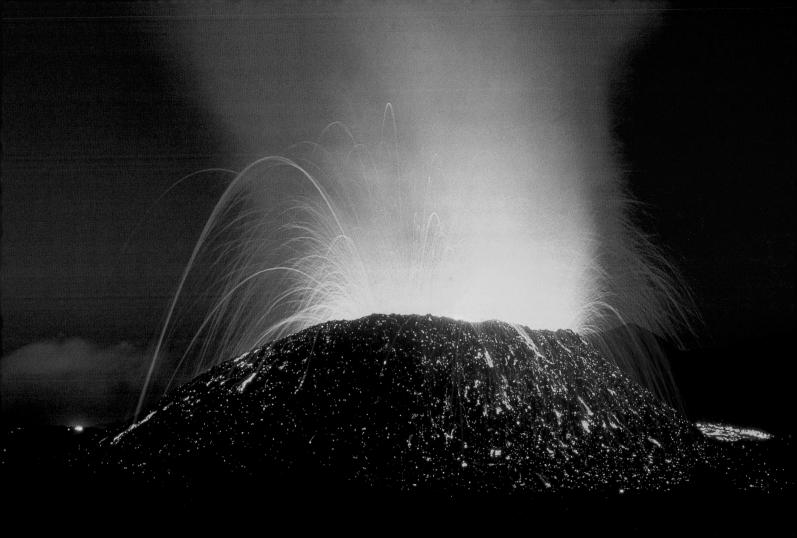

Strive for a Zero Waste household.

Where is the "away" in "throw away"? Eighty percent of what we produce is thrown away within 6 months of its production. In a Zero Waste home, nothing ends up at the landfill-all waste and unwanted items are reused, recycled, or composted.

The Zero Waste concept goes well beyond "end-of-pipe" solutions, such as reducing trash flow. We have to think about how to prevent the manufacture of products that quickly end up in the waste cycle. Zero Waste programs, which seek to reform the systems of production, construction, and consumption, have been successful in bringing communities closer to a zero-waste reality. Washington State has passed "take-back" legislation that requires electronics manufacturers to be fully responsible for the recycling of their products—not only does such as policy save e-waste from heading to the landfill, it will greatly influence how producers design their products, as they will now be responsible for cleaning up after themselves.

Research Zero Waste programs and encourage your city or town to adopt a resolution. In the meantime, get your own home as close to zero as possible.

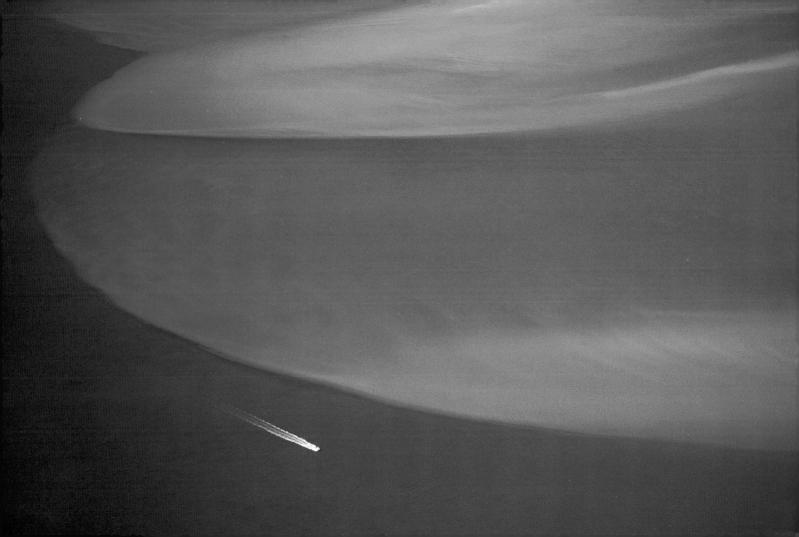

Putting the hoe to the soil makes watering more effective.

Among gardening jobs, hoeing is one of the most significant. It is essential for the health of the soil and for removing weeds, and hoeing aerates the soil and allows it to retain moisture. It is crucial after a heavy rain because the surface of the soil, smooth and packed tight by raindrops, will cause water to runoff the next time it is watered. Loose, well-worked soil allows water to reach the roots of plants and drains water better, rendering watering more efficient.

Hoe your garden! Smart water use is essential when trying to make your garden as environmentally friendly as possible.

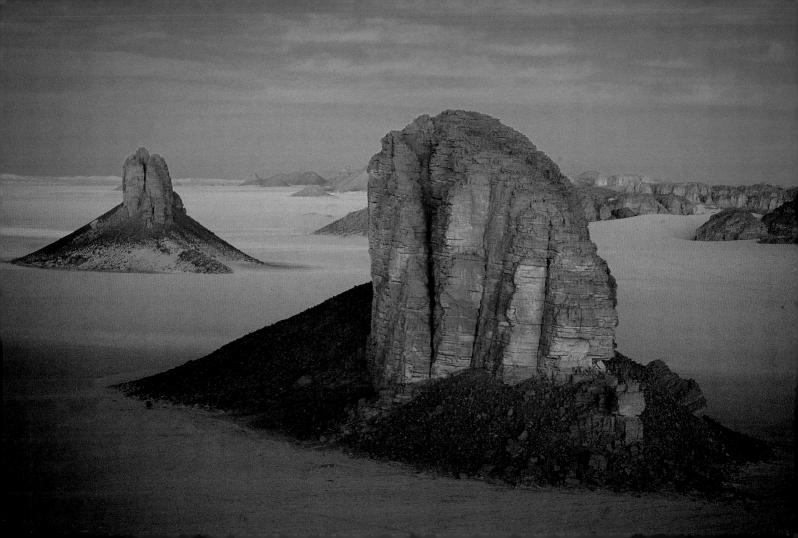

Follow LEED regulations when building or renovating.

Tomorrow's dwellings will have to be of high environmental quality. The LEED (Leadership in Energy and Environmental Design) Green Building Rating System® enables the reduction of energy consumption and emissions of carbon dioxide by means of highly efficient insulation, the use of renewable energy, and better integration of dwellings with their natural environment. Using recycled rainwater reduces the consumption of fresh water and keeps polluted storm water from entering waterways. Moreover, LEED guidelines create a healthy, comfortable indoor environment. Environmentally friendly building is not more expensive, and in fact, pays for itself in less than 10 years, thanks mainly to its savings in energy and water.

If you are planning to build or renovate your home, find out about LEED standards. You will enjoy the satisfaction of respecting nature and turning to it for your dayto-day comfort at the same time.

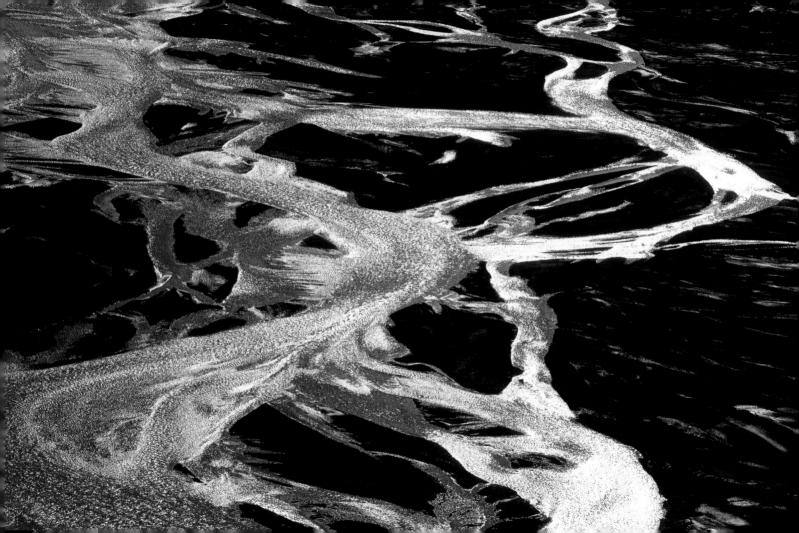

Respect tropical reefs.

A refuge for prey, lair for predators, shelter, nursery, food source, and spawning ground-coral carries out a multitude of functions. Despite its appearance it is not an inert mineral but alive and growing extremely slowly. It takes coral a year to grow 3 to 4 inches, and it may have taken it more than a century to grow a 3-foot block. In a fraction of a second, a clumsy kick or blow with a flipper can destroy a coral formation that has been growing for centuries.

If you are vacationing by a tropical lagoon, do not walk on the reef. When diving, be careful of your flippers. And never break off a branch of coral to take home as a souvenir.

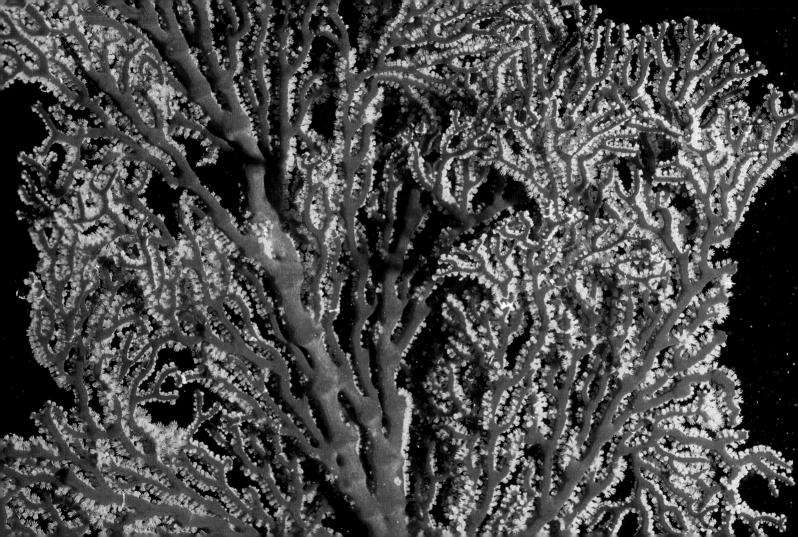

Wash your car with recycled water—or no water.

When you wash your car in your driveway, runoff (including any cleaners you're using and contaminants like motor oil and gasoline) goes directly into storm drains without being filtered or treated. In addition, washing your car yourself generally uses more water than the average car wash (between 80 and 140 gallons versus 37 gallons).

Eco-friendly car washes properly treat and recycle runoff and use biodegradable soaps. Some even use "waterless" methods—car-cleaning sprays that are free of phosphates and use nontoxic, plant-derived solvents, requiring only about 6 to 8 ounces of water to activate. These sprays are also available to consumers who enjoy the ritual of the summer driveway wash.

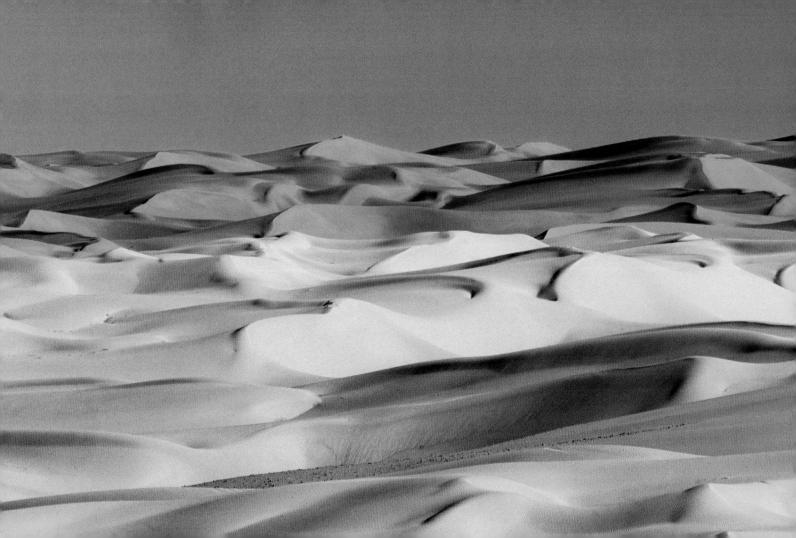

Recycle your steel cans.

Cans-generally made of steel-are 100% recyclable. One ton of recycled steel saves 2,500 pounds of iron ore, 1,400 pounds of coal, 120 pounds of limestone, and the thousands of gallons of water needed to produce steel. Steel recycling saves 75% of the energy it would take to create the substance from raw materials.

Make sure you recycle your steel cans and scraps: They will be transformed into new cans, or into sheet metal for various uses.

Grow your own vegetables.

Spraying pesticides on crops increases productivity in the short term. The long-term use of chemicals, however, produces resistance in pests while wiping out their natural predators. The farmer must increase the dose, thus exacerbating pollution of the soil, air, and water. As a result the world market in agricultural pesticides has almost tripled over the last 20 years.

Rediscover the flavor of something you have grown yourself. A vegetable garden or a few vegetables grown in window boxes will provide produce that is free of both pesticides and superfluous packaging. Cucumbers, potatoes, and squash have high levels of pesticide residue when grown conventionally, but can be grown easily in container gardens or in your yard in many regions.

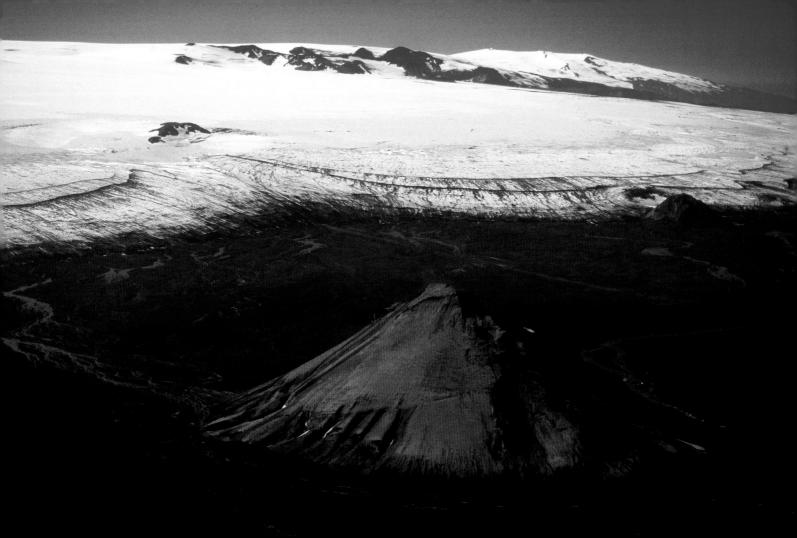

Sort your waste to reduce the amount that needs treatment.

More than 40% of our waste is incinerated. Incineration reduces its volume by 90%, thus saving space in landfill sites. It also produces energy that can be converted into electricity or heating. However, the burning also produces fumes that contain dioxin (which is carcinogenic), acid gases, and other toxic particles. Antipollution regulations demand that they be treated with filters, which, once saturated with toxins, also become waste that requires disposal.

By sorting waste (glass, paper, batteries, engine oil, aluminum, electronics, and so forth) that can be recycled or composted, Americans kept 82 million tons of garbage out of landfills and incinerators in 2006. You can join the effort to keep reducing landfills.

Canyonlands National Park, Utah

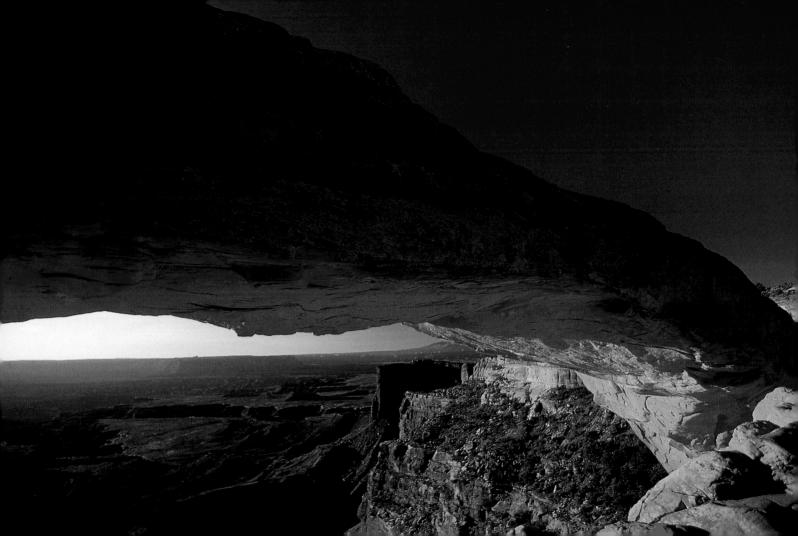

Wash laundry only when it is dirty.

The quality of fresh water is constantly deteriorating because of heavy contamination by polluted storm water running off streets; organic matter; fertilizers; and chemical waste from agriculture, industry, and households. The large quantity of the waste and poisonous products poured daily into rivers constitutes a danger that is all the more severe because water use—and the elimination of wastewater—is increasing daily. In some areas, tap water is regularly cut off, temporarily, because of pollution.

It may seem like common sense, but the best way to conserve water in the laundry is to do less of it! Only wash your clothes when they are really dirty; one wear does not automatically make the clothes dirty.

> Heron, Everglades National Park, Florida

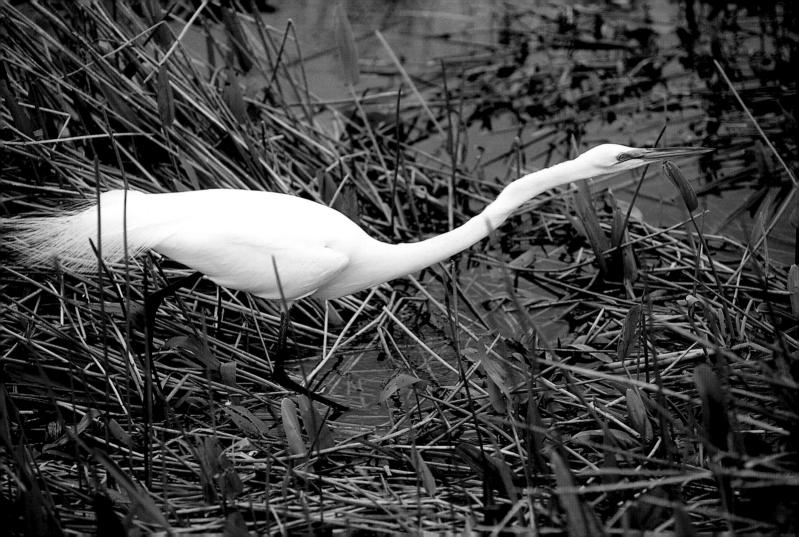

Use the sleep timer.

Scientists say that in the coming years the habitats, natural resources, and species that make up life on Earth will be able to adapt only to an average temperature increase of 1°F, and a 4-inch rise in sea levels. To remain within these limits, worldwide greenhouse gas emissions would have to be cut by 60% at once. This is impossible. The faster warming takes place, the more difficult it will be to control its consequences. Hence the need to act at once.

TVs and stereos often have sleep timers, which allow the appliance to shut off after a given amount of time. If you normally fall asleep watching TV or listening to music, use the timer to avoid wasting the energy of the appliance running all night.

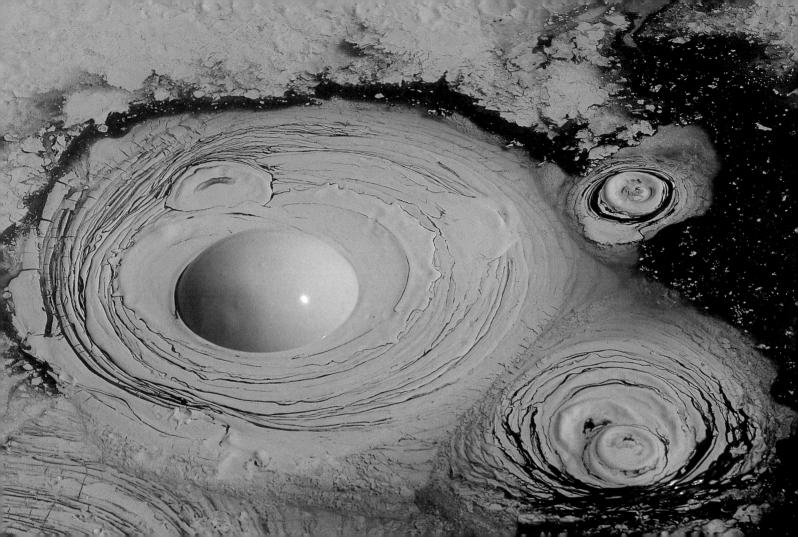

Use power strips to eliminate "phantom" power leaks.

Many electronics and appliances (particularly anything with a standby mode or a clock) continue to drain power even after they are turned off—in fact, 40% of energy used by household electronics is drained when the devices are supposedly off. The only way to ensure that a phantom current isn't leaching energy from your home is to unplug all of these machines.

To truly flip the switch on all of your various chargers and electronics, plug them into a multisocket surge protector and turn the surge protector off. Some "smart" surge protectors have sensors that will automatically shut off the entire power strip once they detect that all devices have been powered down.

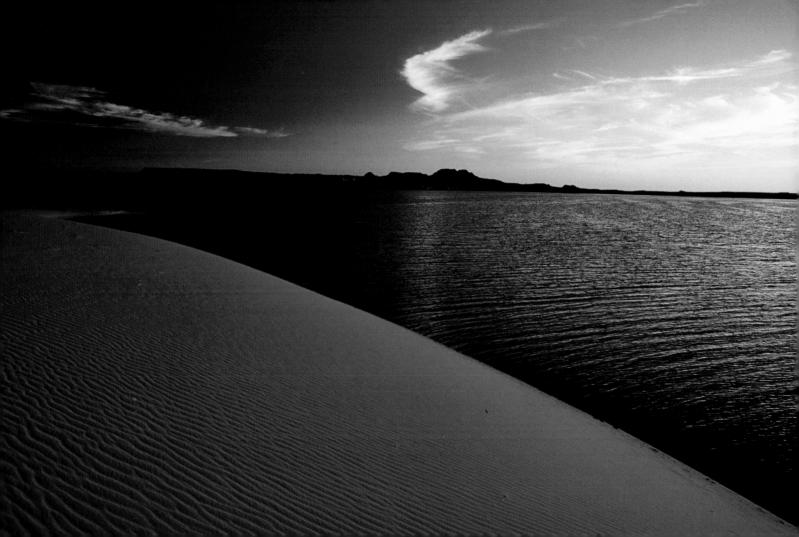

Start an eco-club.

Many tenets of sustainable living involve pooling resources and forming political advocacy committees, so why not start a club to help organize your neighbors and friends around environmental action? From discussing which natural cleaners work best to recruiting volunteers to build a community garden, an eco-club will help spread important information and encourage everyone to keep making good choices.

Events like Green Drinks bring together new arrivals and people who have been working in environmental causes for decades. They also remind us that a shift toward sustainable living is not just responsible, it is fun and energizing. Start a local chapter in your town.

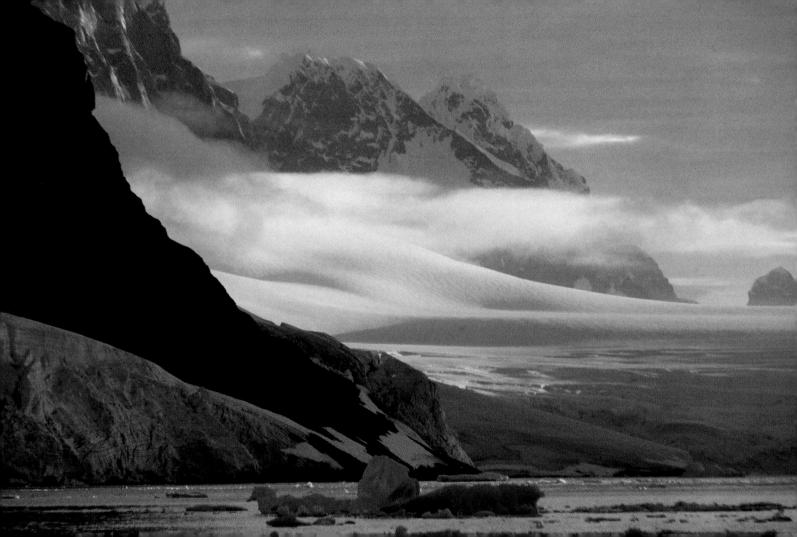

Fishermen on shore, respect your surroundings.

Contrary to appearances, the ships that sail the world's oceans are responsible for only a small part of the pollution of the seas. Oil spills account for only 2.5% of pollution, and cleaning ships' tanks at sea accounts for 25%. Most pollution (about 70%) comes from the land by means of what is emptied into rivers and estuaries. In 1996, the authorities in Corsica found a stranded whale with more than 30 square feet of plastic sheeting in its stomach.

When you fish from the shore, leave pebbles, rocks, and empty shells where you found them, for they may shelter unobtrusive animal life. Make your children aware of the need to respect sea and shore habitats, which teem with life but are vulnerable.

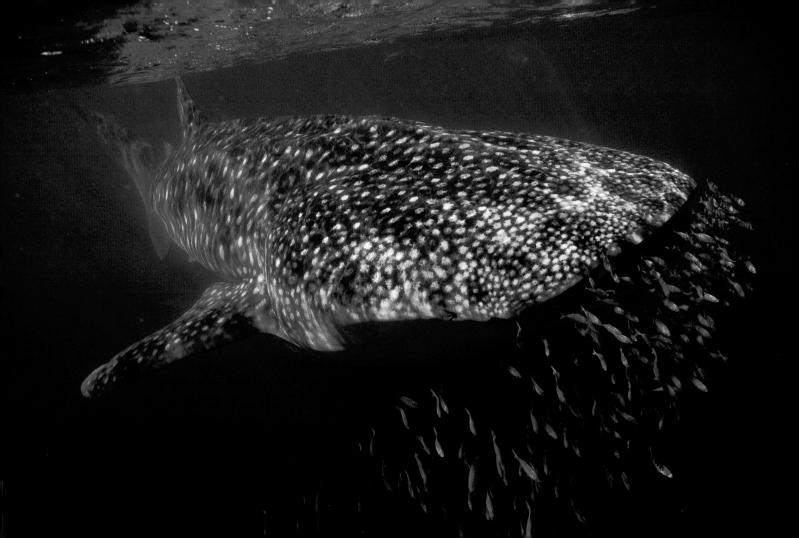

Recycle glass.

In 2006, Americans generated 13.2 million tons of glass waste. Making new glass products from recycled glass saves 80% of the raw materials and 30% of the energy needed to make glass from scratch. The energy is saved because crushed glass melts at a lower temperature than the raw materials used to make glass. Today more than 22% of all the glass made in the United States is recycled. For every ton of recycled glass we save 1,330 pounds of sand, 433 pounds of soda ash, 433 pounds of lime-stone, and 151 pounds of feldspar. Glass can be recycled indefinitely. Keep your glass in the production stream!

You can facilitate and improve glass recycling: Remove corks, plastic, and metal lids and rings from bottles. But keep in mind that not all glass is recylable: Windowpanes, light bulbs, mirrors, Pyrex items, porcelain, and earthenware will contaminate your recycling collection.

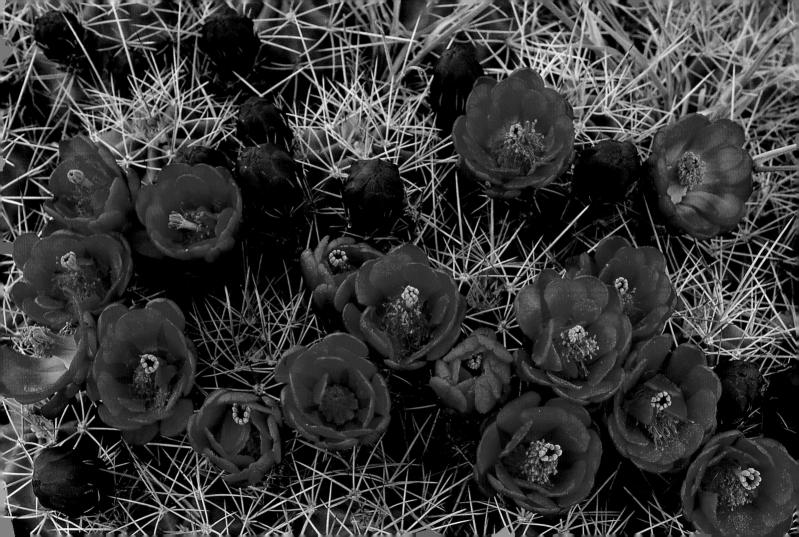

When renovating, think reclaimed, recycled, and renewable.

Flooring, cabinetry, shelving, countertops, tile work—you can find sustainable options for all components of a remodel. Reclaimed wood is a wonderful alternative to new lumber; old-growth wood salvaged from demolition sites is often harder and of higher quality and has a ton of character. Bamboo and cork are both renewable materials that can be made into flooring (bamboo can be used in cabinetry as well). Though linoleum doesn't sound very glamorous, it is surprisingly green, made up of cork and wood dust, rosins, and linseed oil. For new wood, buying FSC-certified products ensures that products are not issued from clear-cutting operations. Recycled-glass tiles are beautiful, and recycled glass can also be made into countertops that resemble ceramic or marble. Composite countertops from recycled paper waste and water-based resins are indistinguishable from standard plastic laminate counters but are more heat-resistant and nontoxic.

Ask builders about incorporating eco-friendly materials into your remodel. Don't worry if your city doesn't have an environmental home center where you can do everything from pick out nontoxic paints to purchase bamboo flooring—many materials like tiles and flooring can be ordered online.

Sandstone, Colorado

Unplug chargers and AC adapters.

World energy consumption rose by 2.4% between 2005 and 2006. By 2030, world energy demand is expected to grow by 57% to 17.7 billion TOE (tons of oil equivalent) as opposed to 11.4 billion TOE used in 2005; electricity use will account for 22% of the total increase. Faced with such forecasts, can we really believe that the damage being done to our natural environment—first and foremost global warming—has any chance of diminishing?

We often leave cell phone chargers and adapters plugged into the wall after we're done charging our devices. However, they continue to drain energy from the socket until they are unplugged. If only 10% of the world's cell phone users routinely unplugged their chargers, it would save enough energy each year to power tens of thousands of homes.

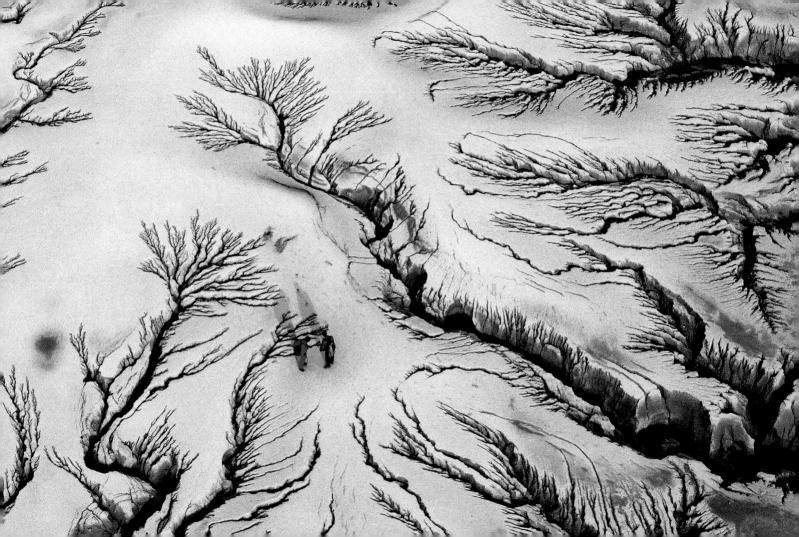

Urge your mayor and municipality to upgrade existing municipal buildings to LEED-certified standards.

In 2004, the United States Green Building Council announced that it had established a rating system for existing buildings. Based on a similar premise as the LEED standards for new construction, the system for existing buildings addresses energy savings, water savings, and healthier indoor environments.

Encourage your city or town to adopt LEED standards for its existing buildings. In the long-term your municipality will save environmentally and economically.

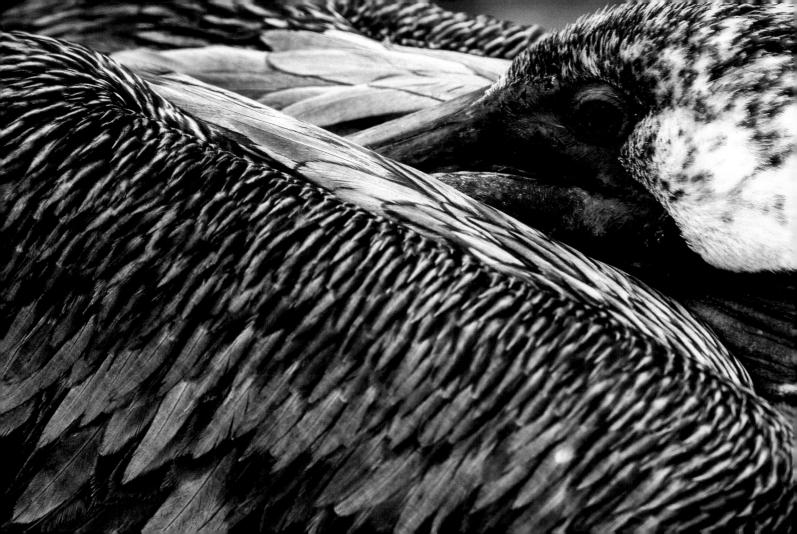

Practice sustainable tourism.

Tourism has become the world's biggest industry, and exotic destinations jostle for space in brochures and glossy magazines. The developing countries, however, often gain nothing; only 30% of the money spent by vacationers remains in the host country. Still, there are new ways of going on vacation that promote equitable tourism.

Patronize local businesses as much as possible; seek out lodgings that pay their workers fair wages; give back to the community by supporting humanitarian projects; use local sources for everything from public transportation to restaurant food; and use tour operators that respect fragile habitats and can show visitors what local conditions are really like. When you travel, you can also have a positive effect.

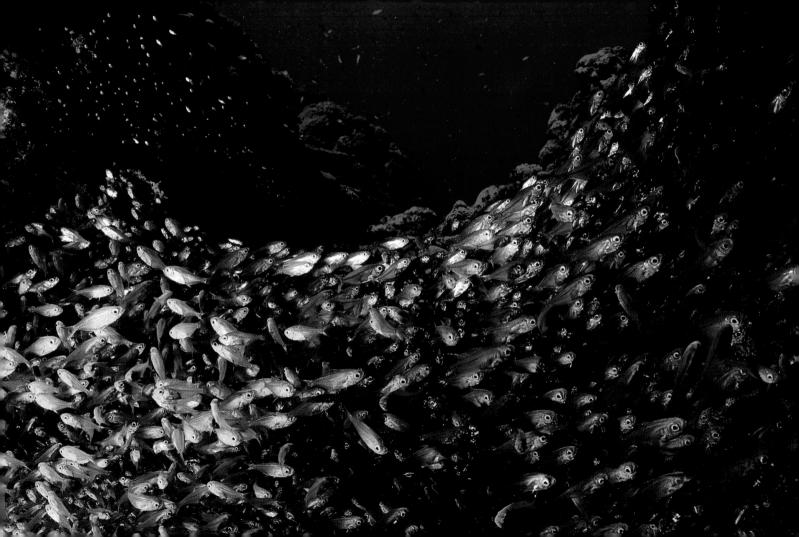

Recycle your old running shoes.

On average 2.3 million pairs of shoes are sold each day in the United States. Serious runners need to replace their running shoes often to avoid injuries, and every year millions of pairs of sneakers get tossed into the trash. To compensate, some big athletic shoe companies, like Nike, run recycling programs and accept brands other than their own. Nike has recycled more than 20 million pairs of shoes since starting the program.

If your shoes are still in good shape, you can donate them to Recycled Runners, and they'll be given to someone in need through both domestic and international organizations. If your shoes are too damaged to be reused, they can be recycled and will live on as playground surfaces, running tracks, and basketball courts.

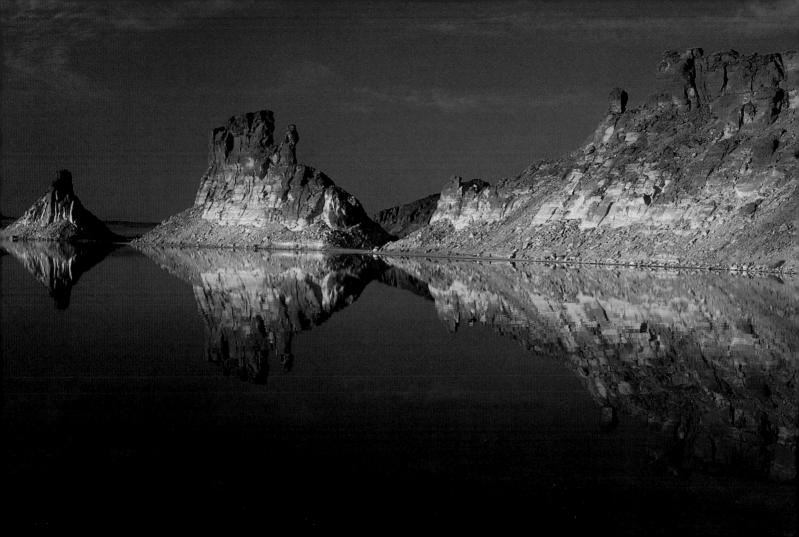

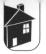

Install your boiler close to where hot water is used.

Thanks to the sun, wind, rivers, and geothermal energy, human beings are able to tap into renewable energy sources that neither pollute nor produce waste that can threaten the future of the planet for generations to come. If we used the best available technology in our buildings and in transport, industry, food, and services, global energy use could be cut in half. Until these sources are widely used, however, we should not forget that the smartest energy use is not using energy.

It is best to locate the boiler close to the hot water's exit points-such as the kitchen and bathroom-to reduce heat loss (and therefore, energy waste) through pipes.

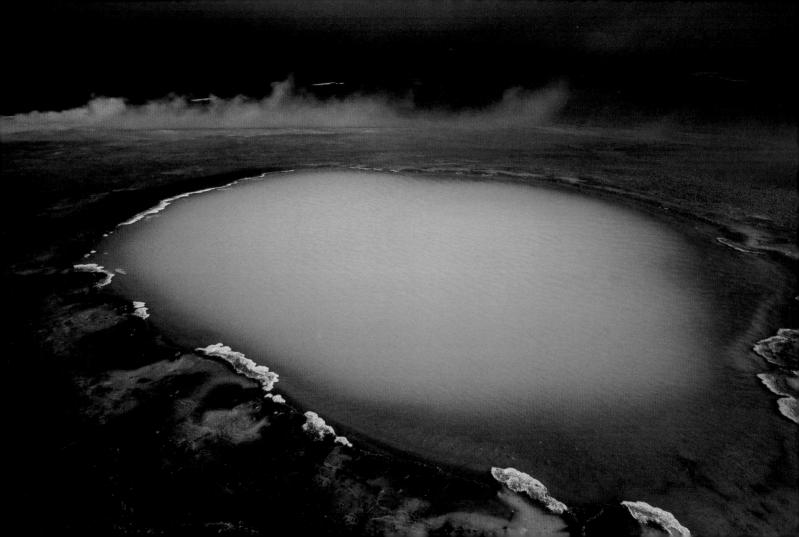

Buy or grow forgotten varieties of fruit and vegetables.

In its headlong rush for profitability, the agriculture industry favors the most productive and pest-resistant types of produce at the expense of many domestic varieties of fruits and vegetables regarded as less efficient. At the beginning of the twentieth century there were more than 7,000 varieties of apples in the United States. Today, only about 10 are available commercially. Over the same period, 80% of tomato varieties, and 92% of lettuce varieties have been lost, or survive only in special conservation facilities.

Standardization is gaining ground, and biological diversity is in free fall.

Consider varying your choices of fruits and vegetables; try different types, and rediscover the flavor of heirloom varieties. Local farms often revive these and sometimes develop their own delicious types of produce based on them. Nonprofit groups like the Seed Savers Exchange collect and sell heirloom seeds to home gardeners.

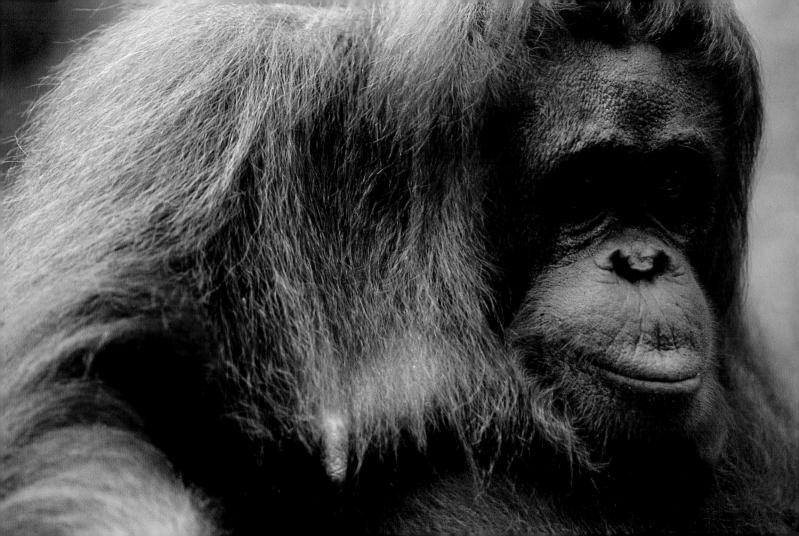

Identify your least-efficient appliances.

Replacing all of your old or inefficient appliances and electronics can be costly-it's usually a multistep process.

Devices like the Kill-a-Watt and the Wattson can help you assess the efficiency of any item that has a cord, from stereos to refrigerators. They calculate how many kilowatts per hour an item uses and what that translates to in terms of cost each month. Once you know which gadgets are the worst performers, you can prioritize—you'll know which ones need to be replaced first and you'll better manage your energy consumption.

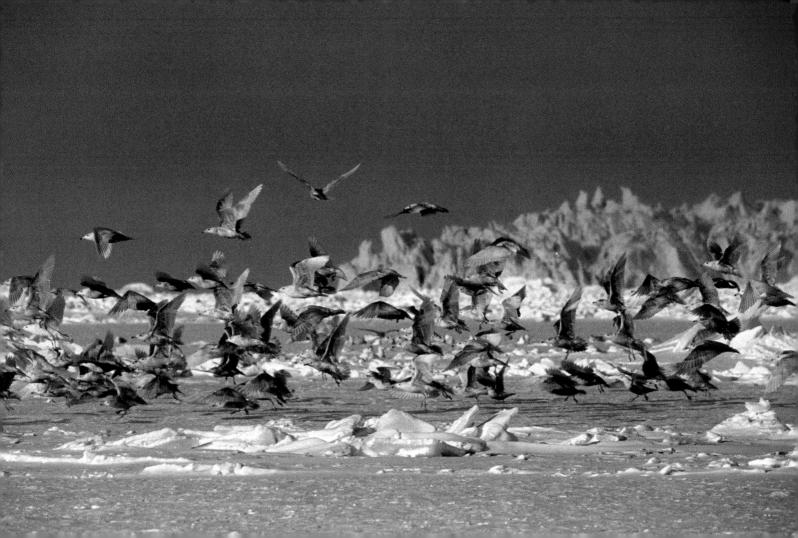

Think twice before booking a cruise.

The average cruise ship generates up to 210,000 gallons of sewage and 1 million gallons of wastewater every week. Over the past five years several major operators have been heavily fined for illegal dumping. In addition, cruise ship anchors cause coral-reef damage—a ship anchoring for one day can rip up nearly one acre of reef.

Not only do cruise ships produce a tremendous amount of waste, put they promote a hit-and-run type of tourism wherein great numbers of people descend on a port for a very short period of time only to go on tours or to shops and restaurants affiliated with the cruise line. Often small communities bear the burden of the pollution caused by the ships without truly reaping the benefits, as the money being pumped into the local economy directly benefits very few people.

If you want to book a cruise, forgo the "floating cities" for small ships that offer a more personalized experience and focuses on the destinations, not the onboard amenities.

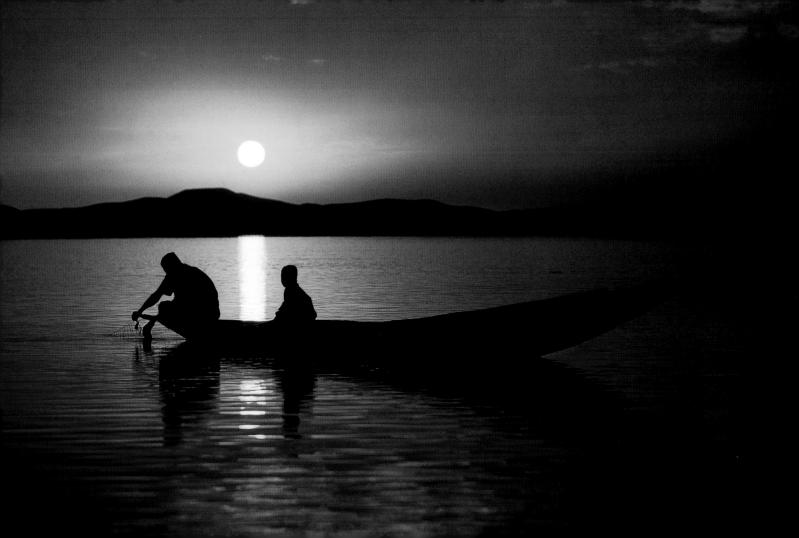

1

Choose cooking oil in glass bottles.

Glass is the recyclable material par excellence: It can be reused or recycled indefinitely, without loss of weight or quality. Unlike paper, the primary benefit of recycling glass comes not from protecting the original source of the material, but rather in conserving the energy it would take to create the new material. Recycled glass melts at a much lower temperature than the raw materials needed to make glass, thus using less energy.

Cooking oil is available in nonrecyclable plastic bottles, and in infinitely recyclable glass ones. Make the right choice.

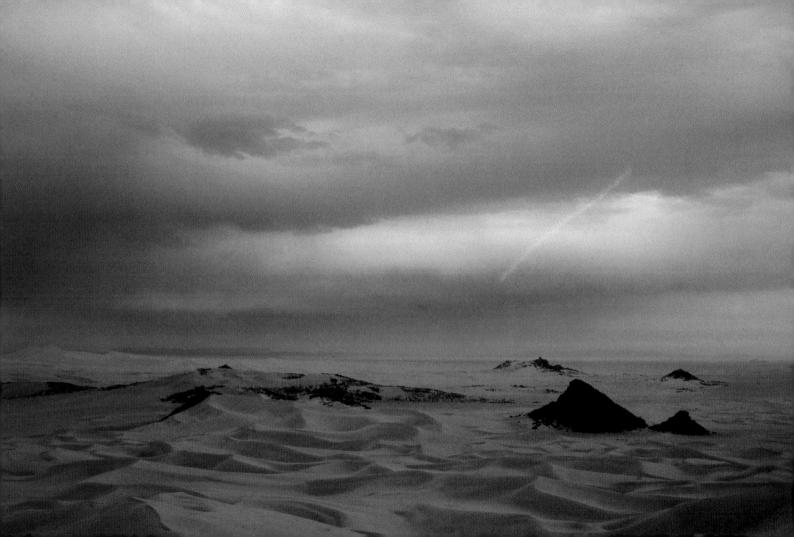

Drink tap water.

The world market for bottled water, estimated at \$100 billion per year, is flourishing. In the United States, sales of bottled water surpass those of beer, coffee, and milk, and are second only to soda. However, the most natural of all drinks is much less natural once it is packaged. To contain the world's bottled water, 2.7 million tons of plastic are required. Manufacturing the bottles, packing, and transporting the water (25% is drunk outside its country of origin) uses natural resources and energy and generates mountains of waste, since most plastic bottles are not recycled. In addition, up to 40% of bottled water is actually tap water, not spring water as it purports to be.

Do not forget that our tap water is treated to be perfectly drinkable, and its quality is rigorously checked. Moreover, it can be as much as 10,000 times cheaper than bottled water.

Divers, respect the sea.

A tiny rise in sea temperature is enough, in some cases, to disturb the growth of coral and cause bleaching, and there have been many instances of this in recent years as a result of global warming. In general, corals recover afterward, but if the stress to which they have been subjected is too intense or too prolonged, it can kill between 10% and 30% of the colony. When this happens, all the fauna living on the reef suffer, and fish stocks are also affected.

When you are diving in tropical seas, be as discreet as possible. Use your flippers carefully to avoid damaging anything around you; do not touch anything and do not feed the animals to avoid interfering with their behavior. When you are not diving, remember all the ways to save energy, and thus limit climate change.

Nudibranch, Australia

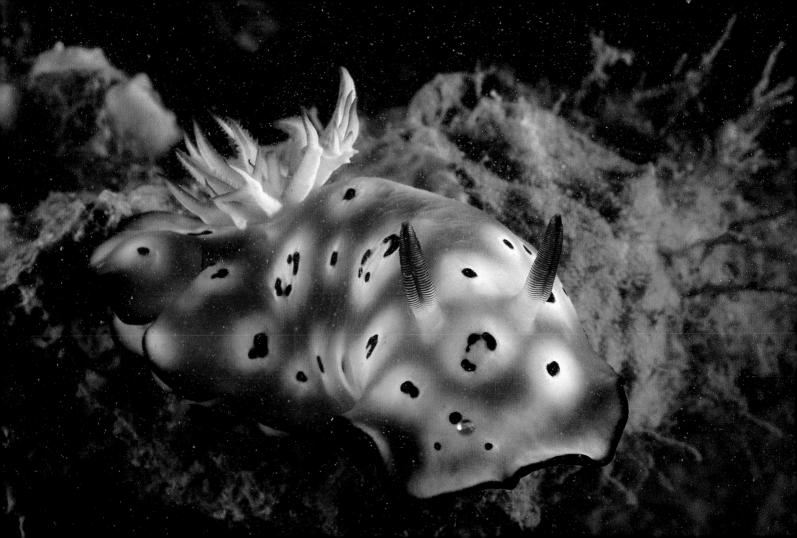

Buy retreaded tires.

Every year, about 290 million tires are scrapped. Of this number, 45% are used for fuel (to provide energy), and 29% are recycled to make material for industrial use. That said, 275 million tires still sit in tire stockpiles that breed rat and mosquito populations and cause air and water pollution.

Retreading uses half as much energy as making a new tire. To encourage this economical and environmentally friendly practice, choose retreaded tires.

Support the Blue Flag when vacationing abroad.

Every year, billions of gallons of wastewater from cities are poured into the Mediterranean Sea. Three-quarters of this water has not been treated. To help curtail marine pollution, the Blue Flag, a European eco-label, annually rewards and honors local authorities and vacation resorts for their efforts toward achieving a quality environment: for their water quality; for educating and informing the public; for environmental management and safety; and so forth. The Blue Flag's high profile acts as an incentive to local elected officials who do their best to gain and keep this distinction.

Look for the Blue Flag when you choose a beach for your vacation abroad. In 2007, it was awarded to almost 3,200 beaches and marinas in 38 countries in Europe and elsewhere.

Patronize hotels that have comprehensive environmental policies.

A lot of hotels recycle, and many are starting to address water consumption by making daily towel and sheet laundering optional. But those efforts alone do not make a hotel green. If a hotel is of new construction, did it choose its site wisely and/or seek LEED certification? Does it make use of local resources or import everything from miles away, giving it an enormous carbon footprint? Some hotels conserve energy with sensors that shut down power and air-conditioning when no one is in a room, and they cut water use with low-flow fixtures and dual-flush toilets. Others go as far as installing solar arrays and graywater recycling systems. Hotels can reduce food waste by composting and donating edible leftovers to charitable organizations. They can protect groundwater and the health of their customers and workers by only using eco-friendly cleaning products. Furthermore, a green hotel limits the amount of printed material it issues and uses recycled papers and nontoxic inks for brochures. And last, a hotel cannot be considered green unless it treats its workers well and pays them living wages.

Support hotels that are truly making the effort to reduce their impact. The Green Hotel Association is one organization that can help identify such properties. If your favorite hotel is behind the curve, let them know that their loyal customers demand greater change.

Laguna, Bolivia

Do not make excessive use of the tumble dryer.

Roughly 6% of electricity in the United States is used to dry clothing. If all of the 88 million dryers in the country were supplemented by line drying just half the time, it would reduce the country's residential carbon monoxide emissions by 3.3%.

Of all household electrical appliances, the clothes dryer consumes the most energy. It uses 2, or even 3, times as much power as a washing machine. The cheapest and most environmentally sound way of drying the wash will always be to hang it up.

Don't overload the dryer, clean the lint trap regularly, and use the permanent press option to finish the drying cycle using residual heat. Invest in a dryer with a moisture sensor—it will shut off as soon as your clothes are dry.

Erosion, Theodore Roosevelt National Park, North Dakota

Buy a green energy certificate.

Every time you use an appliance or turn on your lights, resources are used to generate the electricity needed to run the appliance. Ninety-three percent of the electricity produced in America comes from traditional, nonrenewable resources, which are the number one cause of industrial air pollution in this country. The remaining 7% is generated from renewable resources, such as solar, geothermal, small hydro, biomass, and wind.

Investigate options for supplying your home with green energy. If you are unable to purchase green power directly from your local electric company, one option is the tradable renewable certificate (TRCs or "green tags"). Your money will go toward purchasing renewable power where it currently exists—this will displace nonrenewable sources from the regional or national electric grid.

Altiplano, Bolivia

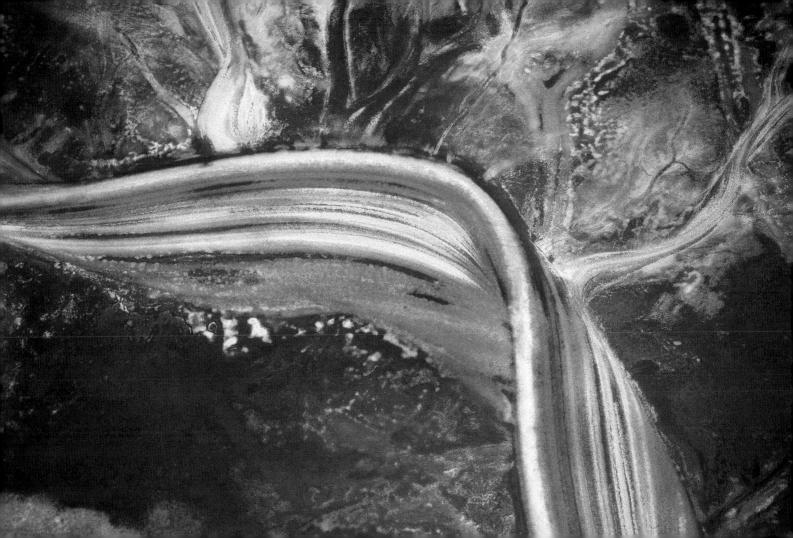

Ask for the MSC (Marine Stewardship Council) label.

Worldwide, fish stocks are in free-fall. Populations have dropped by a third in less than 30 years. Now there are labels that encourage good practice by identifying products that come from sustainably managed fisheries; that is, areas where efforts are made to preserve the natural marine environment and the richness of species while guaranteeing a decent wage for fishermen. In this way consumers can encourage ecologically responsible fishing practices.

Look for seafood products bearing the label of the Marine Stewardship Council, an independent, global, nonprofit certifier of sustainably produced seafood.

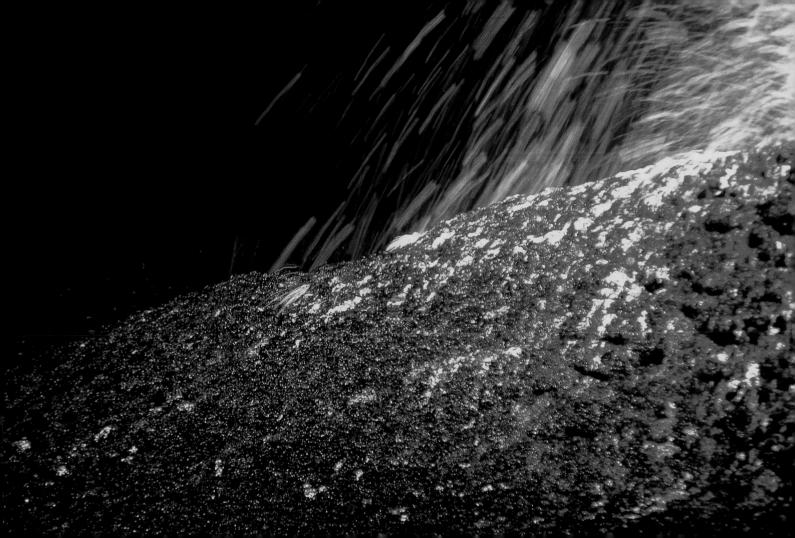

Moderate you air-conditioning use.

The world's energy consumption is increasing relentlessly as standards of living rise. Air-conditioning, a modern comfort, has a particularly voracious appetite for energy. If it is used in excess (that is, to produce cold rather than a comfortable temperature) it uses large quantities of electricity pointlessly.

By being content with a degree or two less, you can save up to 10% of daily energy consumption. Use air-conditioning in moderation in your car as well. Fans generally use much less energy and can help circulate the cool air, so that your airconditioner doesn't have to work quite as hard. Lastly, make sure the unit you buy is the correct size—believe it or not, if an air-conditioner is too large for the space it cools, it will do its job less efficiently (it won't remove the humidity from the air as well as a properly sized unit), wasting even more energy.

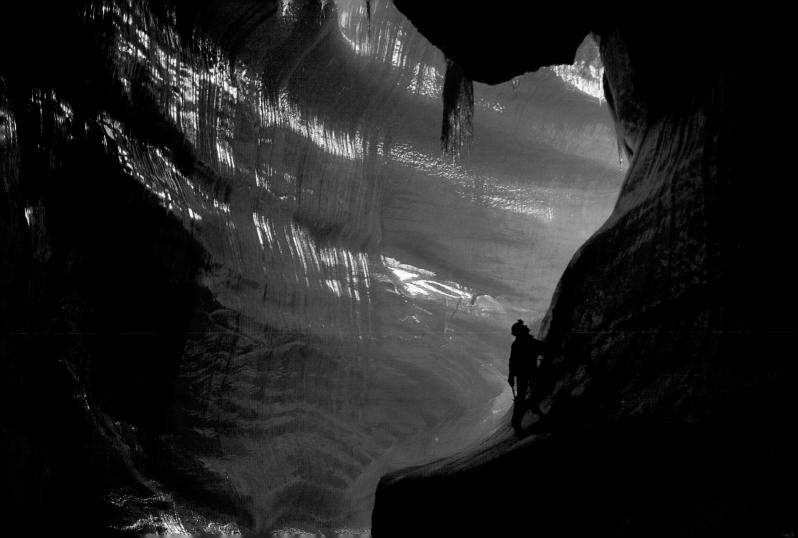

Choose a trailer rather than a roof rack.

A roof rack on a car contributes to pollution and climate change. When loaded, it increases wind resistance by up to 15%, which is reflected in fuel consumption. Even when empty, it increases consumption by 10% at the same speed.

If you need to carry a large amount of luggage when you go on vacation, use a trailer—or ship bags and bicycles to your holiday destination by train, which will produce less pollution. If you must use a roof rack, remove it when you don't need it.

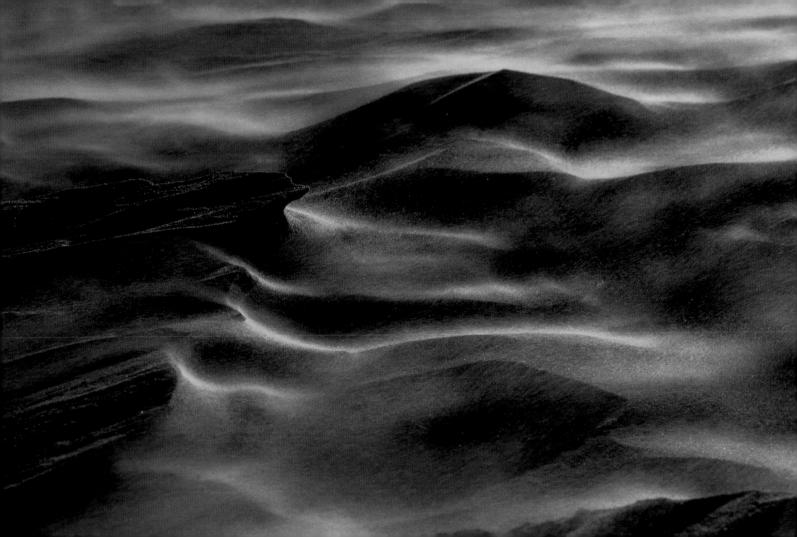

Decide what you want before you open the refrigerator door.

Replacing a 10-year-old refrigerator bought in 1990 with a new Energy Star model would save enough energy to light the average household for more than 3 months, and save more than 300 pounds of pollution each year. In a well-equipped household, the fridge alone accounts for a third of electricity consumption (20% for the freezer and 12% for the refrigerator).

In order to avoid increasing your already high consumption needlessly, close the refrigerator door as soon as you have taken out what you need. Every time you open it, up to 30% of the cooled air can escape. And remember, the tidier the contents, the less time the door needs to be kept open.

Make those around you aware of the problems.

Not everyone has the same level of awareness of environmental problems, although there is general agreement that the planet should be preserved. It is up to you to convey the urgency of the problem.

Share your knowledge and help those around you (family, friends, neighbors, and colleagues) become aware of the need for a good quality environment, and to conserve resources. Encourage them to take simple actions with this in mind.

Reduce your meat consumption, and you'll feed the world.

In the United States and Europe, two-thirds of the grain produced each year is destined for livestock feed. More than half of the grains produced worldwide are not fed to humans. If it were, it could feed 2 billion people. Big agriculture is too costly in natural resources such as water, soil, and energy sources and will not be able to sustain the 8 billion people predicted to be living on Earth in 2030.

Begin to reduce your meat consumption slowly. Choose one day a week to eat vegetarian and increase the number of days at your own pace. The variety of foods for vegetarians and the availability of local farm-fresh organic produce make the vegetarian lifestyle more appealing than ever, and you will be helping to relieve a small part of the pressures of our global appetite.

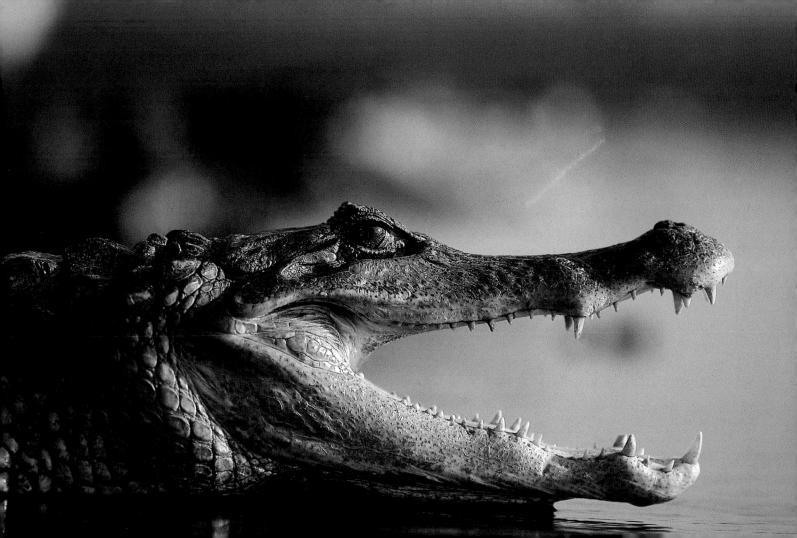

Do not waste water where it is scarce.

About 65% of the water human beings use is pumped from underground aquifers. However, more is drawn off than is naturally replaced because impervious surfaces such as pavements and buildings prevent rainwater from entering the ground. As a result, aquifers are gradually being drained dry. Some aquifers close to the sea—in Spain, for example—have started to fill up with saltwater. In India, the water table has dropped between 3 and 9 feet over three-fourths of the country's area. In some Mexican towns there is barely enough water to provide 5 gallons per day per resident.

In developing countries the average tourist uses as much water in 24 hours as a local villager does to produce rice for 100 days. Avoid wasting this precious liquid: Take short showers, don't ask your hotel to wash your sheets and towels every day, and don't leave the tap running when you do things like brush your teeth.

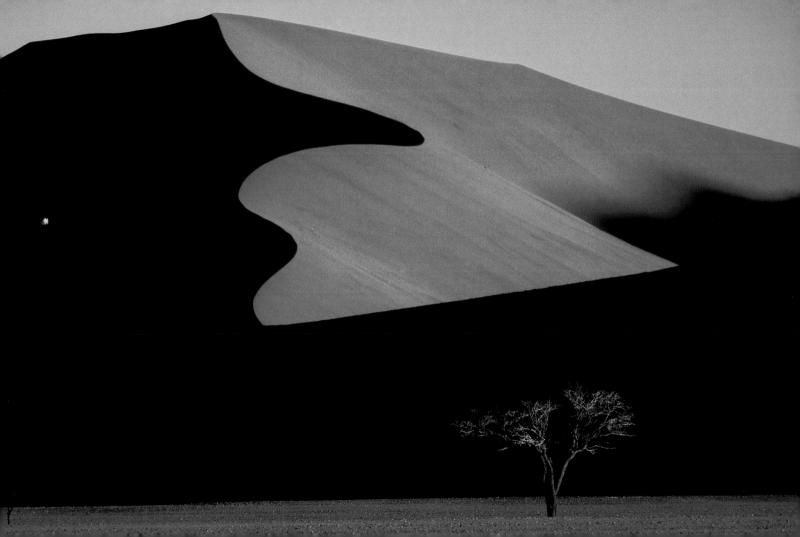

When you take a vacation, give your home a rest, too.

Vacationing is generally a high-impact activity, especially when it involves air travel. Make sure your home isn't using up resources while you're thousands of miles away.

Before you leave, turn off as many appliances as possible. Clean out the refrigerator and turn the temperature down; turn off icemakers. Turn off water heaters or in winter dial them down to the lowest setting. Turn off air-conditioning or heating systems (or, if you need minimal heating to keep indoor plants alive, turn the heat down as low as possible). If you're able to, turn off the water—a leak or burst pipe is a terrible thing to come home to and a terrible waste of water. Unplug all AC adapters and electronics, especially those that continue to draw power through digital clocks and "standby" modes.

Use heat for weeding.

Everyone knows that using too much fertilizer, insecticide, herbicide, and fungicide on crops damages the environment, in particular, water resources. However, most of us do just that in our own gardens and produce the same type of pollution.

You can dispense with chemical herbicide, for example, by using heat: Pour boiling water on the weeds. The weeds darken almost immediately and turn brown within a few hours, much like the effect of a contact herbicide, but there is no toxic residue and the area is immediately safe for children.

Take the train rather than the car.

Most people start their day in a car, fighting traffic and boredom. A passenger on a train, whether traveling for business or pleasure, has the option to roam freely through the train, sleep, read, or interact with fellow passengers. The American rail system, at the turn of the nineteenth century regarded as the bastion of progress, is slowly dying due to lack of passengers.

Discover the comfort of train travel. Your journey will be safer and less tiring, and you will considerably reduce your contribution to global warming.

Quit smoking.

Everyone knows that tobacco is harmful to our health. More than 3,000 substances have been identified in tobacco smoke, including nicotine, which causes addiction; tars, which cause cancer; and carbon monoxide. Moreover, smokers pollute their immediate surroundings. However, the damage does not stop there: Every year about 600 million trees go up in smoke to provide space to cure tobacco leaves; tobacco farming accounts for 5% of deforestation in Africa. Cigarette butts are a huge source of litter and can take a decade to break down.

Smoking is simply not part of a sustainable lifestyle. While you cut back, avoid smoking in enclosed spaces and keep to smokers' areas in public places. Look for organic tobacco and hand roll to avoid nonbiodegradable filters.

Celebrate a different type of independence.

Make your Fourth of July celebration a symbol of your burgeoning independence from wasteful practices, petroleum, and toxics.

Barbecue with sustainably produced charcoal made from reclaimed scrap wood-propane burns cleaner but it is petroleum derived. Don't use lighter fluids. Compose your picnic using organic and locally produced foods. If you need disposable cups and plates for a big bash, buy biodegradable goods (better yet, ask guests to bring their own nondisposable cups and utensils from home). Compost and recycle as much waste as possible. Don't buy fireworks, and ask your town to change to biodegradable fireworks that are free of gunpowder.

Take bulk waste to reuse centers.

What to do with domestic appliances, furniture, old plaster, sheets of metal, and everything else that does not fit in the trash? This waste, which we need to dispose of from time to time, is too bulky for the regular household waste collection service. Traditionally, this type of waste went straight to the dump, but a growing number of reuse centers can take everything from old furniture to plumbing and lighting fixtures to lumber and flooring. One reuse center in Minneapolis estimated that it prevented 35,000 tons of reusable materials from going to landfills.

Before you send an old toilet or closet door to the dump, contact your local reuse center. Anything that's not salvageable should be properly disposed of. If you cannot take it to the dump yourself, your local town hall or public works department will have information on door-to-door collection services.

Namib Desert, Namibia

Look at where your purchases originate.

Everyone knows that private cars pollute. But we often forget that most of the items we use in our daily lives travel long distances, too. The environmental impact of transporting food and consumer goods is considerable: The farther a product travels, the more greenhouse gases are emitted.

To minimize this waste of resources and pollution, check the label to see where the produce or household goods and toys you buy come from. Try to buy from local sources as much as possible.

Telecommute or videoconference.

Nearly 44 million Americans telecommute to some degree. If only 10% of the nation's workforce telecommuted once a week, it would save more than 1.2 million gallons of gasoline each week. If you can do your job remotely, ask your employer to consider trying a telecommuting scheme—the summer is a great time to make this request as the pace slows at many businesses while people go on vacation and take advantage of shortened summer hours.

Videoconferencing, though not exactly carbon neutral—it does require a lot of fancy electronics and energy—is far more eco-friendly than flying to business meetings.

If you don't like tap water, use a filter.

Deteriorating water infrastructures, pollution, and outdated treatment technologies have combined to degrade the quality of water being delivered to Americans. Sources of drinking water are continually degraded by development and pollution. For the moment, drinking water treatment facilities are adequate to ensure that our water is fit to drink—but how long will this be the case?

To reduce the chlorine taste in water, you can install a filter on the tap, or add a few drops of lemon juice to your water pitcher. Or, simpler still, place the pitcher in the refrigerator for a few hours: Chlorine is volatile and will evaporate.

Use eco-friendly sunblock.

There is a difference between sunscreen (which uses chemicals to absorb and reflect the sun's harmful rays) and sunblock (zinc- or titanium-based formulations that physically block UVA and UVB rays). Protecting your skin from the sun is important to your health, but many of the chemicals in brand-name sunscreens are incredibly harmful to coral and marine life. Each year swimmers add roughly 9 to 13 million pounds of sunscreen and tanning products to our oceans. Recent studies show that parabens, cinnamate, benzophenone, and camphor derivatives—all common ingredients in commercial sunscreen—can cause dormant viruses in coral reef algae to bloom, which can eventually kill the coral.

Protect yourself and our oceans by using biodegradable sunblocks that don't contain harmful chemicals. Better alternatives are on the horizon, but for now products that have titanium dioxide and zinc oxide as active ingredients and all natural (even better, organic) inactive ingredients are the safest.

Sandstone, Chad

Do not buy souvenirs made from protected species.

Overexploitation of living things—as a result of hunting, fishing, or excessive harvesting—is one of the main reasons for species extinction. When trade of a species continues despite its being protected, it is called trafficking. Illegal trade in threatened animal and plant species is the third largest form of trafficking in the world after arms and drugs; this trade affects 13% of the bird and mammal species threatened with extinction.

By buying certain objects or souvenirs that come from protected species, you are encouraging this illegal traffic and speeding up the extinction of species. When you are on vacation, do not buy whole shells, preserved animals, or jewelry, combs, eyeglass frames, or trinkets made from, for example, the shells of sea turtles—having inhabited the planet's oceans for several tens of millions of years, they are now in danger of extinction as a result of human activity.

> Geysers, Yellowstone National Park, Idaho, Montana, and Wyoming

Take your old batteries back to the store.

Inside a battery, the chemical reaction that takes place produces energy, which is converted into electricity. Most cylinder and button batteries contain toxic metals such as cadmium, mercury, lead, and nickel, which are extremely harmful to the environment. Even though newer batteries may be disposed of in the trash, it is strongly recommended that you recycle your alkaline batteries.

Many large commercial stores accept batteries for recycling. They may not advertise this fact, so it is a matter of asking the manager. Try to limit the number of products you use that require batteries, and buy a battery charger and rechargeable batteries.

> Yosemite National Park, California

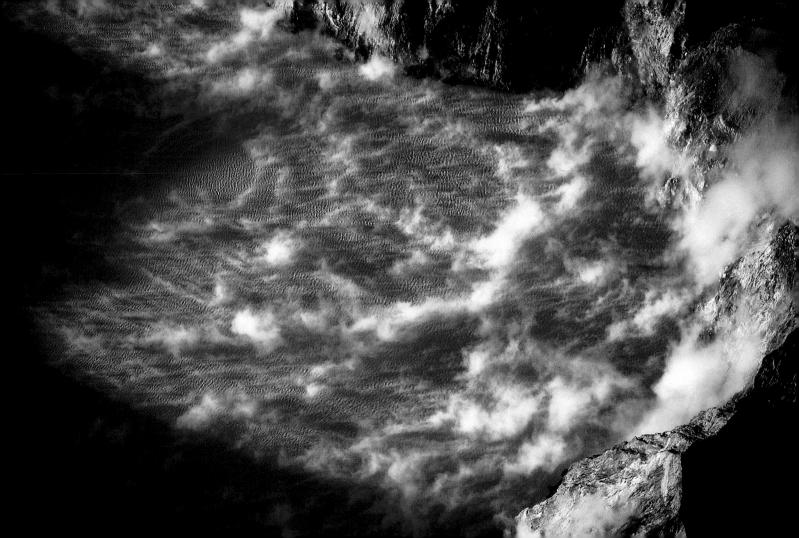

Choose the best gasoline.

Petroleum is a nonrenewable resource, so there is no sustainable oil company. A green lifestyle certainly does not include frequent trips to the pump. But when you do have to fill up, don't pull into any station. Though it may be a "lesser of all evils" game, some oil companies are more worthy of your dollars than others.

Organizations like the Sierra Club have developed criteria to rank the major players. Big Oil is one of the least transparent industries on the planet, but you can get information on pollution released from refineries, environmental disasters (not only spills but destruction of habitat and communities for pipeline), and whether a company has an exit strategy (some actually acknowledge climate change and support alternative energy).

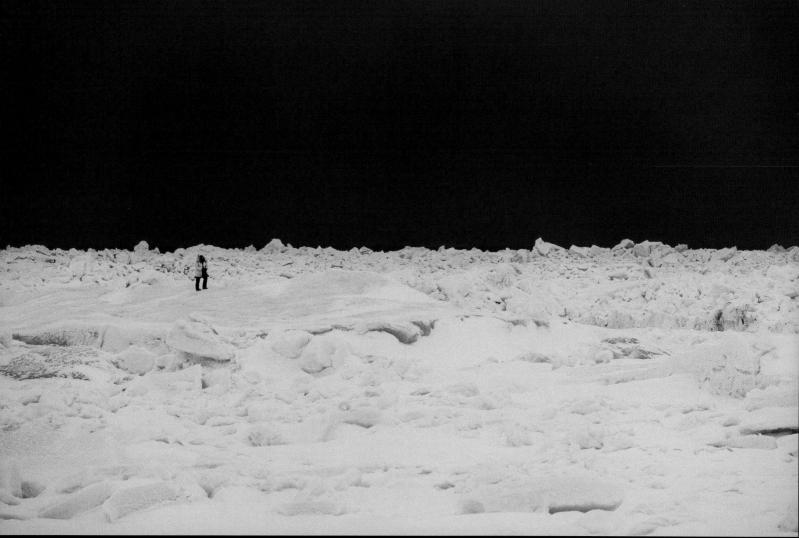

Do not light fires in the forest.

Emissions of carbon dioxide are one of the chief sources of the air pollution that is causing the proven upheaval in the climate. Nearly 5 metric tons of carbon is released when an acre of coniferous forest burns. In 2006 alone, 9.87 million acres of forest in the United States were lost to wildfires. Even if it is more likely that they are started deliberately to clear vast areas for agriculture, many fires are accidentally caused by leisure activity.

Preserve the planet's forests: Don't light fires.

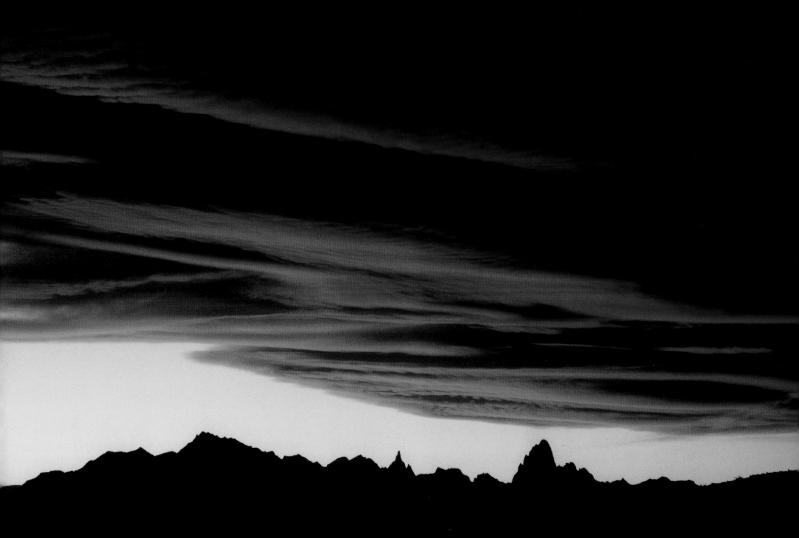

Beware of invasive species. Do not introduce non-native plants or animals.

Nature relies on delicate balances. An alien species, whether deliberately or accidentally introduced into a habitat, may find conditions so favorable that it becomes invasive. Miconia, an ornamental bush introduced to Tahiti in 1937, now covers two-thirds of the island. Caulerpa, a tropical seaweed, monotonously blankets vast areas of the Mediterranean. The water hyacinth, originally from Brazil, chokes rivers in Africa. In Hawaii, the Indian mongoose was released to eradicate rats in sugarcane fields. The mongoose did nothing to slow the proliferation of rats, but instead destroyed most of the local native flora and fauna of the island, bringing many of those species close to extinction.

To avoid an ecological disaster, do not release any exotic animal into the environment, and never smuggle plants or animals in your luggage.

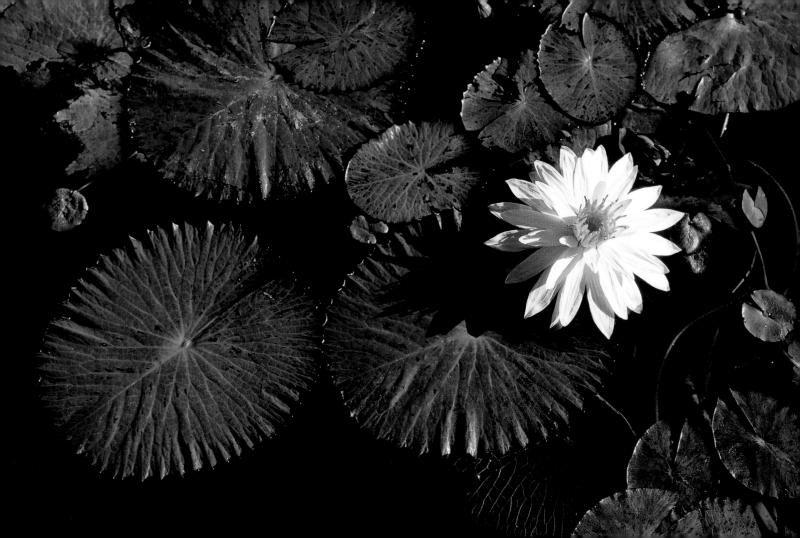

Think twice before visiting endangered places.

In the past few years a new type of travel has become popular—it's called "disaster tourism" by some. Inspired by news reports of disappearing habitats, some travelers are forsaking typical vacation spots to head to Greenland to get a last look at endangered polar bears or to Tanzania to see Mt. Kilimanjaro before its famous snows are gone forever. Although getting to know an endangered place can be seen as a step toward figuring out how to protect it, make sure your visit doesn't compound the problem.

Before booking a trip to an eroding reef or glacier, consider the following:

Will increased tourism have any benefits? The Galápagos Islands, for example, are being destroyed by unregulated tourism; if more people rush to see them before they change, it will hasten their demise.

Will you be able to minimize your impact by patronizing local businesses that follow strict ecological policies? Does any portion of the money you spend on your trip go toward helping those communities affected by climate change?

Finally, ask the toughest question of all: Are you traveling to the destination to make a difference or to secure bragging rights?

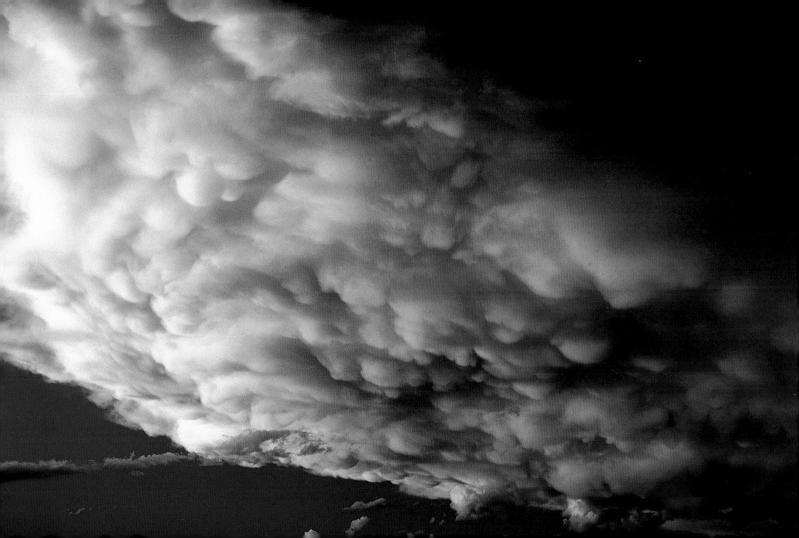

Take your trash with you.

Some waste is biodegradable, which means that it decomposes easily in the environment. Other waste does so much less quickly. Bear in mind that a tissue dropped in nature takes 3 months to decompose, a piece of paper takes 4 months, and chewing gum takes 5 years. An aluminum can decomposes over 10 years, a plastic bottle takes at least 100 years, and a glass bottle requires several centuries.

No matter how quickly you think it will decompose, do not leave waste behind. Always take it with you and find a garbage can, or better yet, a recycling bin.

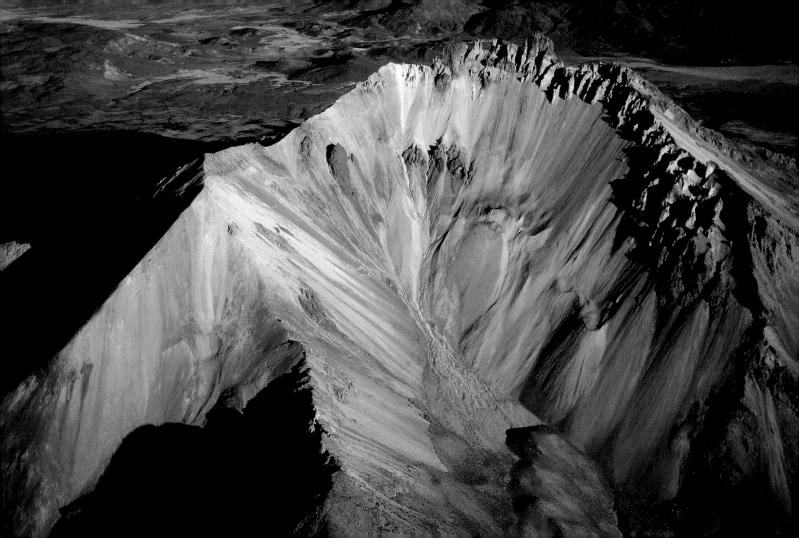

Protect mangroves: Don't eat farmed shrimp.

Mangrove forests, which grow on swampy shores, are a vital habitat for marine life as well as significant to local economies. They offer a refuge and spawning ground for fish and crustaceans; they protect the shore by trapping sediment washed down by rivers; and they slow erosion caused by waves. Mangroves carpet almost a quarter of tropical coasts, but this is only half their former extent, for this fragile, unique habitat is continually receding as a result of logging, pollution, and, increasingly, the expansion of shrimp farming (especially in Asia, which produces 80% of the world's farmed shrimp). Half of the mangroves that remain are considered degraded in some way. The impact of the destruction of mangroves on the coastal ecosystem was recently found to be even more vital when scientists discovered that mangrove forests are crucial nurseries for some coral reef fish species.

Shrimp farming has already destroyed an estimated 2.5 million acres of coastal wetlands and mangroves. Avoid eating farmed shrimp, especially when staying in foreign countries.

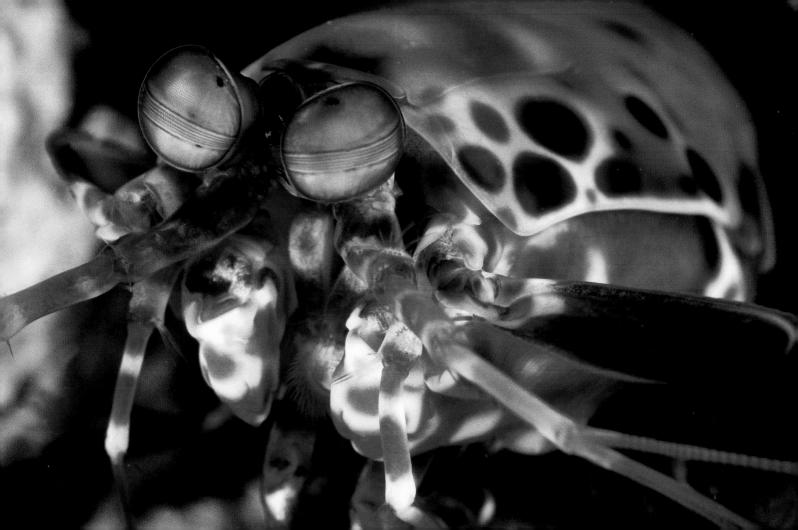

Choose solar-powered heating for your home.

Renewable energy sources produce no greenhouse gases and their reserves are inexhaustible. Why not use the sun to heat your water and your house? People often mistakenly believe that solar heating only works in tropical regions. This is incorrect—it is just as economical to choose solar power at our latitudes. Depending on the situation, energy from the sun can supply 40% to 80% of hot water needs, and 20% to 40% of heating needs. A solar hot water heater may allow a 40% to 70% reduction of energy consumption during the summer.

Various financial subsidies for renewable energies are available, especially when constructing on a large scale—find out about them. Even without subsidy, a solar-panel installation pays for itself in about 7 to 9 years on average, while its life is generally longer than 25 years. The sunlight is free, courtesy of Mother Nature.

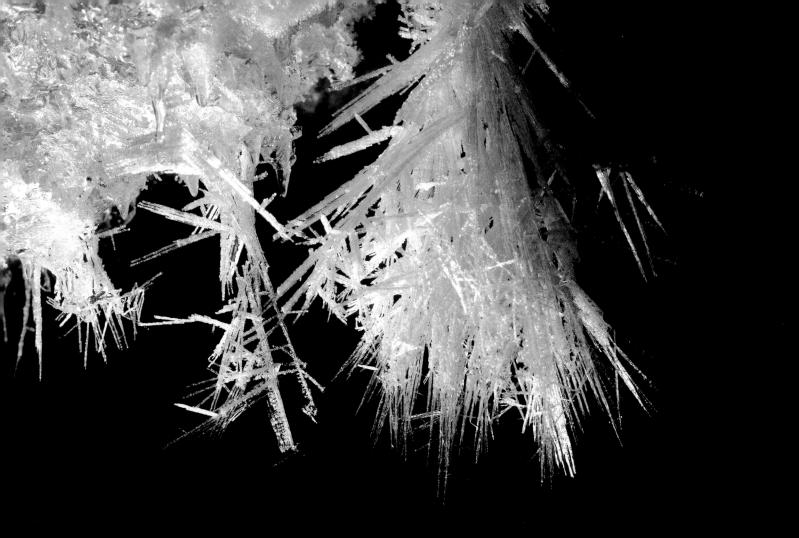

Donate your time to an environmental organization.

The United States is blessed with a multitude of environmental organizations—local, regional, and national. Some focus on issues of access to resources, some on biological and natural integrity, some on public education, and many on all three. Some citizens choose to support these organizations by giving a donation or becoming a member in order to support initiatives financially; others give their time to take part in the organization's activities.

These organizations have a great deal to contribute. They also need you. Investigate the environmental groups in your area, and support their work in some way.

Practice environmentally friendly camping.

Camping would appear to be close to nature and do little environmental damage, but in practice this can vary. Making smarter choices about where and when you camp will reduce the amount of impact your camping trip has on the environment. Always camp in designated campgrounds; choosing your own site to pitch a tent will compress soil and impact vegetation.

The timing of your holiday is also important. If you choose a popular outdoors destination for your trip, choose to go at an off-peak time of year; fewer people in the park will not only add to the enjoyment of your trip but also reduces the amount of impact visitors have on a given day. Carry out all trash and don't dump any wastewater near freshwater sources. Use phosphate-free, biodegradable soaps for bathing and washing dishes.

Olympic National Park, Washington

Make your children aware of the natural world that surrounds them.

Before we want to protect something, we must first get to know it. Inaction is often due to ignorance rather than negligence. Those who are young today will soon have the earth's future in their hands. Let us give them the means to do better tomorrow than we have done today.

Suggest nature trips to your children, such as visits to the botanical gardens, the local environmental center, natural sights, walks, and other open-air activities. Give them binoculars, magnifying glasses, notebooks, and pencils. Complement these with books, nature guides, and discussions about their newfound knowledge. By broadening their interests you will help to increase their awareness and will certainly learn a lot yourself.

Keep your tires properly inflated.

Keeping tires fully inflated reduces wear and lengthens their life, thus saving moneynew tires can be expensive, on average \$250 to replace all 4 tires. It also saves precious raw material: It takes 7 gallons of crude oil to create a new tire. Underinflated tires can increase fuel consumption by up to 10%. Americans waste 4 million gallons of gasoline a day driving on tires with low pressure.

Take care to keep your car's tires at the pressure recommended by the manufacturer. Take 5 minutes every month to check the pressure of your tires.

Iceberg, Antarctica

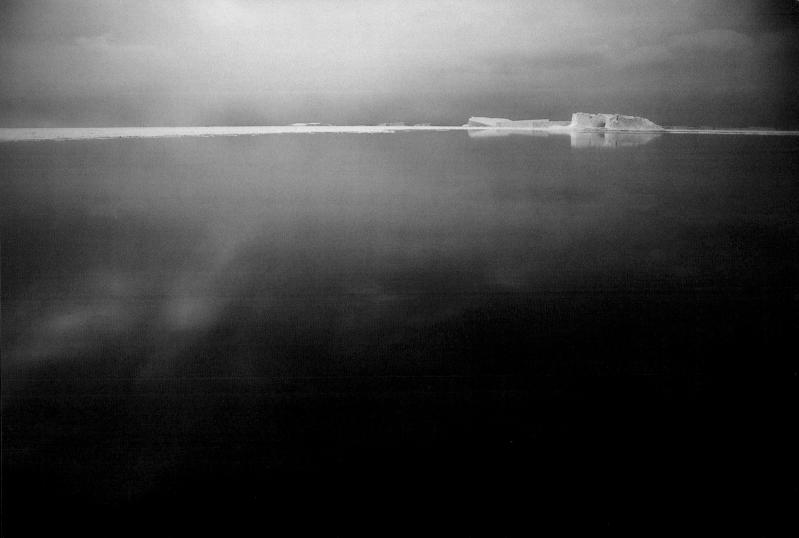

Buy a refrigerator that does not damage the ozone layer or the climate.

International measures for halting the destruction of the ozone layer stipulate that chlorofluorocarbons (CFCs) in refrigeration equipment must be replaced by hydrochlorofluorocarbons (HCFCs) and hydrofluorocarbons (HFCs), which do not damage the ozone layer. Unfortunately, they do contribute significantly to climate change because they contain chlorine, which makes them far more powerful greenhouse gases than carbon dioxide. The anticipated increase in the use of HFCs by the year 2050 will contribute as much to global warming as all the private cars on the planet put together.

Refrigerators are available that contain neither CFCs nor HCFCs but use isobutane instead. When you change your refrigerator, find out about models that do not either damage the ozone layer or contribute to climate change.

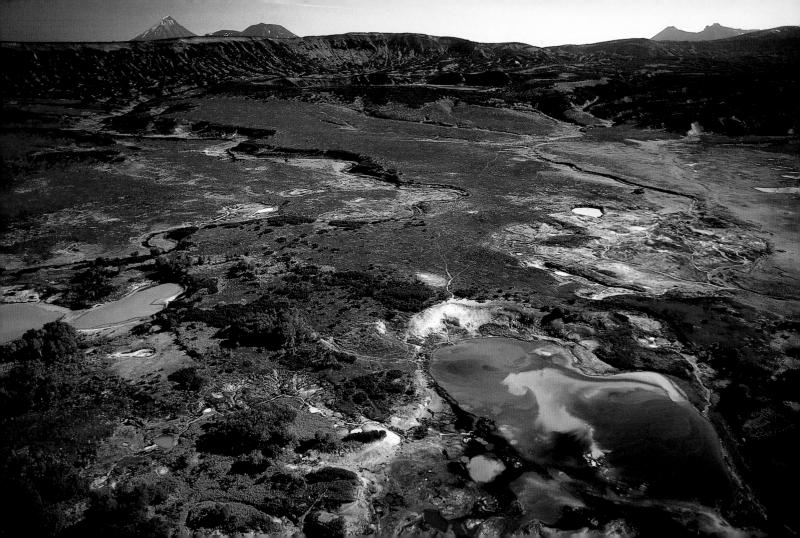

Use the right dose of detergents and other chemicals.

Thanks to the efforts of detergent manufacturers, you now need far less detergent to wash a load of laundry or dishes.

Check the recommended dosage on the packages of the products you use to wash dishes, floors, or laundry, especially for concentrated detergents, and stick to them. Using more soap does not give better results and can cause skin irritations. In addition it is more costly, wastes more packaging—and therefore natural resources—and contributes to the degradation of already polluted rivers.

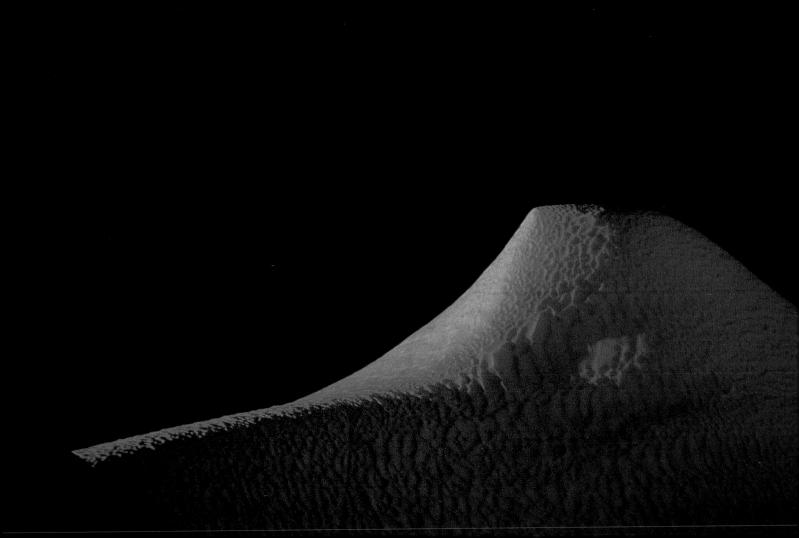

Do not throw away your baby's clothes and accessories.

Joy at the birth of a child is followed by a multitude of expenses for the necessary equipment. The list can be long and the bill high, especially since we generally want the best, most attractive, most modern and, above all, the newest products for the latest addition to the family. A large proportion of these accessories and clothes will see use for an extremely short length of time.

To lessen the impact of a new baby on the family finances, consider looking in consignment stores, obtain what you need from other family members, or borrow items from friends. Then lend things in turn, sell them, or give them away. If the same plastic bath is passed down among 4 children, that makes 3 fewer baths that need to be manufactured.

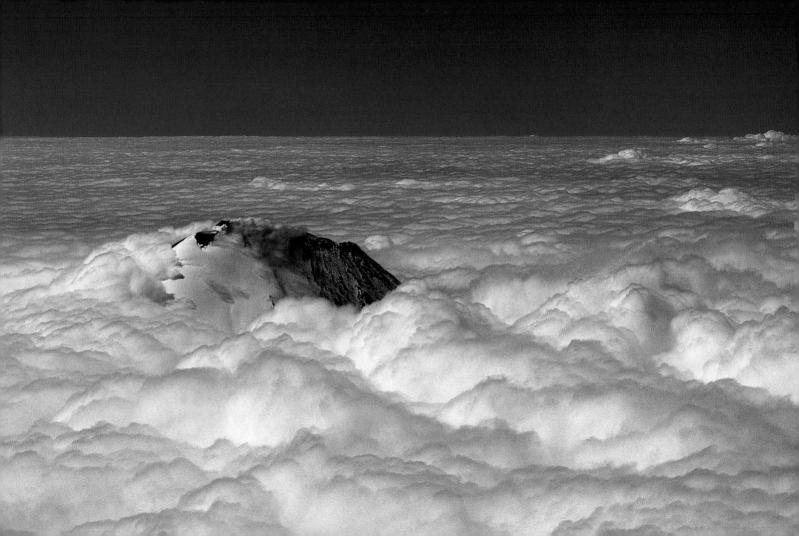

Keep litter out of our oceans.

A motley carpet of some 300 million tons of waste covers the floor of the Mediterranean Sea. Some of the waste will remain there, intact, for centuries. A newspaper takes 6 weeks to decompose in the sea, and a cardboard box takes 3 months. A cigarette butt takes 2 years, and a steel can 80 years. An aluminum can will last 100 years, and a plastic bag 300 years. A piece of polystyrene or a plastic bottle will both remain intact for 500 years. Glass lasts even longer—but is easily recyclable.

Vast though it is, the sea cannot absorb all our pollution. It is becoming saturated. Do not leave any waste on the shore or throw any overboard, and when possible dispose of it in recycle bins.

> Elephant crossing a sea channel, Andaman Islands, India

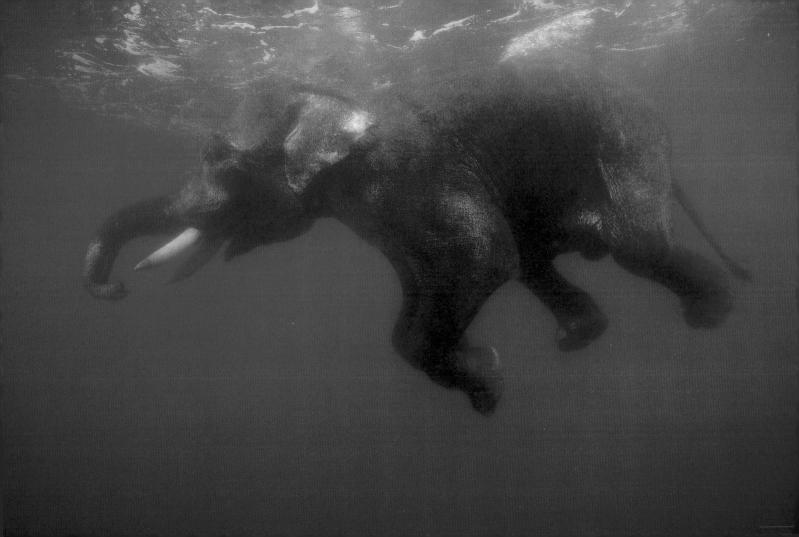

Say "no" to rare fish species on your plate.

Consumption of fish products has more than doubled in the last 50 years. Today, 52% of the world's commercial sea fish stocks are fished to the limit of their capacity, 17% are over-fished, and 8% are exhausted or slowly recovering. For example, in the waters off Newfoundland, cod stocks are struggling to recover despite a moratorium on fishing. A modern factory ship can catch as much cod in an hour as a typical sixteenth-century boat could haul in an entire season. Only a quarter of the world's fish stocks are moderately fished or under-fished, and species that were once plentiful have become rare.

Watch your consumption of Chilean sea bass, swordfish, bluefin tuna, cod, hake, monkfish, sole, and Atlantic salmon—these are just some of the threatened species.

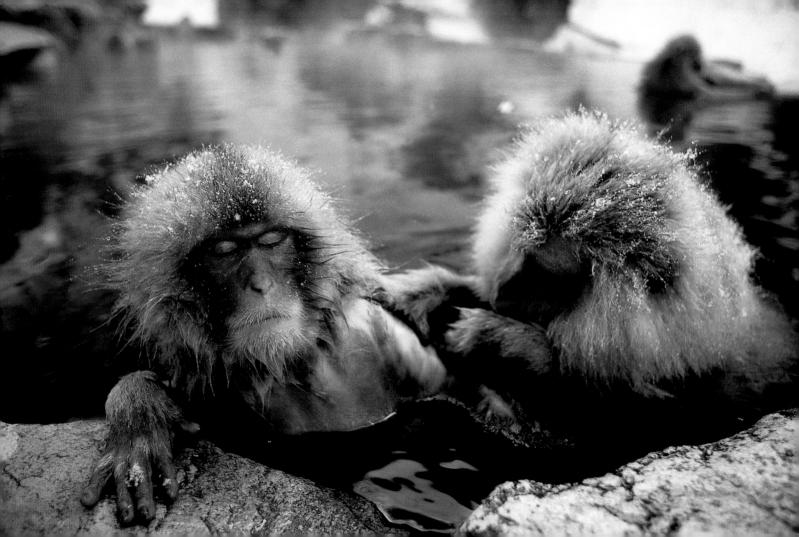

Rediscover the shopping list, to distinguish between desire and need.

We are easily tempted by things we "want," but rarely stop to ask ourselves what we "need." As a result much of what we buy is surplus to our needs. If the entire planet lived the American way of life, we would need 4 planets like Earth.

We only have one Earth. Do not allow yourself to be trapped into overconsumption; bring back the "shopping list" when you visit the supermarket. You won't forget anything, and you will avoid impulse purchases that were not planned and might account for up to 70% of what you buy.

Use your library.

Tropical rain forests are being destroyed at the rate of 56 million acres a year. Every second a tract of rain forest the size of a football field disappears from this planet in order to provide space for cattle or crops, or to provide wood for paper products and furniture. World wood consumption is expected to rise by 58% over the next 20 years. In some tropical forests, a single tree can be home to up to 100 species. What will be left of this biological wealth?

Even if you can afford it, rather than buying novels and other books new, subscribe to your local library. Libraries are precious civic spaces in which everyone should participate.

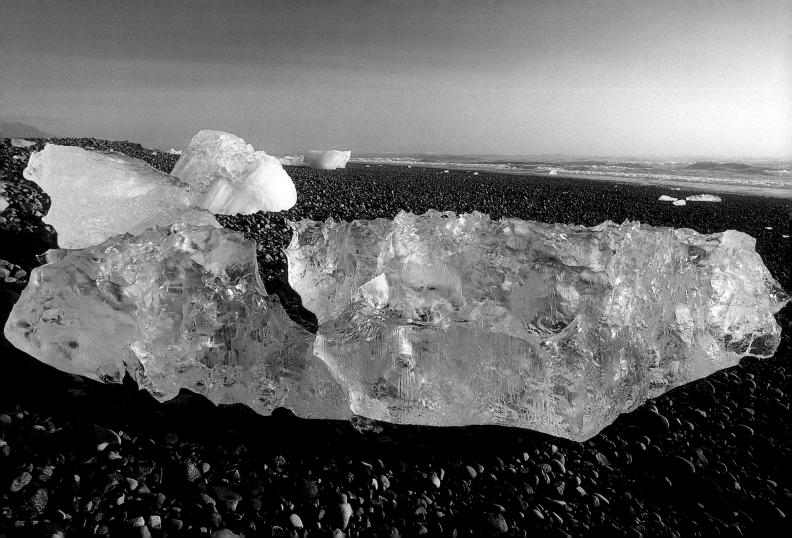

Support environmentally conscious films.

In 2005, Participant Productions, a newly formed film company dedicated to exploring and inspiring social change through filmmaking, released *Syriana*. This dense, grim film about the politics of the oil industry went on to earn several major awards. Participant and like-minded companies strive to not only provide socially compelling entertainment, but to do so while doing their part to reduce their impact on the environment. A study done by UCLA showed that in order to create its blockbusters, California's Film and Television Industry produces nearly 8.5 million tons of carbon dioxide each year. *Syriana* and fellow Participant film *An Inconvenient Truth,* were both carbon-neutral productions.

Support filmmakers who are committed to social change and production companies that address the toll moviemaking takes on the environment. If the theaters in your community don't play such films, arrange DVD screenings at schools or community centers and donate the DVD to your local library.

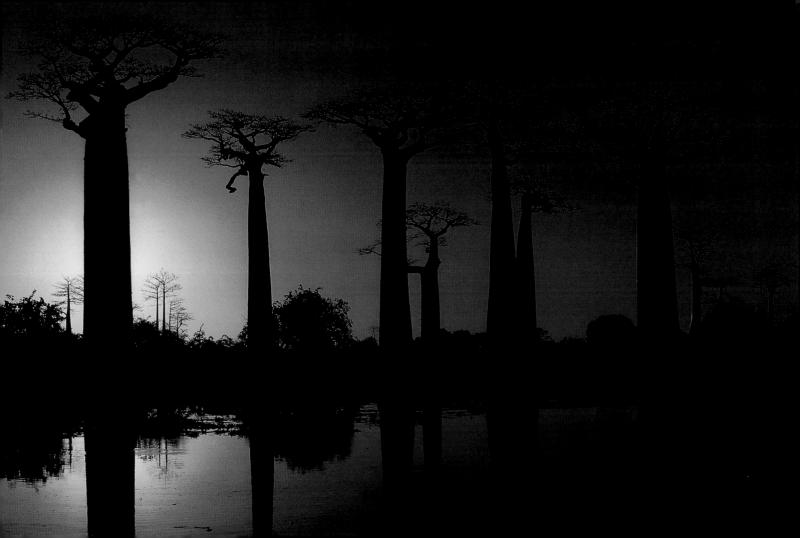

When you eat out, eat in.

In the space of about 30 years the volume of waste generated by household packaging has risen fivefold, and certain materials such as plastic, by as much as 50 times. In 2006, Americans used roughly 14.4 billion paper to-go cups for hot beverages, many of which cannot be recycled. In California alone, the fast-food industry generates 4 million tons of waste each year; packaging from takeout meals comprises 20% to 30% of all litter in the state.

When you stop for lunch avoid buying takeout food, which produces large quantities of waste; in particular, nonrecyclable plastic. Take the time to sit down and eat your food at the restaurant.

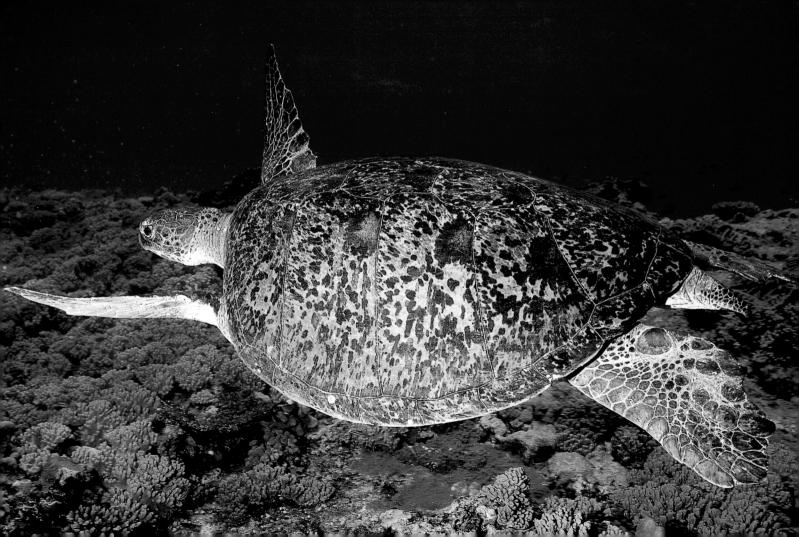

Use nontoxic cleaning products.

The average American household has a total of 10 gallons of hazardous chemicals stored in the garage, under sinks, and in closets. In the local supermarket we can buy acids, phenols, oil derivatives, corrosive solutions, chlorine, and a whole arsenal of toxic products that are supposedly necessary, according to advertising, to keep our homes clean.

Choose environmentally friendly and biodegradable cleaning products, which do not contain the most dangerous substances or petroleum, which is a nonrenewable resource. You will be contributing to the preservation of the soil, air, and water. Vinegar and baking soda are 2 simple household substances that make very effective cleaners. You can also ensure that your cleaning services use ecofriendly products by providing them.

Practice "voluntourism."

Whether guarding turtles laying their eggs on Mayotte; helping to protect wolves in Romania, iguanas in Honduras, or griffon vultures in Israel; or assisting scientists in the conservation of endangered primates in Kenya, the possibilities for volunteering for environmental work are (sadly!) endless. Helping in this way enables you to understand a country by living as local people do, while working for the protection of fauna, flora, or habitats and furthering sustainability projects.

Are you looking for a way to spend your next vacation by doing something both original and useful? Consider planning a trip with a nonprofit or NGO that offers short-term volunteer-based vacations; beyond wildlife conservation efforts, you could help build solar power arrays in an African village or teach basic computer skills to people in a community in Brazil.

Ruwenzori Mountains, Uganda

/ AUGUST 3

Buy products that are free of genetically modified organisms.

Humans have mastered technologies that enable them to modify the genes of plants and animals directly, producing genetically modified organisms (GMOs). These transgenic plants—corn, cotton, and soy, for example—are immune to insects and diseases, resistant to drought, and richer in vitamins. Pro-GM groups claim that their products are more efficient and environmentally friendly; anti-GM groups argue that too little is known about the effect of GM foods on the environment and that multinational biotech groups are the only people who stand to gain. Currently, 5 companies control all of the genetically engineered crops in the world, with Monsanto producing 90% of all genetically modified crops.

Until more is known of the effects of GM foods on society and the environment, try to limit the amount that you buy. Look for "No GM" or "GM-Free" labels.

Take the train rather than the plane.

Each year, aviation generates as much carbon dioxide as all the human activity in Africa. Carbon-dioxide emissions are not the only environmental concern. Deicing airplane wings creates 200 to 600 million gallons of wastewater each year.

Avoid traveling by plane for journeys less than 300 miles. The train or bus are usually the least polluting means of transportation for such distances.

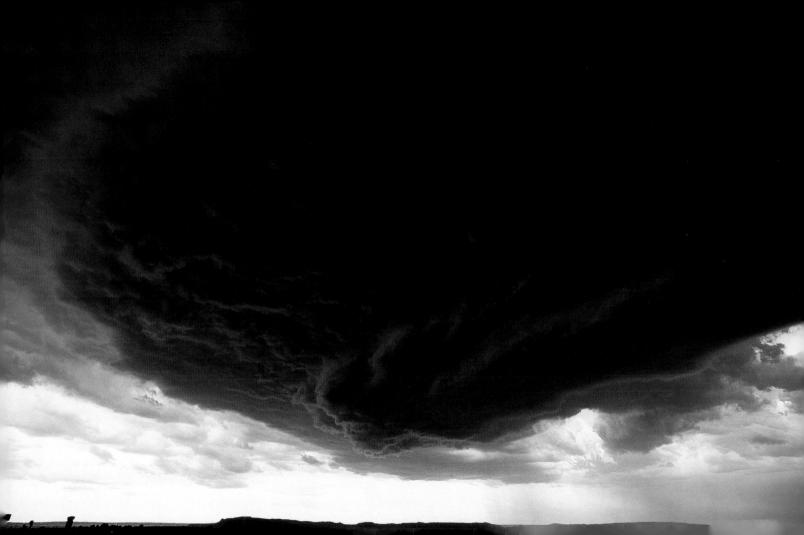

Use public bicycles in your city or create your own program.

For transportation in town, the bicycle has some unique advantages: It is clean, silent, compact, fast, and economical. Many European cities have extensive bike-sharing networks wherein, for a low annual fee, subscribers receive a swipe card that gives them access to bike stations all over the city; once they've finished their ride they can return the bikes to any designated point. Subway and light-rail stations usually have bike-sharing points, making it easy for cyclists to make public transportation connections. Most recently, Paris enacted a program that boasts 20,000 bikes. In the first month of the program it was reported that each of the bikes was being used an average of 6 times per day.

If you find this idea ingenious and would like to see its benefits reproduced in your city, let your town hall know. In the United States, several cities (San Francisco, Washington DC, Chicago, and Portland, Oregon, among them) are in the process of creating bike-sharing programs.

Close-up of sandstone, Chad

Don't smoke in the woods.

In 2003 a human-caused wildfire destroyed nearly 300,000 acres in southern California. Several of the series of wildfires that ripped through the state in 2007, destroying more than 500,000 acres, were also started by humans. One out of every 10 wildfires is caused by a careless smoker. In persistent hot and dry weather (which has increased greatly in many regions of the world), a simple brush fire can quickly grow into a major disaster that burns for days, destroys habitat and homes, and costs billions in resources.

Do not smoke when walking in the woods, and never throw cigarette butts out of your car window, even if you think you have stubbed them out.

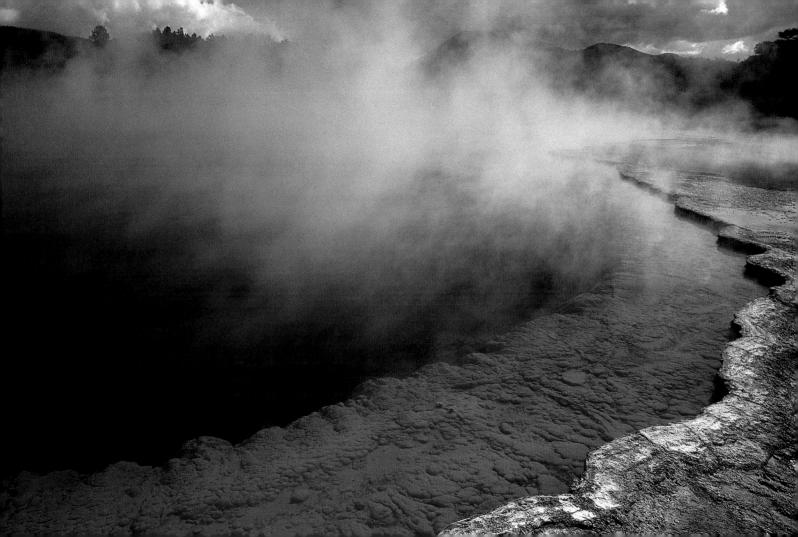

Cool off without resorting to air-conditioning.

In the United States air-conditioning is so ubiquitous that nearly 1 kilowatt-hour out of every 5 hours is used to cool our buildings. According to the National Association of Home Builders, in 2007, 89% of new single-family homes had central air-conditioning systems.

Consider carefully before having air-conditioning installed; it can increase your electricity bill by a third. A fan uses one-tenth of the energy; window shades, blinds, shutters, and the cool of the night use no energy at all. Having shade trees around your home can reduce air-conditioning use so much it can cut coolingrelated energy costs by up to 75%.

Learn to spot "greenwashing."

Now that eco-chic has become profitable, some manufacturers are cashing in on consumers' desire for green goods by "greenwashing"—spinning unsustainable products as eco-friendly. The worst offenders, when it comes to consumer goods, are makers of cleaning supplies, personal care items, electronics, and cars. For example, some products may be mislabeled "eco" if they contain any natural ingredients. And some companies offer green alternatives to inherently destructive items or practices—marketing hybrid SUVs with ads that reassure readers about purchasing any type of hybrid as doing their part to "save the environment" when in truth, most oversized, gas-guzzling cars are impractical and should be taken off the road. Since even the oil companies are becoming quite adept at presenting themselves as part of the solution, consumers have to be vigilant when sifting through the mountain of available "green" products.

Ask yourself the following questions: Is "eco" even being used correctly? Is there a trade-off that negates the so-called positive effects of the environmental element the product is touting? Is the language too vague? "Earth friendly" and "eco-friendly" mean virtually nothing unless those claims are spelled out by the company and backed up by third-party certification.

Pink flamingoes, Kenya

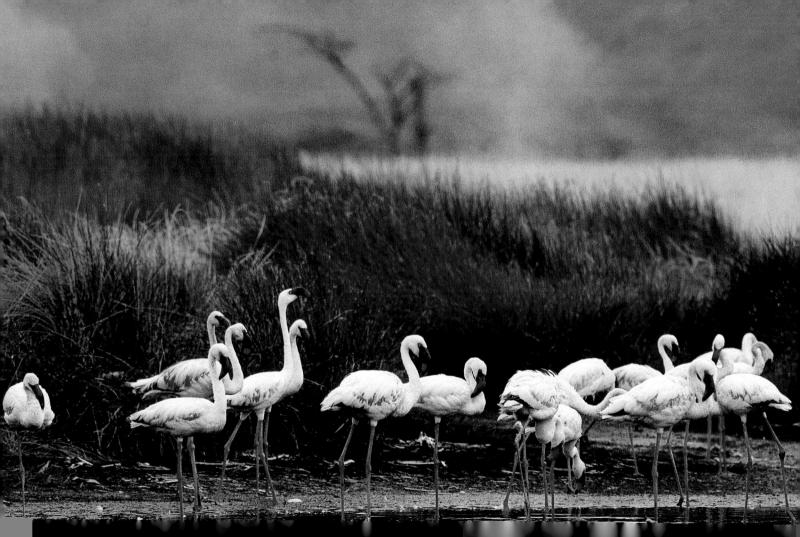

Recycle your old refrigerator.

A 2-mile-long ice core sample taken from Antarctica has shown that the levels of heat-trapping greenhouse gases are higher now than at any time in the last 420,000 years. The heat that these gases trap will cause sea levels to rise by about 3 feet, among other things. The agents responsible include coolant gases such as Freon (a trade name of the infamous CFCs, or chlorofluorocarbons), which are contained in the cooling circuits of old refrigerators, freezers, and air-conditioners. The formidable greenhouse gases are released into the atmosphere when those appliances leak or are dumped.

More than 8 million refrigerators are disposed of every year in the United States. Take your old refrigerator to a facility where it will be dealt with properly, or ask your public works department how to dispose of it correctly.

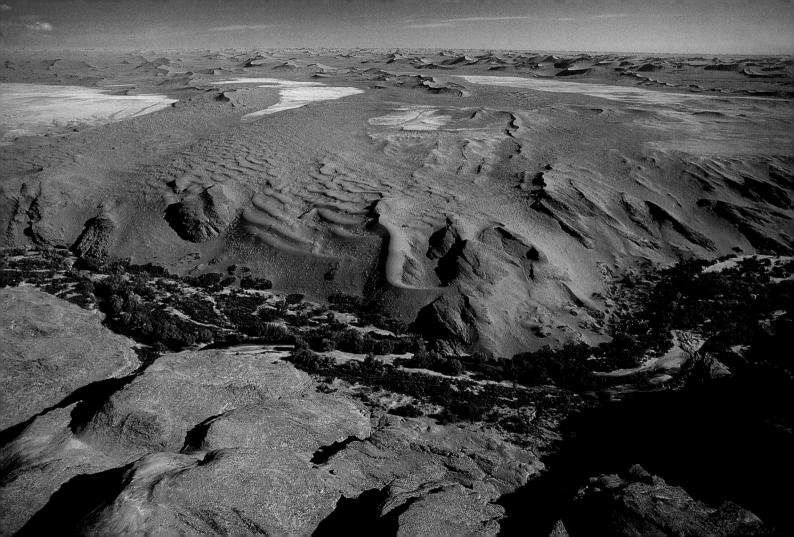

Say "no" to individually packaged portions.

Each person in America generates about 1,500 pounds of trash-called solid waste-every year. By the end of our lifetimes, we will have each created about 117,000 pounds of trash.

The fashion for prepackaged miniportions is no more than a marketing strategy. Take the time to create your own portions. Stop buying individual portions, cans, and other superfluous packaging for children's meals or mid-morning snacks. Invest instead in reusable plastic containers and drinking bottles. When you explain your choice to your children, you can also make them aware of the threat to the planet that prompted your choice.

Buy in bulk when possible.

For every garbage can placed at the curb, 71 garbage cans of waste were created in the course of the production, transportation, and industrial processes used to convert raw materials into finished products and their packaging.

Limiting the amount of waste for disposal inevitably involves reducing the volume of packaging. For cheeses, sliced meats, and grains, buy food in bulk, by weight, or cut to your needs, rather than in prepackaged sizes. This also benefits your pantry, since you will be able to find ingredients for your next meal instead of heading for the store every time you prepare a meal.

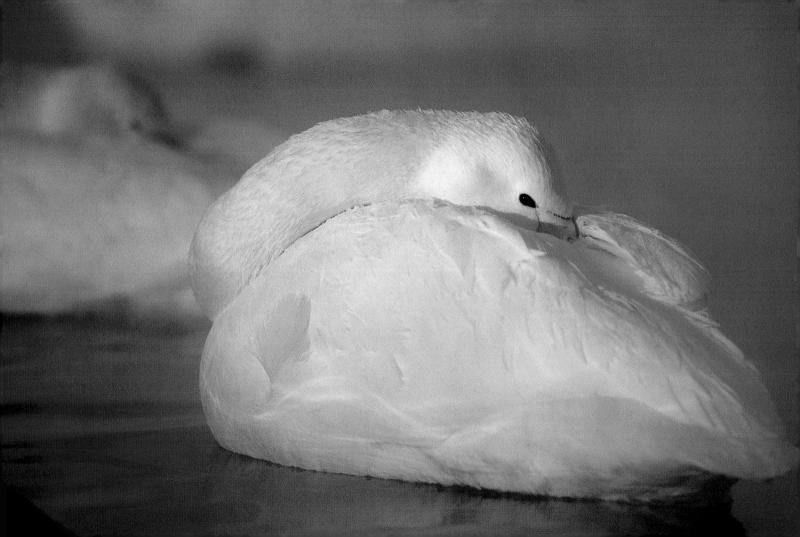

Eat fruits and vegetables in season.

How do grocery stores obtain fruits and vegetables out of season? Most produce is from specially grown crops (using soil-less cultivation or heated greenhouses) that use large amounts of water, energy, and raw materials or are from distant countries where the climate is more favorable. In the latter case, transporting this produce uses considerable amounts of energy (especially if the produce travels by air), increases pollution, and contributes to climate change. A meal from a conventional grocery store uses 4 to 17 times more oil for transport than the same meal using local ingredients.

Fruits and vegetables in season are better quality and healthier, and their cultivation has a minimum impact on the environment when consumed at the right time of the year.

Prairie, California

Do not drive your car on very hot days.

The city of Los Angeles suffers severe pollution on 150 days per year. Poor air quality in cities is caused by polluting gases, such as tropospheric ozone, the main ingredient of photochemical smog, which can cause breathing difficulties. It is formed at ground level from car exhaust gases reacting under sunlight and heat.

On very hot days, drive more slowly. Or, better yet, leave the car in the garage on most days. Invest the money you save in maintaining your bicycle or buying a nice pair of running shoes.

Take nature vacations.

If you are looking for vacation accommodations that are oriented toward the discovery of natural surroundings, try one of the many hostels in the United States located in or around areas of natural significance. From Cape Cod in the Northeast to Point Reyes National Seashore in Northern California and in many locations in between, hostels offer a cheap option for exploring the natural areas of the United States.

When you do travel to these areas, be sure to bring binoculars, wildlife and plant handbooks, maps, and other books with local information. These will all help you to explore the natural beauty before you.

Help to clean up a river.

Local nature conservation organizations regularly organize river cleanup operations. These involve removing the waste that pollutes a watercourse and clearing riverbanks of the detritus of human life. Excessively dense vegetation creates a closed habitat that does not favor aquatic life. This maintenance is beneficial even if the water is not polluted, because it preserves the ecosystem and its biodiversity.

These operations always need volunteers. Do not be afraid to join one: It is an opportunity to learn more about the stream, its banks, and the fauna and flora that live there.

Great Smoky Mountains, North Carolina and Tennessee

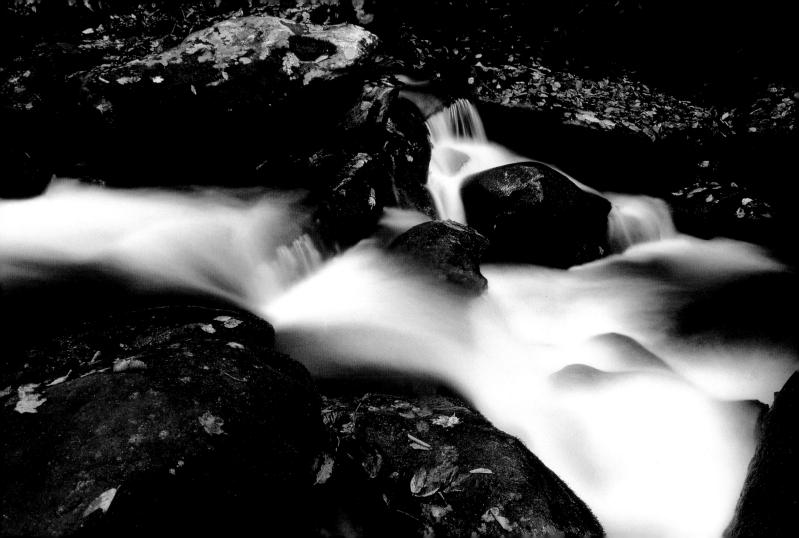

Start a community garden.

Whatever the purpose of a community garden—whether to grow flowers or food for sale or for charity, to beautify and reduce pollution in urban areas, or to offer pleasant waiting areas near institutional buildings like hospitals—creating one in your town will help you connect with your neighbors, get outdoor time, and learn about local plants and produce. Community gardens can raise property values, reduce crime, and provide outdoor classrooms for local schools.

The American Community Gardening Association has advice on how to create a new garden. If gardens already exist in your neighborhood, find out if they need volunteers or if they are in jeopardy—even established and beloved urban gardens get destroyed by developers—and find out how you can advocate for them.

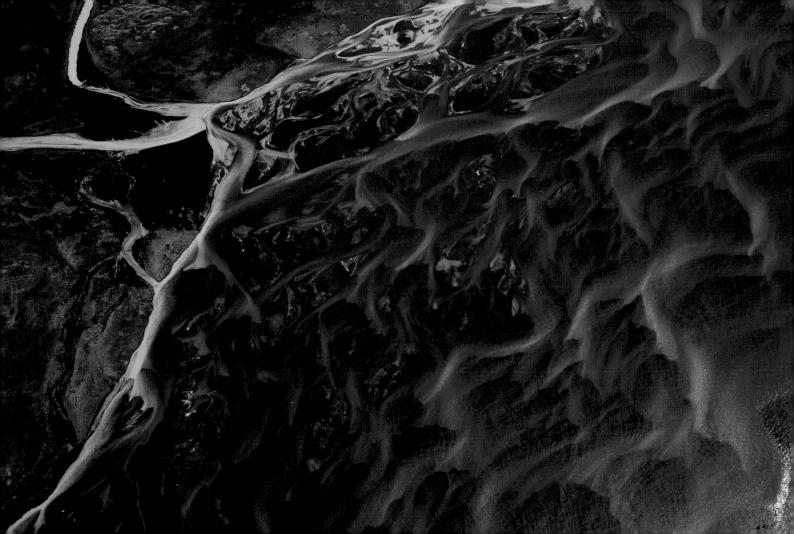

Be careful with pressed-wood products.

Standard particleboard and plywood often contain formaldehyde, a chemical that can aggravate or even cause respiratory ailments along with a slew of other medical conditions. In August 2007, 500 New Orleans residents filed a lawsuit against several companies that supplied FEMA trailers for Hurricane Katrina refugees—they claim that thousands have suffered illnesses from formaldehyde poisoning resulting from off-gassing materials.

Look for formaldehyde-free fiberboard instead of plywood—such products are often made from recycled wood or plant fiber waste. Laminates may prevent some formaldehyde gases from escaping particleboard furniture, but they can't contain all the vapors. The Forest Stewardship Council (FSC) certifies and catalogs formaldehyde-free pressed-wood products. Buying furniture from hardwoods that have been sustainably harvested is always safer.

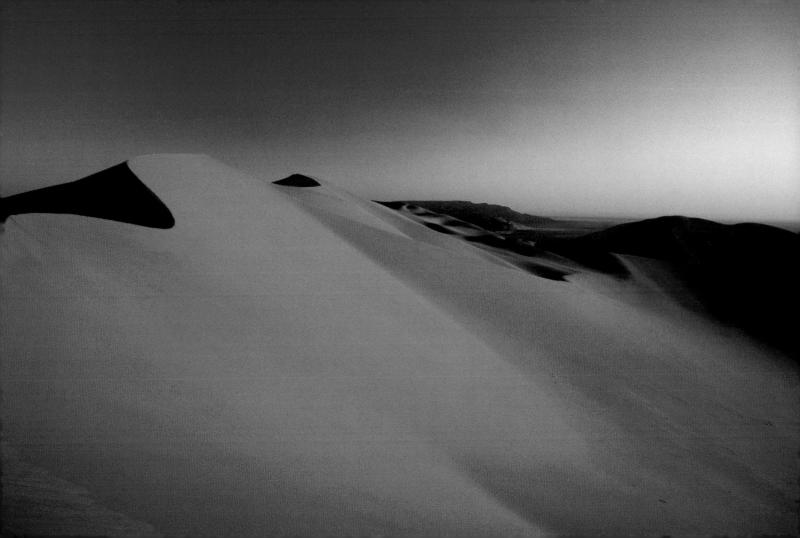

Join a water quality task force.

The world's oceans play an important role in counteracting the greenhouse effect: They are the biggest producer of oxygen (via plankton) and the biggest carbon sink (carbon is dissolved in water) on the planet. Of the 7 billion tons of carbon dioxide produced by human activity every year, the seas absorb 2 billion. They also interact with the atmosphere, a process that governs currents, winds, clouds, and climate. Rich in fish, geological resources (oil and minerals at great depths), and energy (ocean currents and tides), as long as the seas are in good health they are utterly vital to human beings.

Volunteer with a local chapter of the Surfrider Foundation to help monitor the health of our coasts. Activities may include collecting water samples, organizing beach cleanups, or organizing outreach programs to educate the public on the importance of our oceans.

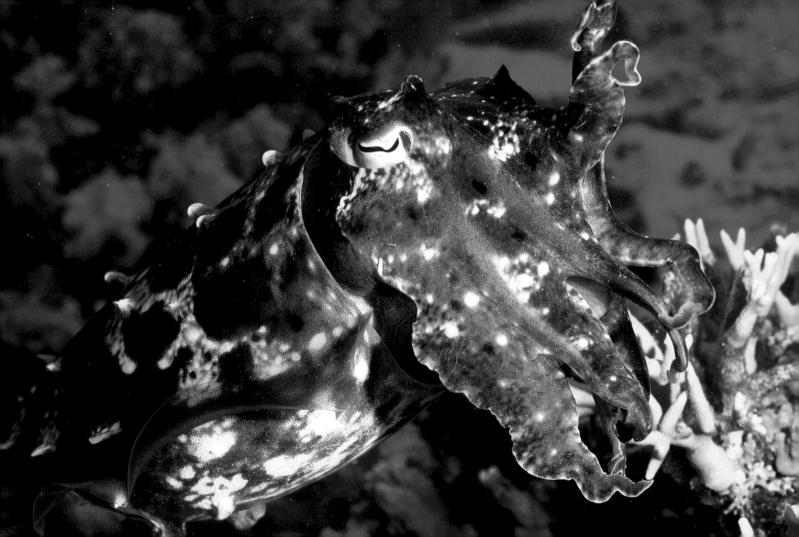

Choose sustainable school supplies.

The return to school in the fall provides an opportunity to choose sustainable items for your children. More than half of a family's substantial budget for school supplies at the beginning of the school year consists of paper products—3.4 million tons of paper is purchased at the start of every school year.

Make sure all of the notebooks contain a high percentage of post-consumer recycled paper.

Choose pencil sharpeners and rulers in metal or wood (neither colored nor varnished). These will last longer and produce less pollution than their plastic equivalents.

Buy pencils made from 100% recycled materials and refillable pens.

Choose a solar-powered calculator rather than a battery-powered one.

Above all, sift through last year's stationery supplies and reuse as much as possible to avoid buying the same reusable product again. Encourage your child to trade supplies with friends to foster an ethic of reuse.

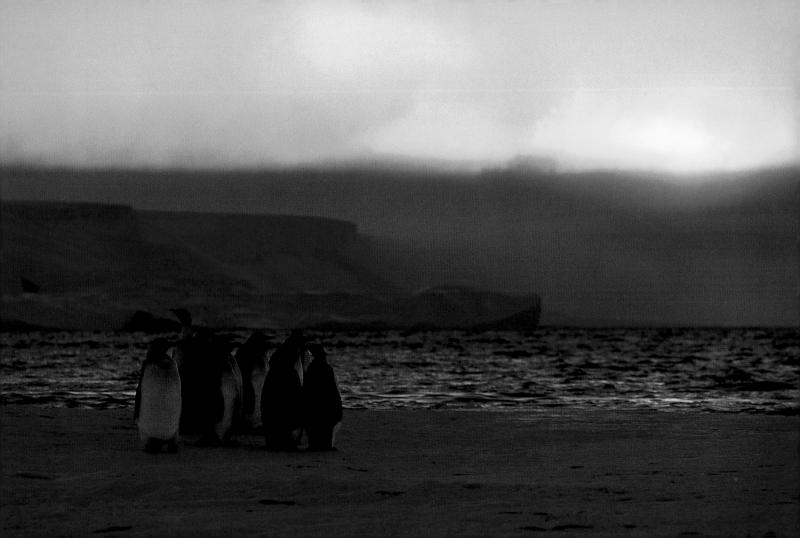

Avoid noisy motoring activities.

Some leisure activities seem far from appealing in light of their impact on the environment and landscape. These include off-road driving, hunting, golfing (whose landscaping demands excessive fertilizer and watering), and skiing, the infrastructure of which permanently blots the landscape.

Devotees of these activities should observe certain rules. For example, avoid noisy motorized activities (such as jet skis, 4 x 4 vehicles, trail bikes, and snowmobiles) that disturb plants and animals outside the areas set aside for them. Never drive an off-road vehicle on a beach, in a marsh, or anywhere near birds' nests.

Don't use disposable cleaning paper towels or cloths.

North Americans toss out about 83,000 tons of disposable wipes per year, 30% of which are used in home cleaning. Many of these single-use cloths are made from nonbiodegradable synthetics and soaked in toxic cleaning agents. Although paper towels come in recycled form and are easily recyclable or compostable, they still require resources to create and their manufacture emits pollution.

Replace single-use, prepackaged wipes and paper towels with a few cloth towels. Microfiber wipes that are handy for cleaning and polishing can be washed and reused hundreds of times and come in organic, biodegradable styles. Switch synthetic sponges for natural ones that come from a sponge farm; they last longer and can be composted. Biodegradable scouring pads made from a variety of materials like palm fibers or fine-grit sandpaper are less abrasive than steel wool and contain no detergents or plastics.

Choose furniture made of SmartWood or FSC-certified wood.

During the last century, half the world's tropical forests disappeared. Tropical forest uses are all around us—from wood furniture to insulation, rope, and medicine. Indonesia loses 5.2 million acres of forest each year and 75% of its wood products are harvested illegally. When we buy FSC- (Forest Stewardship Council) or SmartWood-certified products, we can be sure that they come from a sustainable, managed forest where strict environmental, social, and economic standards are observed and that they have not contributed to the worldwide plundering of tropical forests.

Before buying any piece of furniture, ask where the materials come from, especially where exotic woods are concerned: mahogany, teak, ipe, and ebony are examples of popular exotic wood types. For furniture and carpentry work, abandon exotic woods and rediscover chestnut, oak, pine, fir, and beech; they can be treated in such a way that they become extremely tough. Or look for products made from reclaimed wood.

Buy fair-trade coffee.

Fair trade endeavors to establish equitable commercial relations between rich and poor countries so that underprivileged workers and farmers can live and work with dignity. Workers on conventional farms must often meet harvesting quotas in order to receive a daily wage, forcing them to enlist their families to help them make their quota. Technically, their children are not employees and thus are not protected by any laws. Fair-trade coffee demands that coffee sell for a minimum of \$1.21 per pound or slightly higher if the product is organic. Workers' earnings are unaffected by market fluctuations, thus eliminating the need for unfair quotas. In addition, fair-trade coffee is usually grown on small farms that cultivate under the rain forest canopy and without the use of pesticides.

More than 100 brands of fair-trade coffee are now available in more than 35,000 markets worldwide. Make a commitment to only buy fair-trade coffee.

Cook with gas rather than electricity.

The 1,500 researchers of the United Nations Intergovernmental Panel on Climate Change (IPCC), set up jointly by the UN Environment Program (UNEP) and the World Meteorological Organization, now agree that human activity is affecting the world's climate: Every year, human beings emit more than 30 billion tons of greenhouse gases as they meet their energy needs in transportation, heating, air-conditioning, agriculture, industry, and so forth.

We should be equally aware of this when dealing with the little, day-to-day things in life. On average, a gas cooker uses half the energy of an electric cooker, as long as the burners are regularly cleaned. A clogged burner can use up to 10% more energy than a clean one.

When traveling, take your polluting waste home with you.

In some developing countries you may visit, waste is not collected, disposed of, and treated. Often such countries cannot afford to establish the necessary infrastructure—indeed, most developing countries have this problem.

Take your most polluting waste, such as batteries and plastic bags, home in your luggage, so that they can be disposed of properly when you return. On the other hand, you may leave cans behind with a clear conscience: Local people are often highly skilled in the art of reusing them.

· 4

Wear less makeup.

Cosmetics often contain potentially harmful ingredients like formaldehyde, phthalates, and lead acetate—and many of them contain petroleum derivatives as well. The average woman is exposed to up to 200 chemicals through daily use of makeup and skin products. Makeup is also highly disposable, as trends change from season to season, and some products—like mascara, which goes bad after about 4 months—have very short shelf lives. Most discarded makeup ends up in landfills or incinerators, where their toxic components can contaminate groundwater or the air.

The simplest beauty regimen is the best one for both you and the environment. When it's time to toss old cosmetics, check with manufacturers to see if they accept old containers for recycling. The Campaign for Safe Cosmetics has gotten 500 companies to sign a pact to adhere to the standards of European Union Cosmetics Directive, which provides far more guidelines for ridding products of toxic chemicals than anything issued by the FDA.

Buy refillable products.

One-third of the waste generated in the United States is packaging. Every year Americans use enough plastic film to shrink-wrap the state of Texas. By definition packaging is disposable—you open the package, remove the product, and discard the container.

Reducing packaging enables raw materials to be saved, pollution to be reduced, and needless transportation to be avoided.

To cut the volume of packaging that is thrown out after just one use choose refillable products—soap, liquid detergent containers, coffee cans, rechargeable batteries, pens, and so forth.

Read and know your poultry labels.

By choosing the breeds that produce the highest yields, farmers have succeeded in reducing the average time it takes to raise a 5-pound chicken from 84 days in 1950 to 45 days today. Living conditions for these animals are grim, and their controlled grain-heavy diets lead to nutrient deficits in the meat and eggs we consume. Free-range chicken and eggs have become more widely available as an alternative, but be aware that American labeling is not yet standardized. The label "free-range" when applied to poultry requires that hens have access to an outside area, but it does not stipulate a space requirement per hen.

Look for labels that specify "free-farmed" chicken (verified by the American Humane Association) or total-freedom free-range chicken. Look also for organic products—regulations stipulate that organic feed is used, antibiotics and hormones are not added, and adequate freedom of movement is provided. However, the only true way to ensure that the chicken you buy lived an outdoor life is to get to know your producers: Buy directly from small, local farms that meet your standards or from natural foods markets that closely screen the products they sell. The next time you're at the supermarket, write down the names of the so-called free range producers and research who can actually validate their claims.

Know which companies are actually "all natural."

It's easier than ever to find "all natural" products touting organic ingredients on supermarket shelves. However, big conglomerates are increasingly buying up former mom-and-pop brands, a fact that is often not advertised on the packaging. For example, Tom's of Maine, a trusted brand for natural personal care items, has been bought by Colgate-Palmolive, and Clorox now owns Burt's Bees. Though the quality of the Tom's or Burt's Bees products may continue to be high despite their new affiliations, you have to ask yourself if you want to ultimately support their parent companies, which manufacture many products that are harmful to the environment. In addition, many food conglomerates have created their own organic brands (Cascadian Farm is owned by General Mills, Boca Foods is owned by Philip Morris/Kraft) with dubious results.

When buying so-called organic or all natural packaged products, look closely at the label. Some products may be exactly what they claim to be while others may only include a few organic ingredients and a slew of unwanted others. Trace your favorite brands back to their parent companies so you know exactly who is making your whole-grain cereal or organic yogurt.

Altiplano, Bolivia

Give a struggling entrepreneur a small business loan.

Microfinance is the antithesis of writing anonymous checks to large NGOs. Third-party nonprofit organizations provide loans to help underserved persons in developing nations start a business or grow a current one. (The recipients often lack access to banks and traditional lending schemes.) Microfinance fosters positive connections between donors and recipients: You know exactly where your money goes and get regular updates as real people transform their businesses and their lives. And because recipients must usually present cohesive business plans before being able to request loans, the system ensures self-sufficiency.

Organizations like Kiva provide profiles of entrepreneurs in need; you choose which business receives your loan. Requests rarely exceed \$1,000, but you can give partial loans, and as the sums are repaid, so are you.

When traveling, eat local food.

One study of loss of tourism revenue in Thailand estimated that 70% of the money spent by tourists eventually left the country through hotel chains, tour operators, airlines, and the import of foods and drinks. To counteract this tendency, it is best to choose small, local hotels, local transport, and services that earn money for local people, such as guides, cooks, mule-drivers, porters, and domestic servants.

When you are thousands of miles from home, do not search frantically in strange shops for the food you usually eat at home. Those tasteless apples that traveled halfway around the planet, producing pollution in the process, will never be as good as the local mangos. Try local specialties, fruits, and vegetables, and discover new dishes in the process.

> Great Smoky Mountains, North Carolina and Tennessee

When traveling abroad, look for local ecological labels.

The European Union eco-label (a dandelion flower with a green "E" in the center) identifies accommodations that respect certain environmental criteria, such as water consumption, use of renewable energy, waste management, and environmental education. The label encourages those who run tourist facilities to adopt good environmental practices, and promotes sustainable tourism initiatives. There are other, equivalent international certification programs, as well. Investigate them when planning your next vacation abroad.

Take a vacation where the attention is paid to the environment on a daily basis—take an eco-holiday.

Shark, Australia

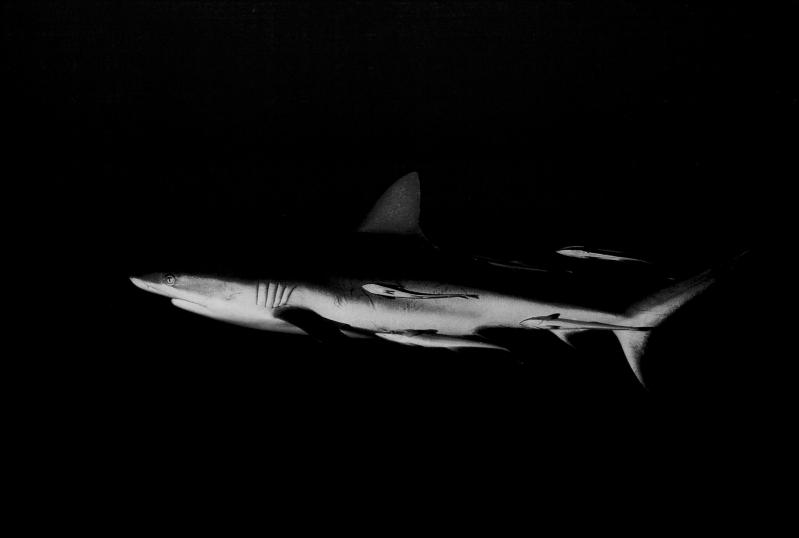

Consider using rechargeable batteries.

The manufacture of a battery uses 50 times as much energy as the battery itself will produce during its life. The only exception is rechargeable batteries. A personal stereo battery lasts 6 days; if you use a rechargeable battery, it can last up to 4 years. Like disposable batteries, some rechargeable ones contain cadmium, but since they can be recharged between 400 and 1,000 times, their impact on the environment is considerably reduced (if they are properly disposed of at the end of their life).

The best alternative for most portable electronics is nickel-metal hydride (NiMH), as these batteries are rechargeable and contain no cadmium. The upfront expense of these and their charger is soon recovered: Their lifetime cost is 3% of the comparable amount of disposable battery power.

Lava, Kilauea Volcano, Hawaii

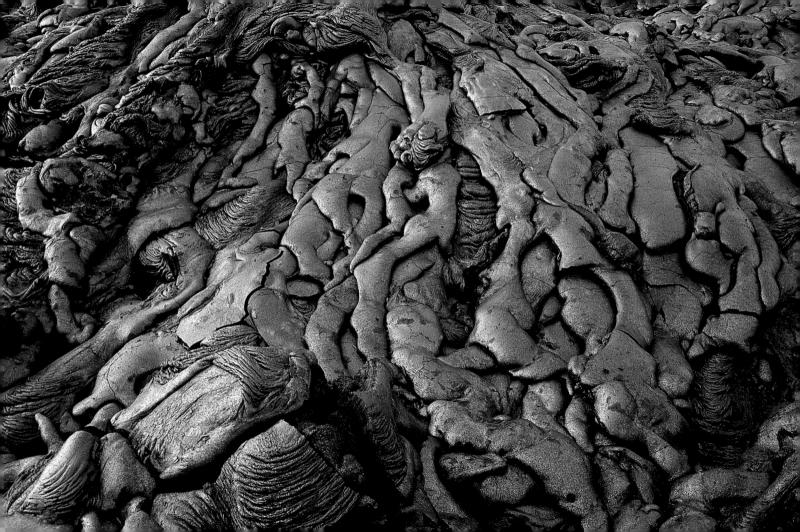

Take your children to school on foot.

Fewer than 15% of children walk or bike to school; although some take buses, nearly 60% are driven. Cars already produce a fifth of carbon-dioxide emissions, and their numbers will increase considerably over the coming decades to meet growing demand in developing countries.

Twenty-five percent of morning commuters are parents and kids on their way to school.

Instead of taking your children to school by car, send them by public transportation or school bus, or accompany them on foot or by bike.

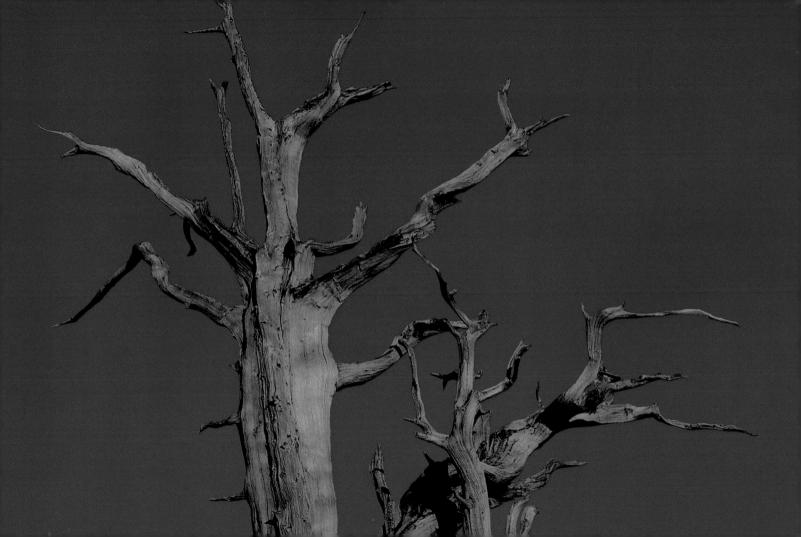

Replace paper and plastic cups with regular cups and glasses.

For the last 20 years our way of living has demanded too much of the earth, which can no longer absorb the pressure that humanity is placing upon it. Human use of biological resources exceeded the earth's natural capacity by 23% in 2006. This figure is expected to rise to between 80% and 120% in 2050.

Many workplaces provide plastic cups for water and coffee. These are in our hands just a few minutes before they become waste. To stop wasting several plastic cups per day, take your own cup to work and urge your colleagues to do the same. Saving the cost of the disposable cups will also reflect favorably on the company's bottom line.

Control the temperature in your home.

Home heating is a huge energy drain, but it doesn't take much to regulate the temperature according to each room's use, the outside temperature, and the times when you are not there.

Install a digital thermostat system that will allow you to set the heating as you desire, room by room, according to the time of day or night and use up to 25% less energy than if your heating were not so regulated.

Reject junk mail to reduce the volume of waste.

We are producing ever-greater quantities of waste. Our mailboxes are clogged with catalogs and advertising. Every year, 100 million trees, 28 billion gallons of water, and \$320 million in local tax money are used for the production and disposal of junk mail. This mail, 40% of which is unread, goes directly to swell the volume of household waste, and thus the cost of collecting and treating it.

When dealing with a company or an organization that knows your address, always tell them to keep your address private. This will prevent them from selling it to other organizations. Opt out of receiving unwanted catalogs. Contact the Direct Marketing Association and declare that you do not want unsolicited mail from their member companies.

Prairie, Mount Rainier National Park, Washington

Follow the rules in protected areas.

About 34,000 plant species throughout the world, or a quarter of the total species of flora on the planet, face extinction in the coming years. Nearly 600 plant species in the United States are listed as endangered; 448 animal species are considered endangered. The U.S. Fish and Wildlife Service has also prescribed habitat conservation plans for 480 areas, where measures have been taken to minimize the impact on habitats, restore ecosystems, and sometimes relocate plants and animals.

Observe the instructions displayed at the entrances to parks—they are there for a reason. You will not disturb the wildlife if you keep your dog on a leash, and by following the marked trails you can avoid accidentally stepping on protected plants.

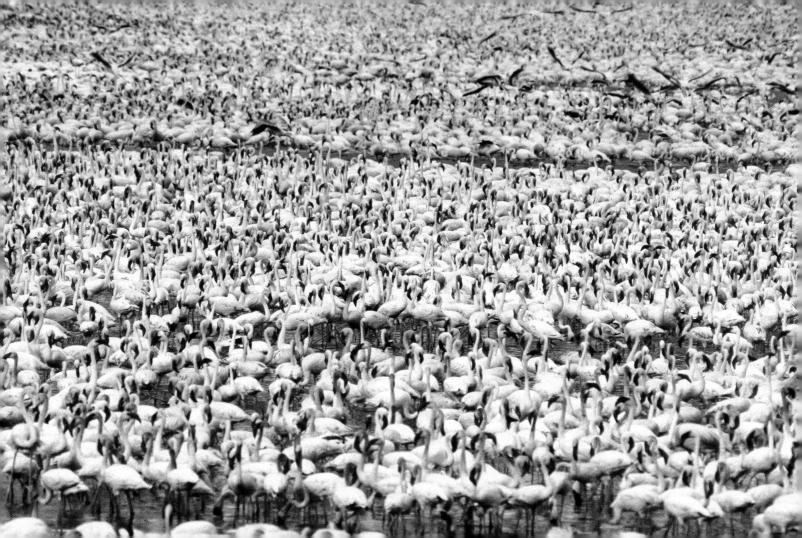

Find a better dry cleaner.

Traditional dry-cleaning operations use a solvent called perchloroethylene, which is toxic enough to be treated as hazardous waste by the EPA. Millions of pounds of this chemical are used every year. It can cause minor allergic reactions among customers and far more serious health problems for workers who are constantly exposed to it. Small amounts of perchloroethylene can seriously contaminate groundwater.

The best alternative is not to purchase clothes that require dry cleaning. Know that you can often hand wash silk, wool, and linen clothes that are tagged "dry clean only."

Otherwise look for operations that offer either "wet cleaning" or a system that uses liquid carbon dioxide, both of which are safer treatments.

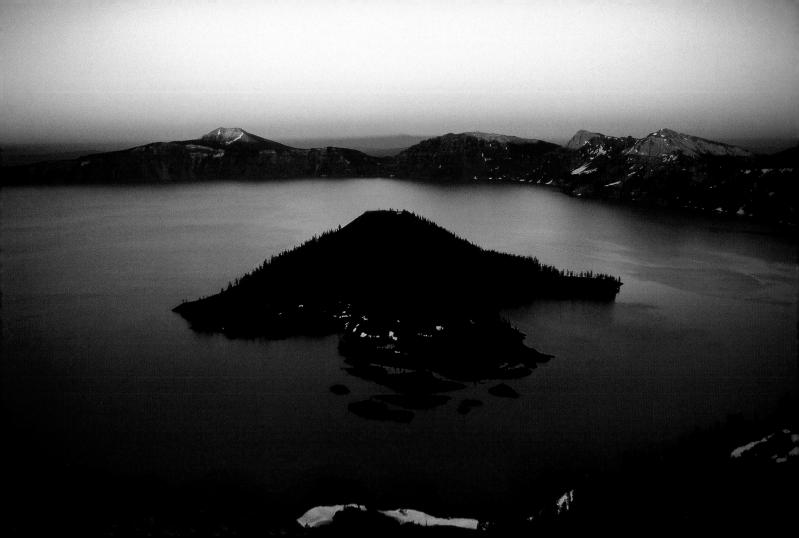

Borrow or lend your power tools.

Power tools are necessary for solid, reliable craftsmanship, but homeowners often invest in these tools without considering how often they may use them. How many hours a year will you use an electric drill? What about the power saw, the high-pressure heat gun, the concrete mixer, and the carpet shampoo machine? Our closets and garages are cluttered with equipment and tools that we use very rarely, if at all.

Rather than investing in new tools, try another approach. Why not borrow them from a neighbor or family member, or buy them together and take turns using them? Consider starting a tool-sharing program in the neighborhood. Learn your neighbor's needs and interests. It's a great way to build community.

Rock, Malaysia

Take your old motor oil to the dump.

Motor oil contains substances—especially heavy metals (lead, nickel, and cadmium) that are toxic to our health and the environment. A third of used motor oil is refined to make new lubricants, and the remaining two-thirds is used as fuel, chiefly in cement works. Approximately 60% of Americans change their own oil. Most simply dump the used oil into the gutter or into storm drains, tossing over 120 million gallons of reusable oil per year. The leftover oil from one change can pollute 1 million gallons of water.

Recycling old oil saves raw materials and energy and spares the environment. It also reduces our dependence on the ever vanishing hydrocarbon: A barrel of crude oil can yield 2.5 quarts of virgin motor oil. It takes only a gallon of used motor oil to get the same amount of high-quality motor oil. Motor oil is collected at dumps and garages. Always bring your old oil there.

Red ibises, Venezuela

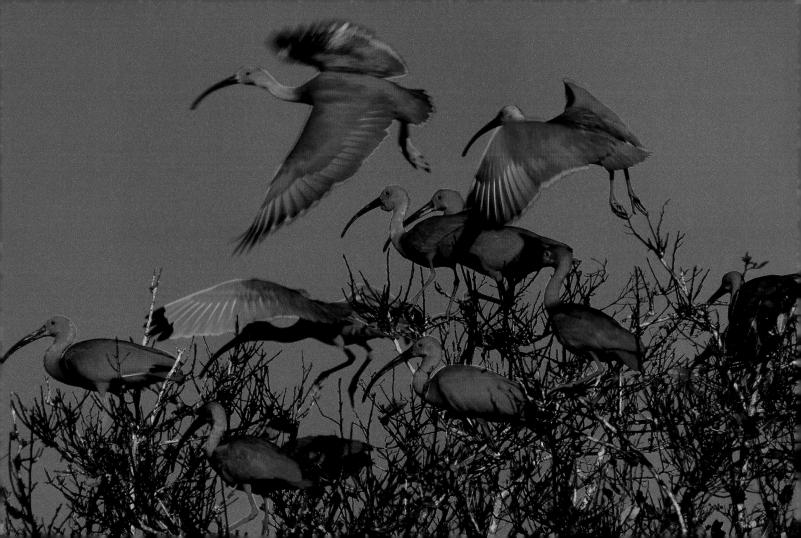

Don't burn the midnight oil.

Long exposure to artificial light at night can affect the body's ability to produce melatonin, which helps to regulate sleep. It can also weaken the immune system and disrupt hormone production. In addition to the detrimental effects it has on our bodies, routinely staying up late also increases the amount of energy our homes use.

So, unless you work the night shift, try to maintain reasonable sleep patterns. You will find yourself feeling better and conserve energy at the same time.

Do not use chemicals near water.

A garden is like a miniature field; even on this very small scale, it is essential not to contribute to water and soil pollution by using too many chemicals. Sixty-seven million pounds of lawn pesticides are used in American gardens every year. Homeowners have been found to be much worse about application of pesticides than other users. They apply 3.2 to 9.8 pounds of lawn pesticides per acre; agricultural land generally receives 2.7 pounds of pesticides per acre.

Do not use fertilizers, pesticides, or herbicides if you are near water, such as a well, stream, pool, or marsh. After each application, these products soak into the soil, sometimes permanently polluting aquifers.

Adopt a pet from your local animal shelter.

According to the U.S. Humane Society, each year millions of dogs enter shelters, yet of the approximately 74.8 million dogs owned in this country, only 10% are adopted from shelters. By adopting a dog or cat from a shelter, you're giving a homeless pet a new chance at life.

Read up on the Humane Society's guidelines for adopting a pet. If you decide that you and your family are ready to make this commitment, don't spend money needlessly in a pet shop, thus encouraging even more pets to be raised. Find your next family member at the local animal shelter instead.

> Yosemite National Park, California

Kick the gadget habit.

Some "innovations" are utterly useless and create complicated machinery meant to perform simple tasks. Do we really need special machines to sort our loose change, a heated bin to warm our bathroom towels, or digital devices (in addition to our computers, TVs, and PDAs) just to give us the weather forecast? Does an able-bodied person even need an electric can-opener?

Don't be fooled into replacing functional objects with appliances that require electricity or batteries and may break down quicker—and be harder to fix—than simpler tools.

Also think twice before purchasing travel-size versions of all your life's accoutrements. Traveling light is more luxurious anyway. Will the mini ionic air purifier really be that useful?

Refuse to accept paper telephone directories.

Every year, telephone companies automatically distribute paper telephone directories in several volumes. About 660,000 tons of telephone books are produced each year; they're recycled only 19% of the time. While recycling these is much better than throwing them away, it is even better not to accept them to begin with-remember, putting something in the recycling bin, while better than the garbage can, always results in the use of some kind of resource to get the recycling done.

a.

How many times have you looked in your telephone directories this year? If you do not use them, call the distributor's 800 number and opt out. Use the Internet to look up phone numbers instead. The Web is also good for finding maps or looking up foreign numbers.

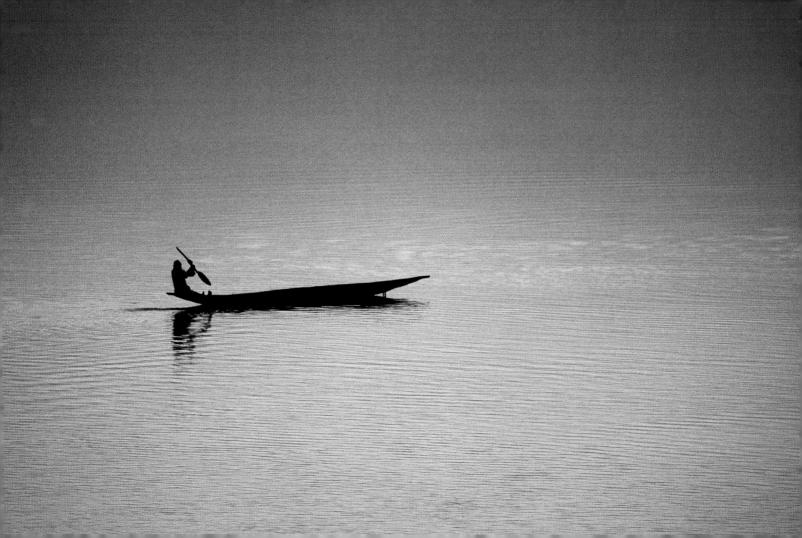

Build the best computer.

Computers help us to be greener in some areas—they reduce paper dependency and allow us to telecommute—but wreak havoc on the environment in other ways by contributing to electronic waste, which accounts for 70% of hazardous waste worldwide.

The challenge is for companies to build the greenest computer. The European Union has devised strict regulations (RoHS) designed to phase out the toxic components of PCs, standards that are becoming more universally applied. In 2007 Energy Star started rating computers, especially useful when purchasing a monitor. Even more advanced is EPEAT (Electronic Product Environmental Assessment Tool), a new environmental certification that uses a LEED-like rating system, awarding bronze, silver, and gold honors based on 51 criteria.

Prototypes with bamboo casings and built-in solar panels promise that computers will continue to get greener. For now, look for products that have high Energy Star and EPEAT ratings and are RoHS-compliant. The best computers will use the least amount of energy, have few toxic materials, can be easily modified to extend use, are made with postconsumer recycled materials and are recyclable, and come with a minimum of packaging.

Plant a tree.

Eight thousand years ago, when human beings settled and began to grow crops, half the planet's land mass was covered in thick forest. Today, less than a third is still forested. Worldwide, over the last 10 years, forest cover has been reduced by 2.4%. In order to live, all plants on the planet release oxygen and absorb carbon dioxide. Two acres of mature forest absorb the equivalent of the carbon emissions from 100 midsize cars over a period of a year.

Plant a tree: You will be joining the fight against global warming and the atmospheric pollution caused by carbon dioxide emissions.

> Lassen Volcanic National Park, California

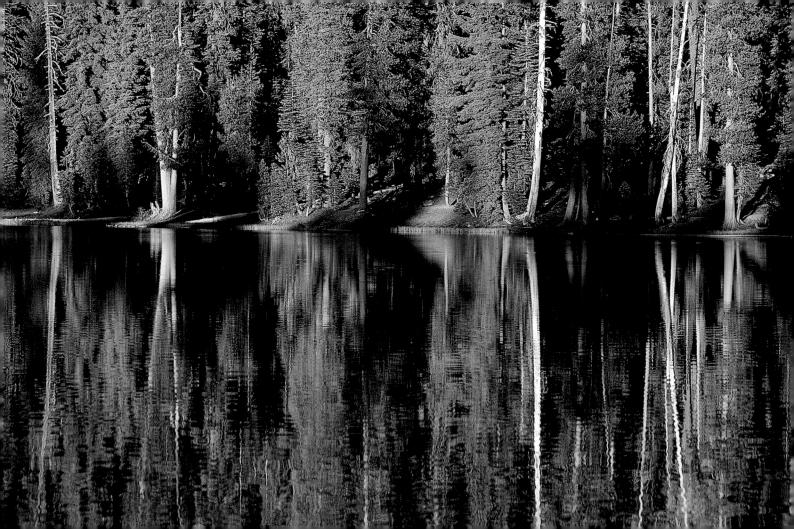

Pick up one piece of garbage every day.

Landfill remains the main method of waste disposal worldwide. In the United States, 220 million tons of garbage end up as landfill each year. Even though decomposing trash in landfill sites still produces 33 to 77 million tons of methane emissions, which contribute to global warming, most landfill sites are equipped with modern barriers to prevent pollutants from spreading and contaminating water.

Even our everyday surroundings are not free of trash. If each of us bent down once a day to pick up a piece of trash, we would remove 290 million pieces of garbage from the streets and sidewalks every day.

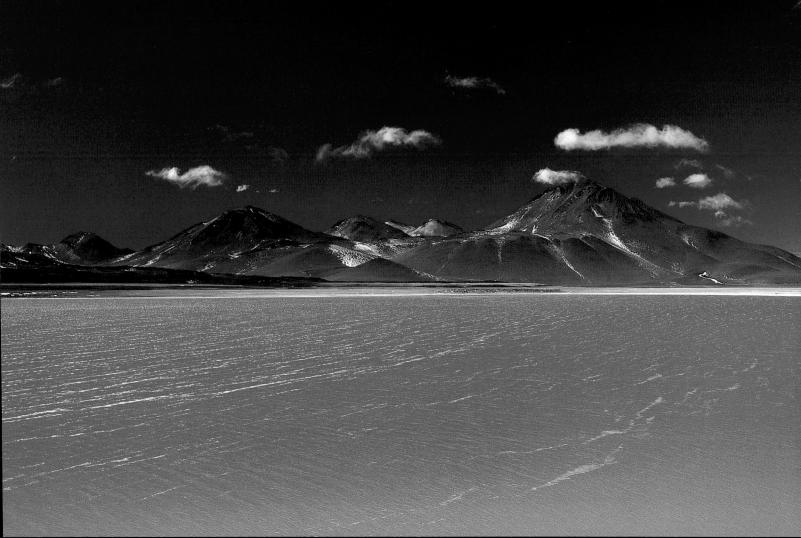

Lend your blog to a greater cause.

On October 15, 2007, more than 20,000 bloggers participated in Blog Action Day, devoting their daily posts to environmental stories. Lifestyle sites offered better recycling tips while technogeeks discussed how optimizing code could save energy. The event garnered a great deal of international (print) press.

Organizers intend to make this a yearly event. Don't have a blog of your own? Post links to environment stories on social networking sites or send an Evite to your friends alerting them to Blog Action Day.

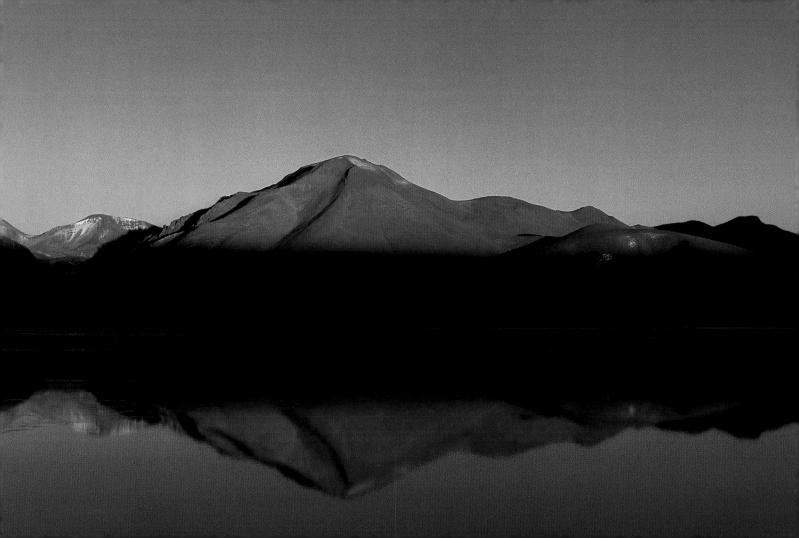

Optimize your computer's energy-saving capabilities.

Only 15% of the energy spent to power a computer is used during actual work time—the other 85% is wasted while the unit idles. The average desktop uses 70 watts of power when idling while the average laptop uses 20 watts.

Always use the sleep mode instead of screen savers (screen savers don't actually reduce energy use and they can prevent the CPU from going to sleep). Setting your computer to go to sleep after 10 to 15 minutes of inactivity can help one person cut their annual carbon dioxide emissions by up to 1,250 pounds.

Remember: Don't leave your computer on when you're done working-always shut it down completely and make sure laptop-charging adapters are fully unplugged. Also, consider buying a laptop-they use one-fifth the power of a desktop.

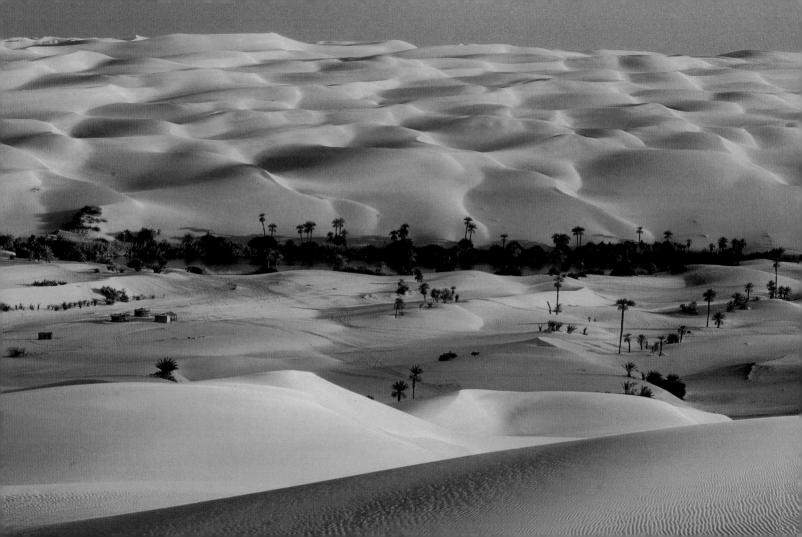

Avoid washing at too high a temperature.

If we reduce the energy used in the home for lighting, heating, cooking, and so forth, we can reduce energy demand. Less electricity needs to be produced by power stations, which in turn leads to a reduction in atmospheric pollution.

Wherever we look, energy savings are possible. About 90% of the energy used by washing machines goes into heating the water. Washing and rinsing your clothes on the hot-water cycle uses 3.5 times more energy than washing in warm water and rinsing in cold. Using only cold water saves even more energy.

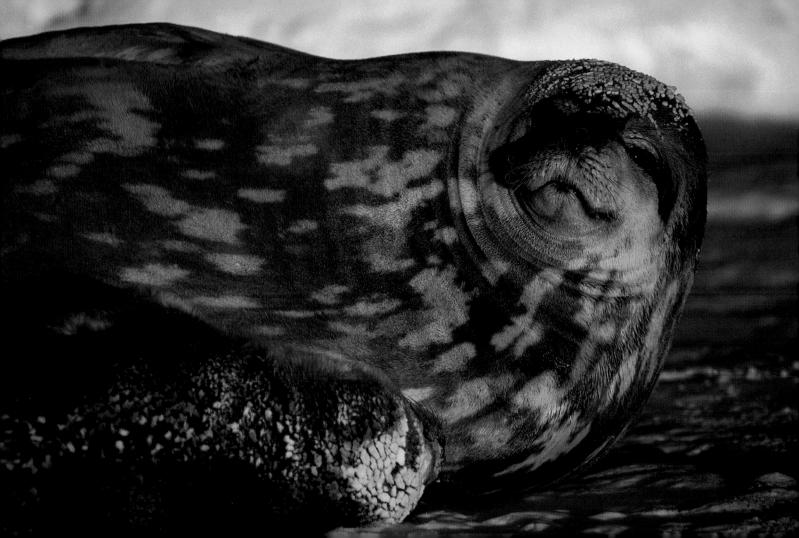

Drive smoothly.

Today the world burns as much oil in 6 weeks as it did over the course of a year in 1950. Oil reserves are running out and, at current rates of consumption, will be exhausted in less than 50 years. Transportation alone accounts for half the world's oil consumption.

You can help to preserve the planet's reserves. In cities, take care to avoid accelerating and braking too hard and too frequently. This manner of aggressive driving increases fuel consumption by 40%, which means spending money needlessly and aggravating urban air pollution.

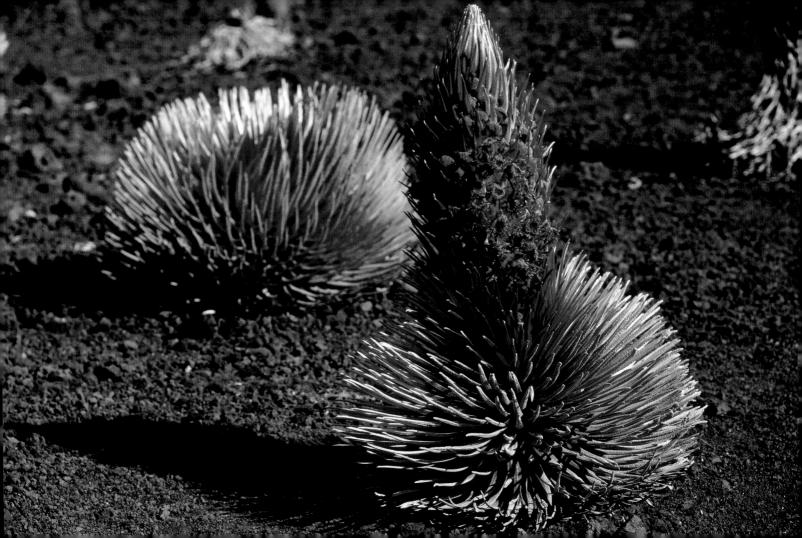

Choose household appliances that use less water.

Water use increases as wealth increases. Greater purchasing power encourages household comforts, and water use increases. Affluence also encourages people to buy more goods, goods that use water in their production. More water is required, for example, for the production of paper than for any other material. Metal and steel works alone account for 20% of the water used in industry.

If you are planning to replace your household washing appliances, allow your choice to be guided by the amount of water they use. Efficient dishwashers can use about 5 gallons of water per load—half the volume used by conventional dishwashers.

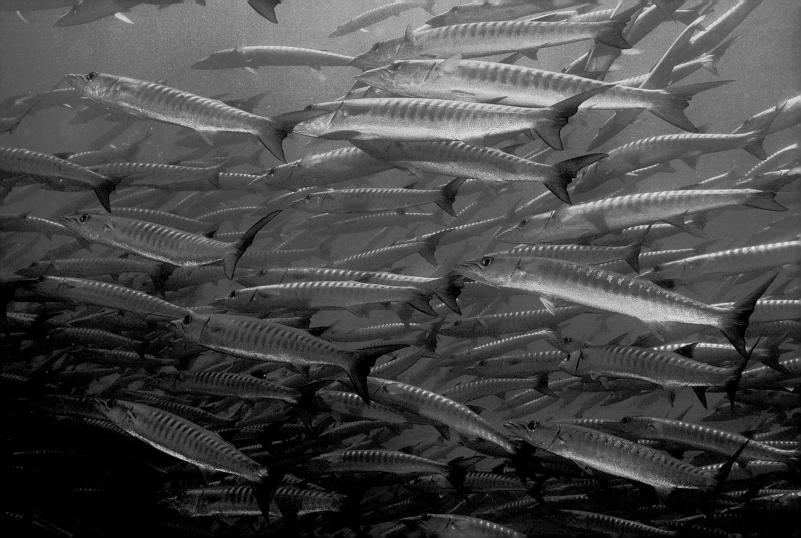

Recycle plastic.

Most plastic bottles today are made of PET (polyethylene terephthalate), which is easy to recycle. The PET symbol, which is marked on the bottom of plastic containers, consists of a triangle of arrows surrounding the number 1. Plastic packaging that has been sorted and recycled is reborn as fleece garments, tubes, watering cans, flower pots, floor coverings, water bottles, carpets, car parts, phone cards, and more. Every ton of recycled PET saves an energy equivalent of 11 barrels of oil.

At home, in the office, or when traveling, be sure to recycle plastic beverage bottles. Encourage your office to start a recycling program if it doesn't have one. Recycling a single plastic bottle saves enough energy to keep a 60-watt bulb lit for 6 hours.

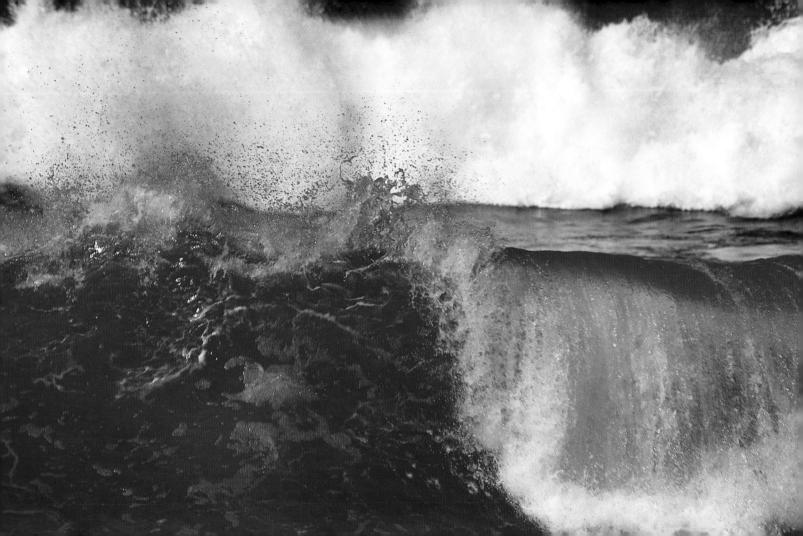

Influence your condominium association.

In our day-to-day social lives, we regularly take part in groups whose decisions may have a strong impact on the environment. Meetings of condominium associations are an example.

Every measure that is voted on can contribute to preserving the planet's natural resources, limiting pollution, and reducing water use. In meetings, speak out in defense of environmental measures, such as environmentally friendly heating, sorting of waste, low-consumption lighting in common areas, creation of green spaces or shared gardens, and maintenance of the plumbing system. And help your fellow members to become aware of these issues.

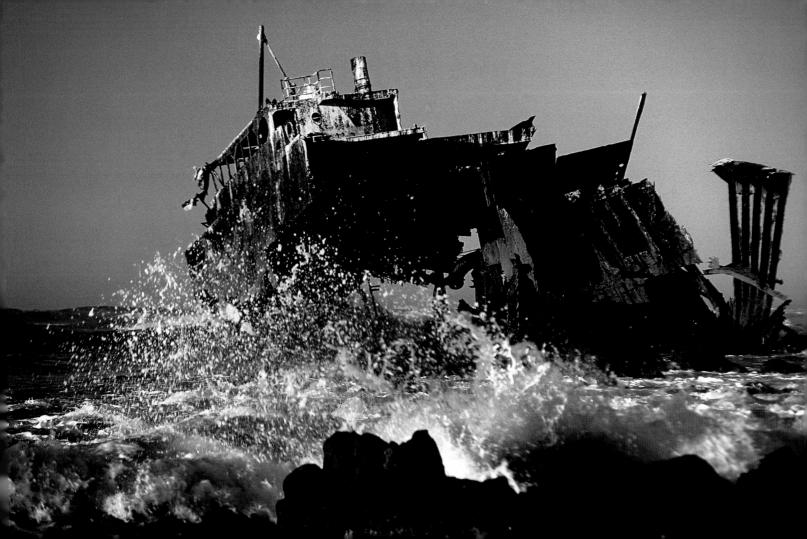

Downsize your life.

The average house in Japan is roughly half the size of the average American house (the size of which is constantly increasing). Small homes with smaller individual rooms are easier to heat and cool. They're also cheaper to maintain and to decorate.

Before investing in a mansion, ask yourself if you're really going to use all of that space. If you're about to trade in the SUV or minivan, ask yourself if you actually need such a big car for everyday tasks. Your television can use up more electricity than a computer and washing machine combined, so ask yourself if you really need a screen so large it dwarfs your living room. Think small and live within your means, not beyond them.

Buy low-phosphate or phosphate-free soaps and dishwashing detergents.

Increased phosphorus concentrations cause excessive algae growth in our nation's water bodies. Though algae are the basis of life for many ecosystems, an overabundance causes lower levels of dissolved oxygen in the waters, which in turn disrupts ecosystems and causes fish kills. Algae blooms also result in decreased aesthetic and recreational values.

You can choose low-phosphate or phosphate-free soaps and dishwashing liquids. Many popular brands, now widely available, have low phosphate levels.

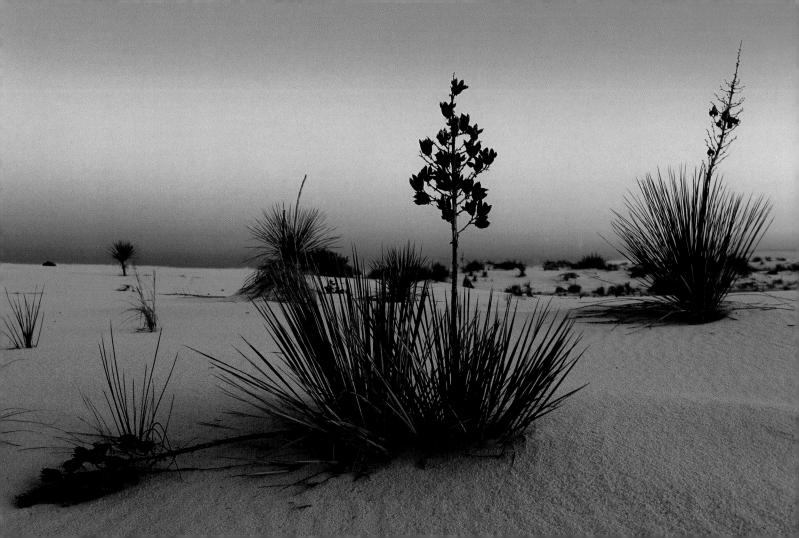

🕏 SEPTEMBER 28

At the supermarket, question the true price of "convenience."

Packaging from processed foods contributes 30 million tons of waste each year. We buy many of these overly packaged products because they seem more convenient than their natural or bulk equivalents. But does it really take that much longer to pop organic loose popcorn in a pot than to heat up a chemical-drenched individual packet of microwave popcorn? Is spooning a condiment or jelly out of a glass jar, which you know will be recycled, so much of a hassle that we need all those plastic squeeze bottles?

Avoid packaging that contains unnecessary pollutants.

Choose jewelry with care.

In war-torn regions of Africa, the diamond industry is one of the biggest funders of armed conflict. "Blood diamonds" or "conflict diamonds" are mined in dire conditions and the profits are used by warlords to purchase more weapons. According to Amnesty International, diamond-funded wars have killed more than 4 million people to this day. In answer to this, more than 70 countries now participate in the Kimberley Process, which tracks diamonds from the mines to the stores.

But the trouble with jewelry doesn't end with diamonds. Gold mining has many detrimental effects on mining communities and the world at large: Chemicals used during the extraction process contaminate groundwater, and swaths of wilderness are being destroyed for new mining operations even though there is technically enough gold already mined to supply the jewelry industry for the next 50 years.

When shopping for a diamond, make sure it is "conflict free" –demand to see certification. Search out eco-friendly jewelers that use recycled metals. Better yet buy rings from vintage shops that sell estate jewelry or recycle those old pieces gathering dust in safety deposit boxes–jewelers can reset stones and metalsmiths can melt down the rest so that they may be reshaped into a new piece.

Kap Farvel region, Greenland

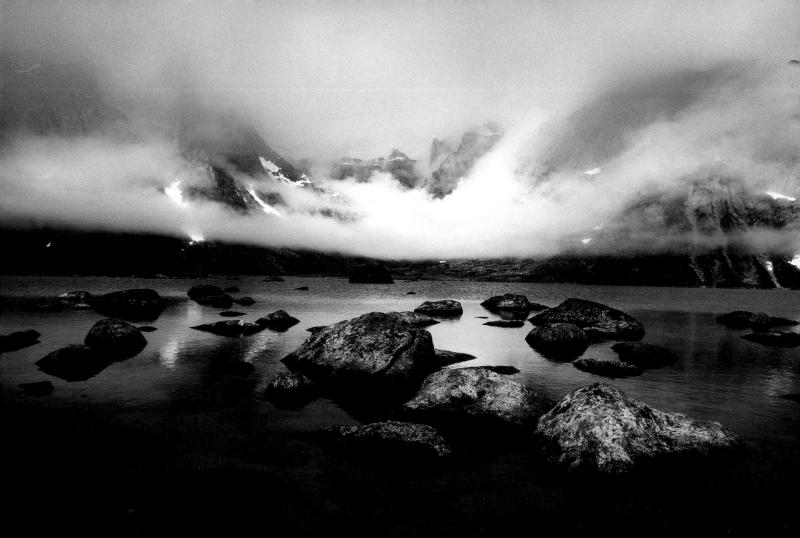

Don't waste residual heat.

Renewable energy resources are beginning to grow although it remains just a fraction of the entire energy market. Solar power technologies have matured greatly since they first entered the market. Solar technologies now offer photovoltaic systems (electricity directly from sunlight), solar hot water systems, electricity produced by the sun's heat, passive solar heating and lighting, and solar technologies for commercial spaces.

All the small habitual changes we make to our energy consumption collectively will make a difference to the planet.

At home, many household items give off enough residual heat to pull the plug a few minutes early. Turn the oven off 10 minutes sooner, and burners 5 minutes before you are done cooking.

Unplug the iron when only one or two garments remain to be ironed.

And throw the second load of clothes into the dryer before the heat from the first cycle has dissipated.

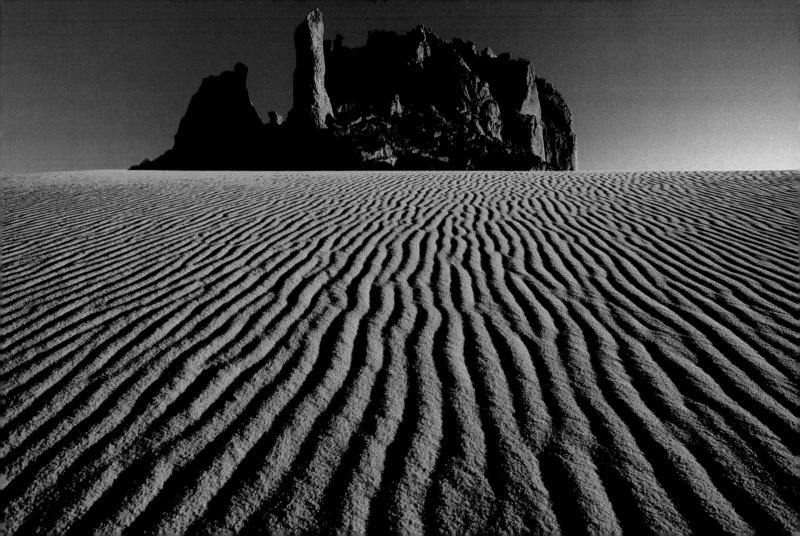

Have your windows fitted with double-glazed panes.

Most air pollution comes from road transport (nitrogen dioxide and carbon monoxide), industry (sulfur dioxide, which produces acid rain), and domestic heating (carbon monoxide). These can damage human health (by causing breathing problems, migraines, and lesions) as well as the environment. Some of these polluting gases contribute to increasing the greenhouse effect.

To reduce your consumption of energy for heating and the polluting emissions thus produced, consider fitting windows with double-glazed panes, which insulates against heat loss (and against noise). For a minimal up-front cost, you can fit window film to your panes. And remember to close the curtains at night.

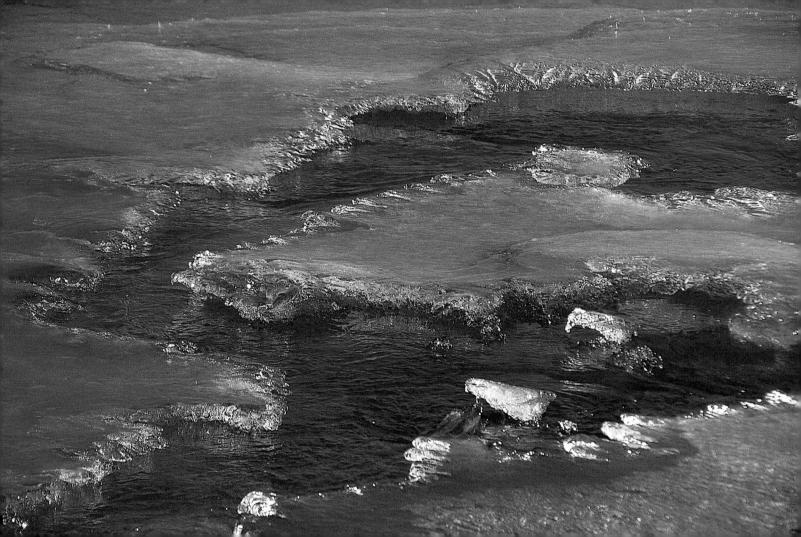

Consider car-sharing programs.

If we do not succeed in curbing the climate change that our actions and lifestyle are causing, tomorrow's climate will be different. Various signs of this can be observed already. Since 1989 Mount Kilimanjaro has lost a third of its snow and the mountain could be completely devoid of snow within 15 years. The spring ice thaw in the Northern Hemisphere happens 9 days earlier than it did 150 years ago, and the first freeze of autumn happens 10 days later. These facts have intense effects on bird migration and crop production.

In cities, more than 80% of cars carry just one person, and almost a third of all fuel is burned by standing still in traffic. Consider car sharing with your neighbors or coworkers: You will reduce fuel consumption and wear on your car, you will take up less road space, and you will help combat global warming.

You may also consider joining a car-sharing program like Zipcar that enables you to rent cars by the hour, picking them up at any designated station in your city. Depending on your needs, you may be able to get rid of your car altogether, simply renting a vehicle for certain errands like grocery shopping. Since you don't pay for gas or insurance, car sharing is often cheaper than owning.

> Erosion, Theodore Roosevelt National Park, North Dakota

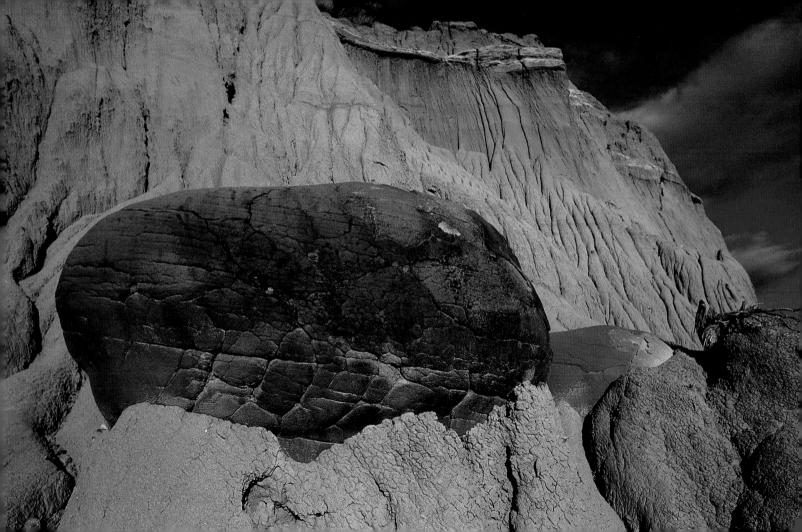

Choose solvents made from plants.

Solvents are powerful enough to dissolve other substances: They attack fats and keep certain products that contain them, such as glues and paints, in liquid form. Most solvents are organic (acetone, ether, white spirit) and belong to the family of volatile organic compounds (VOCs). White spirit is one of the most deadly solvents: It is harmful if touched or inhaled.

For decorating, maintenance, or hobbies use plant-based solvents, which are less harmful to the environment and to your health—orange-based solvents that contain turpene are usually fairly potent.

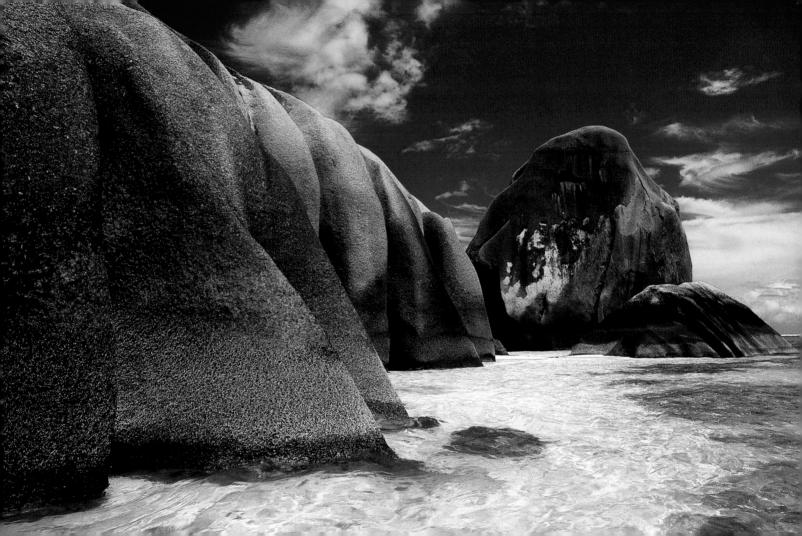

Report any unusual pollution.

About 2,500 species of fish, shellfish, and other sea life are commercially exploited worldwide. Over-fishing by a well-equipped, and excessively large, world fleet is considerably reducing fish populations' capacity to replenish themselves, and pollution of the sea is making the problem worse. Over-fishing and pollution could have severe effects on world food supplies, especially in developing countries, where 1 billion people depend on fish for food.

If you notice an instance of freshwater pollution, such as froth, a brown trail, or the smell of sewage, alert your regional or town water authority. If you notice pollution, such as waste or oil, while at the beach, notify a city or town official at once.

Buy recycled paper.

Recycling paper, while important, is only one part of the lifecycle of paper. We must also look at consumption of paper. Recycled paper products are widely available, and are considerably less damaging to the environment in production. Producing a ton of virgin paper requires 3,688 pounds of wood, 24,000 gallons of water, 216 pounds of lime, 360 pounds of salt cake, and 76 pounds of soda ash. Eighty-four pounds of air pollutants, 36 pounds of water pollutants, and 176 pounds of solid waste are then treated and thrown out. The EPA has found that making paper from recycled materials results in 74% less air pollution and 35% less water pollution. This means that every ton of recycled paper keeps almost 60 pounds of pollutants out of the atmosphere.

Choose paper, box files, folders, envelopes, cards, toilet paper, and paper towels made from recycled paper and cardboard. Be sure to look for a high percentage of "post-consumer waste"-paper that has been used in the home and office and recycled-otherwise a product may simply contain scraps left over from paper manufacturing and is not stopping our used paper from heading to the landfill.

Clean up after your pet.

Keeping pet waste off our sidewalks and streets is more than a quality of life issuerains can wash it into storm drains where it can end up, untreated, in our waterways.

Always clean up after your dog. In off-leash areas, make sure your pet doesn't relieve himself in or near freshwater sources. And it is a good idea to reuse plastic bags from newspapers or the grocery store to collect pet waste, but bags that are biodegradable are better.

For indoor pets, avoid litter that is made from clay, which must be mined (in addition, these products often contain toxic chemicals and are nonbiodegradable). Eco-friendly litters exist, made of a variety of materials from wheat or pine pellets to recycled newspaper.

Say "no" to guaranteed 48-hour delivery times.

A 1-foot rise in sea level causes coasts to recede by 100 feet. Scientists expect the sea level to rise 3 or 4 feet over the next 100 years. This scenario, which the world's climate change experts believe is likely to become reality within less than a century, would completely redraw the world's coastlines, without considering which regions currently are inhabited: 6% of the Netherlands, 17% of Bangladesh, and most of the Maldives could be submerged. Transportation is the biggest contributor to global warming.

If distributors are allowed more flexible delivery times, they can make full use of their trucking capacity, or use less polluting modes of shipping such as rail and canal barges. The demand for guaranteed delivery within 48 hours requires the use of more trucks. Is it really so urgent?

Don't burn or throw out fallen leaves.

Autumn leaves make excellent, micronutrient-packed mulch. Some municipalities collect leaves along with other yard waste to be sent to a composting center, but if no such facility exists, your leaf pile just gets sent to the landfill.

Before you bag up leaves for trash collection, use as many as possible as mulch for your trees, shrubbery, and gardens. If you can't use them, ask around, as anyone who composts might have a use for them (community gardens are a good place to start). Whatever you do, don't burn leaf piles—doing so releases carbon monoxide and particles that can cause respiratory problems.

> Mount Rainier National Park, Washington

Find out what happens to your wastewater.

Water is the source of all life. We depend upon it completely. It is also the chief constituent of all living things: 65% of our bodies and 75% of our brains are water. It plays a crucial part in the economy, and allows the irrigation of cultivated land, the manufacture of industrial products, and the production of electricity. It provides superb leisure facilities. It is irreplaceable, and also guarantees hygiene and the comfort of our day-to-day lives.

Once it is dirty, water vanishes down the drain. Where does it go? Find out where your wastewater goes, how your local treatment plant works, and what happens to the sediment it produces. Let your vision of water see beyond the drain's vanishing act.

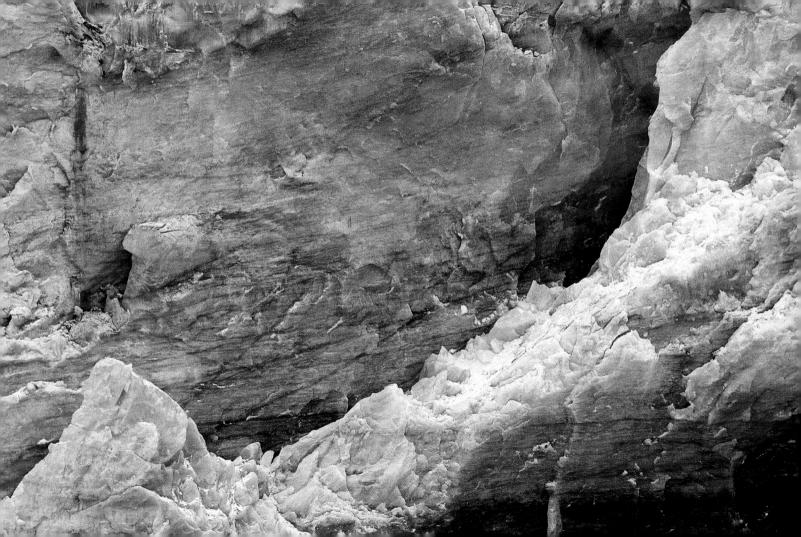

Buy juice in bulk.

Two of the world's largest landfills, now closed, are set to become symbols of restoration and environmental health over the next 30 years. The Paterson landfill site in Glasgow, Scotland, and the Fresh Kills landfill on Staten Island, in New York, are both slated for ambitious urban environmental renewal projects. In Glasgow, 1 million trees will be planted over 230 acres of landfill over the next 12 years, making it the largest urban forest in the United Kingdom. Once the largest landfill in the world, Staten Island's Fresh Kills landfill is poised to become New York City's newest parkland. Its 2,200 acres will be developed into a park 3 times as large as Central Park over the next 30 years.

Help reduce the need for huge landfills like Paterson and Fresh Kills. A household of 4 people can drink more than 45 gallons of orange juice a year. Buy juice in the largest container possible and you will cut down on the amount of packaging waste that goes to the landfill. Most recycling centers accept large plastic juice containers; some will accept wax-coated paper containers. Always check before adding it to your recycling bin.

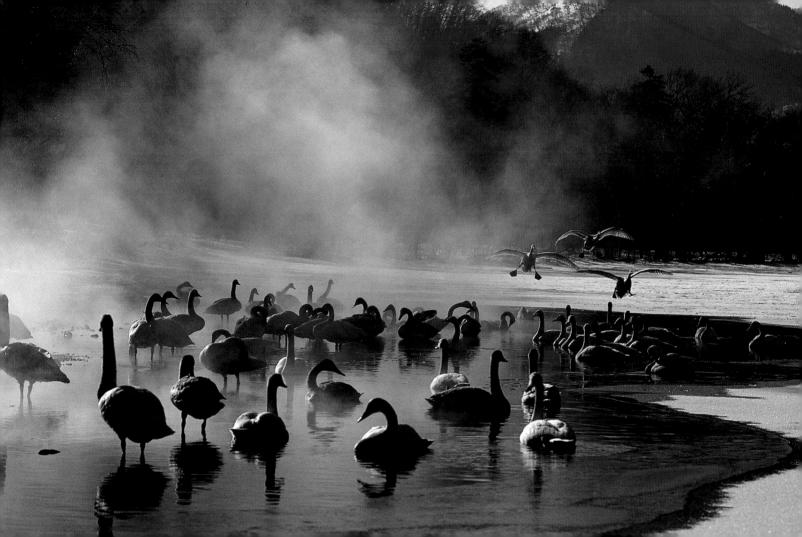

Smart growth is about smart choices.

Wild places are constantly vanishing in the face of human development. Today, the main cause of disappearing forest in the United States is the growth of suburban areas. In the last 2 decades, there has been close to a 50% increase in the forested and nonforested land that has been lost to development. The development of natural habitats is the greatest cause of loss of biodiversity in the world.

Smart growth is not just about how we develop land, but also about where people demand to live. Live as close to your place of work as possible. Commit to public transportation alternatives and rediscover the vibrant, urban neighborhood where you live and work.

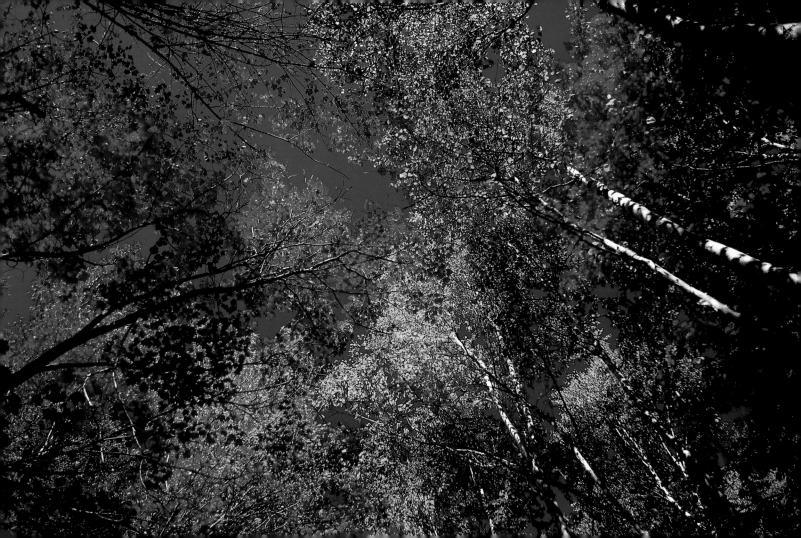

Ask for a home-energy audit.

American homes account for more than 21% of the total national energy load; they cost \$160 billion each year to heat, cool, and light.

Ask your utility company about receiving a home-energy audit—many offer the service for free. A professional will come to your house, assess your cooling and heating systems and structural issues (drafts, insufficient insulation), and offer specific advice on how to make your house more energy-efficient.

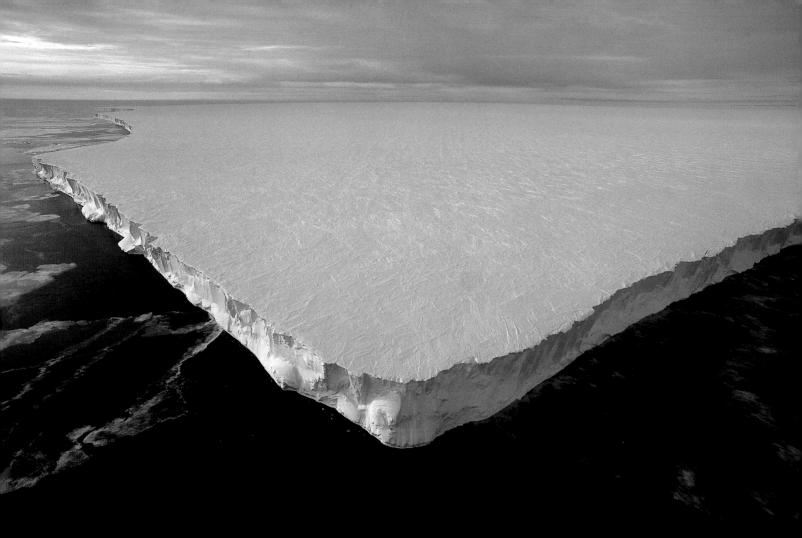

Print on both sides of the paper.

Human beings exploit forests to produce wood for industries, including construction, carpentry, and the manufacture of paper and cardboard. The paper industry uses 40% of commercially produced wood; however, 17% of the wood used to produce printing or writing paper comes from virgin forest that contains centuries-old trees.

Thanks to technological innovation, photocopier and fax machine manufacturers now offer machines that can handle all types of recycled paper and print on both sides. Urge your employer to invest in these; the money saved on paper will be substantial.

Recycle old tires.

An old tire, replaced by a new one, still has several centuries of life left in it: It takes 400 years for a tire dumped in a landfill site to start to decompose. In 2005, Americans discarded 299 million tires. These are a threat to the environment, because of the pollution their storage and disposal create. Alternatives exist, however: Specialized companies can grind them up, melt them down, and convert them into material used by industry. These companies also incinerate tires, providing the same energy production as coal incineration does.

It takes 7 gallons of crude oil to produce one new car tire. Buy your new tires from dealers who take part in tire collection programs and avoid those that do not.

Bison, Yellowstone National Park, Idaho, Montana, and Wyoming

Extend the life of computers.

Computers are built with obsolescence in mind. Manufacturers expect their products to last only a year or two before the next best thing hits the market. Sometimes buying a newer system that is more energy efficient is actually the better choice, but before you chuck your old computer, make sure that it cannot be saved with a few simple upgrades.

You can extend the life of your computer by upgrading it and adding peripherals like external hard drives (to increase memory) and replacing components like video drivers (to keep up with multimedia demands). Also, maintain your computer the way you would your car. Keep it clean (dust free) and take it in for a tune-up every year—having an expert do a simple check can identify computer-killing problems. Temperature control is important for most electronics as heat and humidity can wreak havoc on components; it's particularly important for extending the life of laptop batteries.

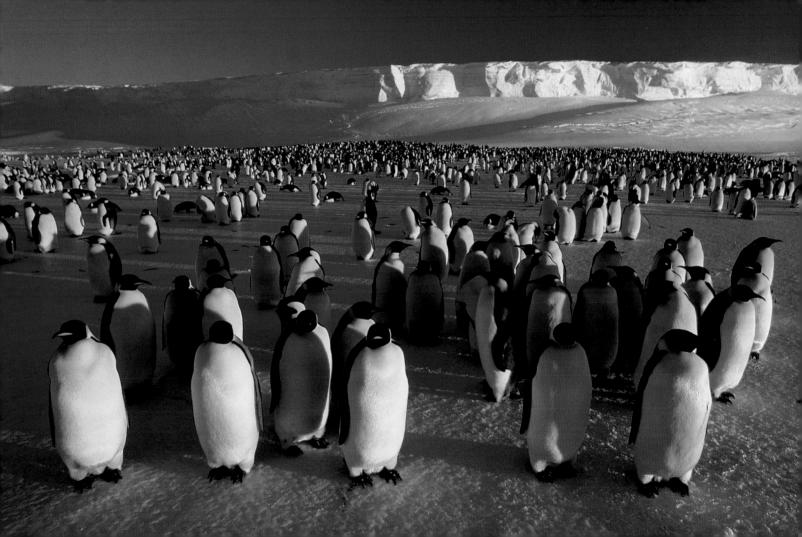

Have your home fitted with thermostatic valves.

Water is essential to the survival of all living things, making it all the more precious. If no wide-ranging action is taken, within 50 years about 3 billion people in the world will suffer from water shortages. Human beings can go without food for several weeks, but without water they die in 3 to 4 days. Access to fresh water has already become a vital issue of the twenty-first century.

To reduce water consumption, have your showers and taps fitted with thermostatic valves that help keep the water at a constant preset temperature. It will prevent your water heater from working overtime because of overheating water past the desired temperature and you won't have to continually add cold water to balance the temperature, thereby wasting water.

Vermilion Cliffs National Monument, Arizona

Wash your windows with vinegar.

Most of the world's pollution comes from developed countries, which produce more than 95% of dangerous pollution. However, in those countries the regulations governing the disposal of dangerous industrial waste have become so strict and involve so much expense that companies have turned to developing countries to take their waste. And industry is not the only area in which chemical products proliferate.

Most window-cleaning fluids contain synthetic compounds that are harmful to rivers. Replace them with a gallon of water to which you have added a few spoonfuls of vinegar. Apply this with a cloth or newspaper rather than with a paper towel.

> Canyon de Chelly National Monument, Arizona

Recycle aluminum.

Aluminum is extracted from bauxite in the form of alumina. Open-cast bauxite mining causes deforestation and destroys ecosystems. The conversion of alumina into aluminum also pollutes water and air, and consumes enormous amounts of energy. Producing recycled aluminum, however, saves 90% to 95% of the energy needed to produce new aluminum.

Take care to recycle your aluminum cans: They will reappear as aircraft and car parts, as well as new cans. The United States could rebuild its entire commercial airline fleet from all the aluminum cans discarded by Americans in one year.

> Yellowstone National Park, Idaho, Montana, and Wyoming

Switch to natural hair care products.

Many popular shampoos include a phalanx of harmful chemicals including methylisothiazolinone, which may cause neurological damage, and formaldehyde, phthalates, and coal tar, which is carcinogenic. Almost all contain petroleum products and synthetic fragrances. These chemicals do double the damage as they go down the drain and end up in groundwater. Personal care products in the United States are poorly regulated; the Cosmetic Safety Database attempts to assess the impact of a long list of hair care and beauty products and you can search by brand or the name of the chemical you're concerned about.

Look for shampoos and conditioners that use organic and natural ingredients like plant extracts, but read labels carefully and be on the lookout for parabens and sulfates. Choose brands that use recycled materials in their packaging—some shampoos even come in bar form, doing away with the need for another plastic bottle.

Don't use the prewash on your washing machine.

Worldwide, 80% of the energy consumed comes from the burning of fossil fuels—oil, coal, and natural gas—which emit polluting gases and increases the greenhouse effect. Renewable energy, which comes from natural sources, only accounts for a small fraction of the energy used, even though it is inexhaustible and nonpolluting: One wind turbine saves 1,000 tons of greenhouse gases per year. The European Union has announced that by 2010, 10% of its electricity must come from renewable sources. Though many statewide initiatives exist—California and Colorado, among others, have set goals of 20% renewable energy shares by 2020—the United States has not yet endorsed a program for renewable energy that would set the nation's goal at 15% by 2020.

As we await the arrival of this cleaner energy, we should not wait to start consuming less. Today's washing machines, which are highly efficient, allow you to bypass the prewash, thus saving 15% of the energy required for the full cycle.

Buy used, sell used.

In 2050 there will be almost 3 billion more people on Earth than there are today. Many will be living in developing countries, and what will happen when the inhabitants of these countries want to live more comfortably, buy their own cars, and use more water or more electricity? The earth's resources cannot be increased at will, and we don't have a spare planet at our disposal.

Rediscover the joy of used goods, second-hand stores, and garage sales and bargaining to buy or sell used items.

Replace disposable paper towels with washable ones.

Disposable products have been with us for several years. In our throwaway world, 90% of the materials used for the production of consumer goods and their containers enter the sanitation system less than 6 weeks after the product was sold. Do not encourage this waste of natural resources.

Are disposable paper towels used in the washroom at your place of work? Why not suggest that they be replaced by washable towels? Even hand dryers, although they require electricity to run, use fewer resources on average than paper towels.

Do not use chemicals to unblock drains.

Chemicals affect our health-causing asthma, allergies, cancers, and reduced fertility-and the health of the environment. They disturb the reproduction of certain species, kill aquatic life, make wastewater even more difficult and expensive to treat, and pollute air and soil. Despite all this, human beings continue to come up with about 1,000 new substances every year, which are added to the 70,000 chemical products already on the market.

Most of the toxic chemicals used to unblock pipes contain lye or sulphuric acid. They are highly corrosive and extremely dangerous. Instead, use a mixture of boiling water, baking soda, and a plunger.

Make your personal care petroleum free.

Many of us grew up thinking of petroleum jelly (Vaseline) as a personal care cure-all—used for everything from easing minor burns to removing eye makeup to moisturizing the face and lips. But petroleum derivatives in personal care are more hurtful than helpful (mineral oil, for example, may lock in moisture but blocks pores in the process; propylene glycol, another common additive, has been linked to liver and kidney damage and weakens cellular structure). You'll find these additives in most cosmetics, and hair and skin care products. In addition to its possible toxic effects, petroleum is a nonrenewable resource, and banning it from our personal care items is significant—we, as a country, spend nearly \$20 billion on personal care each year. The European Union's Cosmetics Directive, which requires European manufacturers to rid their products of chemicals that are carcinogenic, mutagenic, or toxic, has included many petroleum-based additives on its list of banned substances.

Check labels carefully for mineral oil, petrolatum, paraffin, and propylene glycol. Don't automatically trust "organic" brands—some use parabens, which are petroleum-derived preservatives. When choosing lip care products, opt for beeswax.

Emperor penguin, Antarctica

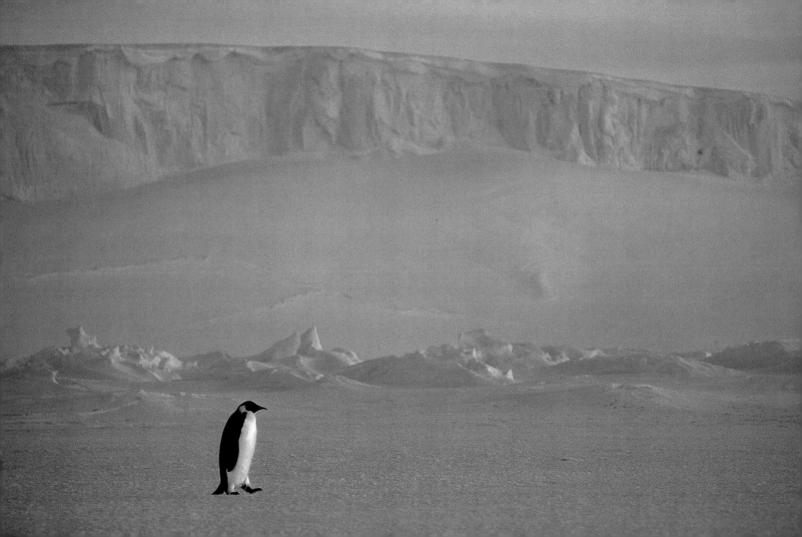

Learn where your paper products originate.

Eighty-five percent of the virgin forests in the United States have been logged, with losses closer to 98% in the lower 48 states. Longleaf pine growths, once dominant along the coast in the South, have been reduced by 98%. Only 20% of the world's ancient forests remain large enough to maintain their biodiversity.

Consider switching to alternative fibers for your paper products, including 100% post-consumer recycled paper or paper made with agricultural residue. There are hundreds of alternative paper companies from which to choose.

Discover the wetlands in your area.

Wetlands—the collective term for marshes, peat bogs, ponds, wet grasslands, and estuaries—account for 6% of the earth's land mass. They filter out pollution and purify the waters that are seeping toward rivers and underground reservoirs and at the same time act like sponges to guard against both flooding and drought. Despite this vital ecological role, they are constantly receding in the face of encroaching human activity: urban expansion, development along rivers and coasts, and agriculture. This is a heritage in danger: Since 1900 half of the world's wetlands have disappeared.

Wetlands have long inspired our country's artists and writers and can be found in nearly every county and climatic zone in the United States. It is likely that wetlands exist in your city or town or quite close to it. Find out where the nearest wetlands are and visit them to learn what you can do to protect them from development.

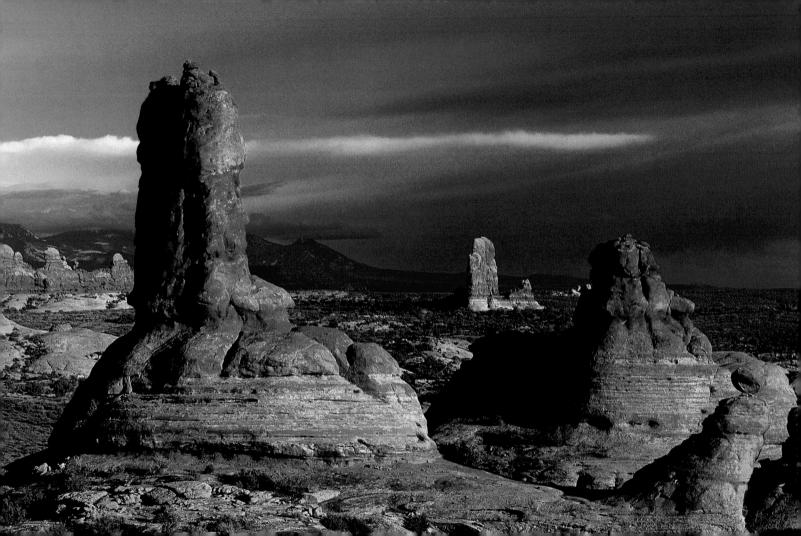

Use reusable shopping bags.

Each year, the United States uses 100 billion plastic shopping bags, less than 2% of which are recycled. If dropped in nature, a plastic bag will last for 200 years. If incinerated, they produce pollutants. In the sea, they prove fatal for crustaceans, which swallow them, mistaking them for jellyfish. And they are not biodegradable in the ocean. A single square mile of ocean may be contaminated by as many as 46,000 pieces of plastic.

Rediscover your trusty old shopping bags, baskets, and boxes and bring them with you to the supermarket. Keep bags on a hook by the front door so you can grab them on your way out to the store.

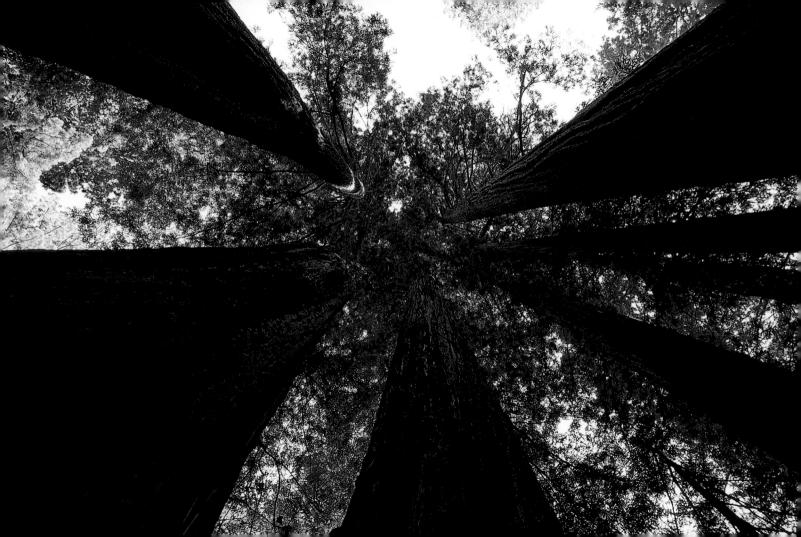

Have your engine serviced and tuned.

The decade of the 1990s was the warmest ever recorded, particularly the end of the decade. By 2100, global warming will have brought major changes. The earth's average temperature will have risen by between 3° and 9°F.

To avoid contributing to global warming, have your engine regularly serviced (carburetor, ignition, air filter) by a professional. With a properly tuned engine, you will reduce your vehicle's polluting emissions by 20% and save up to 10% on fuel.

Don't think of sustainability in terms of sacrifice.

So many green living tips speak of cutting back—conserving water and energy, driving less, reducing your personal waste stream—that it's easy to dwell on what we think we are giving up, instead of what we are gaining. The environmental movement's new guard is not antitechnology or antiprogress: Many of the world's problems will in fact be solved by cutting-edge design and technology. The goods and experiences that replace our unsustainable practices will be of much higher quality than what we know today.

Don't dwell on perceived losses. Think of the exercise you have gotten while walking or biking instead of driving; the greater health you are promoting by eating fewer processed foods; or the better connections you are fostering with other cultures when you travel responsibly.

OCTOBER 30

In addition to fruits and vegetables, buy local products.

The abundance of cheap oil has made the world a small place. Products from around the world crowd our grocery store shelves. Plastic toys hail from a multitude of Asian countries, such as China, India, and Thailand, and every year world transportation statistics rise.

Think of the waste of resources, the pollution, and the contribution to the greenhouse effect from cargo aircraft and trucks. Do not encourage the transport of goods over long distances: Seek out locally made products. This will help create jobs by stimulating economic activity, and encourage the development of shorter, less-polluting delivery routes.

OCTOBER 31

Green your Halloween.

Both kids and adults put a lot of thought into the perfect Halloween costume. Unfortunately, drugstore costumes and accessories are made of nonbiodegradable materials, like plastic and vinyl, and usually end up in the landfill after one wear.

Rent a costume or invest in a better quality one made of natural fibers that can be handed down to younger siblings, added to a toy chest for dress up, or given away. Thrift shops are great sources for retro costumes, and most of the materials can be resold or donated. Don't buy special Halloween-theme plastic bags; use a pillowcase or other reusable bag to go trick or treating. Hand out organic and fair trade goodies. Get a locally sourced, pesticide-free pumpkin and use the carvings to make soup or dessert. Light up your jack-o-lantern with nontoxic candles made from soy or beeswax and remember to thrown old jack in the compost bin.

Save the trees, but see the forest.

So much of the language of sustainability focuses on the state of our natural world that it is easy to compartmentalize our efforts, focusing solely on habitat and wildlife conservation. However, we cannot forget that sustainability has social components: Social inequalities, human rights violations, corrupt or inefficient governance—all of these things make our world harder to live in, our species less sustainable.

We need to keep planting trees and saving energy, but there are many more ways to encourage a sustainable future that cannot be measured in kilowatt-hours—it may be campaigning for freedom of the press in a country where information is heavily censored, working to ensure that basic education is a right and not a commodity, or puzzling out better methods of conflict resolution.

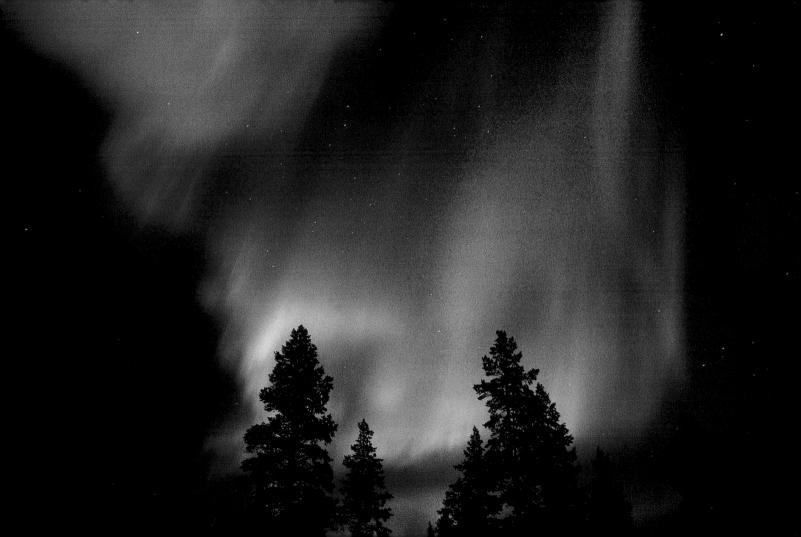

Drive an electric car.

Electric cars are well suited to city use. They are powered by batteries, which are recharged from the main supply via a charger and a plug similar to that of a washing machine. Electric vehicles emit no pollutants and are silent in operation, and are thus effective in reducing urban pollution. Moreover, the cost of the electricity needed to travel 60 miles is a fifth of that of gasoline.

In case you are still unconvinced, an electric car's maintenance costs are 40% lower (there is no need to change the oil), insurance is cheaper, registering the vehicle is less expensive, and parking is free in some cities.

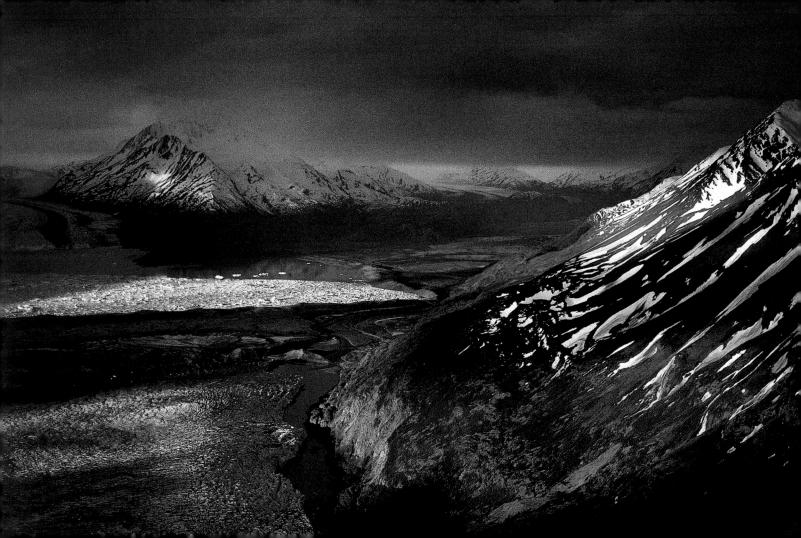

Take action through committees at work.

In your workplace, various measures can be taken to make room for the environment in day-to-day life. These include an employee travel plan, use of clean vehicles, adoption of nonpolluting and energy-efficient technologies, waste recycling, and purchase of recycled, organic, and fair-trade products.

Talk to your colleagues about these choices. Discuss them with those responsible for purchasing, with members of your workplace committee, with the cafeteria chef, and with management to come up with appropriate plans. This is an opportunity to make the staff in your workplace aware of these issues.

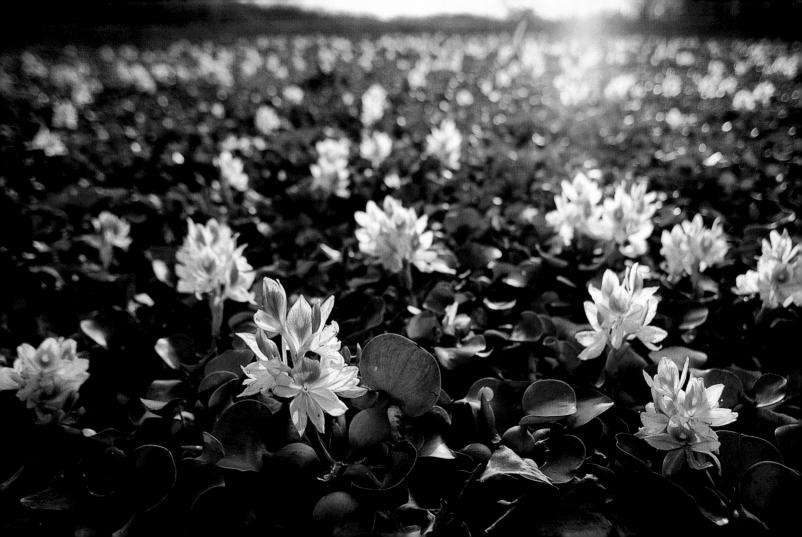

Use your vote.

Voting is the best way to make your hopes and needs known. Our power as citizens includes the election of people who represent us, and whose job it is, in theory, to set an example. Find out the environmental policies of all the political parties, and vote accordingly. It is both simple and essential.

Do not forget that you also cast votes several times each day by what you buy and by your choices as a consumer. These choices influence, sometimes even more than elections do, means of production and the way the economy is organized, and they contribute to the way in which society develops.

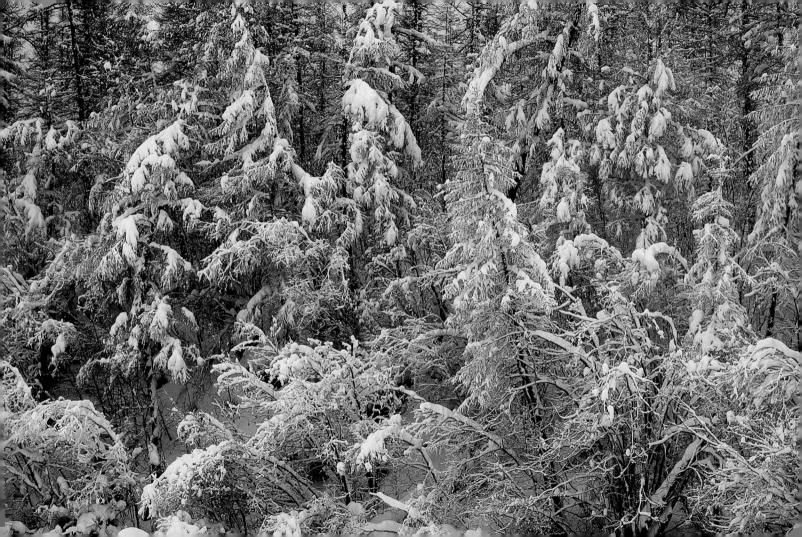

Feed energy back into the grid.

A system called net metering allows you to feed excess power back into the public grid if you produce more energy than you use. You will receive credits from your power company and help offset the amount of nonrenewable energy needed to meet the public demand, which is particularly important in areas where there are few green power options.

Installing solar panels or another renewable energy system can "zero out" your personal power bill.

Yellowstone National Park, Idaho, Montana, and Wyoming

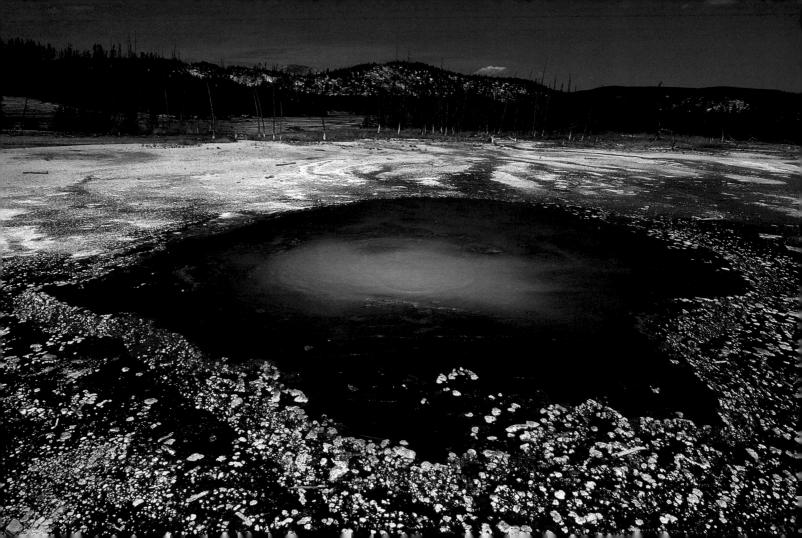

Choose renewable energy for your home.

When a house is being designed, ensuring that it is oriented to receive the maximum amount of sunlight can reduce heating requirements by between 15% and 30%. Solar energy, which is free, easily accessible, and easily converted, can help to heat water and the rest of the house without producing pollution or greenhouse gases. Geothermal heat pumps that use the energy calories stored in the ground (also free, renewable, and nonpolluting) can provide part of your heating and reduce your electricity bill. Most of these installations qualify for grants and financial aid.

Find out more. The energy information section of the Environmental Protection Agency (EPA) provides free practical advice on energy use and renewable energy, which will reduce your bills while protecting the planet.

Give away your old furniture and household appliances.

There are charitable organizations that collect unwanted furniture and old appliances and will repair and sell them, either intact or for parts. At last report, there were some 6,000 organizations in the United States devoted to diverting reusable items from the waste stream. Institutions and companies will discover that finding new uses for housewares, or recycling waste instead of disposing of it, will actually reduce costs as well as provide tax benefits.

Rather than throwing out unwanted goods, find a reuse center in your neighborhood. The town dump is often a good place to start; some dumps have paint exchange programs and book swaps that are free to the public.

> Olympic National Park, Washington

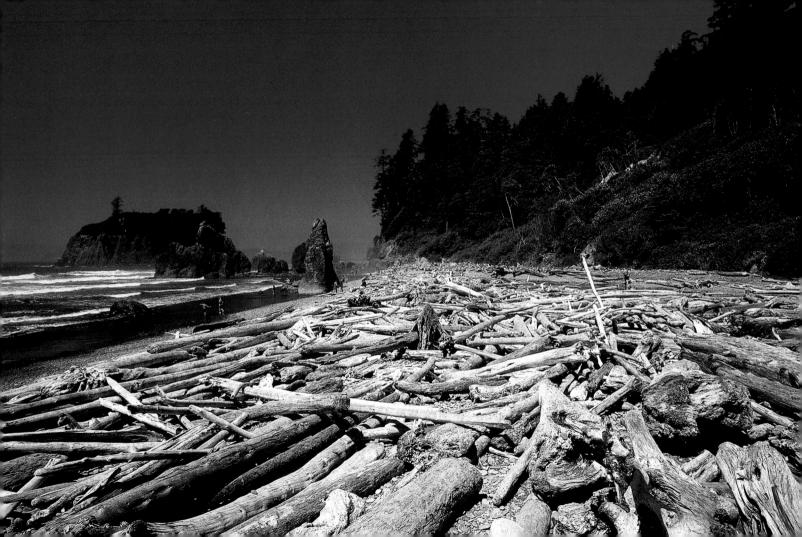

Browse the bulk aisle for shampoos and body lotions.

According to the EPA, Americans generate about 14 million tons of plastic waste a year just in containers and packaging. Not all of those discarded plastic bottles held soda or bottled water. Tons of plastic shampoo, conditioner, body wash, and lotion bottles get tossed every year, many before the contents are fully used up.

Some grocery stores have bulk aisles dedicated to personal care, where you can fill reusable containers with liquids from large dispensers—when you run out you bring your container back and refill it. Alternatively, buy in a bulk size from a beauty-supply store using the extra-large container to refill one smaller, reusable bottle. If you buy lotions from a specialized retail store, ask if they'll refill your empty containers.

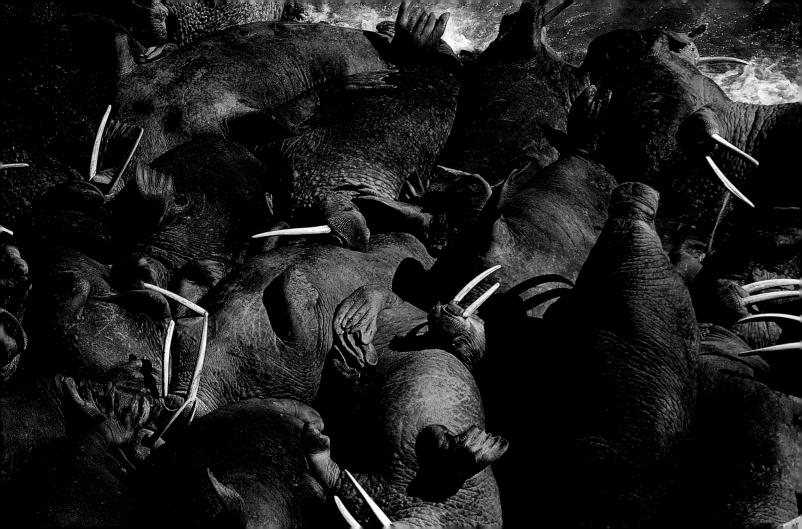

Buy household appliances with the Energy Star label.

Every product comes with an ecological footprint. Everything we buy draws on natural resources for raw materials and for the energy needed for its manufacture, and releases the waste and pollution it generates into the environment. Our present mode of consumption is therefore one of the biggest reasons for the rapid degradation of the environment that we are experiencing on a global scale.

The Energy Star label was developed by the United States Environmental Protection Agency in 1992 and is an internationally recognized indicator of products with superior energy efficiency. Last year alone, America's reduction in greenhouse gas emissions due to the use of Energy Star appliances in the home and office was equivalent to the emissions of 25 million cars. Look for the Energy Star label and save money and the environment.

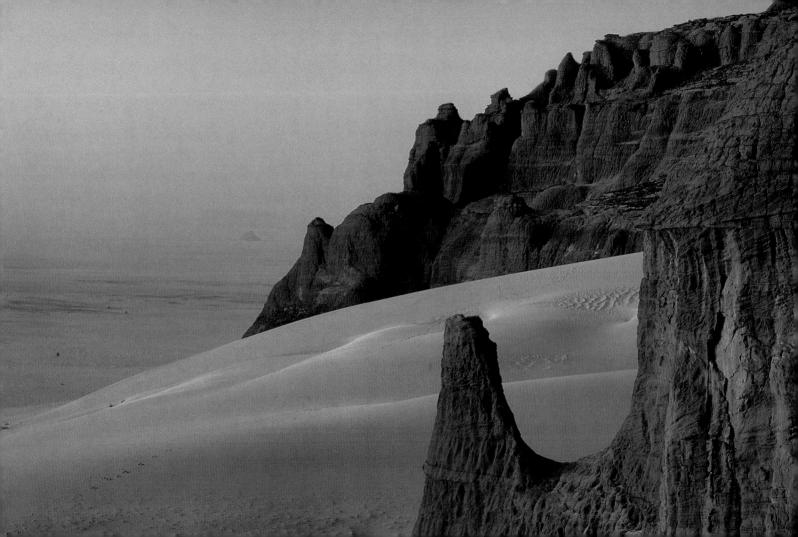

Brew a better cup.

If you've gone to the trouble of buying fair-trade coffee beans, you don't want to offset the good you've done by brewing your coffee in a machine that wastes energy and natural resources. Filterless brewers, like French presses, cut down or eliminate paper waste. If you cannot do away with the filter, get a reusable one or buy unbleached paper filters made from recycled materials that can be composted along with discarded coffee grounds.

If you want an electronic coffee maker, compare the wattage between models (unfortunately Energy Star does not rate them) and choose accordingly. Avoid the ones that brew individual pods of prepackaged coffee—the waste caused by all the excess packaging offsets the energy you save by quickly heating a very small amount of water.

Also, a coffee machine left on all day uses as much energy as it takes to make 12 cups of coffee—switch it off and pour leftover coffee into a thermos to keep it hot.

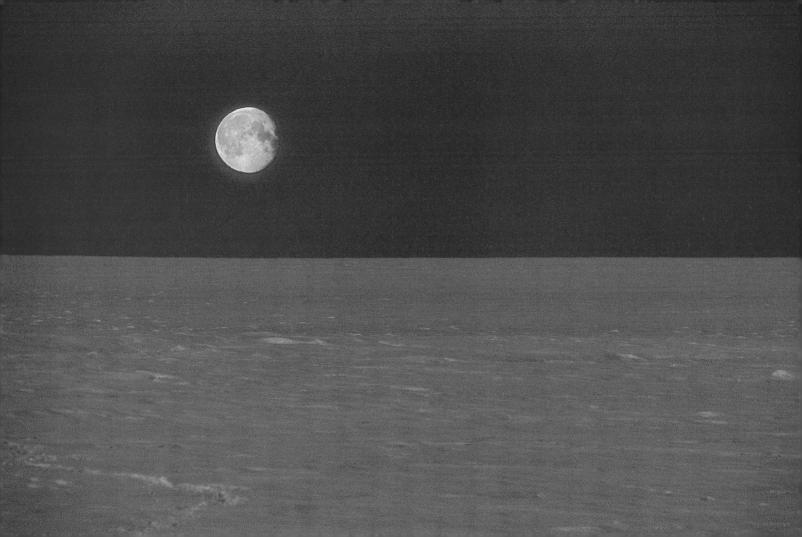

Reduce the noise you make in your neighborhood.

Noise is part of our environment and plays a part in our quality of life. In the 1970s, the Environmental Protection Agency determined the level of noise necessary to protect human health and welfare. The Occupational Safety and Health Administration also began to set limits and regulations for workplace noise levels.

Noise pollution has clear effects on our bodies—it can cause irritability, indigestion, high blood pressure, and lack of sleep. Be aware of the noise level in your home and work environments and try to eliminate as much noise as possible.

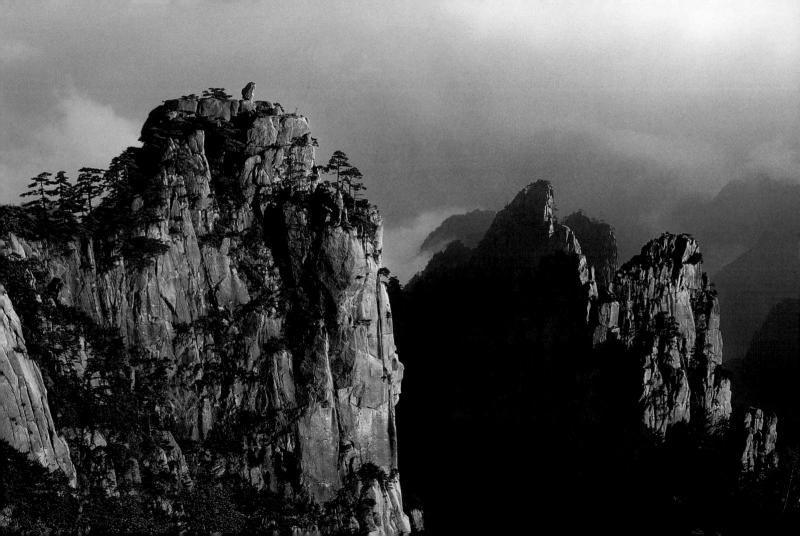

Choose low-VOC (volatile organic compound) paints.

Paints used inside the home may contain up to 50% organic solvents. These render them more liquid and easier to apply. However, they emit volatile organic compounds (VOCs) that are diffused in the air and are a threat to health. Inhalation and absorption through the skin can affect the nervous system and internal organs, as well as irritating the eyes, nose, and throat.

Choose paints that do not contain harmful solvents, heavy metals, or synthetic binders. Replace them with natural paints made from plants that have a mineral base, such as vegetable oils (linseed, castor oil, rosemary, or lavender), beeswax, natural resins (such as pine), casein, or chalk as binders; balsamic oil of turpentine or citrus distillates as solvents; and vegetable pigments (valerian, tea, onion), or mineral ones (sienna, iron oxides). They have minimum impact on the environment and on your health, and their quality is just as good.

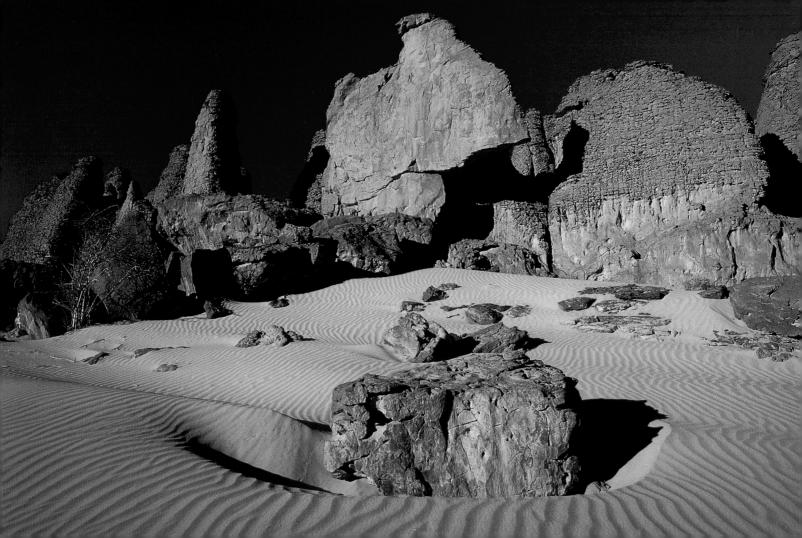

Pressure state legislators to pass e-waste recycling bills.

According to the EPA, New Yorkers generate about 25,000 tons of electronic waste each year. City lawmakers have responded to this by making New York the first U.S. city to enforce producer-responsible e-waste recycling. As of 2008 only 12 states had passed similar statewide laws requiring electronics manufacturers to recycle their obsolete products—and some states still require consumers to foot the bill for recycling with added fees at the time of purchase. Additionally, only 11 states had passed statewide bans to keep e-waste out of landfills and incinerators.

In 2008 e-waste legislation was pending in 19 other states. Find out if your state has made e-waste regulation a priority. Support pending legislation or demand that lawmakers hold manufacturers responsible for recycling the e-waste their products cause at no additional cost to consumers.

Waterfall, Virginia

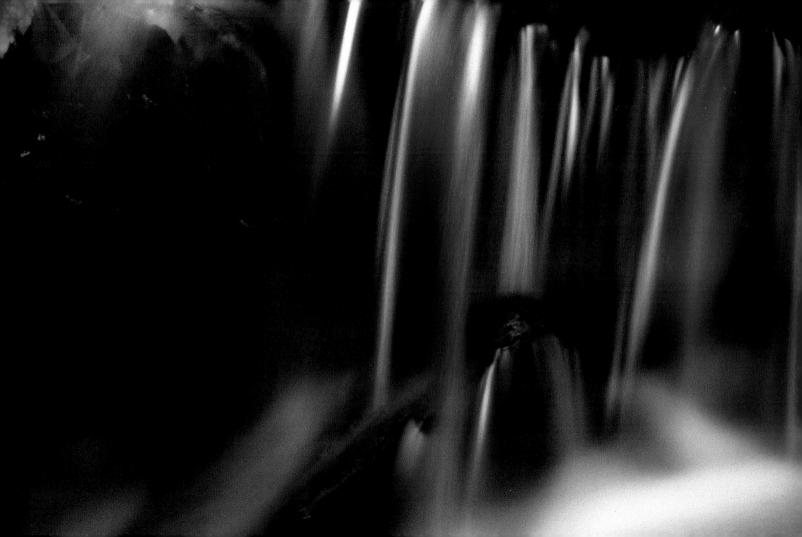

Fight for recycling programs.

Other than consuming less, recycling is the best way to reduce the amount of waste generated, and in addition to the obvious environmental benefits, recycling creates more jobs than waste disposal and incineration. Despite the clear benefits of recovery programs, recycling is mandatory in very few major U.S. cities. Often, recycling programs get vetoed or cut back because it's thought that they are not economical. In 2002 New York City did away with glass and plastics recycling during a budget crunch, but landfill costs rose so much that they ate up any savings the city had hoped for and plastics recycling was reinstated in 2003, with glass following in 2004.

Don't let your recycling program be the victim of budget cuts; let your local legislators know how economically and environmentally beneficial recycling can be. Advocate for residential curbside pickup, which ensures greater participation. If you live in an area where pickup service is limited, identify a few local organizations that produce a significant amount of recyclable waste (such as schools or sporting arenas) and organize a volunteer-based program to help transport recyclables to the nearest collection center.

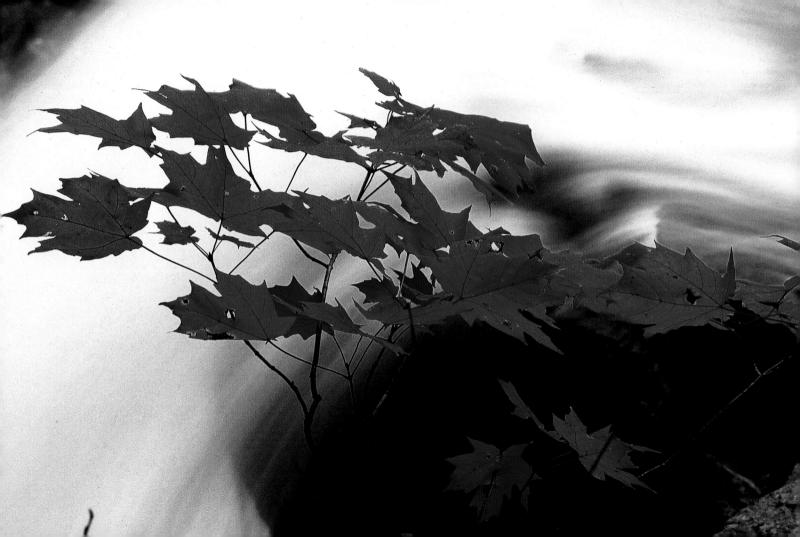

Dust your light bulbs.

You can cut your electricity consumption by using less light and heating at home. If everyone does the same, global electricity demand, and thus consumption, will fall and so will the use of coal, gas, and oil, along with the corresponding carbon-dioxide emissions that contribute to climate change. Conservation is also cheaper and more efficient than technological fixes—that is, changing to an energy-efficient compact fluorescent bulb (CFL) is very good, but turning off the lamp with a CFL in it is even better.

Remember to wipe the dust off your light bulbs; this increases the amount of light they give off by 40% to 50% and provides better lighting for the same cost.

Acid lake, Waiotapu, New Zealand

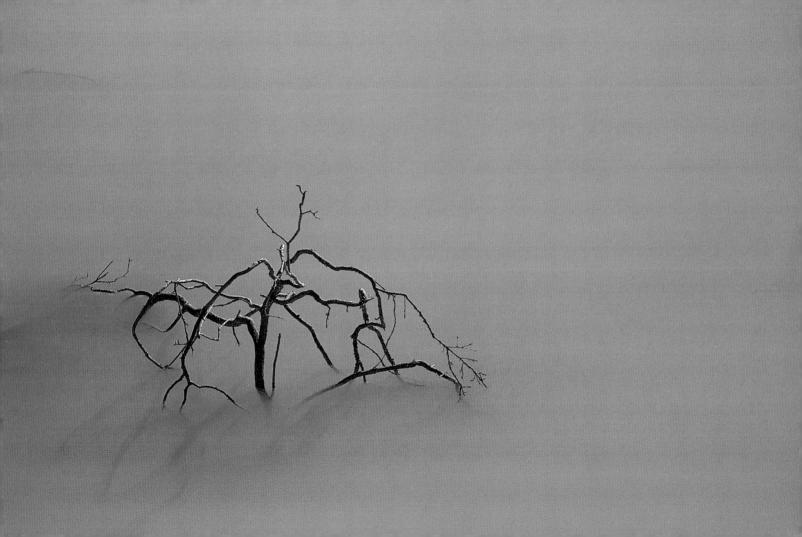

Defrost your freezer.

Our refrigeration appliances use a lot of energy. They use even more if we do not look after them. When the layer of ice inside a freezer is thicker than a quarter of an inch, it is time to defrost it. Any thicker and the ice acts as an insulating layer that can increase electricity consumption by up to 30%.

Take care when defrosting: Do not try to save time by using a sharp object to break the ice. You risk making a hole in the cooling system, which would release polluting gases into the atmosphere, as well as damaging your appliance.

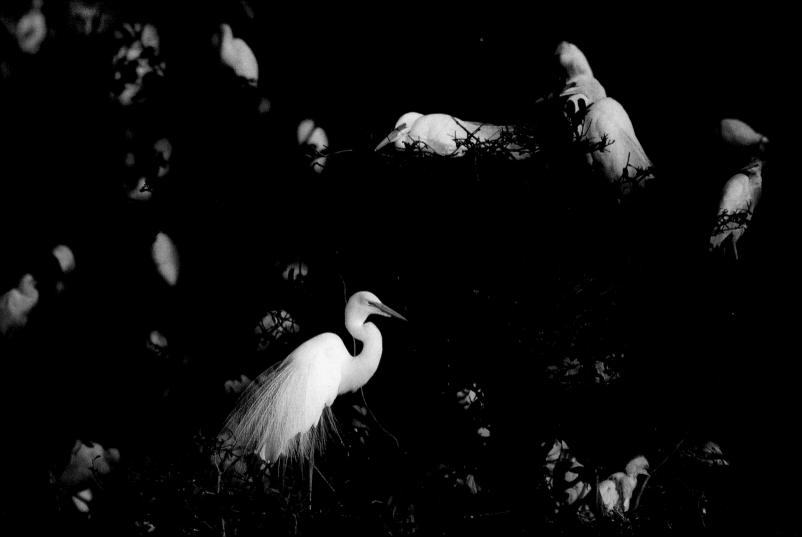

Support organic poultry farming: Buy an organic turkey.

Our choices of food can encourage sustainable farming practices that treat animals humanely and favor ways of raising the animals that respect their basic needs and normal growth patterns. Organic livestock farming does not allow the use of antibiotics, growth hormones, genetically modified organisms, or artificial light. It also supports organic agriculture, since the livestock eat grains and feed produced by such methods.

Make it a rule to buy an organic turkey for Thanksgiving, and investigate heritage breeds; producers of these breeds of turkey seek to put a traditional, more flavorful bird on your table rather than the bland, conventional all-white-meat turkey that most of America buys on Thanksgiving.

Choose your heating apparatus carefully: Consult a specialist.

Electric heating uses a lot of energy and is expensive: This is apparent on your bill in the winter, especially if rooms are not well insulated. If you are having building or renovation work done, now is the time to choose a heating system that uses renewable energy, such as wood-pellet stoves or solar heating. Among fossil fuel energy sources, natural gas heating is the least polluting and pellet stoves are the cleanest of solid fuel-burning appliances—they can burn a variety of organic waste, like wood scraps, corn kernels, and other corn byproducts, pits, and nutshells, and are direct-vented and airtight, so you do not lose the hot air generated through an open flue.

To choose the most energy-efficient and least-polluting heating system, consult a specialist, who will be able to advise on the best energy options for your home and your needs.

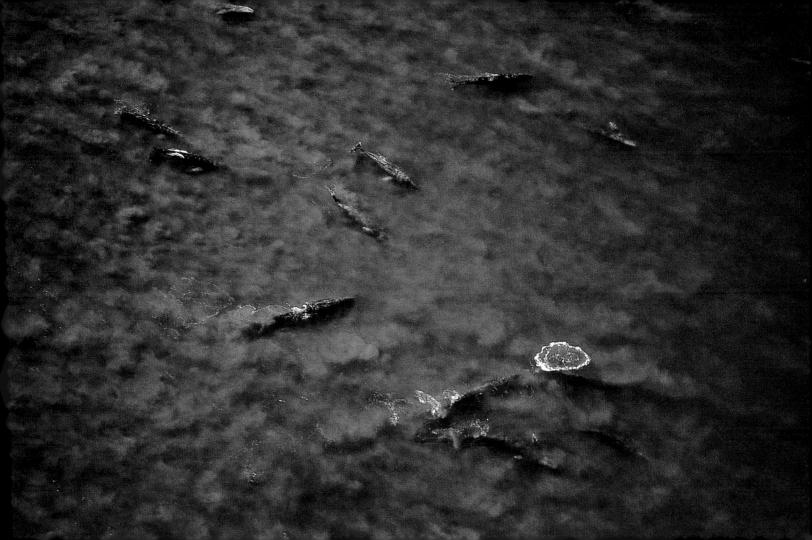

Buy energy-efficient holiday lights.

If left on from dusk until dawn, 10 strings of standard Christmas lights produce roughly 300 pounds of carbon dioxide. The same number of light-emitting diodes (LEDs), on the other hand, generates only 30 pounds. By switching the lights on its iconic Rockefeller Center Christmas tree to LEDs, the city of New York cut the tree's energy use in half, saving, each day, the equivalent of the amount of energy used by an entire family in a 2,000-square-foot apartment each month.

Replace incandescent holiday lights with LEDs. Some manufacturers make lights that come with a small solar panel for recharging. LEDs don't overheat so they are safe to use on trees, and if one light burns out, it doesn't affect the rest of the strand. Even if you use only LEDs, control them with a timer to limit the number of hours you run your holiday lights—don't leave them on all night.

Elephants, Kenya

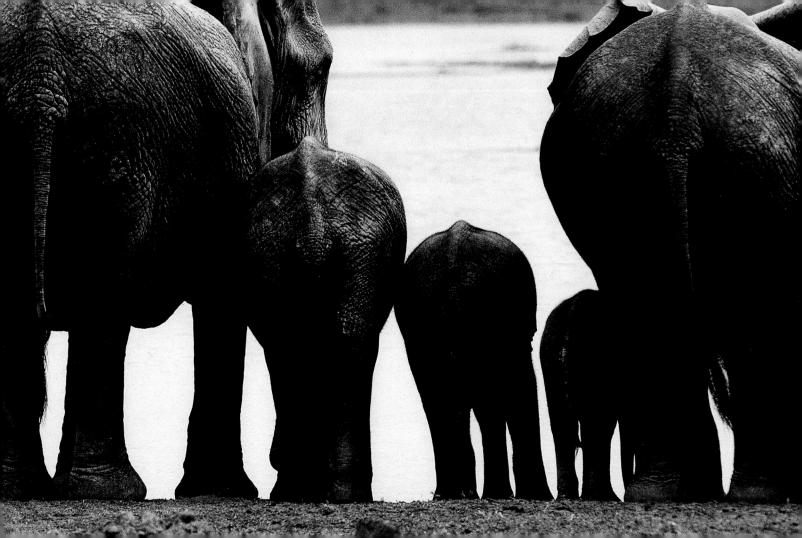

Recycle your computer.

Waste in the form of discarded electrical and electronic equipment–called e-waste– is increasing at the rate of about 20% every 5 years (3 times faster than ordinary municipal waste). According to the National Safety Council, by 2009 nearly 250 million computers will have become obsolete. U.S. landfills already contain more than 60 million unwanted PCs and laptops. Electronics account for 70% of hazardous waste worldwide. Their toxic components–heavy metals and organic pollutants–are harmful to water, air, and soil, and must be treated accordingly. In developing nations, entire communities have become e-waste dumps, where hazardous components are dismantled by hand and materials that have no resale value are burned, emitting large amounts of toxins. In some communities, lead poisoning affects up to 80% of the population.

Most major manufacturers have take-back programs, and there are organizations that collect computers for resale or to donate to schools or humanitarian programs. But be careful about which programs you choose: Though countries like India and China have strict laws prohibiting the importation of e-waste, tons of materials from the United States and Europe still enter their borders illegally every year, some labeled as charitable contributions to escape scrutiny. Organizations like the Basel Action Network maintain lists of responsible recyclers.

Ray, Australia

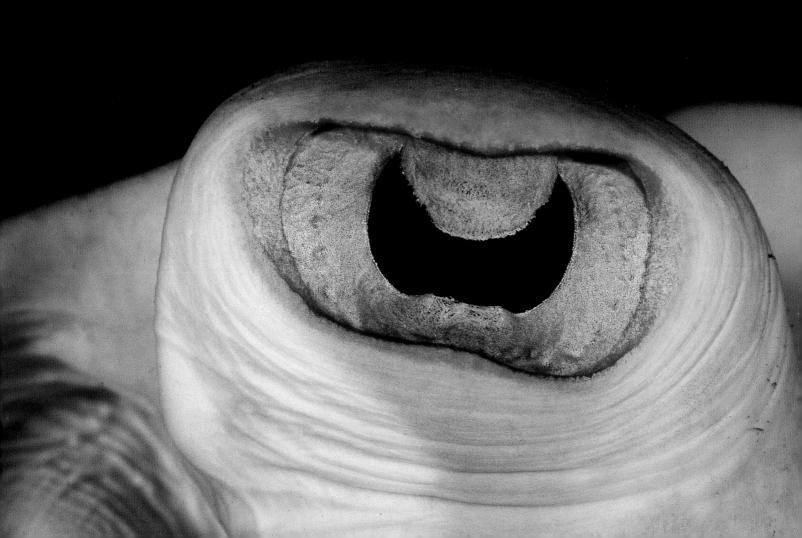

Your saucepans can save energy, too.

Putting a saucepan on the stove is an utterly commonplace act, yet by paying attention to small details you can use less heat and save energy without changing the way you cook.

Use pots and pans with flat bottoms. Do not place a pot on too big a ring if using an electric stove; if you are cooking on gas, turn the flame down so that the content does not boil over and spill around the sides. This wastes the energy that was used to heat the liquid. When boiling food in water, use just enough water to cover it—it is pointless to boil twice what you need.

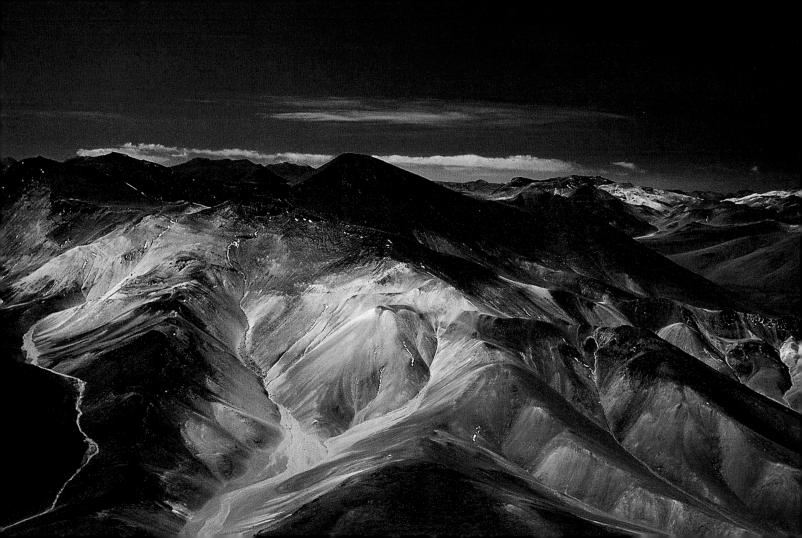

Demand a citywide bicycling infrastructure.

Using a bicycle to commute to work 4 out of 5 days a week for an 8-mile round trip would save an average of 54 gallons of gas annually. If every American worker did this, our demand for and reliance on oil would plummet. However, high-speed traffic, dangerous intersections, and distracted drivers are enough reason to keep most people from riding on city streets. And those who make the switch to cycling are frustrated by the lack of secure bike parking and ways to link bike trips with public transportation.

Demand that your city provide a greater infrastructure for cyclists—one that goes beyond painting a few narrow bike lanes on already congested streets. The Bikes Belong Coalition has tips on how to talk to community leaders and links to local and national advocacy groups.

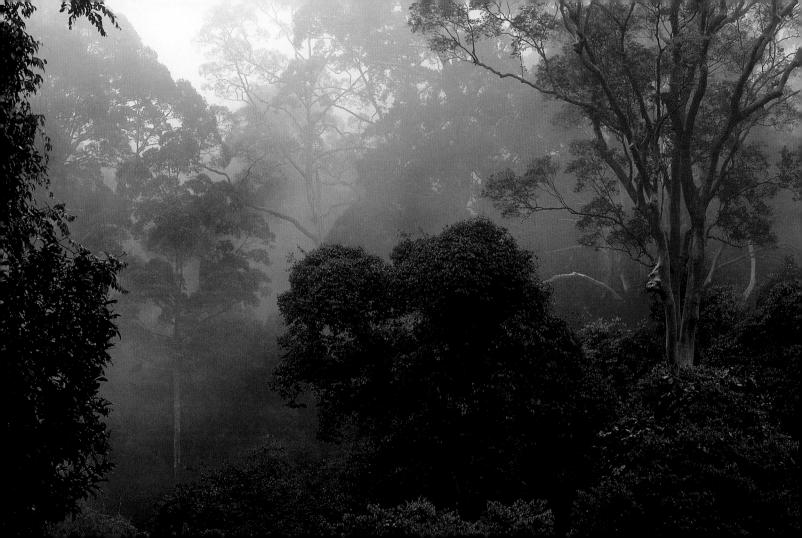

Say "no" to disposable diapers.

It takes 4.5 trees to produce the pulp needed for the 4,600 disposable diapers an average baby needs. A glassful of crude oil is needed to make the plastic found in a single disposable diaper. The diaper is worn only a few hours, but will take about 400 years to decompose in the waste dump. There has always been an alternative: washable diapers. Absorbent, effective, and comfortable, reusable modern diapers are very different from the old, folding variety. A single washable layer can be used for several years. When it is finally thrown out, it decomposes in 6 months, without producing any pollution.

Choose the economical, and ecological, diaper: Cover your baby's bottom in a cloth diaper.

Stalactites, Greenland

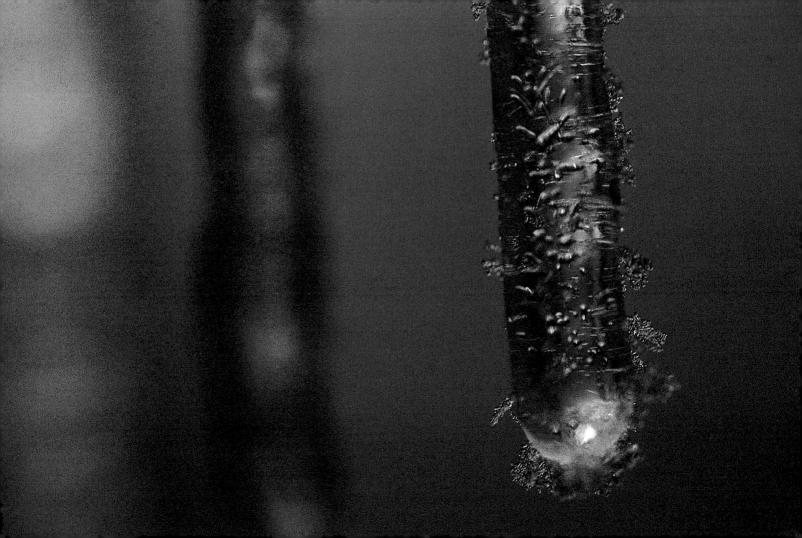

When you fly, pack lightly.

The white plumes of exhaust that fan out from airplanes are called contrails essentially water vapor given off by jet engines as they burn fuel. Contrails can condense and linger in the air, trapping heat and thereby worsening global warming. Airplanes generally fly at higher altitudes to conserve fuel—the air is thinner, so there's less resistance. However, it is at these higher altitudes that contrails form.

Some 747s burn a gallon of fuel each second. The heavier the aircraft, the more fuel it burns. Pack only the essentials and use lightweight luggage.

Yellowstone National Park, Idaho, Montana, and Wyoming

Use organic methods of control rather than pesticides.

Chemical insecticides for garden use have several drawbacks: They harm all insect life, including beneficial species that prey on pests, such as greenflies, caterpillars, and arachnids; and they pollute the land and water. Living biological controls are an alternative; they are the natural enemies of pests and can be used to keep pest populations below destructive levels. They allow the population of an undesirable organism to be reduced by being devoured by its natural predator!

Living biological controls include spiders, ladybugs, lacewings, praying mantises, predatory mites, parasitic flies, wasps, and more. Most beneficial species can be purchased through the Internet or mail-order catalogs. Beware though, for such organic methods affect the natural balance. Before each treatment, make sure that the predator you plan to introduce will attack only the species that is causing the trouble.

Orinoco Basin, Venezuela

Take part in Buy Nothing Day.

Since 1970, world production of goods and services has multiplied sevenfold. The earth lost a third of its natural resources over the same period.

If you are weary of our overconsuming society, don't miss Buy Nothing Day at the end of November, traditionally held on the day after Thanksgiving. It provides an opportunity to think about the social, economic, and ecological impact of global consumption. If you feel particularly resourceful, promote a local Buy Nothing Day once a month, or even once a week.

Take the bus.

Global pollution, such as greenhouse gas emissions, is worrying because of its impact on the balance of the planet's climate. Local pollution directly damages health and well-being, especially in big cities. Thirty thousand American lives are prematurely cut short because of air pollution every year. Cars are the biggest source of urban air pollution: Each car emits, on average, 3 times its own weight—that is, several tons—in various pollutants.

Fight air pollution by using your car less often. And take the bus—a fully loaded bus can keep as many as 40 drivers off the streets.

Recycle ink cartridges.

Every year 350 million laser printer and inkjet cartridges end up in North America's landfills. These are made of plastic, iron, and aluminum, none of which is biodegradable, but all cartridges can be reused up to 50 times—it takes 3 quarts of oil to make a single new cartridge. Recycling cartridges seems like common sense, yet only 2% are recycled, while the rest, worth at least \$588 million, ends up in landfills.

Contribute to the growth of recycling by handing in used cartridges and urging your employer to do the same. There are also organizations that collect them and use the proceeds for humanitarian or educational purposes. You can also purchase refilled inkjet cartridges online and from retail stores.

> Starfish, Olympic National Park, Washington

Donate your eyeglasses for recycling.

In developing countries, 1 billion people need glasses but can't afford them. Meanwhile, nearly 4 million pairs of perfectly good eyeglasses are thrown out annually.

The next time you replace your eyeglasses, donate your old pair, and any unused cases, to an organization that collects and distributes them where they can be reused. Some opticians take part in collection programs. Every year more than 100,000 pairs of glasses find a new pair of eyes that they can help.

Be prepared to pay more for quality.

The combination of globalization and consumerism often leads us to buy irresponsibly. Cut-rate prices are tempting, but products are often made as cheaply as possible on the other side of the world, in countries devoid of environmental legislation. Often of poor quality, these products quickly break down, break apart, and stop working, and are soon discarded.

Choose the alternative that is locally made and of better quality, even though it may be more expensive. Your purchase will be more environmentally friendly and may save you money in the long run because you won't be forced to replace it right away.

DECEMBER 1

Do not use your car for short journeys.

Every large city on the planet is suffocating because of car traffic, oil-fired domestic heating appliances, and industry. Half of all car travel in America is for trips under 3 miles—an easy distance for most people to bike or walk. While citizens of Europe and Japan make 20% to 50% of their trips on foot, Americans make only 5%.

Avoid using your car for short trips. A vehicle produces the most pollution when being started from a cold engine. Moreover, the catalytic converter is fully efficient only when it reaches a certain temperature, which happens after a few miles have been covered.

DECEMBER 2

Use baking soda to clean the oven.

Between 1940 and 1982, production of synthetic substances increased by 350 times. Since 1970, world sales of chemical products have risen from \$171 billion to \$1,500 billion. This vast market leads to the release into the environment of millions of tons of different chemical compounds. This pollution is widely implicated in the increase in cancer rates, loss of biodiversity, and destruction of the earth's ozone layer.

Household oven cleaners contain corrosive and toxic substances. You can replace them with a solution of water and baking soda, which is less damaging and just as effective.

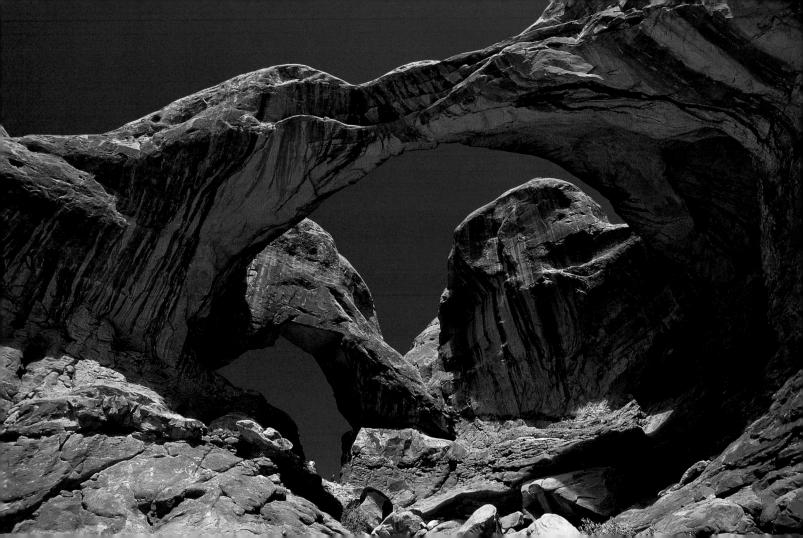

S DECEMBER 3

Persuade your workplace to buy fair-trade coffee and tea.

In many regions of the developing world, earnings are too low for farmers to support their families. Unable to make a decent living from the land, they are sometimes forced to leave it and join the swelling ranks of the urban poor. In some regions, they yield to the temptation to grow coca (from which cocaine is produced) or poppies (which produce opium), both of which will earn them more money.

By building more equitable commercial relations, fair trade ensures a decent wage for craftsmen and farmers, who can then live in dignity from their work. Tell your colleagues about fair-trade coffee and tea, and urge your employer to buy them.

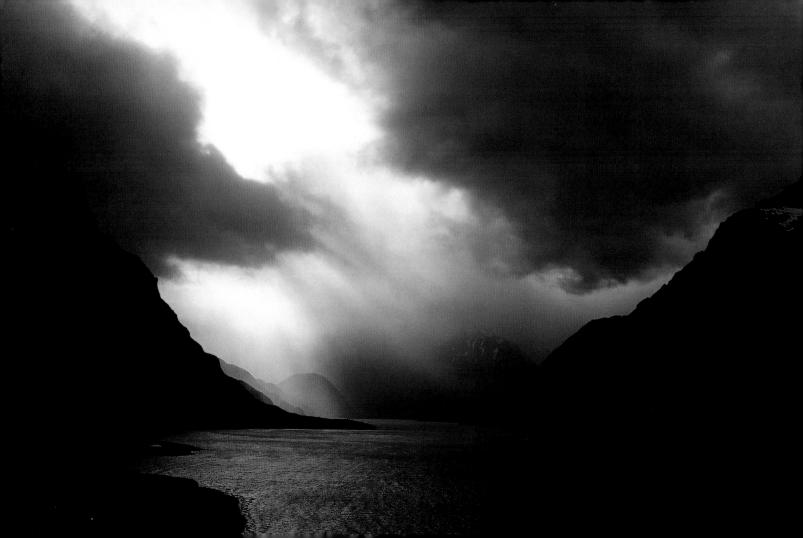

DECEMBER 4

Take biodegradable waste to the compost center.

Composting is nature's way of recycling its own waste. Dead leaves, branches, and plant debris fall to the ground and are digested by bacteria and microscopic fungi. As weeks pass, humus—the natural compost produced by this process—is formed. Composting in specialized facilities gets rid of our biodegradable waste (fruit and vegetable peelings, garden waste) using the same process. This natural fertilizer, which can restore degraded soil to a condition in which plants thrive, is the reason that community composting is so important, particularly given current agricultural practices.

If your local municipal authority does not collect biodegradable waste, find a compost center nearby. Some cities around the United States, recognizing that the reduction of solid waste benefits everyone, have instituted curbside compost pickup. Encourage your local legislators to consider the option of municipal composting.

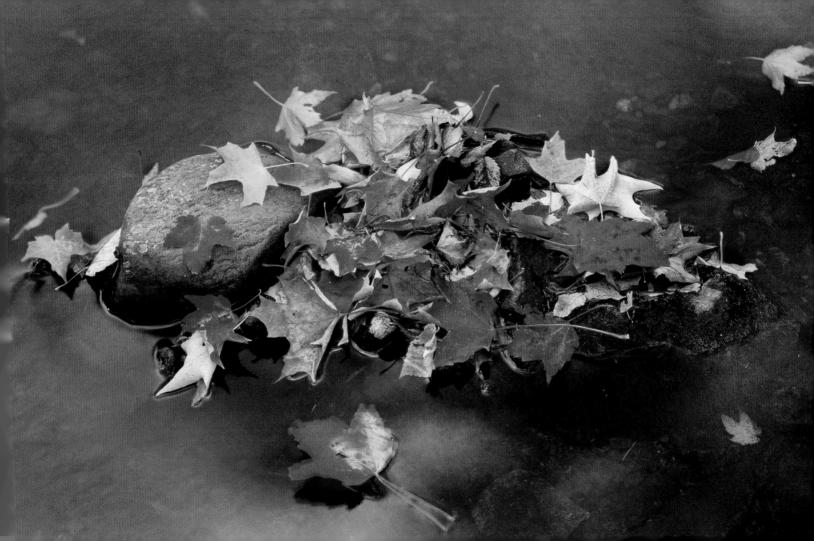

Set your refrigerator to 40°F.

Worldwide, the transportation sector produces a quarter of all emissions of carbon dioxide. Electricity generation produces more than a third of carbon-dioxide emissions. In industrialized countries, electricity generation's share is half of all emissions. The comfort of our day-to-day life consumes vast amounts of electricity, and sometimes wastes vast amounts, as well.

The ideal temperature for the inside of the refrigerator is 40°F. Similarly, the freezer should be set to 5°F. Any setting below these temperatures does not affect how well food keeps, but it does increase energy consumption by 5%. Keep a thermometer in the refrigerator and freezer to check the temperature.

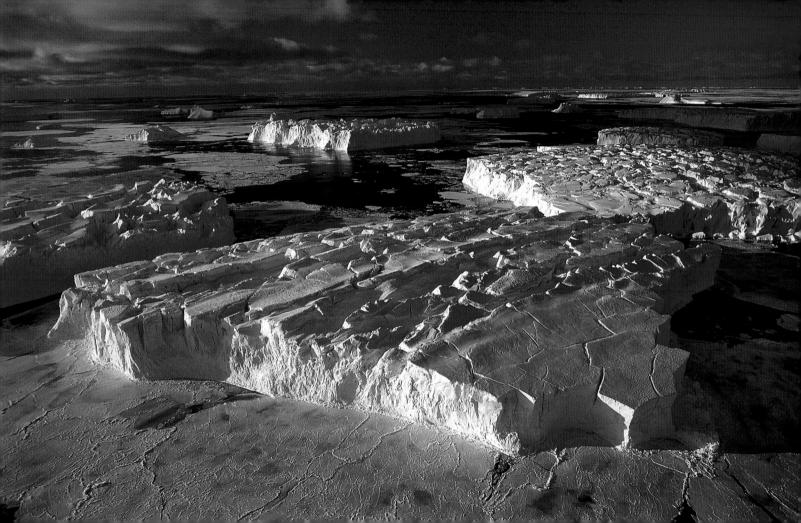

Choose the most energy-efficient TV.

TVs account for about 10% of a home's energy bill. Some plasma TVs consume up to 500 kilowatt hours per year—as much as a new refrigerator, traditionally the biggest energy user in the house. Rear-projection TVs on average still use the least power. LCD flat-panel screens generally use less power than plasma screens; however, the bigger the screen gets, the more power it needs, so a 50-inch TV in any format will never be energy efficient.

When buying a TV, always check the wattage it uses, including how many watts are drained when the set is in standby mode. Look for the Energy Star seal of approval, as those sets are up to 30% more efficient than their uncertified counterparts.

To further optimize your TV, turn down the brightness or backlight (particularly on superbright LCDs) and utilize any built-in power-saving modes. Of course, the less TV you watch, the less power you use.

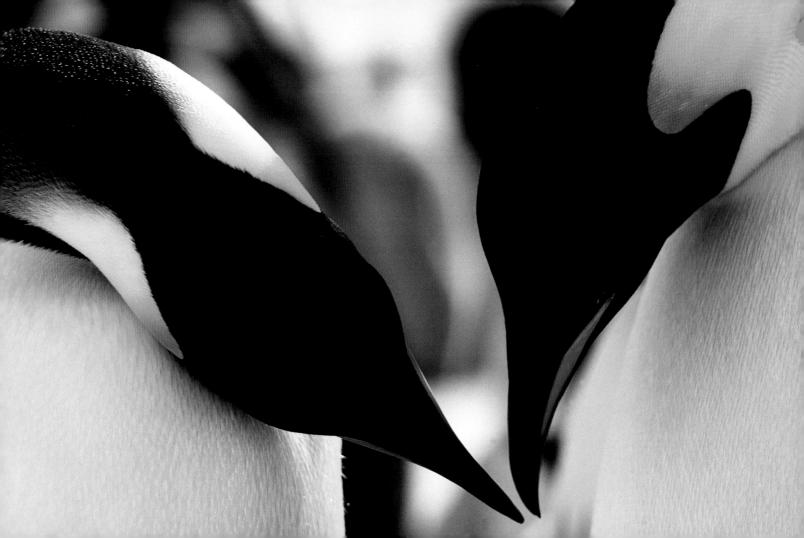

Reduce noise pollution to make our cities more livable.

Compact communities are good for the planet—when we build up instead of out we protect undeveloped habitats and watersheds. However, city living is not always easy and many people leave cities for the suburbs to escape the bustle and noise of urban areas. Three-quarters of the noise in cities comes from motor vehicles. It is so pervasive that we no longer even notice it. A typical pick-up truck passing at 50 miles per hour is 4 times as loud as an air-conditioner and 8 times as loud as a refrigerator. Asked about the noise inside their apartments by a recent British research paper, 21% of people questioned felt their home lives were disrupted by noise. Too much noise causes fatigue and stress, and affects our nervous system.

For cities to remain livable, it is essential to keep noise pollution to a minimum. Car exhausts must be fitted with a muffler. Have yours changed when it becomes too noisy.

Inside the home, carpeting is the best way to soundproof the floor. On tiled or hardwood floors, consider putting padded blocks under the feet of furniture, placing shock-absorbing pads under electrical appliances to reduce the vibrations transmitted through the floor, and laying down rugs to dampen the sound of footsteps.

Red ibises, Venezuela

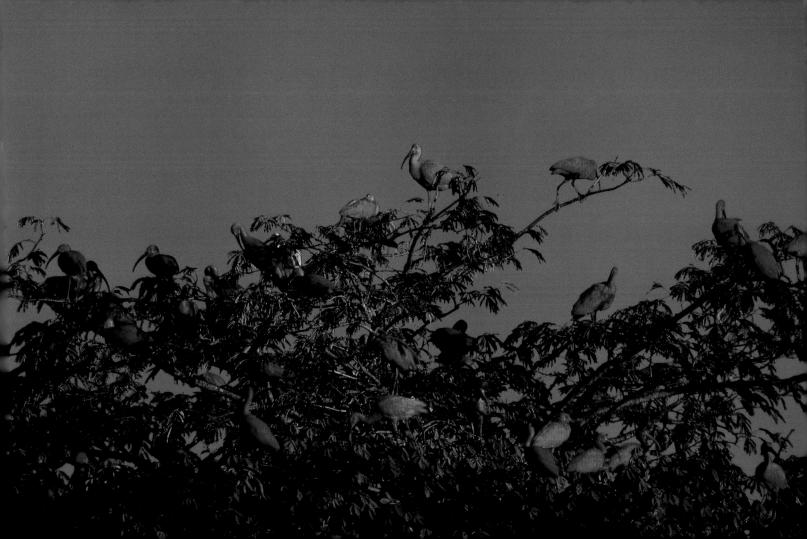

Replace your old domestic appliances.

Recent years have seen a considerable reduction in the amount of water used by domestic washing machines. The Energy Star label is the certified assurance that consumers are investing wisely. Energy Star dishwashers are at least 13% more energy efficient than standard models, and save water, as well. An Energy Star dishwasher saves approximately 1,200 gallons of water a year, which is equivalent to the amount of water that 6 people can drink in a year.

Your appliances may have served you faithfully for years, but if they use much more water and energy than newer models it is better to replace them—especially if they are used frequently. Energy- and water-efficient models may require greater initial investment, but you will continue to see the benefits over the life of the machine.

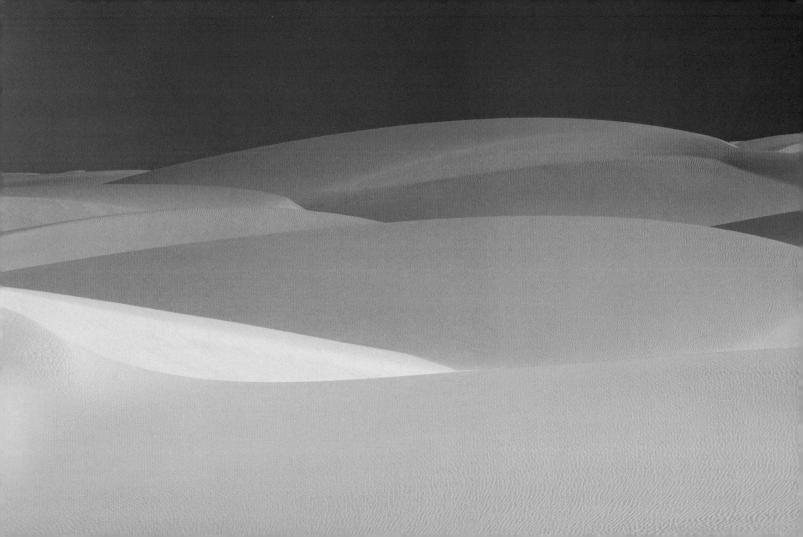

Encourage your employer to invest in an environmental audit.

Not surprisingly, companies, institutions, and schools have a larger impact on the environment than the individual, and thus, when these entities choose to act sustainably, their potential for influence is much greater. There are numerous ways for companies and institutions to assess their footprint on the earth in a quantifiable and productive way. Environmental audits are accompanied by individualized, self-proposed goals and improvements for the short- and long-term that are made by organizations to become more ecologically sound in their operations.

You can encourage your employer to invest in an environmental audit. The goal-making process that follows—where the company or institution decides how best to reduce its environmental footprint—can be a motivational, team-building experience for all involved.

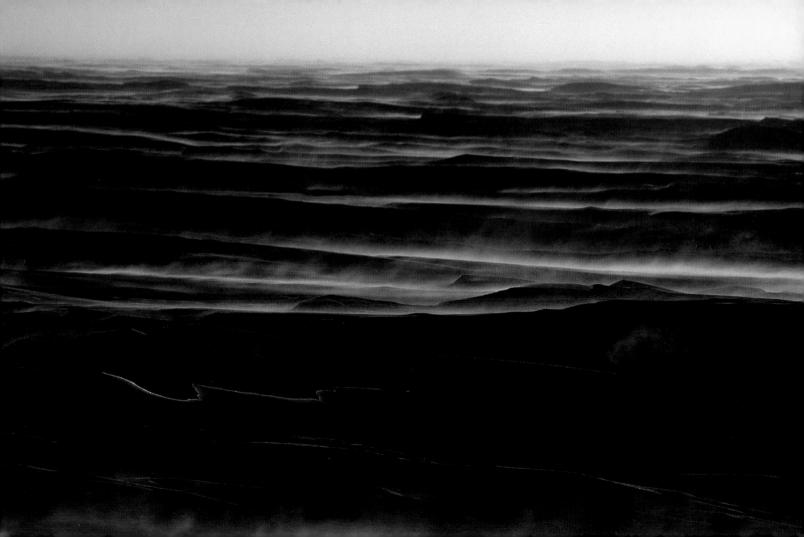

Ask for a matching donation the next time you support an environmental cause.

Many companies offer to match any donations that their employees make to registered nonprofits. Remember that such giving does not begin and end with Greenpeace—providing solar power to a community that lacks the infrastructure to have electricity or constructing eco-friendly temporary housing for climate refugees are just a few of the tangible things your charitable donations can help accomplish.

This year ask your company to double your support of an environmental cause, or instead of having everyone waste \$10 on a Secret Snowflake gift, pick a worthy cause or two, pool all of that money, and ask your company to match the donation.

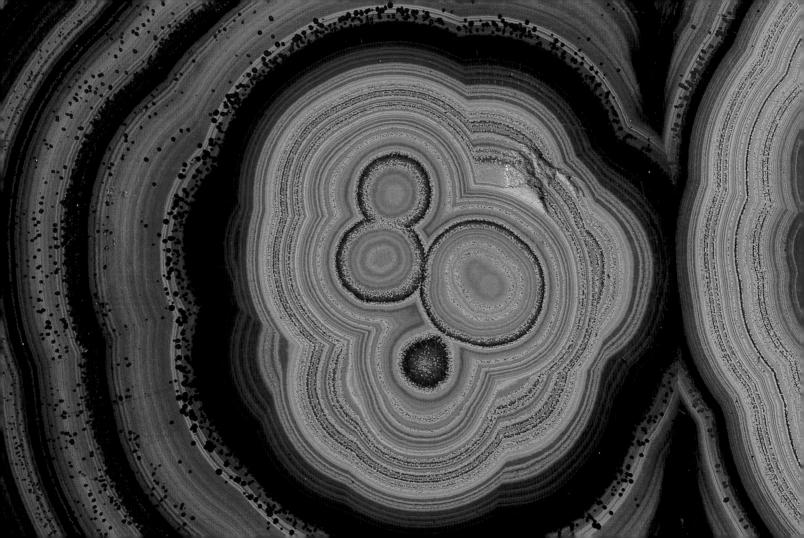

In winter, turn nighttime heating down to the minimum.

Eighty percent of the energy the world uses comes from nonrenewable fossil fuel resources, the combustion of which produces greenhouse gases. Oil, natural gas, and coal reserves are replaced at 1/100,000th of the speed at which we are now using them up. The exhaustion of these resources within a few decades will probably herald the rise of renewable, nonpolluting energy sources. We may yet have cause to regret not having developed them earlier.

To moderate your energy consumption (and reduce your bills), remember that a temperature of 61°F is enough in a bedroom at night. For a healthy, economical, and ecological night's sleep turn your heating down and sleep under a good soft blanket or cozy comforter.

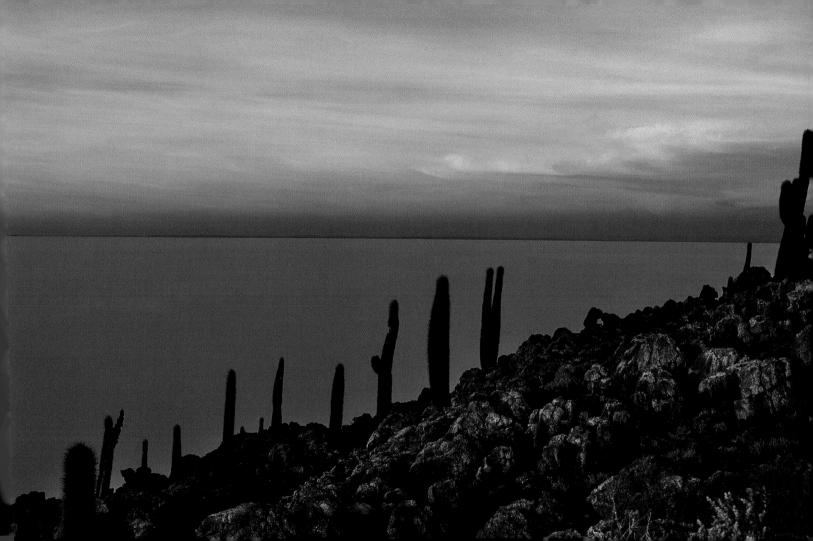

Give a waste-free gift.

Americans throw away 25% more trash between Thanksgiving and New Year's Day. Instead of purchasing an item of dubious quality that may have been manufactured under unfair working conditions and transported thousands of miles to the store at the cost of burning fuel, concentrate on giving people experiences.

Tickets to music, theater, or sporting events; certificates for meals at restaurants that support local resources and use organic ingredients; lessons to help discover new hobbies or further existing ones; or subscriptions to community-supported agriculture programs are just a few examples of gifts that won't get sent directly to the landfill along with a heap of wrapping paper.

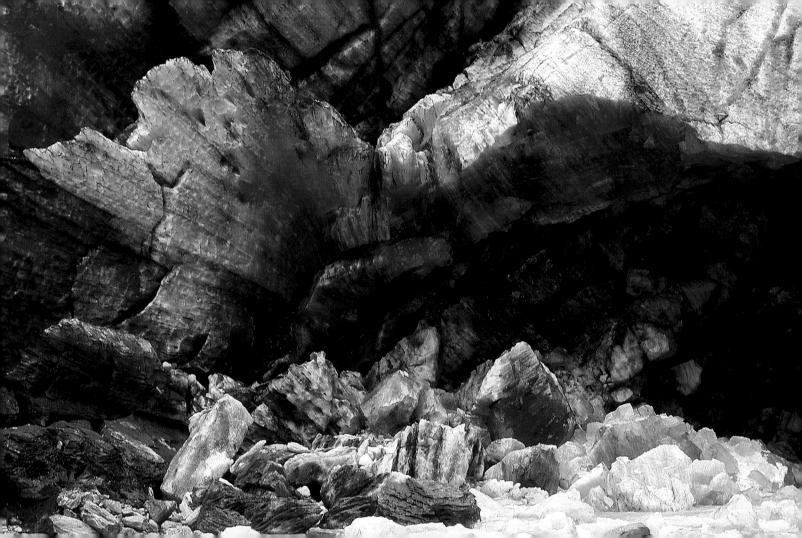

Avoid total treatments in the garden.

Many chemicals regarded as too dangerous are now banned in industrialized countries, yet they are still on the market in developing countries, where 30% of the pesticides sold do not comply with international standards.

If you must use a chemical treatment in your garden, avoid total treatments: Lindane and atrazine kill indiscriminately, eliminating earthworms, which aerate the soil, and beneficial insects, as well as harming birds and the health of the user. Read the information on the packaging, and choose products described as authorized for garden use: They have less impact on the environment. Whatever treatment you use, if you must throw out what is left over, remember that the place for toxic substances is the hazardous-waste disposal facility, not the garbage can.

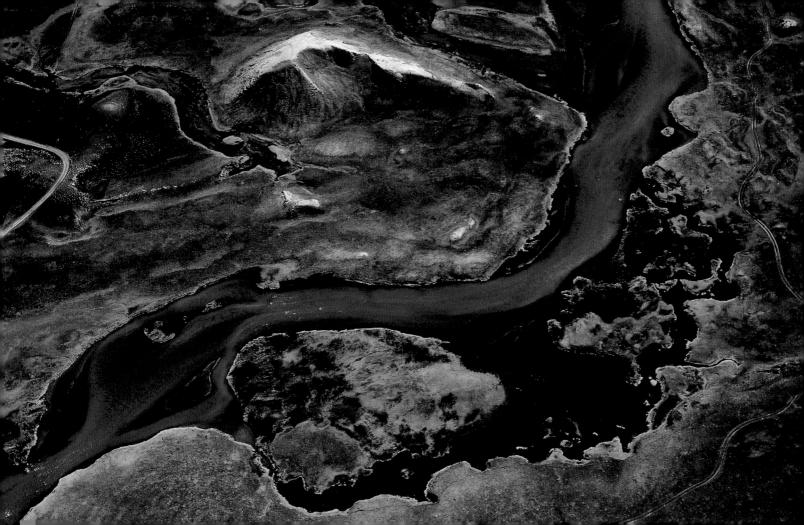

Keep warmth in by insulating your home.

Energy demand in the developing nations of Asia, including China and India, is projected to more than double over the next 25 years. Energy consumption there already has increased dramatically: From 1980 to 2001, India's rate of consumption increased by 208%, mostly due to rapid urbanization and augmentation of population. China's increased by 130%. The world cannot continue to sustain this output of energy—the environmental impacts are simply too great.

You can save energy by improving insulation. On winter nights, increase the efficiency of your heating by drawing the curtains on each window. During the winter, seal your windows with plastic or foam insulation.

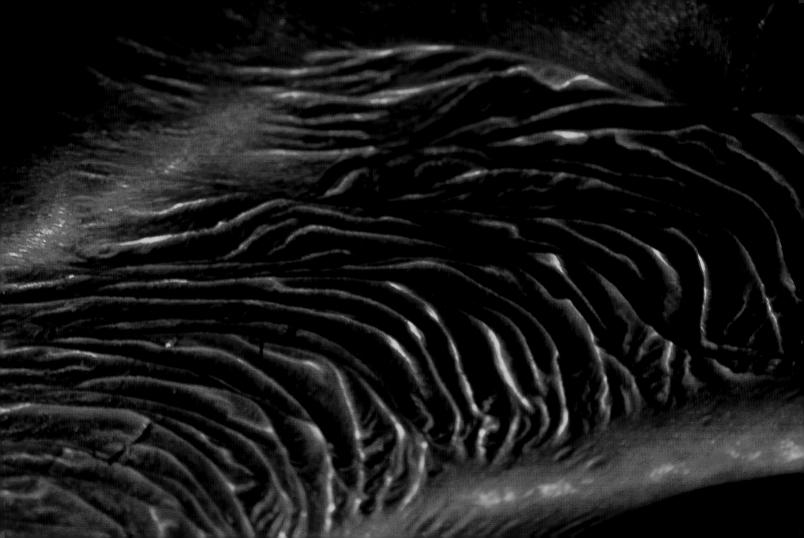

Educate your children.

Indiscriminate use of new technologies; private and state economic interests looking for short-term gain; and disregard for both the common good and for the consequences for future generations are at the foundation of the dangerous situation facing the earth today. We cannot shrug off our responsibility as consumers and as citizens.

Explain to your children that the Western model of consumption has limits. Teach them to have concern for the environment. Be firm about saving electricity, turning off faucets, and turning off the computer when it is not being used. Set an example! When education succeeds, it is often a result of having a model to follow every day.

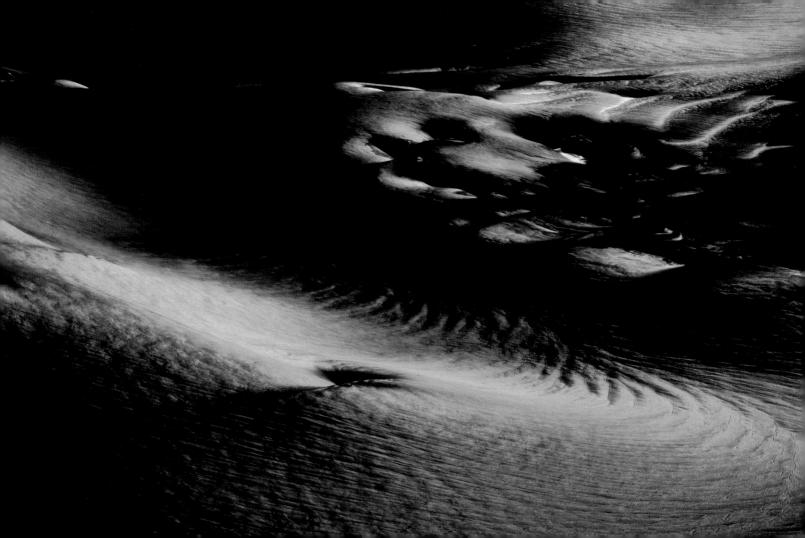

Choose the right Christmas tree.

Christmas tree farms typically use tons of pesticides, and although the trees capture carbon dioxide as they grow, some farms may replace areas of hardwood trees that are better at capturing carbon dioxide than pines. Not to mention that we have created an entire industry—one that requires land—so we can have a few weeks of holiday decoration. Plastic trees, on the other hand, though they are reused for years and years, require petroleum to create and to ship from overseas factories and may contain toxics like PVC and lead. They're also not biodegradable.

So, which is the more sustainable choice? The best traditional Christmas decoration would be a plant, evergreen or other, that has a life beyond the holiday—live, potted trees can be planted outside, whether in your backyard or in another spot in the community. If you are not a traditionalist, you can decorate citrus trees or any sturdy plant. Otherwise, buying a farmed tree from a small grower that uses few pesticides is the best you can do. Or forget the tree and get creative—you'd be surprised at how many household items can do double duty as trees when strung with lights and ornaments.

Parinacota Volcano, Chile

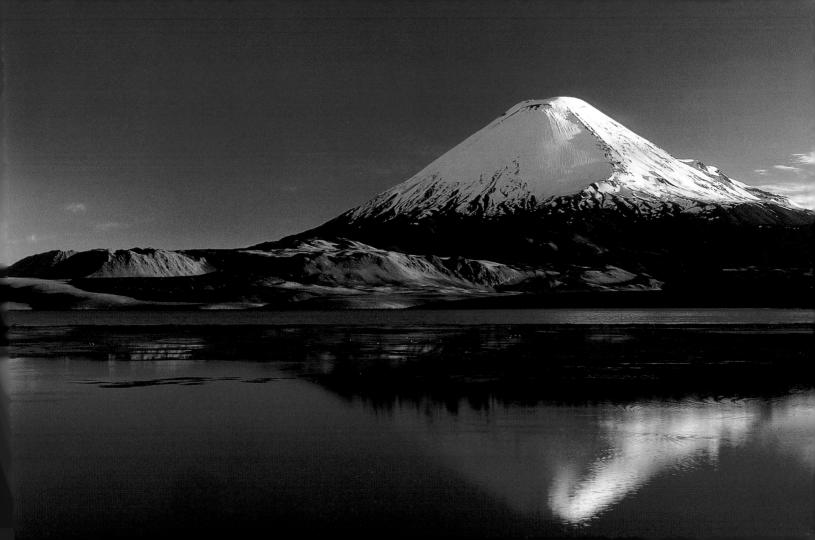

Use wood for heating.

America's forests cover 745 million acres, or 33% of the entire country. Of that total U.S. forested area, 495 million acres, or 67%, are commercial forests that are used to produce timber for wood products. As a source of energy, wood does not contribute to global warming. Although burning it releases carbon dioxide, a greenhouse gas, the amount given off is the same as the amount absorbed while the tree was growing.

Wood heating is more environmentally friendly than electric or gas. Consider using it for your second home, or if you live near forested regions where transport costs will be lower.

> Geyser Valley, Kamchatka, Russia

Invest in a solar charger.

Outfitting your home with solar panels isn't a viable option for most people, especially those who rent or have co-op boards or homeowners' associations to contend with. But everyone can generate a little bit of green power with a small solar charger that's capable of powering laptops, MP3 players, cell phones, and all the other gadgets that require constant recharging.

Solar chargers are portable and affordable. Not only can they reduce your power load at home, they can be of great use when traveling abroad, especially if you are in an area where electricity is a luxury or where there are frequent surges that could harm some electronics.

> Bison, Badlands National Park, South Dakota

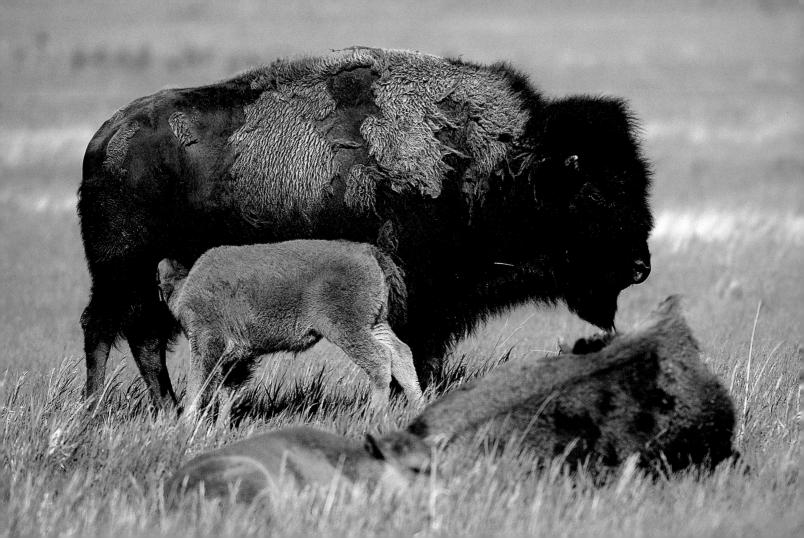

Use compact fluorescent or LED bulbs.

If every household in the United States replaced only 1 lightbulb with a compact fluorescent lightbulb (CFL), it would prevent an amount of pollution equivalent to removing 1 million cars from the road. Although their upfront cost is much more than the normal incandescent lightbulb, over their lifetime they will use up to 75% less energy and last 10 times as long. The savings is unquestionable.

Most states will accept CFLs in the normal trash stream, but check before putting them in the trash. They do contain a trace amount of mercury, but incandescents by proxy generate far more of the hazardous material—the less-efficient bulbs require much more electricity, and coal-fired power plants are our biggest source of mercury emissions. Light-emitting diodes (LEDs) are even more efficient than CFLs—they use 90% less energy than incandescents—but are also more expensive and not as widely available.

Phase out your incandescent bulbs and replace them with CFLs or LEDs. Nearly every shape and type of incandesent bulb has a corresponding CFL version available, including dimmable, three-way, and candelabra styles. If every American family switched 1 incandescent to a CFL we could save enough to light 3 million U.S. households for a year.

> Ol Doinyo Lengai Volcano, Tanzania

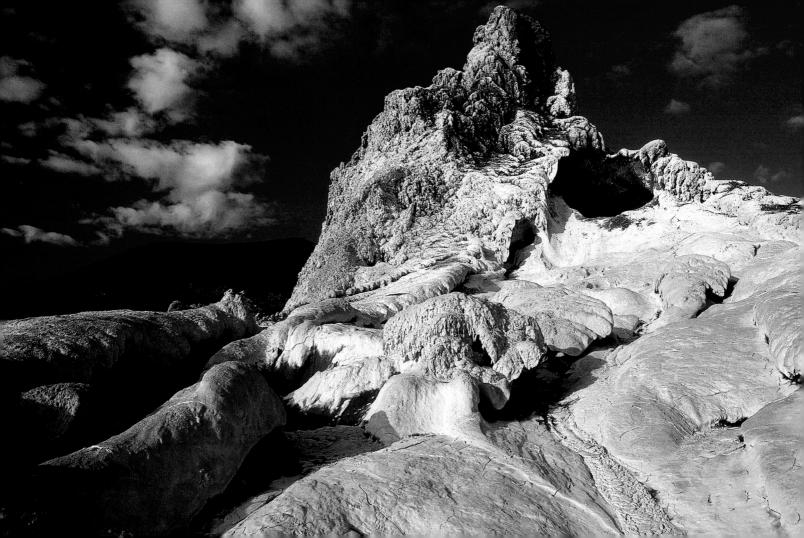

Choose organic cotton.

Cotton accounts for only 3% of the world's farmed land, but it uses 25% of the world's pesticides, making it the most pollution-causing crop. In order to grow the pound of cotton needed for the average T-shirt the conventional cotton farmer uses about one-third of a pound of hazardous chemical pesticides and fertilizers. Industrial processing of the raw fibers is equally harmful to the environment; it involves chlorine bleaching and the use of dyes made with heavy metals that are harmful to people and the environment. When grown without the use of pesticides, organic cotton restores soil fertility and preserves the balance of ecosystems. It is harvested by hand and processed without the use of chemical treatments.

Choosing organic cotton contributes to your well-being, as well as that of those who grow it, and safeguards the health of all humans and the environment.

Sequoias, Redwood National Park, California

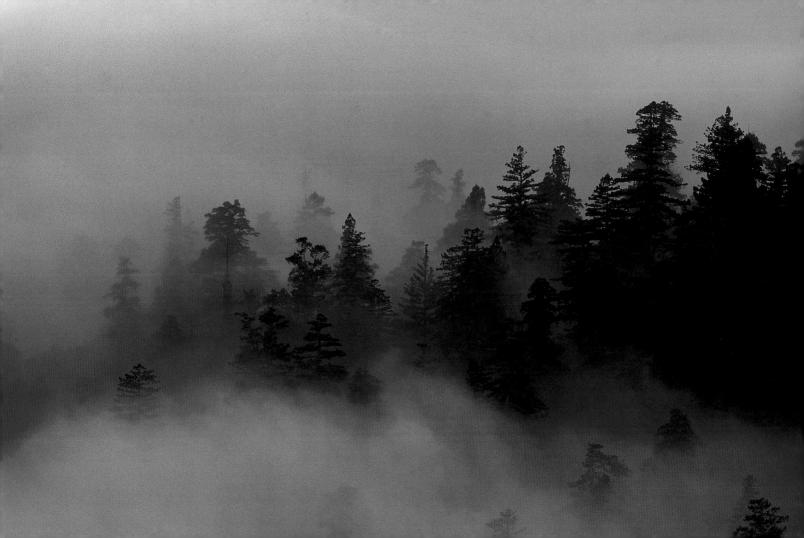

Make your own greeting cards.

To date, scientists have counted 1.5 million plant and animal species on Earth and estimate there are 15 million in all. Every day, however, several species disappear before we have even recorded their existence. Deforestation is thought to be causing the extinction of 27,000 diverse rain forest species—especially plants and insects—every year. Since making just one ton of paper requires 2.6 tons of wood, the amount of deforestation required is almost unimaginable.

When you need to send greetings, choose an e-card (a card sent by e-mail), or one that is printed on recycled paper. Better still, be creative and make your own greeting card from recycled or recovered paper and materials.

Use less wrapping paper.

Every second an area of tropical forest the size of a football field vanishes from the planet. Every year 78 million acres of rain forest are destroyed, including the extinction of 137 plant and animal species every day. Tropical forests are home to more than half the world's biodiversity.

Each year, millions of trees end up as wrapping paper. Use fabric ribbon or cord, instead of sticky tape, to fasten your gift-wrappings: Then you can reuse the ribbons and wrapping paper instead of tearing them up and throwing them out. If you buy new paper, look for products made from post-consumer recycled material (or hemp blends) and printed with soy-based inks. Some types of wrapping paper are recyclable, but what is accepted varies greatly from town to town, and paper with metallic or foil prints is not recyclable (neither is cellophane or all of those manufactured ribbons and bows).

Grasses, California

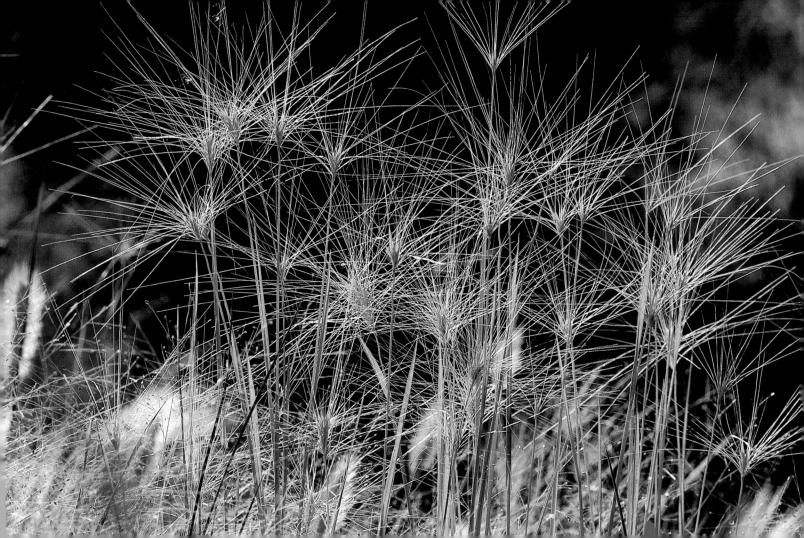

Give fair-trade toys as presents.

At a time when half of humanity lives on less than \$2 per day, Americans spent \$8.5 billion dollars on Christmas decorations alone and more than twice that much on presents. Eighty percent of toys sold in the United States are made in China and Southeast Asia, sometimes by children and with no regard for the social rights of workers, to meet demand from wealthy countries.

If you have had enough of receiving useless Christmas-theme gifts, gadgets that soon break and are eventually discarded, plastic toys that pollute, and packaging that contributes to wastage and produces more waste, then give fair-trade toys and waste-free presents. Pay more attention to the social and environmental quality of your purchases and ask those who are buying for you to do the same.

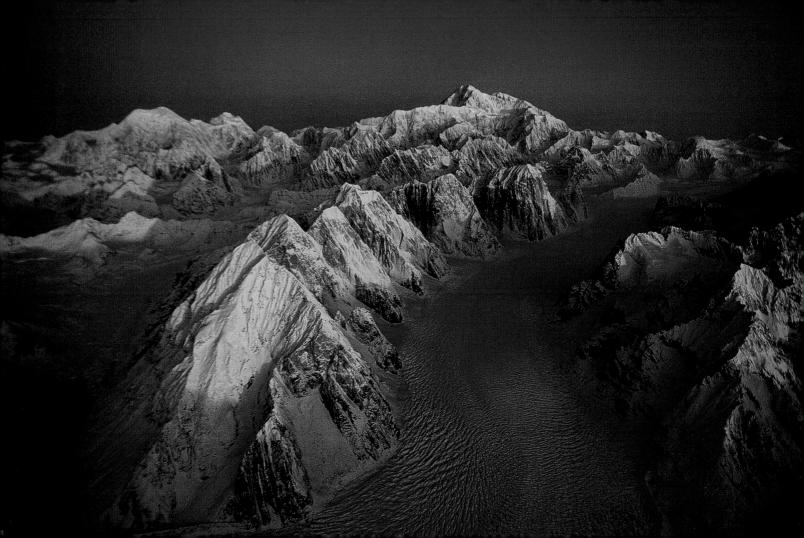

Support green schemes through gift giving.

Sometimes, people who may be open-minded toward supporting green services may be hesitant to try them out if there is an initial cost.

If any friends or colleagues have expressed interest in car- or bike-sharing programs, community-supported agriculture, eco-friendly lawn-care or housecleaning services, or any other community projects that have membership fees, offer to help them get started by paying annual fees or buying a trial subscription. Once they see the benefits for themselves, they are likely to renew the services on their own.

You can also offer to purchase carbon credits for folks who are traveling long distances for the holidays.

Paria Canyon-Vermilion Cliffs Wilderness Area, Arizona

Celebrate Christmas sustainably.

When Christmas approaches, the developed world becomes gripped by a frenzy of consumption, and good environmental resolutions are temporarily forgotten. A fifth more trash is thrown out at Christmas than during the rest of the year.

You can be creative and make your own Christmas tree decorations rather than buying plastic items that were manufactured on the other side of the world and in most cases propped on the tree for just a few days before being thrown out. Make a donation or give your time to a charity.

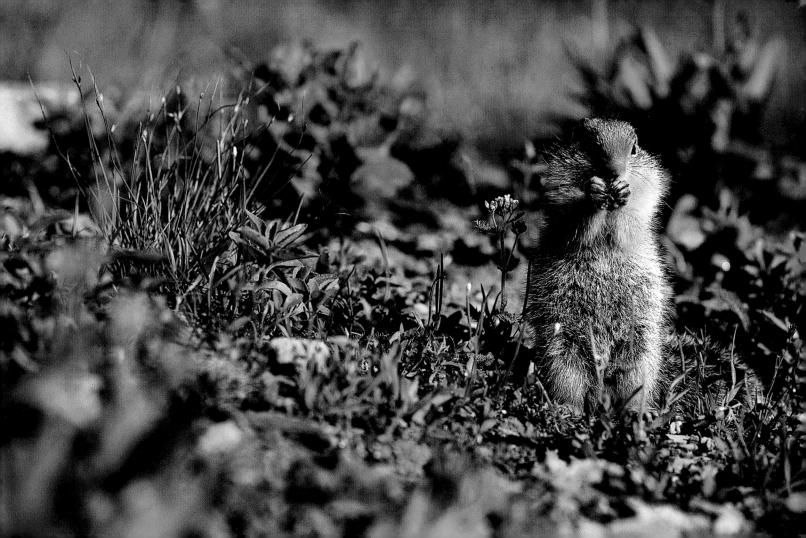

When traveling, respect the environment as you do at home.

In developing countries, the conditions under which tourists live, with swimming pools, air-conditioning, and excessive living areas, often divert natural resources at the expense of the people who live there or the ecosystem at large. For example, a single cruise ship produces 7,000 tons of waste every year. However, some tourist destinations are attempting to reverse this trend. The Seychelles, a group of islands northeast of Madagascar in the Indian Ocean, introduced a \$90 tax on travelers entering the islands. Revenue will be used to preserve the environment and improve tourism facilities.

Abroad, as at home, respect the environment and its resources: Do not waste water; switch off the light and television before leaving your hotel room; do not drop your garbage indiscriminately; and use public transport.

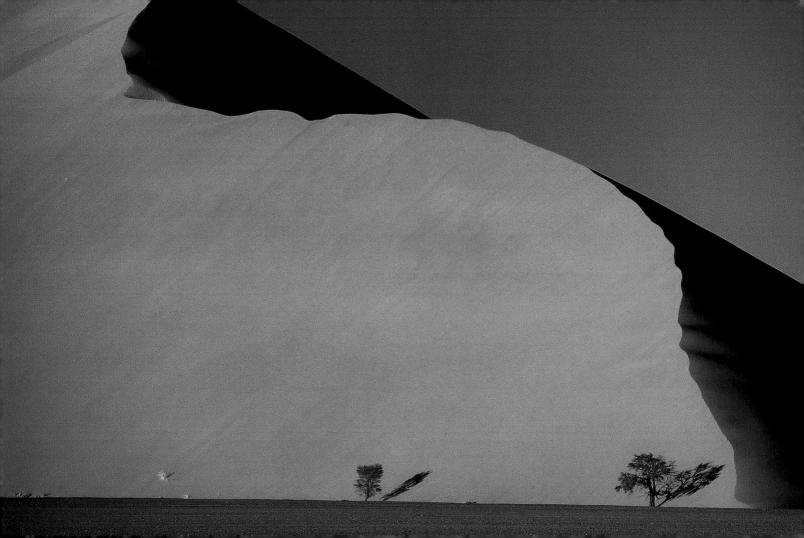

Learn to decipher logos on packaging.

According to the Federal Trade Commission, the "recyclable" label indicates a product can be separated from the waste stream and reused again in some fashion, although the label gives no indication of how environmentally friendly the packaging is.

The difference between recyclable and recycled—that is, between what is possible and what actually happens—may depend on you and whether you sort your waste. To avoid misunderstandings, learn to decipher the array of marks and logos on packaging, and ask your local recycling center what they will accept.

Turn down the heat when you are away from home.

Contrary to what is widely believed, lowering the temperature setting of heating does not cause extra consumption when the system is turned up again. For every degree you turn down your heat, you will save 5% on your heating bill.

Don't wait to turn down the thermostat. During the working day and when you are away for the weekend, turn the heating down 10 degrees below the temperature you usually find comfortable. When you are away for longer, set it just high enough to avoid freezing. On a daily basis, lower the temperature by 5 degrees: You will be doing your heating bill and the environment a lot of good.

Understand the "water footprint" of soft drinks.

One liter of soda requires about 2.7 liters of water to make-this number increases to 250 liters if you factor in the water needed to produce the sugar in that liter of soda. Coca-Cola uses on average more than 290 billion liters of water per year. Although some Coca-Cola plants have started to use rainwater recycling schemes, the company has come under constant attack in the past few years for the stress its bottling plants put on already scarce water supplies around the world. In India, villagers from several drought-stricken states have called for the closing of several plants, alleging that water table levels have dropped significantly since the company started bottling operations.

Find out what measures local bottling companies are taking to decrease their water use. Support campaigns that demand that manufacturers act responsibly in other countries (some college campuses took up the Indian villagers' cause by calling for a ban on Coke products). Reduce your consumption of soft drinks and buy only from those companies that have made documented efforts to address their impact on one of our most endangered resources.

Buy better properties.

Sustainable homes are not built on recycled materials and renewable energy alone. A house could present green features, but if it is part of a subdivision that encroaches on previously undeveloped habitat, is it really green? Too many housing developments are built far from local services and public transportation; in most of our suburbs, walking or even biking to shops or parks is impossible because of the distances involved and the lack of safe routes on low-speed roads.

No matter how many Energy-Star appliances it includes, if a house is oversized it has landscaping that requires a lot of water to keep up, or might be a cookie-cutter property that didn't take into consideration the specific demands of the land it is on. Make sure that you are buying a property that is sustainable on every level.

Keep hope.

To fully implement every change detailed in this book could take far longer than a year. And the suggestions here are just the tip of the (vanishing) iceberg. Pondering the state of our planet, our role in its degradation, and the sheer number of changes big and small that we have yet to enact is, to put it very mildly, overwhelming. But pessimism is not going to solve any of our problems: While sorting through the cold, hard facts, we must also take the time to recognize the enduring beauty of the earth and the resilience and creativity of the people who inhabit it.

Stay positive. Stay motivated. Do your best every day and focus not on the damage already done but on the achievable goal of a sustainable future.

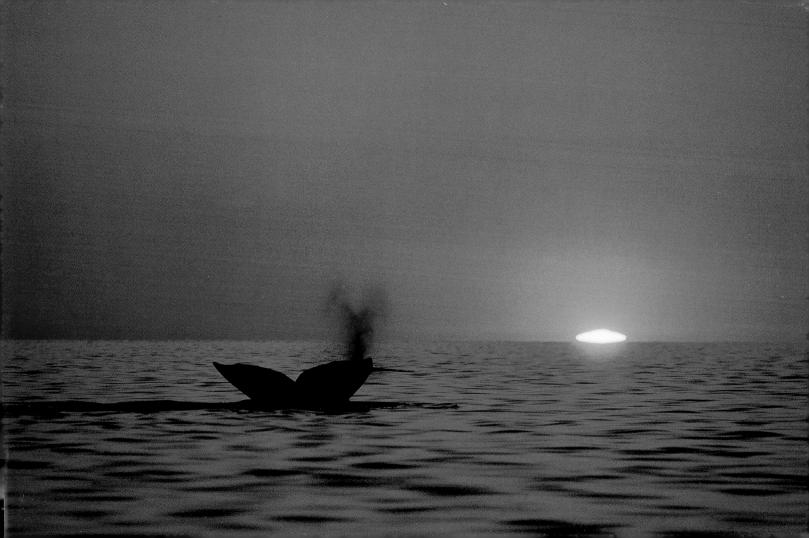

WEB SITES

General Resources/Climate Change

www.climatenetwork.org (Climate Action Network)
www.climatecrisis.net (informational web site for Al Gore's An Inconvenient Truth);
www.ipcc.ch (Intergovernmental Panel on Climate Change)
www.nrdc.org/globalWarming (NRDC's global warming Web site)
www.pewclimate.org (The Pew Center's site on climate change)
www.realclimate.org (ten scientists blogging about climate change)
http://unfccc.int (United Nations Framework Convention on Climate Change; link to Kyoto Protocol)

General Resources/Green Lifestyle Tips

www.thegreenguide.com (National Geographic's guide to environmentally friendly choices) www.grist.org http://sustainablog.org www.treehugger.com

General Resources/Sustainability

www.wri.org (World Resources Institute)

http://dotearth.blogs.nytimes.com (Dot Earth, New York Times' environment blog) www.earthday.net/footprint (calculate your ecological footprint) www.earthshare.org (Earth Share, a nationwide network of environmental organizations) www.earth-policy.org (Earth Policy Institute) www.emagazine.com (online home of *E Magazine*) www.ucsusa.org (Union of Concerned Scientists) www.undp.org/mdg (information on the United Nations' Millennium Development Goals) www.unep.org (The United Nations Environment Program) www.worldchanging.com (WorldChanging, blog covering the most forward-thinking green solutions) www.worldwatch.org (Worldwatch Institute)

Energy/Conservation

www.aceee.org (American Council for an Energy-Efficient Economy)
www.consumerenergycenter.org (source for energy tips)
www.earthhour.org (international energy awareness campaign)
www.energystar.gov (energy-efficient appliances rating system)
www.energy.gov/consumer/your_home/energy_audits (U.S. Department of
Energy's Home Energy Audit page)
www.energy.gov/yourhome.htm (U.S. Department of Energy; consumer energy tips)
www.energyguide.com (smart energy choices guide)
www.greentagsusa.org (Bonneville Environmental Foundation; green tags vendor)
www.green-e.org (green tag certification program)
www.diykyoto.com (Wattson energy-conservation device)
www.p3international.com (Kill a Watt energy-conservation device)
www.terrapass.com/green-store (online store for energy-saving devices)

Energy/Green Power

www.awea.org (American Wind Energy Association)
www.crest.org (Center for Renewable Energy and Sustainable Technology)
www.eia.doe.gov (Energy Information Administration)
www.epa.gov/grnpower (Environmental Protection Agency Green Power Homepage)
www.eere.energy.gov/consumer/ (U.S. Department of Energy Consumer's Guide to
Energy Efficiency and Renewable Energy)
www.eere.energy.gov/greenpower/markets/netmetering.shtml (information on net
metering)
www.homepower.com (online edition of Home Power Magazine)
www.renewableenergy.world.com (Renewable Energy World, an information
clearinghouse)

Business

www.greenbiz.com (green business blog)
www.goodcompany.com (environmental audit company)
www.naturalstep.org (environmental audit company)

www.sharetechnology.org (computer equipment donation)
www.smartoffice.com (Sustainable Development International Corporation; tips on
greening your business)
www.sustainableindustries.com (e-zine for green business owners)

www.telepeeps.com (telecommuting tips)

Consumer Resources/General

www.climatecounts.org/scorecard.php (scorecard that rates corporate responsibility)
www.epeat.net (Electronic Product Environmental Assessment Tool; how to find green
electronics)

www.greenerchoices.org (The Consumers Union site analysis of eco-labels)
www.greenwashingindex.com (forum that analyzes ads for instances of greenwashing)
www.terrachoice.com/files/6_sins.pdf (document explaining the basics of
greenwashing)

Consumer Resources/Fashion & Style

www.conflictfreediamonds.org (The Conflict-Free Diamond Council) http://ecofabulous.blogs.com (green goods and design blog) www.epa.gov/dfe/pubs/garment/gcrg/cleanguide.pdf (EPA's list of green dry cleaners) www.inhabitat.com (stories and links to sustainable fashion) www.nodirtygold.org (campaign to make gold industry more sustainable; links to responsible retailers) www.stylewillsaveus.com (e-zine on sustainable fashion)

www.sustainablecotton.org (information on organic cotton) www.sustainablestyle.org (Sustainable Style Foundation)

Consumer Resources/Organics

www.ifoam.org (International Federation of Organic Agriculture Movements) www.organicconsumers.org (The Organic Consumers Association) www.organic.org (electronic information clearinghouse on organic products) www.theorganicpages.com (Organic Trade Association's searchable directory of organic products)

Consumer Resources/Fair Trade

www.equalexchange.com (fair trade products)
www.fairtradefederation.org (directory of fair trade products)
www.fairtrade.net (Fair-Trade Labeling Organizations)
www.globalexchange.org (fair trade products)
http://transfairusa.org (web page for the Fair Trade Certified label)
www.veriflora.com (eco-label for sustainably grown flowers and plants)

Consumer Resources/Food & Agriculture

www.csacenter.org (electronic directory of Community Sponsored Agriculture Programs) www.centerforfoodsafety.org (information on GMOs) www.eatgrub.org (resource on healthy and sustainable food) www.foodfacts.info/blog (blog with fast food nutrition information) http://greengrog.com (blog about green brewing) www.heritagefoodsusa.com (vendor of heritage breed meats) www.foodalliance.org (Food Alliance, which promotes sustainable agriculture) www.foodroutes.org (information on buying local produce) www.localharvest.org (electronic directory of local produce sources) www.montereybayaquarium.org/cr/seafoodwatch.asp (Seafood Watch, tips on choosing healthy and sustainably caught fish) www.msc.org (Marine Stewardship Council) www.responsibletechnology.org/GMFree (Institute for Responsible Technology; information on GMO-Free food) www.seaweb.org/resources/aquaculturecenter (SeaWeb's page on sustainable aquaculture) www.slowfoodusa.org (Slow Food Movement Webpage and blog) www.vegetariantimes.com (recipes, starter kit)

Health & Beauty

www.aidforaids.org (nonprofit that accepts donated medications)
www2.btcv.org.uk/display/greengym (information on starting a green gym program)

www.cosmeticsdatabase.com (Cosmetics Safety Database)
www.colipa.com (European Cosmetic Toiletry and Perfumery Association)
http://eartheasy.com/live_nontoxic_solutions.htm (online guide to nontoxic cleaning
alternatives)

www.earthsave.org (EarthSave promotes a shift toward a healthy plant-based diet) http://greenlivingideas.com/household-cleaning/index.php (suggestions for making your own nontoxic cleaners)

www.leapingbunny.org (Coalition for Consumer Information on Cosmetics) www.redcross.org (for information on donating medication) www.safecosmetics.org (Campaign for Safe Cosmetics) www.thestarfishproject.org (nonprofit that accepts donated medications)

www.intestartistiproject.org (holipform that accepts donated medications www.uniteforsight.org; www.neweyesfortheneedy.org

Carbon Offsetting

www.carbonfund.org www.climatecare.com www.terrapass.com

Children

www.epa.gov/enviroed (EPA's site for getting environmental education into schools) www.farmtoschool.org (resources to bring healthy food from local farms to cafeterias) www.greenschools.net (The Green Schools Initiative)

www.neefusa.org (National Environmental Education and Training Foundation) *www.projectwild.org* (Project WILD, model conservation and environmental education program)

http://usatla.home.comcast.net (U.S. Toy Library Association) www.walkingschoolbus.org (information on starting walk to school groups)

Gardening & Composting

www.beyondpesticides.org (National Coalition Against the Misuse of Pesticides) www.communitygarden.org (American Community Gardening Association) http://compost.css.cornell.edu/resources.html (Cornell University's school composting programs resources) www.compostguide.com (online composting guide) www.edibleestates.org (project that transforms lawns into gardens) www.epa.gov/compost (EPA's composting guide and links) www.howtocompost.org (online guide on composting) www.nativeseeds.org (seed biodiversity conservation site) www.pana.org (Pesticide Action Network North America) www.plantnative.org (Plant Native, links to nurseries and resources) http://pruned.blogspot.com (landscape architecture blog that often covers sustainability)

www.seedsavers.org (resource for finding heirloom seed varieties)

Green Building

www.buildinggreen.com (articles on green building and links to green products) www.dwell.com/homes/prefab (articles on green prefabs from Dwell Magazine) www.epa.gov/greenbuilding (EPA's site on green building)

www.epa.gov/heatisld/strategies/coolroofs.html (info on creating cool roofs) www.epa.gov/iaq/voc.html (EPA's site on Volatile Organic Compounds used in solvents and paints)

www.fscus.org (Forest Stewardship Council; label for sustainably harvested wood products)

www.greenroofs.net (information on creating green roofs)

www.inhabitat.com (blog featuring green buildings, renovating tips, and info on sustainable prefabs)

www.lowimpactdevelopment.org (The Low Impact Development Center) www.smartgrowthamerica.org (site about building sustainable communities) www.usgbc.org (United States Green Building Council)

Banking & Investing

www.firstaffirmative.com (sustainable investment advisory firm)
www.grameenfoundation.org (microfinance nonprofit)

www.greenmoneyjournal.com (articles on SRIs and other green investing issues)
www.kiva.org (microfinancing nonprofit)
www.socialfunds.com (resources on SRIs)
www.socialinvest.org (social investment forum)

Politics & Activism

http://11thhouraction.com (11th Hour Action Network) www.adbusters.org/metas/eco/bnd (Buy Nothing Day information) www.blogactionday.org (Blog Action Day information) www.consumersunion.org (The Consumers Union) www.computertakeback.com (E-waste take back campaigns) www.epa.gov/tips (Tips on reporting environmental violations) www.globalpolicy.org (monitors policy making at the United Nations) www.greenpeace.org (Greenpeace, wildlife conservation activism) www.hrw.org (Human Rights Watch)

www.lcv.org (League of Conservation Voters)

www.thepetitionsite.com/environment-and-wildlife (compendium of environmental and human rights petitions)

Recycling

http://earth911.org/recycling (tips, facts, and links for all types of recycleables) www.epa.gov (U.S. Environmental Protection Agency; info on recycling and municipal waste issues)

www.ban.org (Basel Action Network; monitors e-waste recycling programs) www.carpetrecovery.org (Carpet America Recovery Effort)

www.cartridgesforkids.com (information on printer cartridge recycling charitable programs)

www.ewasteawareness.org (List of charities that accept old cell phones)
www.greendisk.com (CD recycling service)

www.makezine.com (techie DIY magazine)

http://readymademag.com (DIY magazine featuring inventive reuse projects)

www.recyclemycellphone.org (Earthworks' Cell Phone Recycling page)
www.recycledrunners.com (sneaker recycling program)

Transportation

www.bikesbelong.org (advocacy network with resources and tips on to make your town more bike-friendly) www.bicyclefriendlycommunity.org (profiles of bike-friendly cities) www.bikeleague.org (League of American Bicyclists; articles and information on rallies and National Bike Month) http://bike-sharing.blogspot.com (blog about worldwide bike-sharing schemes) www.carsharing.net (links to car-sharing programs) www.greencarcongress.com (blog on developments in hybrid technology and fuel alternatives) www.hybridcars.com (reviews of hybrid vehicles) www.nearbio.com (resource for finding biodiesel stations) www.raileurope.com (information on traveling Europe by train) www.sierraclub.org/sierra/pickyourpoison (Sierra Club rates major gasoline companies based on socially and environmental responsibility) www.smartbikedc.com (SmartBike, U.S's first bike-sharing program in Washington D.C.) www.traintraveling.com (information on traveling through the United States and Canada by rail) www.zipcar.com (national car-sharing company)

Tourism

www.blueflag.org (eco-label for international beaches and marinas)
www.eco-label.com (eco-label for European products, including tourism facilities)
www.ecovolunteer.org (Eco-volunteer Nature Travel)
www.ethicaltraveler.org (responsible travel blog)
www.globalvolunteers.org (voluntourism site)
www.greenglobe21.com (sustainable travel and tourism information)
www.greenhotels.com (Green Hotels Association)

www.green-key.org (international eco-label for tourism facilities)

www.lonelyplanet.com/responsibletravel (tips on responsible travel from Lonely Planet) www.nationalgeographic.com/travel/sustainable (Center for Sustainable Destinations links and articles)

www.nps.gov (National Park Service)

www.nsaa.org/nsaa/environment (National Ski Areas Association Environmental Charter)

www.peaktopeak.net (links to state park sites and trails and national forests)
www.sustainabletravelinternational.org (directory of eco-friendly operators, resources
on responsible travel)

www.treadlightly.org (tips on sustainable recreation)

www.voluntourism.org (information on voluntourism)

http://whc.unesco.org (information on UNESCO World Heritage Sites)

www.worldwildlife.org/buyerbeware (tips to avoid buying souvenirs made from endangered species)

Waste Reduction

www.epa.gov/epaoswer/education/lunch.htm (how to pack a waste-free lunch) www.dmachoice.org (Direct Marketing Association; opt out of junk mail) www.freecycle.org (reuse and resource sharing organization) www.junkbusters.com (junk-mail reduction) www.privacyrights.org (junk-mail reduction) www.stopthejunkmail.com (United States Postal Service junk-mail reduction) www.zerowasteamerica.org (Zero Waste America program)

Water

www.americanrivers.org (information on endangered rivers and conservation activities and campaigns) *www.awra.org* (American Water Resources Association)

www.cwp.org (Center for Watershed Protection)

www.epa.gov/safewater (info and links on local water quality)

www.foodandwaterwatch.org (resources on how to test and filter tap water)

www.h2ouse.org (guide to making your home water efficient)

www.internationalrivers.org (International Rivers Network; information on conservation campaigns)

www.rain-barrel.net (guide to collecting rainwater)

www.waterfootprint.org (tool to calculate the water footprint of your lifestyle and certain consumer practices)

www.wateruseitwisely.com (water conservation tips, regional news, and links) http://water.usgs.gov (United States Geological Survey's Water Resources Webpage) www.worldwaterday.org (information on worldwide water and sanitation issues)

Wildlife & Habitat Conservation

www.arborday.org (information on tree-planting programs) www.audubon.org/bird/cbc/ (Christmas Bird Count site) www.coralreefalliance.org (international reef conservation foundation) http://citizensci.com (general resource and networking site for citizen science projects) www.fishcount.org (Great Annual Fish Count; citizen science project for divers) www.fws.gov (U.S. Fish and Wildlife Service) www.hsus.org (Humane Society of United States; campaigns against animal cruelty and pet adoption tips) www.mangroveactionproject.org (restoration project for mangrove forests worldwide) www.nature.org (The Nature Conservancy) www.nwf.org (The National Wildlife Federation) www.oceanconservancy.org (The Ocean Conservancy) www.saveourseas.org (Save Our Seas) www.sierraclub.org (habitat and species conservation campaigns and green living tips) www.surfrider.org (Surfrider Foundation; advocacy against ocean and beach pollution) www.tpl.org (The Trust for Public Land) www.traffic.org (Traffic, illegal wildlife-trade monitoring organization) www.wetlands.org (Wetlands International) www.worldwildlife.org (World Wildlife Foundation; info on endangered species and conservation projects)

BIBLIOGRAPHY

Bartillat, Laurent de and Simon Retallack. Stop. Paris: Éditions du Seuil, 2003.

Bouttier-Guérivé, Gaëlle and Thierry Thouvenot. *Planète attitude*, les gestes écologiques au quotidian. Paris: Éditions du Seuil, 2004.

Callard, Sarah and Diane Millis. Le Grand guide de l'écologie. Paris: J'ai lu, 2003.

Carson, Rachel. Silent Spring. New York: Mariner Books, 2002.

Chagnoleau, Serge. L'écologie au bureau. Paris: Maxima, 1992.

Desai, Pooran. One Planet Living. Bristol, U.K.: Alistar Sawday's, 2006.

Dubois, Philippe J. Un nouveau climat. Paris: Éditions de La Martinière, 2003.

Dubois, Philippe J. *Vers l'ultime extinction? la biodiversité en danger*. Paris: Éditions de La Martinière, 2004.

Dupuis, Marie-France and Bernard Fischesser. *Guide illustré de l'écologie*. Paris: Éditions de La Martinière, 2000.

Glocheux, Dominique. Sauver la planète, mode d'emploi. Paris: Éditions J. C. Lattès, 2004.

Hillman, Mayer. How We Can Save the Planet. New York: St. Martin's Griffin, 2008.

Matagne, Patrick. Comprendre l'écologie et son histoire. Paris: Delachaux et Niestlé, 2002.

Ramade, François. *Dictionnaire encyclopédique de l'écologie et des sciences de l'environnement*. Paris: Dunod, 2002.

Steffen, Alex. Worldchanging. New York: Harry N. Abrams, 2006.

ACKNOWLEDGMENTS

I would like to particularly thank:

My editor Hervé de La Martinière for his loyalty.

Benoît Nacci for his attentive photographic selection.

Anne Jankéliowitch for the quality of her research and her work on the 365 texts that accompany my photographs.

Catherine Guigon and Emmanuelle Halkin for their thoughtful arrangement of the texts. The team at Éditions de La Martinière: Dominique Escartin, Sophie Giraud, Audrey Hette, Marianne Lassandro, Valérie Roland, Isabelle Perrod, Sophie Postollec, Cécile Vanderbroucque.

Thanks to:

Everyone who participated in these trips at close quarters or from a distance: Claude Arié, Yann Arthus-Bertrand, Jean-Philippe Astruc, Jacques Bardot, Allain Bougrain Dubourg, Jean-Marc Bour, Monique Brandily, Yves Carmagnolles, Sylvie Carpentier, Jean-François Chaix, Carolina Codo, Richard Fitzpatrick, Alain Gerente, Patrice Godon, Robert Guillard, Nathalie Hoizey, Gérard Jugie, Janot and Janine Lamberton and the Inlandsis expedition team, Monique Mathews, Frédéric and Mimi Neema, Stephan Peyron, Philippe Poissonier, Gloria Raad, Le Raie Manta club, Margot Reynes, Hoa and Jean Rossi, John and Linda Rumney and the Undersea Explorer team, Diane Sacco, Hervé Saliou, Vincent Steiger, Sally Zalewski...

Gero Furcheim, Gaelle Guoinguené, Jean-Jacques Viau at Leica, who have been loyal followers for so long. I worked with excellent Leica R9 and M7 cameras and 19 mm to 280 mm lenses that are reliable in any circumstance.

Marc Héraud and Bruno Baudry at Fujifilm for their help and support. All the photos were shot on Fujichrome Velvia (50 Asa) films.

Olivier Bigot, Denis Cuisy de Rush Labo, Jean-François Gallois de Central Color, and Stephan Ledoux at cité de l'Image.

The Richard Lippman team at Quadrilaser.

My apologies to all those I have forgotten to name and who helped me in this work. I am sincerely sorry and thank them wholeheartedly. Original Edition, published in 2005 by Abrams, an imprint of Harry N. Abrams, Inc:

Anne Jankéliowitch and Ariel Dekovic, Co-authors Simon Jones, Translator Magali Veillon, Project Manager Marion Kocot, Editor

New and Updated Edition:

Magali Veillon, Editor Shawn Dahl, Designer Michelle Ishay and Neil Egan, Jacket design Jules Thomson, Production Manager Valérie Roland, Icon Illustrator Library of Congress Cataloging-in-Publication Data

Bourseiller, Philippe.

[365 gestes pour sauver la planète. English] 365 ways to save the earth / by Philippe Bourseiller. – New and updated ed.

p. cm.

ISBN 978-0-8109-8406-6

1. Nature photography. 2. Environmental protection. 3. Nature conservation. I. Title. II. Title: Three hundred sixty-five ways to save the earth. III. Title: Three hundred and sixty-five ways to save the earth.

TR721.B6813 2008 779'.3092-dc22 2008016676

Copyright © 2005 and 2008 Éditions de La Martinière, an imprint of La Martinière Groupe, Paris English translation copyright © 2005 and 2008 Abrams. New York

Originally published in French under the title *365 Gestes pour sauver la terre* by Éditions de La Martinière, Paris, 2005. Published in 2008 by Abrams, an imprint of Harry N. Abrams, Inc. All rights reserved. No portion of this book may be reproduced, stored in a retrieval system, or transmitted in any form or by any means, mechanical, electronic, photocopying, recording, or otherwise, without written permission from the publisher.

Printed and bound in China 10987654321

Abrams books are available at special discounts when purchased in quantity for premiums and promotions as well as fundraising or educational use. Special editions can also be created to specification. For details, contact specialmarkets@hnabooks.com or the address below.

HNA MARKANIA harry n. abrams, inc. a subsidiary of La Martinière Groupe

115 West 18th Street New York, NY 10011 www.hnabooks.com

This book was printed using environmentally friendly paper and inks.